The Fine Artist's Career Guide

*Making
Money
in
the
Arts
and
Beyond*

SECOND
EDITION

**DANIEL
GRANT**

**ALLWORTH
PRESS**
NEW YORK

08 07 06 05 04 5 4 3 2 1

Published by Allworth Press
An imprint of Allworth Communications
10 East 23rd Street, New York, NY 10010

Cover design by Derek Bacchus
Interior by Charlie Sharp
Page composition by Integra

ISBN: 1-58115-347-3

Library of Congress Cataloging-in-Publication Data

Grant, Daniel.
 The fine artist's career guide / Daniel Grant. — 2nd ed.
 p. cm.
Includes bibliographical references and index.
1. Art—Vocational guidance—United States. I. Title.

N6505.G657 2004
702'.3'73—dc22

 2004001815

Printed in Canada

Contents

Introduction

BEING AN ARTIST NOWADAYS MEANS BUILDING A CAREER ON TWO TRACKS: Track One is finding a job that will cover the essentials (food, clothing, shelter) and then some (art materials, studio rental, student loan payments, among other possible expenses). The average college student graduates these days $14,000 in debt (paying $170 per month for a ten-year loan) only to enter a job world in which the average starting salary is $24,000. Track Two is developing a presence in the art world that will eventually lead to an income, supplementary at first and perhaps full-time later as an artist. Today it is the rare artist indeed who has not needed to have a job to support his or her art. A job, however, is not just something that produces a steady paycheck; it has to be thought about with some care. Waiting tables is not likely to earn one enough money to pay back a student loan and, after years of trying to exhibit and sell artwork, one may only be qualified to wait tables some more. According to several surveys, most artists spend more on art materials than they receive in income from sales, a fact that renders their job income even more crucial. Many artists prefer to seek jobs that do not involve their artistic skills and talents, believing that their art-making energies will be diverted or that their art itself will be corrupted, turning into something that feels like just more work. Others look for jobs within the arts or those that call upon their art training so that the process of earning a living does not take them permanently away from art-making, which is the reason that they sought that training in the first place. Both approaches are valid: the history of art in the twentieth century has seen artists emerge from any number of professions, from wine

merchant (Yves Tanguy), mailman (Arnold Friedman), and lawyer (Vasily Kandinsky and Henri Matisse) to art critic (Fairfield Porter), architect (Tony Smith), and museum curator (Howardena Pindell). This book naturally focuses on jobs—or, perhaps, second careers—that call upon one's art skills and training. Some of these careers may require additional study or degrees, but in every instance a studio art background is relevant and highly advantageous. No one should believe the cynics who claim that training in art only prepares one for unemployment and poverty.

Becoming an artist is not solely the result of a strong will to succeed. People become artists in association with others who are like-minded, joining societies, associations, and cooperative galleries, even living or renting studio space in a building with other artists. The Romantic image of the artist depicts the individual standing alone, but artists have always congregated in some place, providing each other with mutual support, an exchange of ideas, and what we nowadays call "networking opportunities." Artists work and exhibit their work together as well as share information about opportunities. Regardless of the job one pursues, anyone believing him- or herself to be an artist should develop a wide range of attachments with other artists; otherwise, the desire to make art one's career will be only a fading dream.

Selecting an Art School

I N 1930, EIGHTEEN-YEAR-OLD JACKSON POLLOCK LEFT HOME, TRAVELING ACROSS the country to take classes at the Art Students League in New York City, joining his brother Charles, who was already there studying under the painter Thomas Hart Benton. Five years later, Pollock joined the New York workshop of Mexican muralist David Alfaro Siqueiros, following another brother, Sande, and a friend, Reuben Kadish. Earning a bachelor's or master's degree was probably not on his mind; rather, he was doing as artists had done for centuries—following the artistic currents of the time to the cities, studios, and private schools of the artists whose work most interested him.

Nowadays, eighteen-year-olds with an enthusiasm for making art are likely to choose among the hundreds of art schools and university art departments, seeking college degrees and basing their selections on reputation, facilities, student-teacher ratios, and career services offices. Virtually all of the fine and commercial artists schooled in the postwar era have taken this route, learning theories and technical skills and gaining an important credential for the society outside the classroom.

Art academies are not exactly like trade or professional schools, such as those for business, engineering, law, appliance repair, and medicine, which are judged on their ability to produce qualified, employable workers who

will achieve some appreciable level of success in their fields. There are some similarities, however, as the bachelor of fine arts (BFA) is a professional degree. Art schools exist to develop students' skills and understanding of their craft, yet bachelor's and master's degrees in fine arts are also career degrees, for which students have certain expectations. If one could do just as well without going to school, why bother? Many students look to these degrees as the first step in landing a teaching position or gaining gallery representation or assuring some other tangible achievement.

Choosing the Program or School

There can be significant differences between one art school (or one art program) and the next—based on the emphases of a school or program, the number of specialized departments, the quality of teaching, student-teacher ratio, facilities, and overall characteristics of the student body—but the basic approach is essentially the same. Most art students start out with "foundation" courses (two-dimensional and three-dimensional design, which teach problem-solving and critical skills in a variety of media) and introductory classes in various art media, principally painting, sculpture, printmaking, and photography. The classes in painting teach color and composition principles as well as the handling or manipulation of oil (and possibly acrylic) paint; the sculpture course instructs students in materials, processes, and techniques, using a variety of media (metal, plaster, and wood, usually); the printmaking course offers students the opportunity to experience intaglio and lithographic processes; the class in photography teaches the use of large-format cameras, film exposure, and darkroom techniques. There may be other introductory courses in videography, digital imagery, ceramics, and other media.

Most incoming freshmen think of themselves as painters, and painting tends to be the most heavily enrolled department at fine art schools and universities; however, some will be captivated by a medium to which they previously had only limited exposure. Art schools generally do not require students to declare a major until their sophomore or junior year, in part to ensure that specialization does not occur too early and without some knowledge of other areas of interest. "The usual entrée to art for high school students is two-dimensional work," said Greg Skinner, chairman of the art department at Cornish College of the Arts in Seattle, Washington. "Most students say that they're painters without ever taking photography, sculpture, printmaking, video, or anything else. I say to them, 'How do you know you're a painter if you've never tried these other things?'" On a practical

level, art students who may look to teach or create art commercially in the future should cultivate experience in several media, because this makes them more employable.

When evaluating a BFA program—through reading a directory of schools (such as *Barron's, Kaplan's, Lovejoy's,* or *Peterson's*) or a particular college's catalog, talking with an admissions counselor over the telephone or in person, interviewing a current student or graduate of the program, examining the school's Web site, or visiting the school in person—students should look at how many departments exist, how many faculty members work in each department (full- or part-time), and the breadth of course offerings. One might think twice about majoring in an area for which there are only two faculty, for instance, because there might not be sufficient diversity of opinion and techniques to keep a student challenged over a four-year period. On the other hand, small departments with open-minded faculty may offer students personalized instruction. Again, on a practical level, the greater the exposure to various ideas and experiences one receives, the more capable the individual should be at applying skills professionally in different fine and applied art settings. However, determining how many faculty work in a given department is a question for which there is not always an easy answer, because certain instructors work in two or three different departments and the hiring of part-timers and adjuncts is ongoing.

Art schools are not evaluated in the same manner as college humanities departments or law and business schools, using objective criteria (faculty publications and the placement rate of graduates, for instance). *U.S. News and World Report* has periodically rated art schools among its other comparative listings of colleges and universities, but standings are assigned based on polls of school officials, in which they are asked to rate other institutions in the United States. "The better-known institutions get the votes, even if the people voting for them have never set foot on those campuses," said Samuel Hope, executive director of the National Association of Schools of Art and Design, which is based in Reston, Virginia. "Reputational rating doesn't necessarily tell you anything about the nature of the institution or the quality of teaching. There can be a considerable difference between an institutional rating and programmatic quality." He added that such ratings represent a consensus, "and the consensus has meaning—a high reputation is usually deserved, but ratings can be misleading and destructive in individual cases. Getting into one of the top-rated schools is an achievement, but it doesn't automatically provide future success. Students should not be discouraged if they don't make it into someone's top ten."

Another difficulty in ranking a few schools at the top of a list is the assumption that the top school or two is the right one for all students. Also,

the reputational ratings tend to favor those schools that are well known, wealthy, and selective, all factors that have no relation to teaching quality.

Obtaining answers to the range of questions a potential applicant may have about a school involves a considerable amount of work at times. The admissions office has some information, as do the school registrar, student services, dean of academic affairs, and department chairs. Which office could provide a detailed biography of studio faculty differs from school to school; for instance, many catalogues contain extensive information about instructors, while others reveal little or nothing. Before officially applying to (and certainly before enrolling in) a school, prospective applicants should direct the admissions office or whoever has full biographies of faculty to send along that information. These biographies or résumés should indicate not only the instructors' education and teaching experience but the degree to which they pursue an art career actively. Some instructors may be excellent teachers and motivators of young artists with little (or not very recent or not very high-level) personal art careers of their own. The benefit of an active career is that an instructor is apt to have a better sense of how and where to exhibit and sell work than does a faculty member whose understanding of the art market is more theoretical. The ideal instructor is one who (as a teacher) can help the student now and who (as a connection and role model) can also help later, when the student graduates and needs direction in establishing a career.

Not only do prospective students look for schools, but schools also look for potential applicants, and they do so in a number of ways. Almost every student who takes the PSATs or SATs indicates a likely major, and art schools buy lists from the Educational Testing Service of all those who check off "art"; there are usually more than 25,000 names and addresses on that list. "We have ten student interns calling three hours a night to names on that list, to find out if the high school student would like any information about our program," noted Judith Aaron, dean of admissions at Pratt Institute in Brooklyn, New York. Other lists are available from ACT and professional search services.

Art schools and university art programs also advertise in directories, magazines, and newspapers. On a more personal basis, admissions counselors meet with prospective students by visiting high school art classes (they may be invited by an art teacher or just go there routinely if they receive applications from students at the school), as well as attending college fairs, governors' art shows, and portfolio days. Every state has a governor's art show (Ohio Governor's Youth Art Show, Young Talent of Oklahoma, among others) in which two- and three-dimensional works by high school students (recommended by their teachers) are exhibited. High

school students who are interested in applying to an art school might encourage their art teachers to learn about these exhibitions and submit their work.

There are two organizations that hold portfolio days: the National Portfolio Day Association runs events on the campuses at member institutions of the National Association of Schools of Art and Design, sponsoring between thirty and thirty-five events annually, while the National Association of College Admissions Counselors in Alexandria, Virginia, holds performing and visual arts fairs at colleges and universities in twenty-five or so cities around the United States every year. They always take place on a Saturday and Sunday, usually from noon to 4 P.M. Between fifteen and forty-five colleges and art schools may be represented at a given event, attended by as many as 1,500 high school students who come to meet admissions counselors and show their portfolios. Counselors sit behind tables in a large room, such as a gymnasium or cafeteria, handing out information packets on their schools, talking with prospective applicants about their interests, training, commitment to attending an art school, and, finally, discussing the work in the portfolio. Some high school sophomores and juniors attend portfolio days in order to learn about college art programs and receive feedback. For high school seniors and others who will be applying, these conversations count as interviews—admissions counselors take notes, checking off certain areas on a form (such as use of line, color, composition) that will become part of a student's application materials—although the length of time a counselor spends per student is generally under fifteen minutes. "We try to get through the crowd quickly," James Dean, dean of admissions at the Ringling School of Art and Design in Sarasota, Florida, said. "Students get frustrated with long lines and go to a table where the line isn't so long. We try to do twenty-five students in the four-hour period." Based on the variety of reactions students receive to their work, portfolio days may be good opportunities for them to get a sense of how one school differs from another.

Admissions counselors offer quick assessments of students' portfolios (e.g., needs more direct observational work, edit out those pieces, please apply to our school, try that subject again and resubmit the portfolio). What these portfolio reviews lack in depth they make up for in developing a consensus, as students go from table to table, listening to different school representatives in order to get a sense of how they are viewed as artists (their strengths and weaknesses), as well as how suited they may be for art school. Portfolio-day events may seem frustrating and confusing to students, an impression that the sponsors try to ease by informing high school art teachers in advance about what takes place so they can

adequately prepare students. "The portfolio review seems to most students like being sent to the principal because they've been bad," said Greg Skinner. "They're scared to death." If possible, students should try to relax and recognize that the portfolio review is part of the process of learning to be a professional artist.

Of course, the best way to know whether or not a particular school would suit one's needs and interests is to visit the campus, sit in on classes, eat in the cafeteria, talk with students and faculty, sleep in a dormitory. According to the Association of Independent Colleges of Art and Design, the average student-teacher ratio is lower at small art schools than at the largest ones (nine to one at schools with under four hundred students, ten to one at schools with enrollment of between four hundred and eight hundred students, eleven to one at schools with more than eight hundred students in the program), but numbers can be misleading. Freshman introductory courses are going to be much larger than senior electives, and the overall average is not particularly meaningful. More important to track is how intelligent and motivated the students seem (would I fit in with this group of people?), how committed to and involved are the instructors in students' progress (how much time does the faculty spend with students outside of class?), and whether the approach to education is experimental or traditional. Most art schools also offer pre-college summer programs for high school juniors and seniors, which provide a taste of the art school experience. Applicants need to get a "feel" for the schools that interest them; if a personal visit isn't possible, they should be prepared to ask question after question (via telephone, correspondence, e-mail, fax, conversations with school representatives at portfolio days or with current or past students) to obtain the answers that satisfy them.

ART SCHOOL OR UNIVERSITY?

Bachelor of fine arts programs are offered at independent art schools as well as at colleges and universities, and deciding where to pursue the degree is an important and difficult choice. The majority of art teaching in the United States is done by colleges and universities, and many university art departments are considerably larger than most of the forty or so independent art schools in the United States. There are approximately three thousand institutions that offer the baccalaureate degree (BA), and many of them have art programs in which students may specialize or major. Approximately 20 percent of those three thousand institutions offer the BFA. Some universities offer both BA and BFA programs, while independent art schools focus on the BFA. The curriculum does not differ appreciably from an art school to a university—fine art graduates of both art

schools and universities have gone on to acclaim and financial success in the art world—but other characteristics may distinguish them. Both art schools and universities have their advantages and drawbacks. Art schools generally have a lower average student-teacher ratio than university programs, and students there are more likely to receive individualized attention. Art school deans also boast having resources and facilities superior to those at most—although certainly not all—colleges and universities. "University art programs are usually the smallest, least funded, lowest-on-the-pecking-order department in the entire university," Mark Takiguchi, director of admissions at the San Francisco Art Institute, said. Art schools themselves are smaller than most liberal arts colleges or universities; their programs are strongly focused and, as a result, are more likely than art programs within universities to attract recruits. That intense focus, however, is not for everyone and may seem narrow and limited to students right out of high school, who are anxious to get a bigger picture of the world. The general education (non-art) courses offered at art schools attempt to fill in this picture, but those classes are rarely as numerous, varied, or intellectually challenging at advanced levels as the course selections at a liberal arts college or university (see "Liberal Arts" on page 13). "So much more is going on at a university," said Judy McCumber, an admissions counselor at Syracuse University School of Art and Design in New York State. "You have all the humanities to draw on."

One distinct advantage of a university over an art school is that, in a university, one may transfer out of the art department and still be enrolled in college. Those unhappy with art school have a more difficult process ahead—they must transfer to another institution. In addition, students at a liberal arts college or university are usually housed with students in different programs or pursuing other majors, which may be broadening; at an art school, the living experience will not offer the same degree of variety. Having a roommate in the same major and program may help focus one's attention, but the intensity of the relationship (and potential competition) may prove limiting and detrimental for some students.

Art schools, for their part, have been more responsive than colleges and universities to the particular career and employment concerns of fine artists. The University of Massachusetts at Amherst, for example, has a career center as well as an arts extension service as part of its continuing education program, but neither has a specific relationship with the university's art department, which trains students pursuing BFA and MFA degrees. The career center offers general employment-seeking advice to all students, with no one holding expertise in the arts, and the arts extension service counsels local arts agencies on management techniques rather than

individual artists in or out of the university. The art department itself holds no workshops or seminars on career issues, nor does it seek to establish a working connection between its students and either career services or arts extension. One finds the same scenario at most universities, where art students are on their own. The career services office of the Art Institute of Boston, on the other hand, offers an alumni bulletin board on its Web site with information on studio space rentals, exhibition opportunities, and job listings; for current students, the office arranges internships, and holds career workshops and a professional development course per discipline (fine arts, graphic design, illustration, and photography) and individual career counseling.

One may certainly pursue a fine arts minor at a university as part of a bachelor of arts program, majoring in a traditional academic discipline. Obviously, such BA students will not take as many art classes as BFA students—one-third of their courses will be studio as opposed to two-thirds for those enrolled in the BFA program—and it is possible that their portfolios will suffer for it if they apply to MFA programs or art-related jobs. However, graduate art programs and employers generally judge applicants on the basis of the portfolios rather than the degree, and BAs are as likely to win positions as BFAs if the quality of their work is high. On the other hand, the fact that they have undergone a general baccalaureate education may make graduates with a BA more attractive to potential business employers than those with a more specialized training.

MFA PROGRAMS

As opposed to the BFA degree, students seeking to enter a master of fine arts program are selected not by the admissions staff (who are involved largely in processing applications and related materials) but based on a portfolio review by one or more members of the art faculty, such as the dean of the art school, the departmental chairman (based on the applicant's medium of greatest interest), and other instructors. Prospective undergraduate transfer students to art schools, by the way, are usually admitted by faculty on the basis of a portfolio review. While undergraduate art students are given exposure to a variety of art media, selecting a particular area in which to major by their junior year, MFA candidates are expected to have made basic choices with regard to medium, although some students do change their minds once involved in the master's program. A painting major on the undergraduate level may find that the school he or she is attending for an MFA has a particularly dynamic photography department, or the student may be drawn to an instructor in the sculpture department. Most MFA programs are two years in duration, requiring half of one's

course credits in a specific concentration, but the fact that almost all schools allow five or six years in which the student may complete the degree requirements reflects the reality that changes occur, including a change in one's area of concentration.

The liberal arts requirements of the undergraduate degree are gone for MFA students, although some schools require one or two (sometimes more) semesters of art history, theory, or criticism, and all programs require a written thesis in support of one's chosen area of artwork—in effect, an expanded artist's statement with footnotes. That written thesis usually is the conclusion of an oral defense of one's work. A defense does not mean that the work is attacked by faculty; rather, it refers to a discussion, in which the art is placed in context (art history, art theory, current events, opportunities made available by technology, for instance). Various faculty members will ask questions pertinent to the MFA candidate's decisions and interpretations. The defense is usually the tune-up for the final draft of the thesis. Because a faculty advisor has usually worked with the student in the preparation of the defense and thesis, surprises are few, although this is often a nerve-racking experience.

The final requirement is a one-person exhibition, which is not only an opportunity to make public one's work but also a chance to understand firsthand the process of creating a show—installing, labeling, matting, framing, lighting, and transporting artwork, designing the exhibit, and drafting an artist's statement. An artist's work may change dramatically over the years, but the knowledge gained through envisioning and creating an exhibit will last a lifetime (others may help, but the artist is in charge).

Although students seeking an undergraduate degree hope for a number of instructors in a department and look for a variety in teaching styles, applicants to an MFA program who have a firm idea of what they want to pursue often choose a school based on a specific faculty member (a noted teacher, a renowned artist). School catalogs or the College Art Association's *Directory of MFA Programs in the Visual Arts* ($20.00, 275 Seventh Avenue, New York, NY 10011, 212-691-1051) list degree requirements and faculty. An undergraduate advisor also will help students looking to enter an MFA program find a school with the appropriate curriculum or faculty.

Although they claim that their sole purpose is to train professional artists, deans of MFA programs at art schools and universities acknowledge that the majority of their fine arts students expect the degree will make them eligible to teach studio art on the college level. Some schools also implicitly encourage those ambitions by allowing graduate students to teach undergraduate courses, such as the foundation or other introductory classes, giving MFA students the ability to claim teaching experience on

their résumés. While it is certainly true that a qualification for college studio art teaching may be the MFA, the degree itself does not make a job (full-time, part-time, adjunct) any more likely. In fact, according to the College Art Association, which lists art positions in academia, an average of 120 or more applications are submitted for every opening (at certain schools, the number may reach 300–400). Those hired are apt to have years of teaching experience (not just a semester or two) and a lengthy exhibition record. MFA students with an eye on teaching in the near future almost all find that they leave school unqualified for the jobs they seek. In order to prevent a sense of disillusionment and bitterness, students should take the deans at their word, viewing the MFA program not as a ticket to a faculty position but as a continuation of their art training.

THE WIDE VARIETY OF ART INSTRUCTION

The education of artists does not only involve earning a baccalaureate or master's degree. Many of the degree-granting institutions that artists attend have certificate and diploma programs for students who only take the art courses because they already have received a bachelor's degree in another field from a different school, and the same schools usually offer art instruction—often with the same faculty—through a continuing education program. There are also numerous community art schools around the United States and Canada through which artists of a wide range of abilities and experience may take classes, and they are often taught by the same instructors who work adjunct at the art schools and universities (National Guild of Community Schools of the Arts, 40 North Van Brunt Street, P.O. Box 8018, Englewood, NJ 07631, 201-871-3337, *www.natguild.org*). Yet other professional artists teach small groups at their own studios on an ongoing basis or in short-term workshops.

Perhaps the least well-known art school in the country is located at Ft. Meade in Maryland, where enlisted soldiers with an aptitude in art may attend the U.S. military's one and only art academy, the Defense Information School, known by the acronym DINFOS. There, soldiers spend three intensive months learning the basics of art, computer graphics, photography, and video editing.

Three months is not much time to develop into the new Matisse. "The military doesn't want to spend more money to have them there longer," said army sergeant Elzie Golden, a staff combat artist and former instructor at DINFOS who himself went through the program. No need for too much painterliness; most of the school's graduates will work on mundane visual tasks, such as designing training manuals, creating posters for conferences and other events, drawing maps, and utilizing satellite-beamed data to

generate up-to-the-minute battlefield descriptions for military briefings—
"the down and dirty jobs," Golden said. While at school, students learn to
make images based on looking at photographs. There is no drawing from
life and precious little opportunity for what the military calls "freehand," or
what the rest of the world thinks of as art. DINFOS is not set up to help
artist-soldiers find themselves, "but you can aspire to do greater things,"
Golden noted. He himself won the military's artist of the year award in
2002 for his painting entitled "Tracking Bin Laden," which was clearly a
"freehand" effort.

Four of the five branches of the U.S. military (air force, army, marines,
and navy, but not coast guard) send enlistees to DINFOS in order to train
them in skills of visual communication. The school is larger than just its art
program; it also provides instruction in journalism and broadcasting (each
branch of the armed forces has its own newspapers, radio, and television
stations), as well as videography (for training films).

Some of the school's graduates will become combat artists like Sgt.
Golden, creating sketches and paintings of major military events or depict-
ing everyday scenes of soldierly life, while the majority will learn how to
produce (two- or three-dimensional, still, or interactive) presentations for
military planners. "Ideas might take volumes to explain," said Lt. Greg
Kuntz, an instructor in multimedia at DINFOS. "An artist can take complex
ideas and put them into an easy-to-understand visual format."

A small number of the school's art students are college graduates with
degrees in art, but most are just high school graduates who did not see art
school in their future, according to Gene Snyder, former army staff sergeant
and instructor at the school who now is a civilian photographic resource
manager at the army's Center for Military History in Washington, D.C.,
which holds a collection of more than fifteen thousand works of art prima-
rily created by army soldiers.

Snyder himself was not an art school graduate before entering the mil-
itary, but his interest in art was not new. He had excelled in art classes in
high school and went to the Maryland Institute College of Art, but "only for
one semester, because I ran out of money, so I joined the army." After three
years in the infantry, Snyder was accepted into the military art program,
eventually working himself into the position of full-time combat artist sta-
tioned at the Center for Military History from 1994 to 1997, when he was
reassigned as an instructor at DINFOS. "It was great," he said. "I get up in
the morning, come here and paint all day."

For more information, contact the Defense Information School, 6500
Mapes Road, Ft. Meade, MD 20755-5620, 301-677-2173, *www.dinfos.osd.mil*,
or a military recruiter.

CAREER SERVICES

Approximately eleven thousand students receive BFA and MFA degrees every year from the nation's art schools and universities, and then, it would appear, they subsequently vanish. There is little to no tracking of alumni in order to determine whether one, two, five, or ten years later they are earning any or all of their income as artists. (Certainly, artists do not always notify their alumni associations of changes in address, and most do not respond to questionnaires.) Fine artists, who comprise between 30 and 40 percent of that eleven thousand, are assumed to fare far worse than the applied arts graduates at these same schools, because fine artists are not trained to be employable by a firm or organization, a reason that fine arts department chairs bristle at any comparison with trade or other professional schools.

Most art schools, colleges, and universities have some program of career services, although their effectiveness and the degree to which they focus on the particular needs of fine artists is not always evident. Increasingly, art schools have come to create career services offices for their students, in part as a response to demands from current students, their parents, and alumni to help them find jobs that are relevant to their skills and in part as a result of a crackdown by the U.S. Department of Education on student-loan defaults. The federal government has begun to deny these loans to schools whose students have high rates of unemployment six months after graduation. Most career services programs at art schools are less than ten years old. Prospective students should look closely at the schools and universities they are interested in attending to see what kind of career assistance is specifically offered to them.

On the most basic level, a school needs to provide a book or bulletin board featuring job listings and, ideally, should actively and regularly solicit local, regional, and national employers to notify the institution of job openings. This information should be available not only to current students but to alumni. The school should also invite potential employers on campus for recruiting purposes (either individually or as part of a job fair); even if a particular job is not currently available, the opportunity for artist and employer to meet may be quite helpful in the future. Individual career counseling should be available in order that students are directed to employment possibilities consistent with their interests and talents, as well as assisted in preparing résumés, cover letters, and portfolios, and developing job interview and job search techniques.

As well as offering help in locating jobs, schools should maintain current listings of upcoming art competitions, exhibition opportunities, affordable studio and living space, affordable health insurance, and deadlines for grants and fellowships. A library of resource material—such as books of

career advice for fine and commercial artists, guidebooks for writing résumés and grants, and information about locating artists' communities— should also be available.

Art schools and art departments might offer career (often called "survival") courses, which explain the workings of the art world and how to find a place within it, and workshops or seminars that focus on particular aspects of the business of being an artist (such as law and the arts, finding a dealer, or grant-writing). Students often get a taste of the business side of the arts through school-sponsored internships with individual artists, art galleries, museums, print studios, and other art-related enterprises; another informational opportunity might be an "externship," which is a looser, shorter-term form of internship that involves following around someone in the arts to observe what he or she does. California Institute of the Arts has created both a job bank and an internship bank on a guarded Web site (guarded so that only CalArts students can use it via a password). Schools should maintain a close relationship with alumni who have found a place for themselves in the art world, bringing them back to lead career workshops and encouraging them to mentor current students. Visiting artists might be encouraged to talk not only of their techniques and theories but also about their career steps. Schools should also conduct in-service workshops for faculty members, so instructors can develop business-of-art skills that they may not have and reinforce on a day-to-day basis with their students the information that the career services office has imparted.

Schools should also have some idea of what has happened to past alumni in some manner that is not purely anecdotal. Otherwise, it is extremely difficult to determine the quality and effectiveness of the teaching and career services.

LIBERAL ARTS

Contrary to the beliefs of many art school applicants, a bachelor of fine arts is not simply a certificate of training in art but a college degree for which a student must complete and pass both studio and academic courses. (There are schools and programs around the United States and Canada that offer certificates in various media, such as Penland in Penland, North Carolina, and Haystack in Deer Isle, Maine.) At most art schools, as well as in the arts programs at liberal arts colleges and universities, academic subjects account for approximately one-third of the credits toward a BFA, yet these classes are rarely highlighted in art school catalogs.

There is often a conspiracy of silence, with art schools not emphasizing the academic courses required of students and, in turn, many incoming students not asking about the non-studio classes they will have to take. "I've

complained that the admissions department actually shies people away from the liberal arts side, as if they would put a damper on things to talk about it," said Bill Berkson, director of letters and science at the San Francisco Art Institute. "They may show applicants the library but otherwise direct them away from the classrooms. It's seen not as a selling point for an art school." As a result, he noted, "some students come in thinking they'll never crack another book or write another term paper." This situation exists at most art schools: liberal arts faculty must prod students to take seriously their general education requirements. Elizabeth Wright, chairman of liberal arts at the School of the Art Institute of Chicago, stated that "we get more than the occasional eighteen-year-old who says, 'I am an artist. Why do I have to take these courses?'"

Various academic courses are offered to art students, although two or more semesters of English composition and art history are fixtures in BFA programs at art schools and universities. One may also see courses in philosophy, literature, mathematics, the social sciences (anthropology, economics, political science, psychology, and sociology) and hard sciences (such as biology, chemistry, and physics) offered as electives or requirements. At times, art schools create arrangements with neighboring liberal arts colleges where students will take their academic courses. The School of the Museum of Fine Arts in Boston, for example, is affiliated with Tufts University, while the Rhode Island School of Design allows its students to register for courses at Brown University (Brown students may also take art classes at RISD). Most often, however, art schools simply hire their own liberal arts faculty and establish their own programs in accordance with the curriculum guidelines set out by the National Association of Schools of Art and Design, the membership group to which many of the art schools belong. The School of the Art Institute of Chicago once had an affiliation with the University of Chicago, but severed that relationship as "problems arose over teaching style and course content," Wright said. "It's hard to subcontract out teaching. We found we could offer the same quality here, better targeted to our student body." A relatively small number of students of both Brown University and RISD tend to take courses at each other's campuses, despite the fact that the two schools abut each other, probably because the distances are a little longer and since they prefer to remain with their regular friends rather than go to class with strangers whom they fear may be apt to look down on them (stupid artists at RISD, snobs at Brown).

There are often considerable differences between academic courses taught at art schools and those at liberal arts colleges and universities. Reading lists are usually smaller at art schools, and essay exams are more

prevalent than true-false tests or term papers. "Students enrolled for the BFA have to spend so much time in the studio—making art is such a time-intensive activity—that they have less time to spend in a library," said Samuel Hope of the National Association of Schools of Art and Design. Wright noted that academic faculty also tend to understand that, at certain times of the semester, the students' emphasis is on their studio work. "One cannot hold students accountable for reading everything on the syllabus," Wright said. "You need a lot of tolerance to teach in an art school."

For years, the Ringling School of Art and Design in Sarasota, Florida, administered the Myers-Briggs standardized personality profile to incoming students in order to assess their personality types and how they learn. According to Bettina Beer, dean of liberal arts, art students are "very project-oriented, hands-on learners, less abstract learners, who prefer very concrete assignments. We tailored our courses to meet the traits of our students." That tailoring involves a "less is better" approach to general education. "If we are teaching a survey course of world history, we pick out representative figures and trends and look at them in depth, rather than providing a lot of information that may be more difficult for the students to process," she said. The approach also includes greater visual reinforcement of information, using films, maps, and slides, and more hands-on projects.

"Hands-on" may mean drawing a picture of life in colonial America for a history course at Ringling. Students at the Minneapolis College of Art and Design have designed Web sites and made weavings for their history courses, while others at the Art Institute of Boston have recreated Leonardo da Vinci's *Mona Lisa* in order to understand the artist's techniques and materials as part of an art history course. "Students' interests here are perhaps different than at a university," said Robert Walken, head of liberal arts at the Art Institute. "It's not simply what it means and when it was done but how was it made, using which techniques." Other liberal arts deans spoke about art students processing information in a "right-brained way," requiring classes that are more interactive and less "chalk-and-talk."

Not every art school takes this flexible approach with its students. In the minds of a number of educators in art schools and elsewhere, it is not clear that a student really learns art history by doing a hands-on project. Art history is about the development of artistic styles and aesthetic ideas, which working in the manner of Leonardo da Vinci may not teach completely. Students may be encouraged to not learn enough by instructors with low expectations for them. At RISD, according to Baruch Kirschenbaum, dean of liberal arts, "we want our students to be visually and verbally literate. We discourage the emphasis on visuals or studio projects in classes, as studio projects get students away from the traditional focus on scholarship. We

want papers, exams, essays." However, Kirschenbaum noted that, at most liberal arts colleges and universities, "undergraduate courses in art history are preparing students for graduate school, teaching them methodological and bibliographical skills as well as the need for specialization. Here, we're more broadly humanistic in orientation," meaning that academic faculty attempt to tie in humanities themes with the teaching done on the studio side, wherever possible.

Liberal arts electives at art schools are often geared to subjects deemed relevant to the lives and studio courses of students. The Memphis College of Art in Tennessee, for instance, does not offer an English major–type survey of literature or single courses in major historical writers, such as Chaucer or Shakespeare. Instead, the college has electives in Southern literature, Surrealist literature, African-American literature, women's studies, writings of the Beat Generation, and other specialties as its literature program. "The aim is not to be trendy or to teach down to the students," Ringling's Bettina Beer said. "You don't have the luxury of teaching a broad survey of English literature when the students will only be taking one or, maybe, two courses. Instead of asking, 'What will a student miss by taking a course in a very specific area?' one should ask, 'What should a student get out of a literature class?' You want to draw students into an interest in literature that will get them to want to read, and give students the tools to analyze what they read."

As well as the dissimilar teaching approaches between art schools and universities, there are distinct differences in the makeup of faculty. Most university faculty members hold doctorates, and many are full-time employees of the institution; it is on the basis of the credentials and publications of the faculty that tenure is established and that departments within these schools are rated. At art schools, on the other hand, most academic faculty are part-timers with master's-level degrees. "At art schools, a Ph.D. is not the union card it is at universities," Beer said. Some art school faculty do research and publish, but that is not the institution's emphasis; rather, these are teaching schools and, normally, faculty members have heavier teaching loads than do their colleagues at liberal arts colleges and universities.

Many educators would not be a good fit with the student body of an art school. The deans of liberal arts programs at art schools must pick faculty members who are generalists rather than specialists, who will keep themselves motivated and up-to-date in their fields without a lot of similar faculty around them, who are devoted to teaching rather than to research and who have a knowledge of the visual arts. "It can be very frustrating for individuals with Ph.D.s never to teach a major, never to have a conversation on a certain level with students here, because students only take an academic

course as a requirement or as an upper-level elective," said Dana Sawyer, chairman of the liberal arts department at the Maine College of Art in Portland, who teaches philosophy and religion but does not himself have a doctorate. He added that most liberal arts faculty at the college find their intellectual satisfaction at the other schools where they teach; indeed, most general education faculty at art schools are not full-time employees.

Faculty biographies for school instructors are listed in the college catalog (although part-timers are probably not likely to be included), and their degrees, publications, and special areas of interest are noted. Some catalogs list course offerings in both studio and liberal arts; if the catalog does not include such a list, either the admissions office or the academic affairs office will be able to send it to prospective applicants.

Liberal arts courses are offered at art schools not only to satisfy the requirements for a college degree. They inform and provide greater depth to the art that a student is creating and will make in the future. In a classical education, the liberal arts represent a body of thought and help students to develop their own way of thinking about the world; in a more practical sense, the acquisition of knowledge across a number of disciplines is likely to make students more employable, since graduates are not likely to earn a living from the sale of their artwork immediately upon leaving school. For all of these reasons, the general education program at art schools should be examined with care by both prospective students and their parents.

Written material or, better, a visit to the school should answer a number of questions that may arise: Is there depth and breadth in the course offerings, and do these courses have a relationship to the studio majors? Inversely, do studio art projects reflect liberal arts content? Are courses offered in the basic areas (English, history, mathematics, science), and how well equipped are the classrooms (are there laboratories for science classes, for instance)? How extensive are the holdings in the library, and what kind of collection of art books has the library assembled to support the program that the student is undertaking (for example, are there books on computer art for students with that interest)? What percent of the academic faculty have doctoral degrees, and how (and how often) is the overall faculty evaluated? What percentage of the faculty is part-time, and how long have most of those part-timers taught at the school (is teaching a revolving door, or do faculty have long-term commitments to students and the school)? Is there an academic resource center or another program to help students with their coursework (indicating the school's commitment to the liberal arts)? A tour of an art school should include sitting in on a class, a visit to the library, and perhaps a conversation with an academic faculty member or two to get a feel for how a third of one's education will be spent.

Art Schools and the Computer

Back when Dave Richards was earning his MFA at the School of the Art Institute of Chicago, there was an art and technology department, "but I never took a class there. I didn't even know what they were doing there," he says. A generational and cultural shift later, he is now an academic advisor and admissions counselor at the school, looking at applicants' portfolios that are increasingly in the form of zip disks or CD-ROMs (sometimes he is directed to an applicant's Web site to view images), and often contain computer animation and "sound pieces," rather than the traditional album of drawings and paintings. A drawing these days is as likely to have been created on Freehand—a computer software for artists—as actually done by hand.

Not every applicant to art schools and university art programs is computer savvy, and most schools continue to require applicants to submit traditionally created drawings, paintings, and sculpture; these institutions also continue to teach traditional media. However, computer technology has invaded every medium and many time-honored courses, right down to the instructional classes that freshmen are required to take.

The impetus for this sea change in how artists are educated has not come from within the schools but from outside: employers of animators, architects, and designers demand that their hires be proficient in a variety of computer applications and software, and that demand filters into the school through the instructors who have a foot in both the commercial and academic worlds. "The design faculty is working in fields in which new technology is in constant use, and they're bringing that knowledge and need for change into the classroom," said Joe Deal, provost at the Rhode Island School of Design. Students specializing in film and video also soon learn that they need a variety of digital skills (no one splices by hand anymore, for instance).

Fine artists may not have as obvious a need for advanced technological skills as design and filmmaking students, but many come to art school with them and wanting more. In some cases, these fine art students are looking to create multimedia pieces, incorporating paint, photography, sculpture, sound, and video (or some combination thereof), which require advanced computer skills. Renee Pariss, records coordinator at the School of the Museum of Fine Arts in Boston, noted that there is a "waiting list" for many computer courses, especially animation. "There are only so many computers in the classrooms, so the spots fill up quickly," she said.

"Students here don't feel burdened by technology," John S. Gordon, provost at Pratt Institute in Brooklyn, New York, said. "They demand it. They are hungry for it, and we're under the gun to develop more digital-based applications. We're constantly getting more computers, upgrading those computers, then getting more computers."

Almost every degree-granting art school and university art program has followed suit, adding courses for digital media, changing courses to include digital media, and breaking down distinctions between media as a result of digital media. At the Rhode Island School of Design, there are approximately four hundred computers connected to labs and academic spaces, or one for every five students. In this new realm, the education of artists has changed dramatically. Many art school administrators and faculty refer to the current period as transitional, as schools attempt to strike a balance between traditional art instruction and the new fascination with computer technology.

For one thing, art faculty find themselves spending a considerable amount of time teaching students how to use the computer and the various programs and applications of software. "In computing, you have to spend some time learning a new medium; it's not as easy as picking up a pencil and starting to draw," Deal said. "There's a lot of student interest in comput-ers: a lot of them have come to school with experience in word-processing, e-mail, and chat rooms, and they expect computers to be part of the class-room, but there are also a lot of students who have little experience with computers, and you have to spend more time teaching them the basics. We're still trying to figure out how, in one classroom, to teach some kids with few computer skills and others with a lot of computer skills."

A secondary, and perhaps more basic, concern is that art faculty may find themselves primarily teaching the use of machinery, rather than fundamental art concepts (color, form, texture, values, line, composition, volume). "The concern in my mind is, are we turning art education into vocational education, teaching students to run machines instead of teach-ing them concepts that they may use to create significant works of art using the machines?" said Samuel Hope, executive director of the Reston, Virginia–based National Association of Schools of Art and Design.

This worry is echoed at art schools around the country. "We teach con-cepts here," said Rebecca Alm, chair of the fine arts department at the Minneapolis College of Art and Design. "It would be crazy for us to just teach technology." Peter Gena, chair of the art and technology department at the School of the Art Institute of Chicago, noted, "Old-fashioned artistic skills are important. It comes up every so often at faculty meetings. Someone will say, 'Do the students really need two semesters of drawing?' and I say, 'Yes, they

need it for the discipline.'" At the University of Massachusetts at Amherst, the fundamentals-first idea is structured into the art curriculum, as students must maintain a B average in their instructional foundation courses (that make sparing use of computer technology) in order to apply for a concentration area, where they are more likely to come into contact with computers. John Gordon of Pratt Institute also stated, "Some students come here wanting to use technology right away, and we try to accommodate them as best we can, but we still want them to master the fundamental skills before that happens. If they haven't mastered them, we may send some back to the drawing board, literally."

On the other hand, balancing traditional, fundamental skills, and new technology is, perhaps, more difficult at the San Francisco Art Institute and the School of the Museum of Fine Arts in Boston, where foundation courses are optional rather than mandatory. "There certainly are students who are strong in computers and weak in other art areas," said Carl Sesto, a digital-media professor at the School of the Museum of Fine Arts. "We won't force people who aren't interested in traditional art to spend a year drawing and painting. If they just want to sit in front of a screen for hours at a time, that's fine. It's not the goal of art schools to create well-rounded artists."

The use of new technology within traditional media has served to blur the distinctions between media. What, for instance, is a painting that has been scanned into a computer onto which photographic images are electronically pasted (the photograph itself having been altered in terms of color, background, and the positioning of images) and then printed out on canvas? Moviegoers probably have already experienced (even if they were not aware of the fact) backdrops and sets that never existed in fact but were compilations of images and colors created on computer and electronically collaged with the actors. A hands-on field such as sculpture becomes something else when an artist creates a digital file that is put out as a casting. Technology has helped give rise to a myriad of hybrid art forms that defy easy classification. "Cross-media is the norm here," said John Williamson, director of admissions at the School of the Museum of Fine Arts.

New art forms are more difficult to teach than traditional media, because the criteria for evaluating the artwork is not well established, and it is therefore difficult to find a basis for pointing students in one direction or another. It took, for instance, the better part of a century after the invention of the camera for photography to arrive at its own aesthetic, instead of being judged by the standards of painting. Art schools are criticism-based, but "there is not a set of criteria for critiquing digital art," said Dike Blair, a painting instructor at the Rhode Island School of Design. "There's not much

to fall back on. Both the student and teacher are, in effect, groping together for some way to evaluate what's going on."

Because of this, the use of new technology has also served to blur the distinctions between students and faculty. Can one still be a teacher when one's students are creating in uncharted territory, and, if so, what does one teach? Computer technology is changing and advancing rapidly, and teachers who may be up-to-date one year may fall behind the next. Samuel Hope's concern that art students will simply be taught to run machines may no longer be a possibility, as students sometimes know more about particular software applications than their teachers. To combat this knowledge gap, a number of schools have offered regular computer training in new software for faculty. The Rhode Island School of Design actually has a faculty computer lab, donated by Microsoft, where teachers may experiment, conduct research, or simply learn a new program. The Massachusetts College of Art and the Maryland Institute College of Art also both have faculty computer labs, and free classes and workshops are offered to teachers at the Corcoran College of Art and Design in Washington, D.C., and the Minneapolis College of Art and Design. At the Maine College of Art in Portland, each department was provided with powerful Macintosh G4 computers on which faculty can learn and experiment.

Where new media is part of the curriculum, the traditional, hierarchical relationship between teacher and student has given way increasingly to a more collaborative approach. At the Corcoran College of Art and Design, this is called "team teaching." "Both teachers and students collaborate in the process, with the student's work as the center of the dialogue," said Samuel Hoi, dean of the Corcoran.

Various schools have sought to gain their footing in the new world of art and technology in different ways. Some schools, such as the School of the Art Institute of Chicago and the Minneapolis College of Art and Design, have developed new media centers where the bulk of the high-end digital work can be done. The Minneapolis College of Art and Design, in fact, created an entirely new department and degree—a bachelor's of science and visualization—that mixes elements of a business school with technology applications and art training. "We knew there was an audience of people who wanted to study at an art college but didn't want to do the full studio track," said Michelle Ollie, director of the science and visualization program, who also teaches a course there on marketing analysis. As opposed to the more theoretical training of designers in the bachelor's of fine arts program, students in the science and visualization program are given real-world assignments from paying clients, such as creating Web sites for the Science Museum of Minnesota and the Minnesota Scholastic

Awards organization. Students also intern at businesses in order to receive hands-on training.

On the other hand, at the California College of Arts and Crafts, the studios themselves are in the process of being wired for computers, a reflection of a school-wide enthusiasm for digital technology. "The idea of the computer lab, segregated from the studio, is an outmoded approach," said the college's provost, Stephen Beal. "Students will do their computer work right in the studio."

There are some schools that have not jumped onto the computer bandwagon, and they continue to teach traditional disciplines in traditional ways. The Lyme Academy College of Art in Old Lyme, Connecticut, and the Pennsylvania Academy of Art in Philadelphia are both degree-granting institutions that stress drawing and "the mastery of classical fundamentals," according to Henry Putsch, president of the Lyme Academy. "We don't do computers here." The advertisements and catalogs for art schools and university art programs are likely to indicate whether or not computer technology is a significant element in the curriculum. Also, within schools that have advanced computer labs and numerous courses that teach software applications, students who look to pursue traditional art-making may pursue their art unencumbered by pressures to work in a digital mode. The faculty, which is older, certainly understands.

Even as schools continually purchase and upgrade their computers and software, there is a lingering sense of trepidation among administrators and faculty about where this is all leading. Linda Burnham, chair of the school of fine art at Otis College of Art and Design in Los Angeles, noted, "I see a lot of digital artwork from graduates that all looks the same. You can give ten people a pencil, and they'll all use it differently. That's not so with a computer." She added that "a lot of people who focus on the computer in art school end up working as technicians from nine to five after they graduate."

The emphasis on computer proficiency has been seen as distorting art students' education, since someone may create a credible image with a computer relatively quickly, while more traditional media may take years to master. As a result, schools find many students gravitating toward digital media because they can pick up the technical skills in a few weeks. "The problem of immediate gratification affects the culture of painting," said Tony Phillips, chair of drawing and painting at the School of the Art Institute of Chicago. "Students want an idea to be reflected very quickly."

RISD's Joe Deal noted, "Many faculty feel ambivalent about computing in the studio, because of how different drawing by hand is than drawing on the computer. On the computer, there isn't the same resistance of the

material; there's not the same tactile experience or hand-eye coordination." Similarly, Linda Burnham complained of the "culture's shortened attention span," which computers abet by "yielding a quick, superficial response." She pointed out that the benefit of the traditional art school's figure drawing class is "not so much to learn anatomy as to learn to hold your attention for a long period of time. The work is slow and handmade."

Some students need to be convinced that the computer isn't the answer to every problem. The technical part of an artist's education lasts two or three semesters, and the remainder of their school experience focuses on intellectual development and finding the appropriate visual media for what they look to express. The teacher's role is to help them in that process, as well as to put into words what they are doing and why they are doing it in this form. "Sometimes," said Robert Coppola, chair of the studio foundation department at the Massachusetts College of Art, "the only thing you can really identify in a work is that it was created with Photoshop"—a popular computer program for fine artists and designers. "It's easier to identify the technique than the concept. I tell some students that they need to do some hand roughs before they use the computer. Kids today are part of the digital age, but they need to understand that there are other ways to approach a problem than just the computer."

Art schools are thought of as teaching older skills, but the enthusiasm for computers at art schools and university art programs has shifted the focus to the actual and presumed needs of the future, creating a precarious balance. Art schools these days are full of great hopes and deep fears. Jay Coogan, dean of the fine arts division at the Rhode Island School of Design, worried that student enthusiasm for computer-generated art would lead them to concentrate on creating artworks that don't have a real market, because collectors still prefer paintings and sculpture that are created by traditional means. "There are a lot of interesting questions that digital art raises for the art world," he said. "If you are marketing a work as original art, what is original in a digital arena? Also, when you see a work on the computer screen and when it is printed out, are they the same or different works of art? But, in a more practical sense, it is hard to know where or when the market will develop for digital art."

How Schools Select Their Students

In general, art schools base their admissions on five or six criteria: the first is the portfolio, followed by the applicant's academic history (grade point average and school- or art-related extracurricular activities), test scores (SATs

or ACTs, as well as achievement exams where they are required), interview, recommendations, and essay. Many schools attempt to treat these categories objectively, assigning numerical values to each. Otis College of Art and Design in Los Angeles, for instance, applies an A, B, or C grade for each applicant's portfolio, test scores, and essay that is matched with the individual's academic grade point average. Least weight is given to personal interviews, Michael Fuller, director of admissions, noted, "because that is the most subjective area. The applicant and counselor may really hit it off, but the student isn't otherwise qualified; conversely, the student and counselor may not get along, but the portfolio and academic history are terrific."

The Art Institute of Boston uses a 1–10 scale in evaluating applicants, with 10 being the highest score. The school grades portfolios (3 for A, A-, and B+ artwork, 2 for B and B-, and 1 for C+ and C), assigns numbers to grade point averages (3 for A, 2 for B, 1 for C) and SAT results (1 point for 600–1090 cumulative, 2 points for 1100 and up). One point apiece can be earned for an essay or interview that is judged favorably by the school. According to Diane Arcadipone, dean of admissions at the Art Institute of Boston, all students scoring a 5 or better are admitted into the BFA program, while those receiving a 3 or 4 are admitted on a provisional basis. Those scoring less than 3 are rejected. The provisional students are thought to be qualified for college in one way but not in another—the most common instance is a student whose portfolio is strong but whose grades and test scores are low. These students usually take a smaller course load during their first year, including a remedial class or two. If they maintain a B average during that year, the students may move into the regular degree program.

Based as it is on a number system for selecting incoming freshmen, individual admissions counselors at the Art Institute of Boston make their own acceptance decisions. The majority of schools, however, use a selection committee composed of the entire admissions staff and, sometimes, members of the art faculty. (At the Memphis College of Art, faculty members are involved "so they cannot come back to us and say later, 'Why did you admit this person?'" said Susan Miller, director of admissions.) The size of the committees range from three to a high of twenty-one (at the Rhode Island School of Design). At art schools, most admissions counselors have received art degrees (BFAs or MFAs), and it is that knowledge of an art program that informs their sense of which applicants are likely to succeed. "A lot of times when I'm interviewing an applicant, I'll be asked about my own background," said Carol Conchar, director of enrollment management at the Atlanta College of Art, who received an MFA from Cranbrook Academy of Art in Michigan. "Students and their parents want

to see how qualified I am to judge." Other schools specifically hire their graduates to work in admissions because of their familiarity with the particular program. Indeed, Judith Aaron of Pratt Institute observed, "all my admissions counselors are Pratt graduates and know what it takes to get through."

Most schools have some method of grading portfolios, academic history, and test scores, and the committees evaluate applicants' strengths and weaknesses on an individual basis. Students with impressive portfolios but weak grades or test scores may be given the benefit of the doubt. Becky Haas, admissions director at the Minneapolis College of Art and Design, stated that "the average grade point average here is 2.9," which is equivalent to a C+. "A number of our applicants have lower averages than that, so we tend to concentrate on how the student did in English and history. If someone had a bad year in science, bringing down their grade point average, we're not going to hold that against him." Similarly, Mark Takiguchi, director of admissions at the San Francisco Art Institute, noted that, in assessing SAT scores, "we look at the verbal and disregard the math." For its part, Cooper Union only looks at the verbal scores.

On the other hand, in the case of students whose grades and test scores are more impressive than their portfolios, it is recognized that many high schools around the United States have weak or nonexistent art programs and that their students will not have the preparation equivalent to that of others who have received years of art instruction. Admissions committees look for signs of potential in reviewing portfolios, attempting to determine whether or not an applicant will fit comfortably into the school's program, and they also may weigh factors such as test scores and high school grade point averages more highly in some cases. "Good grades show prior success in school," said Susan Miller, "and they are weighted as highly as the portfolio."

While the portfolio remains the key element to be considered, there is a growing trend on the part of art school admissions counselors to focus equal attention on an applicant's academic history. "Students who have done well in high school, even if they haven't had as much art training as other students, are more likely to do well here than students who haven't demonstrated high achievement in high school," said Judith Aaron, who noted that a typical Pratt student's high school grade point average is 3.0 and above, and the average SAT scores are a cumulative 1100. She cited a declining dropout rate at art schools that have increased their academic standards for admissions. William Barrett, executive director of the Association of Independent Colleges of Art and Design, also noted that students who have done well academically in high school are more likely to

stay in art school, while those with low grade point averages and SATs are apt to leave before earning a degree. "The retention rate has more to do with the characteristics of the students rather than with what the school does to them after they arrive," he said.

The incoming classes at the majority of art schools are between 45 and 50 percent in-state, with another third from neighboring states (the remainder are from elsewhere in the United States, with a small percentage of international students). This heavy concentration of in-state and regional students reflects the percentage of their applications for admissions—most students prefer to stay relatively close to home—as well as the fact that a higher percentage of students who travel far are more apt to drop out of the program.

STAYING POWER

Art schools and university art departments are able to do a better job of tracking their dropouts than their graduates. Most of the students who will drop out do so after the freshman year—between 10 and 40 percent—and, Barrett noted, only about 48 percent of those who enroll in a BFA program will graduate within six years. According to the U.S. Department of Education, only 45–50 percent of students in colleges and postsecondary schools will graduate, which makes art schools not all that different from other schools. However, that national average is dragged down by the horrendous default and dropout rates at technical schools and community colleges, which attract many students who have not enjoyed academic success in the past and may not do so in higher education either. Art schools and university art programs, on the other hand, draw from a more select group, and there may be many factors for the high dropout rate among art students.

Students who drop out, according to most school surveys (exit interviews or mailed questionnaires), do so for the following reasons: they or their families cannot shoulder the financial burden of tuition; they thought art school meant no more classes; "they transfer to another school for majors we don't offer, such as film, video, and computer art," said Brian Reed, an admissions counselor at the Cleveland Institute of Art; they miss a far-off girlfriend or boyfriend or become homesick. A student may need psychological counseling in order to adjust to being away from home or in a more demanding school environment. Another psychological factor is the stark contrast between art classes in high school, which last fifty minutes, and those in art school, which may go on all day. "Traditional students in high school art classes do pretty much whatever they want, and are told over and over again that they are much better than everyone else," said

Becky Haas. "Then they get to art school and are made to study the basics. They see that everyone else in the school was an art star in high school just like them. They don't stand out quite as much anymore, and that comes as a blow to many of them."

The first year of art school also may not meet high schoolers' expectations of becoming professional artists. Ed Newhall, director of admissions at the Rhode Island School of Design, described the freshman program as "art boot camp" for its heavy concentration on required foundation and basic drawing courses, which emphasize the mastery of critical and technical skills. It is not uncommon for students to ask when they can take a "real art class" or if they may postpone a foundation course until their sophomore or junior year. Some students may discover that the art school experience is more intense, or less fun, than they had imagined and that they would prefer to take art electives as part of a liberal arts program at a college or university. "The foundation program is integral to everything else students do here," Newhall said, "but the student's commitment to the serious study of art may not be great enough, and some leave."

At some schools and universities with MFA programs, the freshman courses are taught by graduate students, who are given these assignments in order to gain teaching experience and (sometimes) because senior faculty do not want to teach foundation. Because theirs is not a long-term commitment to the school and its undergraduate students, some graduate students are less likely to spend extra time with freshmen who need help with their course work or who need help just adjusting to college. At other schools, foundation courses are handled almost exclusively by adjunct faculty, who again are unlikely to have an ongoing stake in the success of their students. Those considering applying to art school or an art program should find out whether or not senior faculty teach foundation and, if not, who does. Some undergraduate art programs recognize the need for freshmen and senior faculty to meet and develop a relationship that may continue throughout the four years. "We don't allow faculty empires here," said Richard Cook, chairman of visual arts at the College of Santa Fe in New Mexico. "Everyone teaches everything here. We don't just have adjuncts teaching fundamentals." As do many other universities, Drexel University in Philadelphia, Pennsylvania, has a one-credit freshman seminar designed to integrate the student into college life, and this has reduced the attrition rate. At the University of Massachusetts at Amherst, the traditional separate foundation courses have been combined into a yearlong workshop, in which the sixty freshmen meet with three senior faculty members (usually breaking up into three groups of twenty) to draw or paint an object or the human figure, or to work on some other project.

Traditional issues of color, drawing, two- and three-dimensional design, as well as technique and art history are interwoven within the discussions of each activity by the faculty members.

Some schools simply may not be selective enough in their admissions process, considering a high number of dropouts as a normal cost of business. "We're not rejecting large numbers of students," said Diane Arcadipone, dean of admissions at the Art Institute of Boston, which loses 25 percent of its class between freshman and sophomore years. "Applying to art school is a self-editing process, and students know when an art school is right for them." Many other private art schools echo those sentiments. Perhaps one reason for the lower student-teacher ratio in upper-class courses is the fact that so many art students have dropped out along the way. According to periodic surveys conducted by the Association of Independent Colleges of Art and Design, 25 percent is the average dropout rate at art schools. The attrition rate was generally higher at schools with one thousand students or fewer (averaging 30 percent) and lower at larger institutions (approximately 20 percent). "The larger schools are more selective, on the whole, looking for students with higher SAT scores, better academics, and those who come from higher income families," William Barrett said.

Cooper Union selects for admission approximately 13 percent of its applicants, and its dropout rate is below 10 percent. On the other hand, the Cleveland Institute of Art, San Francisco Art Institute, and Syracuse University School of Art and Design accept between 65 and 80 percent of all applicants, and large numbers of these students edit themselves out before enrolling or later, after a year or two. The San Francisco Art Institute loses between 12 and 18 percent of a given class annually, according to Mark Takiguchi. Before enrolling in any school, prospective students should try to discern how many others tend to leave the program and why.

PORTFOLIO

"The portfolio is a good indicator of whether someone is an appropriate student for the school," said Carol Conchar. "We use it to weed out students." There is no one universally accepted type of portfolio that all schools require, such as a sheet of slides, a photograph album, a video, a sketchbook, or some combination of those. Some schools provide very concrete assistance in this. Moore College of Art and Design in Philadelphia, Pennsylvania, sends out to prospective applicants a brochure, entitled "How to Prepare Your College Portfolio," with specific assignments (such as "Put three pieces of fruit and/or vegetables on a table. Use an isolated light

source like a candle or lamp to cast shadows and create values"; or "Draw a self-portrait from a mirror with oil pastel. Your portrait does not have to look exactly like you. This is an image of you, not a picture"). Otis College of Art and Design in Los Angeles has what it calls a "pre-portfolio review" in which students will be told what to edit from or add to their portfolios in order to bring them up to acceptable standards. The schools that offer precollege summer programs for high school juniors and seniors are often useful in assisting students to develop strong portfolios.

In general, school admissions offices should be asked directly what they require or will accept; some prefer to see at least one or two original artworks ("You want to see the process," said Greg Skinner), although they all take slides for review. A portfolio should be tailored to the particular school: a strictly fine arts academy would have little use for applicants demonstrating an interest in cartooning or graphic design. "The work may be good, but it is for a department we don't offer," said Mark Takiguchi.

The number of portfolio pieces submitted should be limited to between ten and twenty and reflect a range of styles and media (not all drawings or just paintings). Admissions counselors unanimously claim that they don't want to see everything an applicant has ever done or doodles on the margins of notebook paper because this does not form a cohesive body of work. Most high school student applicants are likely to have in their portfolios a preponderance of work from their art classes, but it is important to include work that was done independently, as that indicates initiative and a dedication to art. Approximately half of the portfolio should consist of drawings from direct observation, such as a still life, figure, portrait, or landscape, regardless of the student's intended major (photography, for instance) or favored style (such as surrealism or abstraction). This type of work reveals how accurately an applicant can render an object, and how inventively. Introductory drawing courses occupy much of an art student's first and, sometimes, second year of school, and they focus on direct observational work; students without a reasonable amount of experience in drawing directly are not likely to last long in the program. Direct observation does not include copying a photograph, said Michael Fuller of Otis College of Art and Design, "because the composition, the values, the light and dark areas are already given to you." He noted that "drawing is the fundamental basic tool of art, as you are taking a three-dimensional world and describing it in two dimensions. You have to give your subject a full visual analysis, with proportions, values, composition, texture, line quality, and other formal elements that require you to slow down and really look at the choices you are making. That's what we in admissions look at when we make our decisions about acceptable candidates."

When admissions staff at art schools examine a portfolio, they are generally looking to identify a student's technical competence in one or more areas of art-making, as well as the applicant's inventiveness with a medium. Imaginative ability, personality, and the willingness to try something new cannot be taught and, therefore, reflect artistic ambition. A number of admissions counselors noted that prospective students often worry about the impression their work will make, purchasing expensive paper, mats, and frames for pieces they submit. "Students should not be product oriented," said James Dean. "We can look past the quality of the paper students have drawn on to determine ability."

Art school admissions counselors examine applicants' work with students on portfolio days and at interviews as well as without the presence of the applicant. The most common submissions are high school art class assignments, science fiction imagery (frequently of the "Dungeons and Dragons" variety), and copies of other images. Usually, between half and two-thirds of the applicants are told that their portfolios need some revision, usually more direct observation sketches, although some admissions counselors recommend that such applicants study with a professional artist or simply try again with certain artistic subjects. At the Maine College of Art, which has a two-year foundation program, direct observational work is given the highest priority, with pieces rated on a 0–5 continuum for drawing ability, color, composition, concepts, and three-dimensionality, within the overall artistic experience of the applicant. At the San Francisco Art Institute, on the other hand, which places a greater emphasis on personal artistic exploration and where the average age of undergraduate students is twenty-four (for graduate students, the average age is twenty-seven), "direct observation work is not a great concern for us," said Mark Takiguchi. "We look for personality, creativity." Art Institute admissions counselors rate portfolios as A, B, C, and "need to see more work."

Most schools, in fact, use an A, B, C system of evaluating submitted work. Pratt Institute grades portfolios from A to E, and applicants in the D and E groups are usually rejected outright. A typical enrolled class, Judith Aaron noted, consists of 10 percent A portfolio applicants, 30 percent B portfolios and 60 percent whose work was graded a C. "A C portfolio is still pretty good," she said.

One should not confuse being told that a portfolio needs additional work with rejection from the school. Many applicants simply submitted the wrong type of artwork or not enough of what the school is looking for. There is a higher than average likelihood that applicants who resubmit portfolios will be admitted, according to Carol Conchar, "since we know they're really committed to coming here."

Interview

Most schools do not require interviews because the travel cost might be prohibitive for applicants who live at a considerable distance. Interviews are often recommended, however, because they offer both the school and prospective students an opportunity to learn about each other in a direct way. "We don't require interviews," said Judith Aaron, "but those living within two hundred miles are strongly encouraged to come in for an interview. Someone who comes in and stays overnight is much more likely to be admitted. Ninety percent of our students have been seen by an interviewer." In most cases, the work in the portfolio tends to be the focus of the conversation, which then moves on to a discussion of the student's training and career aspirations. Admissions counselors also describe the school's curriculum (reminding students that there is a foundation year) and facilities, as well as answer questions from students and their parents. The average interview is thirty minutes, although some last as long as an hour. At the Maine College of Art, the hour-long interview involves a forty-five-minute meeting of the admissions counselor and the student followed by another fifteen-minute session to which the parents are invited. According to Beth Shea, director of admissions at the college, students generally want to know "what life is like at school, how long classes are, will a bad grade in math keep me from getting in, while parents are more interested in hearing about financial aid and what kind of career their children can expect to have after they graduate."

Counselors generally ask students why they want to go to art school and why they want to go to this particular art school. In answer to the first question, they are most often told that "being an artist is what I've always wanted to do" or "making art is what I like better than anything else," neither of which is a particularly inspiring answer. (Describing the type of artwork one has done, the technical challenges faced and the kind of satisfaction gained from mastering a technique or completing a piece suggests a greater maturity.) Answering the second question requires some research about the school, such as studying the college's catalogue for its departments, faculty, course offerings, and curricular philosophy (a formalist tradition, for instance, or a leaning towards abstraction) or a narrative guide to art schools (such as *Peterson's Professional and Degree Programs in the Visual and Performing Arts*). It also works to the applicant's advantage to mention the benefits of the school being located in or near a major city or other cultural magnet as a reason for wanting to enroll.

Some schools have a strong fine arts focus, while others may predominantly educate applied artists. Art Institutes International (300 Sixth Avenue, Pittsburgh, PA 15222, 800-592-0700, *www.artinstitutes.edu*), for instance, operates nineteen art institutes around the country—Atlanta, Boston, Charlotte (North Carolina), Chicago, Colorado, Dallas, Denver, Fort Lauderdale, Houston, Los Angeles, Minneapolis, Philadelphia, Phoenix, Pittsburgh, Portland (Oregon), San Francisco, Seattle, Schaumburg (Illinois), and Washington, D.C.—which all offer the same basic design curriculum.

Three schools are geared exclusively toward fine artists (Pennsylvania Academy of Arts, San Francisco Art Institute, and the School of the Museum of Fine Arts in Boston), and these academies also attract older students. Otherwise, there is no way around investigating each school individually. The majority teach both fine and applied artists, allowing students to take courses in both areas and, in effect, develop two types of portfolios—one for galleries and one for art directors. It is quite difficult, however, to major in both art and design in most schools, developing a solid portfolio in both areas. Usually, one can major in one area and minor in another, but in some schools even that is not allowed.

Applicants may also be asked about the type of art they are currently working on and how much time they devote to their artwork on a daily or weekly basis. The answers to these questions reveal the degree to which prospective students are dedicated to their art, whether they confine their work to the high school art class, for instance, or make time throughout the week for their interests. Greg Skinner noted that he likes to hear applicants discuss their work in a critical manner, because that is a "statement of maturity. I like to see the discerning and critical powers, the student who says, 'I included this piece in my portfolio for a reason, but I'm not completely happy with it because of this and that.' They are going to art school for a reason; they're not professional yet."

In general, admissions counselors look for a seriousness of purpose, a sense that the applicant understands what art school consists of, where that education can lead, and what it means to live one's life as an artist. According to Judith Aaron, the interview can "carry a lot of weight, especially if the applicant is borderline. We look for students who are really driven, articulate, and motivated to succeed."

Admissions counselors frequently meet with applicants who appear tentative, unsure whether they want to attend an art school or a liberal arts college; in these cases, most counselors automatically recommend the liberal arts college. "I tell them, they should probably not go to art school if they are only 'sort of' interested, because it really takes a lot of drive, ambition, and desire to get through," said Becky Haas.

ESSAY

An applicant's essay carries weight equal to an interview when there has been no interview. If there has been a face-to-face meeting of an applicant and an admissions counselor or art department chairman, most of the same points have been made; the essay now functions primarily as an indicator of a student's writing ability. If the essay stands in for an interview, the applicant should state why he or she wants to go to art school (and why this particular art school), the individual's training in art and participation in extracurricular activities (joined an art club, taught children or senior citizens, took part in a townwide art show), or accomplishments (won an award, sold a piece). "The students should write convincingly," said Michael Fuller. "What is their passion, why are they pursuing this career choice? But don't start, 'I always wanted to be an artist.' That's like, 'It was a dark and stormy night.'"

As opposed to an interview, in which an applicant is responding to an admission counselor's specific questions, an essay may range further afield, to whatever art-related interests the individual may have. Students' essays may describe, for instance, "artists they admire, exhibitions they've seen, social or political issues that they've been involved in, whatever excites them," Judith Aaron said. In effect, applicants may pose questions to themselves, using the essay to answer them. An essay gives control of the discussion back to the applicant, who won't have to field follow-up or unrelated questions for which he or she has not prepared.

Still, the essay will never have the immediacy of a face-to-face meeting in which a personal bond may develop that helps convince an admissions counselor of an applicant's worthiness; further, in an essay, a student's own questions about a school cannot be raised.

Financial Aid

It is easy to be judged needy these days, and most art schools, colleges, and universities report that between 70 and 90 percent of their student bodies are on some financial aid, which may refer to grants, loans, scholarships, tuition waivers, or other forms of monetary relief. A student whose combined family income reaches over $100,000 may be as likely to receive financial aid as another applicant from a far more impoverished background, because the criteria are family expenses.

For many forms of assistance, the general starting points are the Free Application for Federal Financial Aid and the Financial Aid Profile, which are available at any college and most high schools, or one may contact the

U.S. Department of Education (800-433-3243) for the paper application or the electronic file on disk. Once completed, these forms are sent to a federal processing center (the applications come with a preprinted envelope). After that, one applies to a school's financial aid office, which determines the types of aid for which an applicant is eligible, basing its decisions on the information in the federal forms.

COLLEGE WORK-STUDY, GRANTS, AND LOANS

Among the kinds of assistance available are the following:

> *College Work-Study* is a federally backed program, through which students may earn between $1,300 and $2,900 annually for working between 10 and 15 hours per week at minimum-wage rates in jobs at the school;
>
> *Pell Grants* are awards of up to $2,700 per year (based on need);
>
> *Perkins Loans* are low-interest (5 percent fixed interest) loans of between $500 and $2,000 per year (based on need), which one need not begin repaying until nine months after leaving school; and
>
> *Supplemental Educational Opportunity Grants* provide between $300 and $4,000 per year (based on need).

Pell Grants have federally mandated criteria. They are given out on a fixed numerical formula, based on need and the cost of attending the school with no variance allowed. Schools and colleges are allotted a certain amount of money for the Perkins Loans and Supplemental Educational Opportunity Grants, and financial need is the only criteria—money must go to the neediest students who apply for aid, and there is little room for the schools to maneuver.

Generally through a school's financial aid office, one may also apply for other forms of loans:

> *PLUS* (Parent Loan Program) provides money to cover a child's costs of tuition, housing, books, transportation, or other related educational expenses. Parents are responsible for the loan, which may be spread out over ten years (the minimum payment is $50 per month) and requires that repayment begin within sixty days of the money being awarded.
>
> *StaVord Loans* (formerly Guaranteed Student Loan Program) come in subsidized and unsubsidized versions. Students demonstrate their financial need in order to qualify for subsidized loans and are responsible for their repayment. With subsidized loans ($2,625 for freshmen,

$3,500 for sophomores, and $5,500 for juniors and seniors) there are no payments required or interest accrued until six months after the student leaves school (regardless of whether or not the individual graduated). Unsubsidized loans ($4,000 for freshmen and sophomores, $5,000 for juniors and seniors) are for students who do not qualify for subsidized loans; they are still eligible to borrow money but must begin repaying the loan immediately.

In addition, states have grant programs for permanent residents who are attending an in-state college, for which one also applies through the financial aid office. Michigan, for instance, has $2,450 Tuition Grants and Competitive Scholarships, and Georgia has a $3,000 Hope Scholarship for all students who have maintained a B average through high school. Art schools themselves award merit or need-based scholarships based on a review (sometimes a second review) of an applicant's portfolio; and one applies for these through the admissions office, too. At the Atlanta College of Art, for example, incoming freshmen are eligible for Presidential Scholarships (between $500 and $1,000, renewable for four years up to $5,000), Dean's Scholarships ($1,000 for students with SAT scores of 1200 or above, or a 27 or above composite score on the ACTs), Georgia High School Drawing Competition Scholarships ($1,000), and House Parts Scholarships (for students demonstrating an aptitude for drawing). The California College of Arts and Crafts in Oakland similarly awards selected entering freshmen Creative Achievement Awards ($500–$7,000), Trustees Scholarships ($1,000–$5,000), President's Scholarships ($1,000–$8,500), Named Scholarships ($1,000–$8,500), CCAC Scholarships ($1,000–$8,500), and Diversity Scholarships ($2,500–$9,000). Separate awards and scholarships are also offered at most art schools to selected sophomores, juniors, and seniors.

The University of Massachusetts at Amherst provides an annual Chancellor's Talent Award for seven undergraduate students in studio art, paying the students' entire tuition renewable up to four years. These awards are made after the first semester to students with an excellent portfolio who maintain a grade point average of 3.0.

These and other awards, fellowships, and scholarships may be found through the Foundation Center Directory (*www.fdncenter.org*, and at public libraries) and other financial aid directories.

Looking for a Job

WHEN EMBARKING UPON A CAREER OR JUST LOOKING FOR A NEW JOB, the most important questions to ask are "What am I qualified to do?" and "What would I like to do?" Assessing one's skills and interests, especially for those who are just graduating from school, is no easy feat, because it requires looking at oneself in a very different light. Art school graduates must start to see themselves as others in the general labor market might see them; the skills that got them through school may have only a marginal relationship to the jobs for which they are eligible. Being qualified for a job is different than simply knowing one can do it.

Assessing Skills

Job seekers must make an inventory of their marketable skills. One's employment history may be a laundry list of baby-sitting and lawn-mowing jobs, but the skills that have been learned at school and can be demonstrated are likely to lead to more serious employment. Because computer literacy is important, for instance, job seekers should make a list of the programs with which they are conversant. The same is true for design and model-making skills, experience in photography, even foreign languages in

which they are fluent. Friends, peers, and teachers could also be asked to describe what they believe the job seeker does well and might be interested in doing. Career counselors at one's school should be able to help identify a student's or graduate's areas of knowledge or expertise, and in which fields those skills are relevant and desirable.

Current students and alumni need to make frequent use of their school's career placement office, looking through job listings and finding out which employers have hired graduates in the past. Alumni are often disposed to helping recent graduates, putting in a word with whoever is in charge of hiring; in addition, those who are working as professional artists may need assistants. One should try to meet with these alumni, at their offices or studios or at the school, to discuss one's interests and solicit the advice and direction that the alumni might offer (see "Developing a Network" on page 46).

Employment agencies are also practical and useful for people not long out of school. The jobs for which they recruit tend to be on the lower salary end and require fewer advanced skills, but through them one can gain job experience and a taste for a certain field in which one may or may not choose to advance; think of it as a postgraduate internship. In general, employment agencies earn their money from employers, receiving flat fees or a percentage of the salary for the job. One should avoid whenever possible those agencies that ask job seekers to pay up front; once the agency has received its money, it has little incentive to work hard to find the applicant a job.

One may find, in the search for work, that new skills need to be learned (for instance, computer programs used in design, illustration, or word processing) or another class taken. Education is a lifelong experience, with skills needing to be assessed and improved regularly. It does not end with a diploma.

Preparing a Résumé

Some people have likened the résumé to a sales brochure marketing the job seeker as the product. As a marketing tool, the résumé needs to make a strong and favorable impression, both visually and through content, on those who read it: one should use a high-quality dot-matrix or, preferably, laser printer with black ink on standard-size 8×11-inch white paper (twenty-pound bond or more). It is helpful to use white space generously, for instance, creating wide margins as well as spaces between different jobs in order to focus the reader's attention on the content. Too many capitalized

letters or words printed in boldface and too many pieces of disparate information packed closely together generally have the effect of distracting the reader from the sense of the words, leading that person to concentrate instead on the way they look—ostentatious or disorganized, which is not the best first impression.

A résumé succinctly describes one's employment history and career accomplishments, emphasizing the most recent experience (the past five or ten years) with less attention devoted to jobs in the more distant past. Current and recent employment should come first, listing the name of the employer (and division within the company, if relevant), actual job title and dates (years or months, if a short-term job) of employment. The only exception to the reverse chronology résumé is for those who have been out of the professional job market for a long period of time—a result, perhaps, of a maternity leave, schooling, or a prolonged illness—and for whom it makes sense to highlight relevant experience.

For each job position listed, emphasize the most significant accomplishments (such as "directed the computerization of inventory" or "managed the budget for supplies") rather than offering a job description. One wants to be seen as an employee accomplishing tasks and achieving goals, not just as the person "responsible for" this-and-that task. These accomplishments will be most evident when using strong, active verbs, such as *administered, budgeted, controlled, designed, developed, directed, evaluated, maintained, managed, negotiated, organized, originated, planned, produced, streamlined, structured, supervised, trained, uncovered,* and *won.* Strong verbs suggest initiative and hard work, while passive verbs indicate simply filling a position.

Résumés need to be targeted toward specific employers. While the job history does not change regardless of which position one seeks at a particular time, the accomplishments cited on a given résumé may better reflect an individual employer's interests. Managing a budget may have been a small aspect of previous employment, and it may not merit mentioning for a job that does not involve financial responsibilities; however, for another job that requires some degree of knowledge in operating a budget, that earlier experience should be cited, again in strong verbs. This should not be confused with lying about one's experience, because no false claims have been made. Rather, it is making the strongest case for your qualifications. Of course, résumés don't win people jobs. They are a prelude to an interview, a way to get one's foot in the door.

Artists are likely to have two or more résumés based on their marketable skills and their artistic accomplishments. A résumé for a dealer, art critic, or college art department dean may be a lengthy document, listing (in separate categories) one-person exhibitions, group exhibitions, awards, fellowships, and

grants received, commissioned work, art teaching experience, juried shows entered, works in private or public collections, articles, books, and reviews written about the artist as well as articles, books, and reviews written by the artist. This résumé, also known as a "curriculum vitae" (or "CV"), is designed to track one's professional achievements as an artist. Perhaps, over the course of scores of one-person and group shows, no artworks were sold; this type of résumé is not concerned with how an artist earned a living but with how much activity has taken place professionally in the individual's career.

A résumé for a job, on the other hand, is an employment history, detailing the job titles held and skills used in lucrative work. Page after page of exhibitions, awards, teaching stints, and articles written not only are unlikely to reveal one's marketable skills and employment record but suggest that the job applicant has too many other interests and concerns to perform one job effectively. A lengthy résumé is also cumbersome for an employer, who wants to know at a glance what a prospective employee has done and can do. Many entry- or lower-level jobs will strike artists as beneath them as college-educated, highly trained, and resourceful individuals, and they are undoubtedly correct. A résumé that lists a variety of seemingly lofty achievements unrelated to a particular job, however, suggests one's disdain for the more mundane work in question, which an employer can easily sense. Résumés have to be specific to the sought-after job, not serve as a salve for the applicant's ego.

As noted previously, the résumé acts as a marketing brochure; it needs to capture a reader's attention and convey information clearly and easily. A summary statement toward the top of the résumé may be worth considering. This statement is a "headline" of three to five lines encapsulating one's experience and relevant skills. This piques the interest of potential employers, who at a glance can compare the applicant's skills with his or her requirements for the job rather than having to ferret out that information by reading through all the individual's work experience on the résumé. Some job seekers describe an objective (clerical supervisor, foundry manager, toy designer, for instance) instead of a summary statement, which may appeal to a prospective employer but may also be limiting (people change their minds about what they want to do, or there may be a better job available). A job applicant must discover which skills the employer is looking for, a search that may require a telephone call or personal visit. The more assistance one offers to prospective employers, who are probably receiving scores of other résumés, the more grateful they will be. A résumé is not merely a retrospective—about the past and the good deeds that have been done over the years—but an indication of potential for the future. In a résumé, as in an interview, one must be positive and forward-looking, revealing ambition.

A standard, job-oriented, reverse-chronology résumé would look like the one below.

Melissa Painter
P.O. Box 252, Salt Lake City, UT 84002
(801) 555-5555 (home) • (801) 555-4444 (office)
[*e-mail address, if applicable*]

SUMMARY

I am skilled in Windows, Quark, PhotoShop, and other Apple and PC-based computer software that has applicability to business. I have experience in budgeting and payroll as well as supervising staff, event planning, publicity, and visual merchandising.

EMPLOYMENT

2001 to the Present

Office manager, Arcadian Art Supply, Salt Lake City. Selected and purchased products from wholesalers, developed the annual budget, managed payroll, hired and supervised the full- and part-time sales staff.
• *Computerized product inventory*
• *Originated and coordinated the monthly "Artist Talk" series*
• *Installed annual regional juried art exhibitions*

2000 to 2001 (part-time)

Curatorial staff assistant, University Gallery, University of Utah at Ogden. Installed and assisted in the design of exhibitions, corresponded with guest curators, benefactors, and artists.

1998 and 1999 (May–August)

Sales clerk, Books & Things, Salt Lake City, Utah. Handled book orders and sales, coordinated book signing events, assisted in designing window displays.

RELATED EXPERIENCE

Foundations course instructor, University of Utah at Ogden (1999 and 2000). Painting instructor at Hopkins Retirement Home, Salt Lake City, Utah (Summer, 1997).

EDUCATION
Master of Fine Arts, University of Utah at Ogden, 2000.
Bachelor of Fine Arts, Spokane College of Art and Design, Spokane,
Washington, 1998.

Résumés for those with less job experience, lots of short-term jobs, or long periods between employment may need to be structured differently. Certainly, companies understand that summer is the time when students are able to work full-time; the brevity of employment is not held against a job seeker. When the applicant's history of employment consists of a number of jobs that lasted only a few weeks or months, an itemization of every position with start and end dates as well as responsibilities would look odd and raise questions about the individual. Instead, one may create a category like this:

Jobs Held between 1999 and 2003
Sales clerk, Books & Things, Salt Lake City, Utah.
Library aide, University of Utah at Ogden.
Secretary, Howards & McCann Law Offices, Ogden, Utah.
Cashier, Pick & Save, Ogden, Utah.
Lifeguard, Ogden Parks and Recreation Department, Ogden, Utah.
Nanny, Mr. and Mrs. Richard Atlee, Salt Lake City, Utah.

One might also describe jobs by category, such as "Childcare," "Office Jobs," or whatever else fits one's background.
An artist's CV concentrating on *artistic* achievements might resemble the example below.

Melissa Painter
P.O. Box 252, Salt Lake City, UT 84002
(801) 555-5555
[*e-mail address, if applicable*]

EDUCATION
Master of Fine Arts, University of Utah at Ogden, 2000.
Bachelor of Fine Arts, Spokane College of Art and Design, Spokane,
Washington, 1998.

ONE-PERSON EXHIBITIONS

2002
Green River Center for the Arts, Green River, Utah.

2001
Lawrence Hazelit Gallery, Monroe, Utah.
Eugene Venman Gallery of the Solomon Jones Library, Salt Lake City, Utah.

2000
Lawrence Hazelit Gallery, Monroe, Utah.

SELECTED GROUP EXHIBITIONS

2002
"The Landscape Today," Kingsman-Marcum Gallery, Salt Lake City, Utah.
"Northwest Artists Invitational," Sprague Art Museum, Sprague,
Washington. Curated by Clint McConnell.
"Spring Annual," Lawrence Hazelit Gallery, Monroe, Utah.

2001
"The Realist Tradition," Millcreek Center for the Arts, Milcreek, Utah.
Curated by Wallace Everly.
Place and Time Cooperative Gallery, Spokane, Washington.
Prairie Artisans and Artists Gallery, Midland, South Dakota.
"Spring Annual," Lawrence Hazelit Gallery, Monroe, Utah.
"A Woman's Place," Glenrose Cultural Center, Glenrose, Washington.
Organized by Western Women in the Arts.

2000
"The Next Wave," University Gallery, University of Utah at Ogden.

1999
"The Art of the Matter," Kingsman-Marcum Gallery, Salt Lake City, Utah.
"Walla Walla Invitational," Northwestern Exposition Grounds, Walla
Walla, Washington. Curated by Elinor Herter-Johnson.

1998
"Annual Spring Show," College Gallery, Spokane College of Art and
Design, Spokane, Washington.
"New Voices/New Songs," Seattle Visitors Center, Seattle, Washington.

TEACHING

1999 to 2000
Foundations course instructor, University of Utah at Ogden.

1997
Painting instructor at Hopkins Retirement Home, Salt Lake City, Utah.

ARTICLES AND REVIEWS
"Soft Focus on the Landscape," by Karen Wentworth, *Seattle Post-Intelligencer,* 2002.
"Landscapes at Lawrence Hazelit," by Theresa Lidel, *Monroe Repository,* 2001.
"Painter: A Well-Named Artist on Her Way," by Art Myers, *Salt Lake City Tribune,* 2001.
"The Next Wave at the University," by Mary Chester-Reed, *Ogden Standard-Examiner,* 2000.

AWARDS
Purchase Award, Glenrose Cultural Center, Glenrose, Washington, 2001.
Carl Dalton Outstanding Graduate Scholarship, 1999.
Millicent E. Wensdale Merit Scholarship, University of Utah at Ogden, 1998.

COLLECTIONS
University of Utah at Ogden.
Spokane College of Art and Design.
Sprague Art Museum.
Mr. and Mrs. John Hathaway.
Berryman Tree Farm.
Ronda Tuttle.
Carolyn Nevelson.
Mr. and Mrs. Roger Zion.

A résumé should not raise questions or provide unnecessary information, such as indicating why one left a particular job (if for a better job or more money, it needn't be mentioned; if because of a problem, mentioning it would cause an employer to wonder if the applicant has problems with everyone) or how much one earned (a prospective employer may be turned off by an applicant who has earned more than he or she will be offered). Those points may come up at an interview, at which time one may discuss

them at length and in the context of the job sought. In general, one should leave off a résumé the names of references, offering them selectively when specifically asked (there may be different reference contacts for different jobs), and offer briefer descriptions of jobs five or ten years in the past than for those that are more recent.

One might note membership in a relevant trade association, union, or club, because that reflects knowledge of, and a commitment to, the field in which one is applying for a job. However, mention of groups or personal hobbies not specifically related to the area of employment (such as a fraternity, book club, religious affiliation, or rock climbing) tend to distract a prospective employer from one's professional qualifications and may lead the hirer to conclude that the applicant's outside interests are paramount. Further, job applicants should not include personal information (age, health, height, weight, marital status, or religion) or a photograph.

Newspaper advertisements can be a particular challenge to job seekers, since the descriptions of the positions and the skills sought are often quite clipped, usually because employers look to limit the amount they spend on a classified ad. The company name may not be revealed, and the address may be a box number in order to avoid phone calls and walk-in job seekers. In these cases, it is difficult to tailor one's résumé effectively.

Résumés, of course, are not sent alone but are introduced by a cover letter, which establishes the reason for which the résumé was sent (for example, responding to an advertisement, inquiring about a possible job, seeking the assistance of a mutual acquaintance or a search firm). Cover letters should not be lengthy—two or three brief paragraphs are generally adequate, with each paragraph limited to one idea—but one's goal should be stated in a clear and succinct manner. The correct spelling of the name and the correct title of the person to whom one is sending the letter and résumé are vital and may be verified by a quick call to the company switchboard. (When the company's telephone number leads directly to a recording, dialing zero usually leads to an actual operator.)

The body of a cover letter describes one's experience and skills, listing one or more accomplishments and how this background would be well suited to the particular employer. The final paragraph requests an interview with the person to whom the letter and résumé are sent. (One's home and work telephone numbers should be included in the letter; if one does not wish to be called at work, use a message service or have a friend take the calls.)

There are many opportunities to write other types of letters in one's employment search: a thank-you note to someone referred by a mutual acquaintance for any advice or leads given (showing appreciation for the individual's time and efforts, maintaining that person's willingness to offer assistance in the future); a thank-you after a job interview for the individual's time and consideration (affording job seekers the opportunity to restate their qualifications and interest in the position); an acceptance of a job offer (expressing pleasure in the opportunity to work together and restating the terms of employment—salary, starting date, and title, for instance) or a rejection of one thanking the employer for the offer). A note might also be sent to an employer who did not hire the job seeker after an interview, expressing thanks for the individual's time and interest and the hope that one might be considered if a similar job opens up in the future.

A response from a recent art school graduate to an advertisement for a very generally described job might look like this:

Arnold Sculptor

289 Grand Army Plaza
Brooklyn, NY 10129
(718) 555-5555
[e-mail address]

[date]

W & J Advertising
79 East 19th Street
New York, New York 10011

To whom it may concern,

I am responding to your ad in the *New York Times* for a graphic artist. A copy of my résumé and several color copies of my work are enclosed. I would be happy to present my full portfolio to you at your convenience.

Two of the samples were produced at Pratt Institute, where I recently received my bachelor of fine arts degree. I created the cosmetics circular for Victory Drug Store as a freelance assignment.

I have considerable experience with current computer design programs, such as Illustrator, PhotoShop, and Quark, and others used in desktop publishing. I look forward to meeting you to discuss your needs and how I may contribute to your agency.

Very truly yours,

Arnold Sculptor

Developing a Network

Newspaper want ads are the most public place to look for a job, but these advertisements represent only a small fraction of the available and future employment opportunities. The others? Some jobs are filled by internal candidates (those already working within a company), while other openings are made known only to one or more search firms. Many positions are filled by people acquainted with, or referred to, the employer. People who work in those companies or have professional or personal relationships with individuals employed in the same or related businesses often know when a job becomes available. There may be an expansion planned in one area, someone's retirement, a new position created or just contemplated. This is insider information, requiring job seekers to develop a system for gathering facts.

The most effective system is a network of friends, family, acquaintances, coworkers, business associates, fellow members of clubs, professional associations, religious organizations, other job seekers, and even teachers. All of these people have their own formal or informal networks of friends and associates. One's contacts can only grow. From all of these people, one will learn about the following: which companies are currently or will soon be hiring; what will be asked in a job interview and the salary range offered; trends in certain industries or individual companies; how one's skills may be applicable to other types of employment; how to improve one's résumé, making it more responsive to a particular employer; other people whom one may contact in a job search.

Establishing a job-search network and pursuing people for their help and advice may be a psychologically wrenching experience for some. Asking others for advice elevates their sense of importance and may make

the job seeker feel like a supplicant. People one may not know well or even like suddenly become privy to a job seeker's life, and the advice offered may not stop at the names of contacts to call for an interview. Being out of work or searching for a better job is an emotionally charged situation for many who may believe that the fewer "experts" (self-appointed or otherwise) involved in their search for employment, the better.

Obviously, one must select a network with care, based on the maturity of the individuals pursued and the ways in which they can be beneficial in one's job search. It may be worthwhile to rehearse (two or three times with a friend or spouse) how someone will be approached for help so that the words come out of one's mouth naturally rather than in an embarrassed, self-conscious way. One needs to be able to do the following: briefly describe one's career interests, skills, and current (or past) job; ask whether or not the individual approached knows of a current or upcoming job opening in a particular field, as well as who should be contacted and in what manner; maintain composure and not dispute advice that seems off-the-mark or insulting. After a few contacts, the embarrassment is likely to disappear on its own as one moves from a self-image of outsider or pariah to membership in a community. This may be more of a psychological shift for males than females, because interconnectedness seems a long-established trait for women, but it is important and, in some cases, imperative if one is to achieve success in a job search.

Finding a job is a job in itself. Unhappiness in one field and a desire to try out something else is not a flaw in one's character but a fact of life in a society where the average person will have multiple jobs through their working years and change careers three or four times. No one is alone in these feelings. Talking with other people about one's career interests and job prospects will eventually lessen rather than increase one's anxiety.

The job search is full of emotional ups and downs. Leads turn out to be dead ends, desirable jobs are listed, only to be given to other applicants with an "in." Meeting potential contacts and landing an interview are emotional highs (something finally may be happening), while rejections, failure to reach the interview stage, anger at various people, jealousy of others who have been hired, and worries about changing one's career are lows that make keeping a positive attitude difficult. There are no tricks to overcoming feelings of powerlessness, low self-esteem, and frustration. One must recognize that these are normal, even predictable, feelings that accompany a job search, rather than the product of wrongs perpetrated by employment contacts, a spouse, friends, family members, or even the cat. Job seekers should look for all the needed support they can get from those around them rather than alienating others. Anger that isolates the individual also works against presenting oneself (and one's credentials) in a positive light.

Interviewing

In the job search, obtaining an interview is a high point, but it is also a precipice. An interview that does not result in a job offer may lead to discouragement and less willingness to pursue other opportunities vigorously. There may be many interviews over the course of a job search and many inquiries about jobs for which one is qualified that do not lead even to interviews. It must be remembered that a positive attitude during an interview will increase one's chances for landing a job, and when hired will set the tone for one's employment.

For an applicant to get to the interview stage a résumé has to be examined and found relevant to the available position; the credentials have to be deemed superior to the applicants who have not been invited for an interview. There are likely to be other candidates for the job, some of whom may have stronger backgrounds or an inside track (knows someone in the company, referred by someone respected by the employer, has had a previous professional relationship with the employer), but the focus of the interview is a particular applicant and no one else.

Frequently, job seekers approach interviews passively, prepared to answer general or specific questions such as "Tell me about yourself," "Where do you want to be in five or ten years?", "Describe your strengths and weaknesses," "Why did you leave your last job?", "How do you feel about working under pressure?", "What are you looking for in this job?" They place an emphasis on making no mistakes, but this kind of thrust-and-parry strategy may work better in a court of law than in the interview setting where one's questioner is not an adversary but a potential ally who must be won over. These standard questions are not meant to be answered blandly in a way that casts no shadow over the applicant ("I am interested in this job because it offers opportunities for advancement") but should lead to other questions that reveal the character of the applicant. If the job seeker's responses are all technically "correct" but seem defensive or vague, little in the way of rapport will be established and an opportunity may be lost. (A favorable impression may work in one's favor even if one isn't offered the particular job, such as being considered for another opening or a recommendation to another employer or an offer of freelance work.) It is wisest to approach an interview with an agenda, prepared for the standard questions that are asked but looking for an opportunity to guide the conversation. That agenda may be one's ideas ("I see the industry moving in such-and-such a direction, and my work would be . . .") or ability to solve problems (cite some examples and how they would be relevant to this

employer) or particular skills and training. The agenda may also be specific goals for the company (achievable, of course, by the individual to be hired) or a better way of doing business (through the Internet, for instance, or through more face-to-face meetings with customers). By taking charge of the interview, applicants are more likely to be viewed as capable of taking charge of the job and remembered by employers when it is time to review notes on all the job seekers.

In order to make that forceful impression, applicants need to research their prospective employers: How long has the company been in business and how long has the interviewer worked for the company? (The more one learns about the interviewer, the more an applicant's answers may be tailored to the questioner and the likelier a rapport is to develop.) What does the company produce and what are its future plans? (Trade associations and articles in the business press are apt to reveal that information.) What is the organizational structure of the company? (It is not enough to have ideas— one must know how new projects are proposed, accepted, and implemented within the company.) There are a number of books that reveal significant information about a company and its top management, including *Standard & Poor's Register* (updated annually), *Ward's Business Directory of U.S. Private and Public Companies* (updated periodically), *Dun & Bradstreet Million Dollar Directory* (updated periodically), *Thomas Register* (updated periodically), *Macrae's State Industrial Directories* (updated periodically), *Directory of Corporate Affiliations* (updated periodically), and *The National Directory of Addresses and Telephone Numbers* (updated periodically). Many businesses also have annual reports and a Web site or are members of a chamber of commerce, from which one may discover how a company sees itself and what it is recognized for by others. There may be an opportunity during the interview to point out a civic project supported by the company, which a chamber of commerce staffer had recalled. Inside knowledge reveals one's commitment to working for this company and generates a favorable response.

Applicants should also know the major responsibilities of the job, to whom they would report and why the position is currently available. In most cases, that information is available through contacting the company between the time when one is invited for an interview and the day of the interview itself. The switchboard operator, departmental personnel, human resources office or the interviewer him- or herself may be able to answer these questions.

Role-playing or interview rehearsals with a friend, spouse, or family member may help alleviate some of the nervous tension that leads applicants to talk too much or too fast or say the wrong thing. Repeated rehearsals tend

to decrease self-consciousness as well as fright, panic, and other sweat producers, and they also get job seekers accustomed to speaking about themselves in a certain way. If all an employer wanted were appropriate qualifications, applicants would be hired on the basis of their résumés. Interviewers judge the composure of applicants and how naturally they can describe both themselves and their ideas or accomplishments.

Other than role-playing, job seekers need to find ways to relax and not feel the pressure of the moment. Laying out one's clothes the night before a morning interview eliminates the need to fret right before meeting a prospective employer; starting a little early (for instance, catching an earlier train) lessens worries over potential delays. Reviewing notes about the company will help focus one's attention on the matter at hand, and one should also use the time sitting in a reception area awaiting the interviewer to catch one's breath and take in the "feel" of the office. One may also gather information about the office or the interests of the interviewer from what is hanging on the wall or displayed on a desk, and that knowledge may help personalize the interview.

At the interview itself, one should sit up straight, offer firm handshakes (at the beginning and at the end), make eye contact, sound positive and enthusiastic (confident but not bragging), and thank the interviewer for his or her time as the session closes, asking about the next stage of the job-hiring process. One should be prepared to provide three or four references—current or former employers, current or former colleagues, customers or clients, for instance—presented on a separate sheet of paper, listing full names, titles, places of employment, and office or home telephone numbers. These individuals should be asked to be references before their names are offered to prospective employers, and job seekers should coordinate with them what they plan to say in advance. Otherwise, recollections may differ, and references who believe themselves responsible for a project for which the job applicant is taking credit may spoil a good opportunity. References are usually asked about their relationship to the job seeker (supervise the individual, work alongside that person, know socially), the applicant's responsibilities and accomplishments, strengths and weaknesses, reason for leaving a job (if applicable), personal qualities (getting along with others, handling deadlines, willingness to stay late), and an overall assessment. It is wise that references have a current copy of one's résumé, if only so that they do not contradict one's employment dates and job title. References for seriously considered job applicants are checked most of the time; one should be certain both the recollections of the reference dovetail with the experience cited by the applicant and that the reference is willing to vouch for the job seeker.

Resources for Job Hunters

There are also a variety of Web sites that list jobs, company profiles, and the names and addresses of recruiters and offer suggestions to those seeking employment. Some of them are better than others. One cannot always vouch for the accuracy of all information included on these sites, or how current this information is; job seekers should check these leads through other means before dashing off a résumé. Still, this is a way in which much of the "hidden" or unadvertised job market is increasingly being discovered. The obvious advantage of browsing Web sites is that much of the information is free and available at any hour of the day, seven days a week. Finding a job listing through the Web has the added benefit of demonstrating one's Internet skills to a prospective employer. Among the leading Web sites for job seekers are:

AdSearch
www.adsearch.com
Listing jobs by occupation.

Advance Careers
www.advancecareers.com
Listing jobs.

America's Job Bank
www.ajb.dni.us
Listing jobs available nationwide, this site categorizes positions by location, job title, and salary.

Asia-Links
www.asia-links.com
Listing jobs.

Asia-Net
www.asia-net.com
Listing jobs.

ASTD Job Bank
www.astd.org
Listing jobs.

BA Jobs
www.bajobs.com
Listing jobs.

BAMTA
www.bamta.org.bamtajb
Listing jobs.

Boston Works
www.bostonworks.com
Jobs listed in the *Boston Globe.*

Brass Ring
www.brassring.com
Listing jobs.

Career Blazers
http://cblazers.com
Job training and placement.

Career Exposure.Com
www.careerexposure.com
Listing jobs.

Career Journal
www.careerjournal.com
Listing jobs.

Career Magazine
www.careermag.com
Both a discussion area for potential networkers and a site for job listings, employer profiles, and resources for job seekers.

CareerMart

www.careermart.com

Listing jobs by location and category.

CareerBuilder

www.careerbuilder.com

Listing jobs.

CareerNET, Career Resource Center

www.careers.org

Listing jobs by title and industry as well as resources for job seekers.

CareerSite

www.careersite.com

Listing jobs.

Careers in Government

www.careersingovernment.com

Listing jobs.

Chronicle of Higher Education

http://chronicle.com/jobs

Listing jobs.

Crew Net

www.crewnet.com

Listing jobs in film, television, commercial, and stage industries.

DICE High Tech Jobs Online

www.dice.com

Listing jobs.

Employment Edge

www.sensemedia.net/employment edge

Career placement.

Employment Wizard

www.jobexchange.com

Listing jobs.

EPages Classified

www.mediainfo.com

Listing jobs.

FedWorld

www.fedworld.gov

Listing jobs.

Government Jobs

www.govtjobs.com

Listing jobs.

Government Job Bank

www.govjob.com

Listing jobs.

Graphic Arts Information Network

www.gain.org

Listing jobs and resources.

H.E.A.R.T. (Human Resources Electronic Advertising and Recruiting Tool)—Career Connection's Online Information System

www.career.com

Listing jobs.

Higher EdJob.Com

www.higheredjobs.com

Listing jobs and resources.

Historically Black Colleges and Universities

www.hbcucareercenter.com

Listing jobs and resources.

Internet Career Connection

www.iccweb.com

Job listings and resources for job seekers.

Job Asia

www.jobasia.com

Listing jobs.

JobBank USA

www.jobbankusa.com

Listing jobs.

Job Boards.Com

www.jobboards.com

Listing jobs.

Job Circle.Com

www.jobcircle.com

Listing jobs.

Job Net

www.jobnet.com

Listing jobs.

Minnesota Jobs.Com

www.minnesotajobs.com

Listing jobs.

Monster Board

www.monster.com

Listing more than 10,000 current openings, this is one of the Internet's most popular job search sites.

MonsterTrak

www.monstertrak.com

Listing mostly entry-level jobs, resources, and career tips for job seekers; one gains access through a college or university that is a MonsterTrak member.

Nation Job Network

www.nationjob.com

Listing jobs.

Net-Temps

www.net-temps.com

Listing jobs.

NewsJobs.Com

www.newsjobs.com

Listing jobs in newspapers.

Online Career Center

www.occ.com

Listing jobs by location or key-words; includes an area for job seek-ers to post résumés.

Playbill Jobs Search

www.playbill.com

Listing jobs for actors, and professional and technical jobs in theater.

Portfolios.Com

www.portfolios.com

Source for both job seekers and those hiring talent.

Publishing Jobs

www.publishingjobs.com

Listing jobs in publishing companies.

Recruiters Online Network

www.recruitersonline.com

Listing jobs.

Resunet

www.resunet.com

Listing jobs.

Saludos.Com

www.saludos.com

Listing jobs and internships, resources for job seekers with Latino backgrounds.

Search Ease

www.searchease.com

Listing jobs.

Summer Jobs

www.summerjobs.com

Listing jobs and internships in camps, resorts, national parks, and companies worldwide.

Total Jobs.Com

www.totaljobs.com

Listing jobs.

Virtual Jobs

www.virtualjobs.com

Listing jobs; includes an area for job seekers to post résumés.

Washington Post

www.washingtonpost.com

Listing jobs in the D.C. area.

Workopolis.Com

www.workopolis.com

Listing jobs.

As this list indicates, some Web sites allow job seekers to post their résumés, a service that offers benefits as well as risks. Prospective employers may find qualified candidates for positions within their com-panies in this manner, and new opportunities for networking may also

result. However, once posted, a résumé becomes a public document, and one cannot control who looks at it (it may be a good idea to inquire who has access to the database and how that access is granted). If an individual is currently working, his or her own employer may discover that this person is looking for a job, for instance. Some job seekers are reluctant to tell the world their home address and telephone number, although using an e-mail address, post office box, or a voicemail account may circumvent this problem. While many Internet services allow job seekers to post a résumé for free, they may charge for subsequent changes or updates. A popular database will delete résumés in three or six months unless updated.

Some Web sites provide a form on which job seekers may prepare a résumé, while others simply allow one to post a preformatted résumé. As a general rule, applicants should always include their e-mail addresses so potential employers have a means of contacting them. In addition, employers often save résumés in a plain text format (also known as ASCII or DOS text), which means that any special formatting or information placed in a "header" or "footer" will be lost. Even if one is sending a résumé as an attachment, it may be advisable to include a copy of the résumé in the body of the e-mail, since many recipients worry about opening attachments because of the possibility of contracting a computer virus. In addition, an applicant's word processing program may not be compatible with the recipient's software. It is a good idea, after preparing a résumé in text, to send it electronically to a friend so someone else can check it for formatting problems or mere typos.

There are different types of electronic résumés—those sent by e-mail (or e-mail attachments), others that are "scannable" (and entered directly into a database), and yet others called "Web résumés" that are created using HTML and which can be uploaded. The traditional paper or hard copy résumé is intended to attract the human reader to the prospective job applicant through its eye-catching design and compelling language. Electronic résumés, on the other hand, may not be seen first by human beings but, rather, are scanned by computers using applicant tracking system programs that hunt specific keywords relevant to the job in question. (Only résumés that pass the computer keyword test are likely to make their way to a human.) Résumés intended to be seen first by computers must be written differently than those to be read exclusively by humans, including more industry-related jargon and highlighting specific technical expertise. Preparing an electronic résumé (or even a traditional one) may require some help. Among the sources of assistance available on the Internet for applying for jobs are:

CareerXRoads
www.careerxroads.com

Distinctive Documents
www.distinctiveweb.com

Kennedy Info
www.kennedyinfo.com

Online Recruitment
www.onrec.com

Sorcerer's Apprentice
www.netrecruiter.net/resource.html

Weddle's
http://weddles.com

There is more information to be collected than which companies are looking to fill a job. One should learn about a company (how it sees itself and how others view it), its location, and employee salary ranges, for starters. Among the online sites that provide this information are:

The Clearinghouse
www.clearinghouse.net
Information on specific industries and employers.

EDGAR Development Project
www.sec.gov/edgarhp.htm/
Business financial reports on numerous companies.

Editor & Publisher Interactive
www.mediainfo.com/edupub/
Access to local news reporting on companies through links to more than 600 newspapers around the world.

Hoover's Online
www.hoovers.com
Profiles on companies, including addresses, telephone and FAX numbers, personnel, and links to additional Internet information sources.

JobSmart Salary Surveys
http://jobsmart.org/tools/salary/index.cfm
Salary information covering more than seventy occupations.

Pathfinder
www.pathfinder.com
Created by Time Warner, this site contains business articles written about major companies.

Public Register's Annual Report Service
www.prars.com/index.html
A source for annual reports for more than 3,000 publicly traded companies.

Career Advice for the Fine Artist

As a growing number of artists look to the Internet to view, show, and, perhaps, sell artwork, they may also find a burgeoning supply of career advice directed at them as well. With any type of advice, one need always consider the source, and much of the help offered comes in the form of a teaser—information to pique one's interest for something the advisor is selling. For

instance, the Artist Help Network (*www.artisthelpnetwork.com*), which was created by artist career coach Caroll Michels and contains resources of interest to artists, is actually the appendix of her book, *How to Survive and Prosper as an Artist*. Clearly, the Web site aims to generate new buyers of the book. However, as opposed to a book, the information on the Web site is regularly updated and amended in order to keep artists up to date. This is quite helpful, since addresses and phone numbers change so often.

Michels also has a separate Web site that focuses exclusively on her consulting work for artists (*www.carollmichels.com*). Other artists' career advisors, however, combine information on their services with free information and advice for artists, such as Alan Bamberger (*www.artbusiness.com*), Geoffrey Gorman (*www.gormanart.com*), Susan Schear (*www.artisin.com*), Constance Smith (*www.artmarketing.com*), Sue Viders (*www.sueviders.com*), and Sylvia White (*www.artadvice.com*). The advice and help come in different forms— Bamberger writes medium-length essays on a number of topics, Gorman sends out a free e-zine every month with brief tips and news reports to interested artists, while Viders takes and answers questions online in an "Ask Sue" column—but put together these sites may allow artists to obtain a free education in the business of art.

There's more: the Toronto-based *Arts Business* (*www.artsbusiness.com*) is an e-zine of resources, opportunities (commissions, calls for art, job openings, etc.), and art business news covering Canada, Great Britain, and the United States. In another free e-zine, *Selling Art on the Internet,* published by Benecia, California, artist Marques Vickers (*www.marquesv.com/ezine.htm*) looks at Web-based marketing and sales approaches, while Chris Maher's "Selling Your Art Online" Web site (*http://1x.com/advisor*) also offers a variety of articles and resources for artists in this new and daunting field. Perhaps the most all-encompassing career development site for artists on the World Wide Web is the Philadelphia-based The Art Biz (*www.theartbiz.com*), which charges a membership fee—$125 per year, $45 per year for students—for access to opportunity databases (updated daily), an electronic newsletter, a professional exchange page that includes information on approximately thirty thousand artists and potential art buyers (art dealers, interior designers, corporate art consultants, corporate art buyers, among others), and a downloadable career-development tutorial for artists. The Art Biz also features an online bank, operated by BankCorp.com, that offers no-fee, no-minimum checking and savings accounts for artists, and one need not be a member of The Art Biz to open an account. According to Dana Sunshine, president of The Art Biz, incentives for opening an account with the bank include a gift certificate for art supplies.

Additionally, there are a number of Web sites that feature, for free or by subscription, employment opportunities in the arts, including:

*American Symphony Orchestra
League Bulletin*
1156 15th Street, N.W., Suite 800
Washington, D.C. 20005
(202) 776-0212
$25 to receive monthly listing of
conducting positions; $25 for
monthly listing of performing posi-
tions; $30 bi-monthly listing of
administrative positions.

Artists
Plymouth Publishing
P.O. Box 40550
Washington, D.C. 20016
(703) 506-4400
$25 for twelve monthly issues,
listing jobs for artists, arts
administrators, and arts educators.

Art Deadlines List
Resources
Box 381067
Cambridge, MA 02238
www.xensei.com
$30 per year for twelve monthly
lists of competitions, jobs, fellow-
ships, internships, and scholarships.

Artjob
3285 Casa Riconada
Santa Fe, NM 87505
(505) 471-4148
www.artjob.org
$30 for six monthly issues; $45 for
one year.

Artsearch
Theatre Communications Group
355 Lexington Avenue
New York, NY 10017

(212) 697-5230
$40 for twenty-three issues.

Association for Educational
Communications and Technology
1025 Vermont Avenue,
N.W., Suite 820
Washington, D.C. 20005
(202) 347-7834
http://www.aect.org
Jobs are listed on the Web site.

Aviso
American Association of Museums
1575 Eye Street, N.W., Suite 400
Washington, D.C. 20005
(202) 289-1818
$33 for AAM nonmembers.

Central Opera Service Bulletin
Metropolitan Opera Association
Lincoln Center
New York, NY 10023
(212) 799-3467
$35 individual; $50 company and
institution.

Chronicle of Higher Education
www.chronicle.com
Listing jobs in education.

Chronicle of Philanthropy
www.philanthropy.com
Listing jobs in the nonprofit sector.

College Art Association of America
Placement Service
275 Seventh Avenue
New York, NY 10001
(212) 691-1051
$23 subscription for one year.

College Music Society
Music Faculty Vacancy List
1444 15th Street
Boulder, CO 80302
(303) 449-1611
(303) 449-1613
Membership, which is required for
a subscription, is $35 per year,
$25 for students.

Creative Artists Network
P.O. Box 30027
Philadelphia, PA 19103
(215) 546-7775

*Cultural Alliance of Greater
Washington*
410 Eighth Street, N.W.
Washington, D.C. 20004
(202) 638-2406

*Cultural Arts Council
of Houston*
1964 West Gray, Suite 224
Houston, TX 77109
(713) 527-9330

Current Jobs in the Arts
P.O. Box 40550
Washington, D.C. 20016
(703) 506-4400
$22 for three monthly issues.

Dance U.S.A.
777 14th Street, N.W.
Washington, D.C. 20005
(202) 628-0144
$15 per year for ten issues of the
periodical, listing mostly manage-
ment positions.

Dispatch
American Association for State and
Local History
530 Church Street, Suite 600
Nashville, TN 37219
(615) 255–2971
Membership costs $50; members
receive the monthly newsletter.

Employment Opportunities
National Guild of Community
Schools of the Arts
P.O. Box 8018
Englewood, NJ 07631(201) 871–3337
www.nat-guild.org
Membership costs $70; members
receive the monthly newsletter.

Forum
International Society for the
Performing Arts
2920 Fuller Avenue, N.E.
Suite 205
Grand Rapids, MI 49505
(616) 364-3000

Global Art Jobs
*www.globalartsinfo.com/info/
artjobs.html*
Listing jobs in the nonprofit
sector.

Greater Philadelphia Cultural Alliance
320 Walnut Street
Suite 500
Philadelphia, PA 19106
(215) 440-8100

HireCulture
www.hireculture.org
Listing jobs in the nonprofit sector.

IAAM News
International Association of
Assembly Managers
4425 West Airport Freeway
Suite 590
Irving, TX 75062
(972) 255-8020
Membership costs $250; members
receive the twice-monthly
news-letter.

*International Ticketing Association
Newsletter*
250 West 57th Street
Suite 722
New York, NY 10107
(212) 581-0600
Membership costs $180; members
receive the newsletter, which is
published eight times per year.

Job Contact Bulletin
Southeastern Theatre Conference
P.O. Box 9868
Greensboro, NC 27429-0868
(910) 272-3645

The Job Show
P.O. Box 227
Marshfield Hills, MA 02051
(781) 834-0550
www.jobshow.com/careeradv.html
General job search information,
marketing strategies.

National Arts Placement
National Art Education Association
1916 Association Drive
Reston, VA 22091
(703) 860-8000
$45 for nonmembers.

*National Network for Artist
Placement*
935 West Avenue 37
Los Angeles, CA 90065
(213) 222-4035
Publishes a *National Directory of Arts
Internships* ($55) that lists internship
opportunities at small and large arts
organizations around the country.

New York Foundation for the Arts
www.nyfa.org
Free listing, updated weekly, of
employment and internship oppor-
tunities for artists, administrators,
and teachers.

Opera America
777 14th Street, N.W.
Washington, D.C. 20005
(202) 347-9262
$37.50 per year for the periodical,
listing mostly management posi-
tions.

OpportunityNocs
www.opportunitynocs.com
Listing jobs in the nonprofit sector.
(A New England version of this
Web site is *www.opnocsne.org.*)

Release Print
Film Arts Foundation
346 Ninth Street
San Francisco, CA 94103
(415) 552-8760

Resources and Counseling for the Arts
308 Prince Street
St. Paul, MN 55101
(612) 292-4381

(800) 546-2891
www.info@rc4arts.org
$30 for three months of weekly job listings, mostly in arts administration in the Twin Cities vicinity.

United Arts
416 Landmark Center
75 West Fifth Street
St. Paul, MN 55102
(612) 292-3222

Visualsonline.com/jobpostings.html
Free listing of employment and show opportunities for artists and craftspeople.

Worldwide Art Resources
www.wwar.com
Employment opportunities.

Most state arts agencies (go to *www.arts.gov*) and art schools maintain job listings. Their method of collecting these announcements is usually passive—a notice is sent to them, which is then placed in a folder—and not all listings are current. One should also examine the classified sections of service organizations' newsletters, which may list job openings, and some of these organizations also maintain a job file within their offices of currently available positions.

One of the more innovative programs helping artists to find jobs is a two-year professional development fellowship sponsored by the College Art Association, which assists artists of color and other diverse backgrounds (ethnicity, race, and sexual orientation) who are in financial need and in the process of earning an MA, MFA, or Ph.D. During the first year, the artist receives a $5,000 award; in the second year, the artist is assisted in finding a job for which the College Art Association provides a subsidy to the employer.

Establishing a Presence in the Art World

A QUESTION THAT MANY YOUNG ARTISTS ASK IS, "How are artists discovered?" But the fact is, artists discover their own audiences and peers. An audience is developed by putting one's work on exhibit in order to see who responds to it and in what manner; peers (other artists and like-minded critics and dealers) are found by becoming a part of the art world, joining associations, attending art openings, and otherwise meeting people.

Making Connections

Meeting people and becoming known as an artist is very important; many believe it should be one's top priority in an art world that places considerable emphasis on who-you-know. "When I came to New York, I did a lot of hanging around, at openings, bars, and clubs where artists, critics, and dealers went," said painter Lucio Pozzi. "You enter into a system of influences." One of the people he met through hanging around was the already established

painter Michael Goldberg, who "introduced me to a few people," including several dealers with whom Pozzi later showed his artwork. In addition, "I'd go to dinners with other artists, and dealers were there. I became friends with the dealer John Weber at a dinner party, and now I show with him."

Introductions don't create a career but simply eliminate one obstacle in it. "An introduction avoids the horrible process of bringing in your slides to a dealer and then having the dealer say that he'll get back to you," Goldberg said. "It gives you a face-to-face meeting, and from there it's up to the artist and the dealer." Obviously, meeting people and forming relationships has to be a matter of shared ideas, interests, and tastes: professional relationships, like personal ones, cannot be rushed simply because one is in a hurry to achieve something now. The relationships that prove helpful to artists are those that develop over time. An art career is a long-term commitment, and no one wants to be used simply as a conduit to a dealer. "You go to a number of openings and get to know people," said painter Tom Christopher. "Just go up to people and start talking. Don't announce to people, 'I'm an artist,' because that will turn people off right away, but ask people questions about their art, about themselves. Sooner or later, they'll start asking questions about you." As in every other field, people in the art world talk about each other, and word spreads about artists whose ideas and work are distinctive. One of the people to whom New York dealer David Findlay listened was Patrick O'Connor, a dealer whose Galerie Tamenaga closed in the early 1990s. "When Galerie Tamenaga folded, I was looking for another dealer," Christopher said, "and Patrick gave me an introduction to David Findlay. I met with David and we got on pretty well, and I've been with that gallery ever since."

Sculptor Mel Kendrick noted that, in the early stages of his career, he regularly "invited people I met at openings and elsewhere to my studio, and some came." Slowly, he created his own society where ideas as well as art world contacts were shared. While acknowledging that "the art world is run on connections," Kendrick warned against placing "the wrong emphasis on who-you-know. I don't know of any instance in which a dealer has taken on an artist he didn't like just because some other artist told him to." Dealers are part of the "system of influences," however, and have associates and friends whose opinions they value highly. It is not uncommon for artists, critics, or dealers to suggest that a gallery owner take a look at the work of a particular artist, or serve as a character reference (is the artist a serious and reliable person? prolific? reasonable?) once an interest has been established.

Sometimes, personal relationships open doors for artists; other times, the first introduction to artists is through their artwork. For Greg McPherson, there was a bit of both. A 1970 graduate of the University of

Kansas with a BFA in painting, McPherson moved to New York City in 1975 with the idea of just painting, living on $1,500 that first year (in a $50-per-month unheated loft and surviving on 99¢ breakfasts). In 1977, "just as my checks were starting to bounce," he met a print publisher at a party who, after visiting McPherson's studio, hired him to produce a series of mezzotint prints that were sold in limited editions. For a period of years, he alternated between prints (which sold) and painting (which did sell but more slowly), and he also began to market editions on his own. In 1982, an image entitled *Yankee Stadium at Night* was exhibited as part of a group show at New York's Mary Ryan Gallery. Many prints of it were sold, including one to the corporate collector for American Express, who asked the dealer whether or not McPherson also painted. The artist was invited to compete for a mural project in the company's auditorium lobby on the theme of views of New York City. McPherson was selected and produced a ninety-foot-long (six feet high with four separate panels) mural entitled *Waterways and Rivers of Manhattan.*

It was through an accidental encounter that he received a second mural commission from American Express. "When I was installing that mural, I happened to scratch the sky in one area, and I came back the next day to fix it," he said. "By chance, I came to do this repair just as the chairman of American Express happened to be there looking at the mural. We talked for a little bit; he told me he really liked my work, and he asked me if I'd like to do another one." That second mural was a 365-foot-long (11-foot-tall) project for the company's main lobby. The seven-year-long process of creating the two murals—for the first, McPherson rented a one-time diner in Brooklyn as a studio, for the second, American Express rented a floor of a factory for him—turned him from a part-time printmaker into a full-time painter.

Internships and Assistantships

"Hanging around" the art world is a good way to meet people, but it doesn't pay the bills. Working in an art gallery is one way that some artists draw a paycheck while keeping an eye on the art world. One learns through gallery sales not only who are the largest, most prestigious buyers but also how to sell art, how to determine what individual collectors are looking for, and how to turn one-time buyers into repeat customers. Learning the business side of art may be best accomplished on the business side of the art world. Other young artists look to serve as assistants to professional artists, learning how the art world works and becoming acquainted with some of the

high-powered artists, collectors, critics, curators, and dealers who operate within it.

Beyond the chance of building a career, working for an artist offers the opportunity to witness the entire artistic gamut, from the first sketches an artist makes for a new piece to the opening party: there is no other way to see the big picture of all of the people and stages involved. Working for Dorothea Rockburne "injected me into the art world," Mel Kendrick said. "It got me out of the student milieu. I met the people I had only read about—Richard Serra, Mel Bochner, Robert Smithson, Sol LeWitt. The lives they were leading were like the one I was living, and that was very validating to me."

The actual jobs one performs as an assistant may range from the most menial (answering the telephone, making coffee, stretching a canvas, cleaning a cat box) to helping create the actual artwork, and there is quite a range in between. "I do everything. I keep his life together," said Seth Ferris, who has been painter Ross Bleckner's assistant since 1984. "I manage the money, contact galleries, critics, and collectors. I run the studio. I arrange his afternoon delights, keeping his two o'clock separate from his four o'clock."

The working arrangements between artists and their assistants are as varied and flexible as the individuals involved. Photographer William Wegman, for instance, lets his studio manager, Bridget Shields (who received an MFA in photography from Bard College), borrow cameras and other equipment, while Mel Kendrick allowed one of his assistants, Stacy Petty, to live in his studio rent-free. Considering the fact that Kendrick paid Petty $300 per week with no benefits for full-time assistance, the free rent made living in New York City more doable for a young artist. Few artists pay much better, however. Wegman pays between $10 and $15 per hour to most of his assistants, and painter David Salle offers $20 per hour—both without benefits (paid holidays, sick or maternity leave, health insurance).

Some artists establish a personal, collegial relationship with their assistants, talking with them about art (the artist's, the assistant's, or someone else's), family matters, and other topics, while others converse with assistants solely about tasks that need to be performed. "I hardly ever discuss art with the woman who is in charge of the archives," said painter Brice Marden. "The only way I'd know what she does is by asking other people here." That employer-employee distance may come as a shock to young artists who (accustomed to the experience of art school) expect that working with a professional artist will necessarily lead to a mentoring relationship or a coming-together of equals. Mary Schwab, who worked for painter Richmond Burton for a number of years before moving to the studio of David Salle as his studio manager, said that "certain artists think it's a privilege to work in their studios. 'This kid can kneel on the floor all day and stretch my canvases.'

These *kids,* though, all have college degrees." For their part, artists describe assistants with "ego problems" (Dorothea Rockburne), who don't "integrate with my system of thought" (Lucio Pozzi), who "aren't committed to helping me—I'm not running a school here" (Ross Bleckner), who "don't understand that the writers, collectors, and dealers who come to my studio are there to see me, not look at an assistant's work" (Mel Kendrick). Conflicts may be inherent, as assistants see their work as an opportunity to advance their own art interests, whereas artists want assistants who will put their understanding of the art-making process to the service of their own artwork. Marden, who worked for Robert Rauschenberg as an assistant for four years, noted that "my job was to make it easier for Bob to paint." Assistants who can maintain that attitude will have an easier relationship with the artists.

At times, there is a payoff for assistants who stay long enough to learn from the artist and develop relationships with art world people with whom they have come into contact. Marden's work was bought by Rauschenberg and hung in the studio for all to see, and Marden has carried on the favor by purchasing and displaying some of his own assistants' work. Cause and effect are not always easy to establish in an art career, but Marden noted that "I first met the de Menils"—prominent Houston art collectors and museum founders—"when I was working for Bob, and they later started collecting my work." Victor and Sally Ganz, also collectors of Rauschenberg's work, began buying the paintings of Dorothea Rockburne, whom they first met when she was working at his studio. Rockburne stated that she in turn tries to "open doors for my assistants. I've brought dealers and collectors to their studios." To the studio of one of those assistants, Carroll Dunham, she brought a French dealer who "bought it out, allowing Carroll to quit working for me and paint full-time."

Meeting important art world movers and shakers may prove to be a point of frustration for young artists, who are not ready to pursue these contacts or may feel intimidated by them. "It takes a lot of confidence to call on curators and dealers and collectors I've met working at an artist's studio," Mary Schwab said. "I think, 'They're used to working on that level. They don't want to operate on my level.'"

An ever-present problem of working for a successful artist is influence, which may change one's work as well as the way one thinks about making art. Young artists struggle to develop their own ideas and style in a realm that critic Harold Rosenberg described as "anxious" ("'Am I a masterpiece,' [an art object] must ask itself, 'or an assemblage of junk?'"). The master artist needs one or more assistants because his or her art is in such demand, and very few assistants will be able to resist the lure of artworks that have found acceptance. "It's a natural phase of working with another artist,"

Rockburne said. "Your work is going to look like theirs at some point, but I often tell artists to work through that to get to the other side. If you can do that, it shows your strength of character as an artist."

At times, the effect of working as an artist's assistant is the cessation of art, at least for a period of time. Jason Burch noted that his own art-making trailed off for a number of years while working for Wegman because of his intimate involvement in the artist's work. "It's my job to think enough like him to be a step ahead when we're working together, so I can move faster and be ready for his next move," he said. "When I got back to my own work, I would think, 'Is this something Bill would do?' I hear his voice inside my head. I know just how he'd do things." The ideal assistant is selfless, yet forgoing one's ego is probably not a healthy activity for an aspiring artist. Mary Schwab also found that, when she worked for Richmond Burton, the more input she had in his artwork, the less able she was to do her own. "I became creatively satisfied in his studio," she said. "I was treated as an equal. We talked about art all the time. I was included in dinners with critics. I worked on the paintings, making decisions, developing the composition, mixing the colors. It sucked the creativity right out of me."

Her response was, eventually, to leave Burton's studio and set up firmer boundaries in her employment with Salle. As a result, there is "more space left in my mind" for her own artwork. "It's dangerous when you have so much of a dialogue about the work. I'd say to Richmond, 'I think you should change the color and move that over there,' and I'd see my ideas going into someone else's work. When the piece is finished and exhibited, no one is going to say, 'It was Mary who decided to change this color and move that over there.' I've learned to keep my mouth shut." What Schwab has learned about how to be an assistant is satisfactory to David Salle, but it would not be acceptable to all artists. Kendrick for one stated that he has "never hired someone who has worked for other artists. I think they're keeping something back."

There is no future in being an artist's assistant: the pay is never very high, and one cannot move up the corporate ladder to become the artist. Some individuals work as a particular artist's assistant for a very long time, which maintains continuity and limits artistic interruptions, but sometimes both artist and assistant recognize that a long association is not healthy for either one. Kendrick stated that, after a number of years, an assistant's view of art-making becomes overly narrow. "Basically, the assistant learns your way of working and feeds it back to you," he said. "An artist can ossify." For his part, Marden noted, "I like having contact with the younger world. New people bring in new ideas."

There are various ways that young artists may get hired as assistants. Talking to dealers about which if any of their artists may be looking for an

assistant is one way, as is asking people who are currently working as assistants for leads (they often know each other and have their own networks, as well as information on which artists are generous, respectful, or cruel to their assistants). "The people I've hired as assistants are usually friends of other people who have worked for me," Kendrick said. Many artists or their studios are listed in telephone directories, and one can call to inquire. Seth Ferris was hired after he made a "cold call" to Bleckner's studio. Some young artists are hired as assistants after they have worked as interns in an artist's studio. Stacy Petty, for example, came to New York City as an intern through the New York Studio Program, which is administered for the Association of Independent Colleges of Art and Design by Parsons School of Design. He worked for a semester for Kendrick, who asked him to come back after he graduated from the Ringling School of Art and Design in Florida. Through the same program, Jason Burch interned at Polaroid's 20 × 24 Studio, where he worked with Wegman, and Wegman asked him to come work at his studio as a full-time assistant. Two publications from the National Network for Artist Placement (935 West Avenue 37, Los Angeles, CA 90065, 213-222-4035)—the *National Directory of Arts Internships* ($55) and the *National Resource Guide for the Placement of Artists* ($50)—provide employment opportunities in a wide range of arts organizations. The career placement centers of art schools also should have information on internship programs for students and alumni.

Balancing the Day Job and a Rising Place in the Art World

Day jobs. They make fine art possible for so many artists, affording them the resources—if somewhat abridging the time—to create the work that (they hope) leads to shows, sales, and (God willing) the ability to leave their day jobs and pursue art full-time. The history of art over the past hundred-plus years is filled with white- and blue-collar jobs that artists have held until they could afford to do without them: Yves Tanguy was a wine merchant, and Arnold Friedman a postal employee; Vassily Kandinsky was a professor of law, and Henri Rousseau a customs agent.

The jobs don't assume much space in the biographies of these artists—they're not regarded as meaningful parts of their true-life stories, even in cases where the artist held the job for many years. Like the clothes they wore, the jobs offered protection from the world and some comfort; as their stars rose in the art world, however, these jobs gracefully receded into the background.

Well, not all the time. Gossip borne of jealousy, negative performance reviews from supervisors who want to discourage outside interests, and a tense work environment have been the experience of many artists whose reputations in the art world have risen while drawing a salary.

One of the true horror stories in this area was Dean Mitchell's tenure at Hallmark, Inc., in Kansas City, Missouri. He was encouraged to continue to create and exhibit his work when he was first hired. Yet within two years, Mitchell was taking prescription muscle relaxers to relieve the stress of a seemingly endless array of criticisms of his work for the company, which he attributed to jealousy of his art world successes on the part of his supervisors. "I was getting my paintings into shows, winning awards at juried competitions, and suddenly something was always wrong with my work. I'd get told, 'You need to move that figure one-sixteenth of an inch,' and I'd do it, then they'd say, 'It just doesn't look right. Try again.' It wasn't this, it wasn't that. There was always some problem."

Mitchell was criticized for not working fast enough and for not producing enough cards. He received complaints that he didn't take his work home with him. An array of different supervisors did not boost his morale much, since they all seemed to recommend that he give up his painting and concentrate solely on Hallmark images. His first supervisor learned that Mitchell had won an award from the National Watercolor Society and told him, "You're just dreaming." Another supervisor complained to him that "You do too much outside." Yet another supervisor announced, "Hallmark doesn't need any superstars." A different supervisor put the problem to him quite plainly: "Decide: are you in here or out there?"

For many employed artists, that question frequently arises, limiting their ability to keep a foot in two careers. Tom Christopher, a painter of growing prominence who also works steadily in commercial illustration, noted that many art directors look down on fine artists for not working hard enough and being unreliable. "They have a living-in-a-cold-water-flat-and-chopping-off-your-ear conception of artists, and they look at me and say, 'Is that what you are these days?'"

The academic world is somewhat better, since art schools and university art programs promote themselves by proclaiming how actively involved the faculty are in their art careers. On an individual basis, however, schools may prove less accommodating to those careers than their pronouncements suggest.

"To begin with, I was the only woman in the entire sculpture department, and some of the older faculty didn't feel at all comfortable with my presence," said Elyn Zimmerman, who lasted three years at the State University of New York at Purchase. "When I started to get commissions to

do public works, they were even more unhappy." That unhappiness mani-
fested itself by assigning Zimmerman unpopular evening hours in which
to teach and not affording her time to visit the sites of her installations.

The competition between artists for scarce full-time teaching jobs may
also create tensions, leading to "a lot of back-biting" within a department,
according to Sam Gilliam, a painter in Washington, D.C., who has taught at
a number of schools, including the University of Maryland, the Corcoran
College of Art and Design, and Carnegie-Mellon. "If someone thought that
you were getting more praise than they got, that person would try to make
life hard for you." He noted that one faculty member at Carnegie-Mellon
"searched art magazines to see if I [got] a bad review. If there were any, he
would read it aloud to his classes." Another time, Gilliam was walking past
an office where he heard one instructor telling another, "'[Gilliam] doesn't
know color at all.' I stuck my head in the door and said, 'Hey, I thought we
were buddies,' but there you are."

In order to advance at a school—obtain a raise and a choice of classes,
become tenured and promoted—faculty must demonstrate a primary com-
mitment to the institution, which may conflict with the needs of being an
active artist. "When artists teach in an institution, it is very easy to get swal-
lowed up by that system," said painter and photographer William
Christenberry of Washington, D.C. "A lot of my artist friends who started
teaching at the same time I did are no longer practicing artists."

Christenberry taught at Memphis State University from 1962 to 1968,
and has since then been an on-and-off faculty member of the Corcoran
College of Art and Design. Christenberry credited art schools in general and
Corcoran in particular with providing greater latitude to art faculty than the
majority of college and university art departments. There is no hard-and-fast
rule about which types of institutions of higher education hire art teachers
who also happen to be artists and which look for artists who also teach. "If
one of my faculty—say, Elizabeth Murray—has an important show, I'll tell
her, 'Go,' and I'll find some way to cover her class," said Judy Pfaff, a sculptor
and co-chair of the art department at Bard College in New York State. That
type of flexibility and willingness to acknowledge that a faculty member's
career interests are on par with, or take precedence over, school-related
responsibilities is only rarely found. As much as he lauds Corcoran,
Christenberry said that it took "some time" for the college to accept the fact
that he sees his career as primarily outside of the institution and that the col-
lege benefits from that other work. "Over the years, the school has come to
realize that when I go somewhere I'm representing them and not just
myself," he added. "I think of myself as an effective teacher," he said, "but I've
never put as much into my teaching as into my art." Noting that "I had to get

out of Memphis State—I couldn't remain there and continue to be an artist,"
Christenberry stated that almost every university art department he has
known has been rife with "petty jealousies" and "fiefdoms." "I spent a week at
one university as a visiting artist. It was during a faculty evaluation period.
One poor soul was reprimanded for exhibiting too much; another was criti-
cized for not exhibiting enough. I was happy to get out of there."

Artists resolve the problem of balancing a rising art career and their
day job in different ways. Christenberry left one school, taking a pay cut to
come to the Corcoran, because the working environment was more suitable
to him. Zimmerman just left, shortly after having put up a successful bat-
tle to reverse a decision that denied her tenure. "I recognized that I wanted
to pursue my own art more, and the rewards of teaching lessened, espe-
cially as I felt all these hassles." Mitchell endured long periods of "agony and
frustration" at Hallmark, which intensified when the company fired him
after three years, but he found strength in the fact that "I had given them
my best work." In fact, he had learned the craft well enough to support him-
self by freelancing to other card companies until his own paintings could
free him to work on his fine art full-time. Tom Christopher also strives to
provide commercial clients with good, on-time work, "to show them that
their ideas about fine artists aren't true." For her part, Pfaff tries to sched-
ule her shows during spring break or other times when Bard is not in
session, "so it causes the least amount of interference."

Throughout his years teaching at the college level, Gilliam kept remind-
ing himself, "My future lies outside of this." Certainly, Gilliam's future
increasingly rests with art collectors, curators, and historians who period-
ically make determinations on his place in art history. Perhaps that kind of
reminder is useful for all artists who hope to keep in perspective the tur-
moil and jealousies around them as they set their sights on a higher prize.

Exhibiting One's Artwork

There are many opportunities to show one's work—at juried art shows, on
the walls of banks, bookstores, cafés and restaurants, community and art
centers, realty companies, department and jewelry stores, hospitals and
libraries, in one's own studio, at colleges, nonprofit and alternative art
spaces, art galleries and museums. Almost any walled surface (for two-
dimensional artists) or open space (for sculptors or installation and
performing artists) is a potential exhibition site, and most artists who
expend any amount of effort at all will eventually find some place that will
agree to exhibit their artwork for a limited or extended period of time.

Exhibitions have their purpose and value, but they are not synonymous with an art career. A career entails establishing a market for one's artwork, generating sales and interest in future work. The value of showing one's art publicly, from a marketing standpoint, is threefold:

- **To gather comments about one's work from other artists, critics, would-be collectors, and experts (academics and dealers).** Artists need to know whether or not they are communicating effectively and how they are perceived by others. They also need to know who their audience is (young, middle-aged, or old, homeowners or renters, socially or politically conservative or liberal) so that they may target their search for collectors or dealers more effectively. It is wise for artists to be present at their exhibitions in order to meet the people who come to their shows. When works are sold, artists should personally deliver them in order to see how and where the buyer lives, the color scheme of the house, and the style of other artwork on view. The friendlier the relationship becomes, the greater the chance for future sales.
- **To gather names of the people who look at one's work, for instance, through a visitors' book.** Many of these names will form the beginnings of a mailing list, individuals who can be sent postcards or brochures about upcoming exhibitions or newly completed one-of-a-kind works or editions, or perhaps just updated information about the artist. Exhibitions take place irregularly, and there is often a considerable amount of time between one show and the next; shows can be ephemeral events, lasting for just a few weeks and then forgotten by most people who attended. Artists need to think about marketing their work on a year-round basis, not simply at those brief moments when there is an exhibition, and the mailing list is one of the key mechanisms for reminding those who have shown interest in their work of additional possibilities to see and buy the artwork (visit my studio, buy my work for an anniversary or Christmas gift, come to my lecture or demonstration at the local arts center, come bid on my artwork that will be donated for the charity auction). Mailing lists, of course, do not have to consist solely of strangers: there are many people whom artists know (friends, employers, business associates, coworkers, teachers, parents of friends) or know by extension (friends of parents, employees and business associates of parents and siblings) who may be induced to look at the art and, perhaps, buy it. Penelope Dannenberg, director of artists' programs and services at the New York Foundation for the Arts, recommended an idea that she called Tupperware for the Arts: "Ask someone you know to have a cocktail party with ten people," she said. "At the party, the host introduces you,

and you show your work and talk about it. In this kind of intimate setting, you are likely to have some sales. Once one person offers to buy something, others will follow. Then, you get those ten people to invite ten other people to parties, where you do the same thing."

- **To generate media attention for one's art.** Exhibitions are news events, which make them of interest to newspapers, magazines, radio and television stations. Artists should prepare press releases, highlighting what is novel or significant about the show (new technology employed, based on a recent trip to Spain, focuses on oppression of women), sending this material several weeks in advance to these media (six months for magazines) and following up with additional material (biography, artist's statement, black-and-white or color slides or prints, clippings of previous reviews or articles on the artist) and a telephone call or two to the most relevant reporters or editors, and perhaps all of them (arts editor, art critic, weekend editor, calendar editor, Sunday editor, features editor, managing editor, assignment editor, women's section editor). Call to find out who should receive press - material (name, title, and telephone extension) and the date by which they should have it. Artists should seek to develop relationships with the media (invite to the studio, a gallery or museum show, lunch or dinner, meet at an opening) so that whenever there is a news or features event pertinent to them (lecture, demonstration, open-studio day, charity auction, public installation) they will not have to start from scratch.

Many artists believe that art galleries are the only means by which they can show and sell their work, but the fact is, they can sell on their own—through brochures or open studios, juried competitions, and art fairs. There are thousands of arts and crafts competitions and fairs annually taking place around the United States, many of them listed in such publications as *Sunshine Artists* (3210 Dade Avenue, Orlando, FL 32804, 800-597-2573, $34.95 per year for twelve monthly issues), *Art Calendar* (P.O. Box 199, Upper Fairmount, MD 21867-0199, 410-651-9150, $32 per year for twelve issues), *American Artist* (One Color Court, Marion, OH 43306, 800-745-8922, $29.95 per year for twelve issues), *The Artist's Magazine* (P.O. Box 2120, Harlan, IA 51593, 800-333-0444, $36 per year for twelve issues), and *The Crafts Report* (P.O. Box 1992, Wilmington, DE 19899-1992, 800-777-7098, $29 per year for twelve issues). Many of these competitions charge entry fees, and there is almost always a booth-rental fee for shows, ranging from a few hundred dollars to a few thousand dollars.

For Virginia Cobb, entering exhibitions and becoming a member of such groups as the National Academy of Design and the American Watercolor Society were part of a career plan. Cobb won awards at shows sponsored by these societies, and these shows travel around the country. Commercial art gallery owners in the cities where these exhibits travel have called her, asking to see more of her work.

Cobb stated that "membership in national societies gave me credibility as an unknown, both in helping to sell my work and in getting a lot of invitations to teach," adding that, "to some collectors, membership matters. Credentialing in art is ridiculous because it has nothing to do with my art. But, in order to do what I wanted to do—to paint and to teach—I needed to get those credentials."

Entering national competitions also enabled Midwesterner Cobb to "choose a way of life that has to do with living in this part of the country, which I would have had to give up to move to a major art center on one of the coasts. In New York, I'm unknown, but being a New York artist was never my goal. It's important to get your work out somewhere, but 'out' can be to cities like Denver or Houston."

Robert Rauschenberg was born in Texas, and Jackson Pollock in Wyoming. Both knew that they needed to go to New York City in order to continue their education and become professional artists, but, to Cobb's mind, it is no longer so important to move anywhere in order to be an artist. Traveling exhibitions that include her work as well as membership in widely respected artist associations means that potential collectors and dealers throughout the United States may see her art and find out about her. "Transportation is so available that I can get a painting anywhere I want overnight," she said. "I don't need to live anywhere else."

Some artists develop casual relationships with galleries, arranging for exhibitions when they have available pieces but otherwise maintaining the exclusive rights to sell their own work. "I'm not represented by any dealers at present," said New York painter Peter Halley. "I have a half-dozen relationships with dealers in the United States and around the world, a constellation of galleries to which I can bring work when I'm ready but to whom I have no commitments and have made no promises." These galleries are located where he has a critical mass of collectors (New York, Los Angeles, France, Germany, and Italy). Previously, Halley had been represented exclusively by New York galleries (at first Sonnabend and then Larry Gagosian), but he discovered that foreign buyers were not always willing to come to New York City to purchase his work and that galleries were uninterested in splitting commissions with a gallery abroad in order to exhibit his work

there. "The exclusive relationship was not to my benefit," he noted, adding that Gagosian was "more concerned with his agenda than with mine."

Art Worlds

One of the most important facts to remember when building a career as an artist is that there is no one art world. There are numerous art markets; some overlap others and some do not. If the art represented in *Art in America* or *Artforum* (ubiquitous and studiously followed in art schools and university art programs) is one's entire conception of the art world, a great deal is being missed. High-end publications reflect a certain vision of art that is quite exclusive. Traditional realism, for which there are far more buyers than for more progressive styles, is not represented in *Artforum*, but, of course, *Artforum's* choices won't be found in the pages of *American Artist* or *Wildlife Art*, either. There are segments of the art world devoted to a variety of subjects—equine images, miniatures, religious art, to name just a few—and each genre has a stylistic range (tight or painterly realism, for instance). Each art world is a specialty market, and the artist's job is to find his or her audience.

For instance, Charles Allmond of Wilmington, Delaware, who sculpts animal figures, looked through the pages of *Art Calendar* and *Wildlife Art* magazines for "shows that featured animal art and even shows that didn't feature it but where it wouldn't look out of place." Art shows featuring animal art, of course, would expectedly draw collectors of that specific genre, but Allmond also sought out juried competitions sponsored by charities (Ronald McDonald House and United Cerebral Palsy, among others) or taking place in a museum, "because your work is seen by a different group of people, and a lot of them have money and may already be collectors."

He also developed a relationship with Franklin Mint, a mail-order collectibles company that sells small bronze multiples of animals among other items, and with a gallery in Santa Fe, New Mexico, that now sells his originals. Perhaps most advantageous was joining the Society of Animal Artists, a New York City–based international association that sponsors between one and three exhibitions per year for its members. Those exhibitions are usually held at a sponsoring museum (for instance, the Washington Historical Society in Tacoma) or at a conservation organization (such as the Friends of the MacArthur Beach State Park in West Palm Beach, Florida), which helps expand the number of people who learn about or come to buy this genre of artwork.

It was through repeated shows at the Society of Animal Artists that painters John Schoenherr of Stockton, New Jersey, and Guy Coheleach of

Bernardsville, New Jersey, were contacted by galleries and print publishers. Both artists started their careers as commercial artists—Schoenherr illustrated children's books as well as science fiction and *Readers' Digest* articles, while Coheleach worked in advertising—but moved slowly into the fine art area of their interest. "I did brassieres and can openers for years on Madison Avenue—strictly commercial art—and I decided I wanted to just paint animals," Coheleach said. He began to submit his work to nature magazines, such as *Audubon,* and then to art shows where animal art was prevalent. A number of print publishers, including Hadley House and Mill Pond Press, approached him about creating images for limited-edition prints, the royalties from which allowed him to leave off commercial work for good.

Schoenherr's transition was somewhat more abrupt. After a serious car accident in 1974, a year in which two family members also died, "I decided that I wanted to start painting more and not just talk about it. The accident was a life-changing event." From that point on, he began to paint animal imagery, entering those works into juried competitions. Twice, he won awards of excellence from the Society of Animal Artists, and he also won a medal from the Philadelphia Academy of Natural Sciences. Within the world of animal art, those awards were quickly noted, bringing dealers to him, including a fine art gallery in Denver, Colorado, and a sports gallery in New York City. The seemingly esoteric world of animal art supports these artists and many others, as well as galleries, publishers, an association, and a variety of juried shows.

Private Commissions

At exhibition openings, by mail and over the telephone, art collectors regularly ask Northampton, Massachusetts, painter Scott Prior to produce works just for them. Sometimes, these collectors suggest an image they want him to paint. Most of the time, they simply tell him, "I want anything." Money and praise are offered, but Prior approaches these offers warily. "I'm not encouraging," he said. "For every ten people who ask me to do something, I may do one. When I don't know the person, how can I be confident there won't be problems down the road? With strangers, I don't even know what the problems might be."

Actually, Prior knows generally what the problems are if not the particulars of a specific collector. He may find himself dickering over the price with "someone who thought that going to the artist directly means paying less. For me, it doesn't." Commissioned paintings aren't shown in galleries, which for a slow-producing artist like Prior means that they take away from

his main form of promoting work and hold less prestige than pictures he created on his own initiative. These works also take more time than others because of the need for meetings, telephone conversations, and making appointments. "I had agreed to do a portrait of a woman in Boston, but just the time it takes to drive to Boston and back, taking photographs, talking with her and negotiating this, that, and the other was more than I could spare. I had to write her a letter asking to be let out of our agreement because 'I just don't know when I'll ever get to do it.'"

There may be other problems as well, including the possibility that the collector may not like the work when it is completed. "People wanting to commission a piece say, 'I have this in mind,' but it's hard to interpret what they actually have in mind," said Sue Furlan, studio manager for Santa Fe, New Mexico, sculptor Larry Bell. "There have been touchy situations where people are not satisfied. You don't really know what they had in mind." If the commissioned work is a portrait of the collector, the likeness may also not be pleasing to that person. Gregory Gillespie, a painter in Belchertown, Massachusetts, noted that when he has been asked to do a portrait ("I'm not a portrait painter; I'm not about absolute likenesses"), he makes two stipulations in his agreement: "First, the portrait may not be flattering and it may not even look like you," he said. "Second, I can take as long as I want." He added that "someone who wants me to do his portrait basically wants a Gillespie with himself in it."

In a larger sense, individually commissioned artwork will be a variation of an artist's previous work, rather than something new and original in itself. For that reason alone, it may be less interesting to create. However, as the commissioned piece will be based on past work, it may be easy to price. The first step in arranging a commission of this type usually involves the collector coming to the artist's studio to look at earlier work—the actual pieces or photographs of them—"to see if there's anything they like," Prior said.

For New York sculptor Alice Aycock, who doesn't "have stock items," she assumes that "anyone who would commission me would know my work pretty well." She and the collector have an extended conversation about what the individual wants, after which she makes "a drawing of the proposed piece and, if that is approved, I will price the work."

Her price includes the entire cost of designing and fabricating the piece, plus a markup of between 10 and 20 percent as profit. If the collector's price restraints come up early in the conversation, however, she can "design to a budget." Prior and Gillespie both work on verbal agreements, but Aycock, who has received a number of both public and private commissions over the years, writes her own contracts ("I have enough contracts around that I can refer to them in writing up my own"), occasionally

consulting a lawyer. The contractual points in these contracts include: how the sculpture will be constructed and installed, payment by the collector (usually in installments, such as one-third deposit, another third when the piece is half done, and the final third after the work is installed), timeliness (when work will be completed, when final payment is due), who pays for insurance (in shipping and installing the work as well as liability insurance), who pays for shipping and installing the piece, who controls the design (the artist), and that there will be no alterations in the final work (unless approved by the artist).

The contract would also clearly state that the artist owns the copyright, including photographic rights to the work. If the work will be photographed and those images are to be used in some manner, such as on a company's stationery, the artist would charge an extra (negotiable) fee. Tom Eccles, executive director of the Public Art Fund in New York City, stated that a contract should describe how damage to the artwork will be handled. "You want to know if the work will be restored or removed," he said. "You don't want something looking hideous out there with your name on it, because that can be damaging to your reputation."

There may also be provisions for mediation (if there are disputes), legal expenses (if the artist isn't paid on time and must sue), reimbursing the artist for travel (food, lodging, transportation), and framing (selecting and paying for it). Daniel Greene, a portrait painter in North Salem, New York, noted that his New York City framer sends him photographs of a variety of different frames, from which he and the individual or group commissioning the portrait make a selection. "If convenient, I try to meet with the client or committee to see what other portraits they may have commissioned, to see how they are framed, to see where my portrait will be hung and what might be relevant to the background," he said.

At times, the collector or commissioning agent will write a contractual agreement, which may be brought to a lawyer for review or handled solely by an artist who feels confident in the terminology and the area of law. When Neil Estern was selected by the federal government as the main sculptor of the Roosevelt Memorial in Washington, D.C., he was sent a forty-page contract "of which maybe seven pages referred to me and what I was going to be doing. They piled responsibilities on me that I didn't want, such as insurance that I don't want to carry and crating and shipping that I won't be responsible for. I rewrote those seven pages to make them more to my liking, and I never heard a complaint."

Commissioned work usually involves having the piece approved by the buyer during one or more steps of the creation process—for instance, the design, half-way done or at the end. (Collectors who only buy work from

exhibitions, on the other hand, approve or disapprove of the artwork on the basis of their decision whether or not to purchase it.) In addition to the design, Aycock allows an inspection of the work in progress, while Estern's work may be approved as a design, in clay and when completed. Commissioned art tends to be more collaborative, and the artist must be willing to work with the collector during the process of creation, which may bring up issues of personal confidence and integrity. "You have to know where to draw a line and where to bend a little," Gillespie said. "If I'm doing someone's portrait and the guy says, 'I can't stand this painting,' I might be open to certain suggestions. If he says, 'My wife is allergic to yellow,' I might tone down the yellow. But if they want a totally different painting, they have to go to a different artist."

Greene noted that he asks for a one-third deposit and bills for the remaining two-thirds after the portrait has been completed. "I don't ask for a second one-third payment because that would suggest that they should approve the work-in-progress," he said. "If they don't like the final work, they don't have to take it—that's my guarantee—but I won't make changes in the middle." To protect himself from possible rejections, Prior noted, "I won't do a painting on commission that I wouldn't do anyway." Similarly, a rejected commissioned piece by Larry Bell "would go into the other realm of sales," Bell's studio manager Sue Furlan said—in other words, gallery art. Artists concerned about the possible financial loss might want to add an "acceptance upon proposal" clause to a contract stating that, if the final work conforms to the proposal, the artist will be paid in full regardless of whether or not the collector likes the piece. (There could also be a provision that the artist would be reimbursed for his or her time and expenses if the work is not approved.) Certainly, if there are changes to the original design that the artist looks to make during the process of creating the piece, those need to be approved by the individual or group commissioning the work.

To Sell or Not to Sell (Directly)

Buying a work of art has its own etiquette. At auction, one may wave a card or subtly touch one's nose; a top art dealer may want prospective buyers to "prove" their commitment to the dealer by purchasing something other than what they originally wanted (and by some other artist); sensitive artists with fragile egos who sell out of their studios may compel collectors to walk on eggshells when discussing price.

Each type of buying arrangement has its benefits and drawbacks. Auctions are where one might spend less (dealers, for instance, frequently

obtain the pieces they sell in their galleries through auction houses) or much more (only at a competitive auction would a collector spend $82.5 million for van Gogh's *Portrait of Dr. Gachet*). An artist may sell his or her work for less money than a dealer might charge, precisely because the artist isn't paying a gallery commission, but artists are not often involved in the sale of their work and may take great offense at being "lowballed" by a potential collector (dealers are used to negotiating price without taking underbids personally).

Whereas, in the past, artists were thought of as slightly disreputable people, now many moneyed collectors want to have artists as part of their circle of acquaintances. For many, there is a romance about buying from the artist. "A lot of collectors want to know the artist behind the art," said Arthur Dion, director of Gallery NAGA in Boston, "and we may arrange to bring the collector to the artist's studio." Janelle Reiring, director of New York's Metro Pictures, also occasionally arranges studio visits in order to satisfy curious buyers, since "collectors generally know that artists are somewhat colorful personalities."

"Some collectors boast that they get their paintings directly from the artist," Christopher Watson, one of the directors of New York's Nancy Hoffman Gallery, said. "They feel like they have some inside scoop." At times, Watson added, "a visit to the studio tends to bolster enthusiasm for buying the artist's work." However, that is not always the case. According to Christopher Addison, director of the Addison-Ripley Gallery in Washington, D.C., some collectors "get turned off buying the artist's work after meeting the artist. We represent some fairly abrasive artists, and some of our collectors have a particularly imperious manner. The chemistry is all wrong, and it is a great embarrassment to bring together people who obviously won't get along."

Some artists also don't want to be bothered in their studios by collectors, especially those with whom they do not have a long and personal relationship. "For me, it depends upon who the people are and why they've come," New York City painter Pat Steir said. "Some people just want to look at my work and see my studio. Someone thinks it sounds fun to meet the artist. I don't let people I don't know come into my studio and see unfinished work." In addition, a growing number of dealers have exclusive arrangements with the artists they represent, forbidding the artists from selling their work in any way other than through the gallery.

Buying art through a dealer not only may be a necessity but a strong preference on the part of the collector. Galleries are generally open five or six days a week, allowing potential buyers to drop by whenever convenient to look at a work rather than when it suits the artist's schedule. Galleries are

set up to display artwork properly, permitting collectors to imagine the piece in their own homes, while an artist's studio may be full of clutter without relief.

Dealers often act as advisors to collectors, developing an understanding of what the buyer is looking for (a particular theme in painting by a variety of artists, for instance) and in which price range. "Collectors don't generally run around from studio to studio, looking to discover new artists," Janelle Reiring said. "They rely on a certain network of dealers to learn about new artists for them." Dealers also provide a certain connoisseurship to their customers, such as determining the best work by a particular artist; it is almost impossible to ask that of an artist. They may locate artworks that match the collector's current decor—which most artists greatly resent—and offer advice on how to frame, insure, light, and take care of the objects. Many dealers have returns policies (return the artwork at any time and get your money back) and allow buyers to upgrade their collection (trade in current work toward the purchase of a better piece), which artists do not. They may also assist a collector in buying or selling a work at auction. These services are truly what distinguish dealers from auction houses and artist studios when it comes to purchasing works of art.

Buying through a dealer may also allow the collector to speak more candidly about what he or she likes and dislikes than if buying directly from the artist. Collectors, for example, may be more interested in what a particular artist created in an earlier period than in the current work. Artists also are frequently committed to a specific aesthetic outlook, while collectors may have quite eclectic tastes, buying pieces by different artists that seem to contend with each other. Dealers are more likely to accommodate that kind of eclecticism than are artists, who might feel betrayed or misunderstood. "Dealers act as a neutral partner," Addison stated. "It's a lot harder to offend us."

The issue of fixing a price is one of the major reasons that many collectors, seeking to avoid the emotional aspects of making a deal, prefer purchasing through a dealer. Likewise, many artists are content to let their dealers haggle for them. "It's much harder to talk money with an artist than with a dealer," said Neil Weisman, who has amassed a substantial realist painting collection with his wife, Donna. "Artists feel it's like taking a piece of themselves and saying, 'I'm only worth this much.' On the other hand, some artists have a major ego at stake when it comes to price. They'll say, 'This is the best painting I ever did,' and they'll say that about everything they do."

Collectors and dealers may have more natural affinities than do collectors and artists. For artists, far more than for those who buy their work, the

art is central to their lives; it may also be their only source of income, limiting their willingness to concern themselves with a buyer's budget. Collectors and dealers, on the other hand, are united by the enjoyment of original artworks around them as well as (frequently) a business background. In addition, few collectors or dealers limit themselves to the work of just one artist, developing a range of art objects to buy and sell.

Dealers sometimes arrange for collectors to pay for works on an installment plan, perhaps accepting another artwork or valuable object (such as jewelry) from collectors in lieu of money, whereas artists—who may have incurred major expenses creating various pieces or are behind in the rent—look to be paid in full and in cash as soon as the art is sold. "Dealers know how to get money that is owed to them," Marsha Perry Mateyka, owner of the Marsha Mateyka Gallery in Washington, D.C., said. "Many artists have had trouble collecting money owed to them. A collector puts down a deposit and takes the piece, and the artist never receives the rest. Artists generally haven't a clue what to do about it."

Despite the fact that some buyers are curious about artists and want to associate with them personally, most dealers find that the majority of their collectors show only a limited amount of interest in knowing who the artist is or in meeting that person—for example, attending an exhibition opening where the artist will be present—believing that what the artist has to say is best stated through the artwork itself. "Eighty percent of our collectors never ask a question about the artist," Ivan Karp, director of New York's O.K. Harris Gallery, said. "When I'm talking about a certain work, I may describe the artist as a fine person, add some plaudits to help enhance the sale, but collectors generally buy the work, not the creator."

Finding a Dealer

Looking for a dealer is among the least pleasant activities in which an artist may be engaged, in part because no one likes to be judged (especially on the nonaesthetic criterion of "Will this sell?" rather than the basis of "Is this good art?") and because no one wants to be rejected. Galleries need to be researched in order to ensure that the type of art one creates is in keeping with the theme or taste or medium of the work regularly on display there. It is always possible that a gallery devoted to academic realism will take on an installation artist, but it is a long shot. The best type of research is actually visiting the gallery on more than one occasion to look at the kind of work on display and inquire about the price range of these pieces and who buys them. One has to fit aesthetically not only into the gallery but into the

market to which the gallery caters. Another source of information is the annual summer issue of *Art in America* (P.O. Box 37003, Boone, IA 50037-0003, 800-925-8059, $15), as well as the regional guides of *Art Now Gallery Guide* (P.O. Box 888, Vineland, NJ 08360, 201-322-8333, $35 per year for ten issues). These publications list the major galleries in various locations (the gallery director's name is also listed in *Art in America*) and which artists are shown in each. From this information, someone with knowledge of the contemporary art world may gain a reasonable idea of the type of art and artist exhibited there.

Unless an introduction to a gallery director has been made, a presentation by an artist consists of an envelope including a packet of slides (fifteen to twenty on a sheet, well photographed and representing a consistent style of work rather than a retrospective) or an album of photographs of one's work, a CV or biography (listing a record of exhibitions, awards, commissions, past buyers, and education—see chapter 2), copies of selected articles about the artist or reviews of shows, and, perhaps, an artist statement. Certain galleries have viewing days—one should call to find out if and when a dealer might be interested in seeing a portfolio— and other times when this material may be picked up. In some cases, an artist may prefer to also submit a self-addressed stamped envelope, allowing the gallery to return the portfolio at its convenience. Sometimes, a gallery will hold onto the artist's packet for a period of time, contacting him or her months or a year or more later. Preparing a portfolio can be expensive, but it is an investment and artists should be concerned less with getting material back than with the possibility of their work staying in a dealer's mind.

When a dealer expresses interest in showing an artist's work, it may be on a one-time basis (try it out to test collector response) or as a regular member of the gallery. An artist's enthusiasm for having work shown should not cloud other questions, which may be raised in a cordial environment, usually in a face-to-face meeting (or over the telephone) and followed up by the artist (if not by the dealer) in a letter. The artist's relationship with the gallery is a kind of marriage, in which both parties have mutual interests (selling work, being emotionally and financially supported) and passions (the art itself), but it is also a business arrangement, involving a variety of obligations and responsibilities. The discussion between artist and dealer should specify a number of points, including:

- Term, or the length of this agreement (one show, a year or two, indefinite). Artists would generally prefer a fixed period of two or three

years, in order to see how well the gallery markets work and lives up to its word. If, after a few years, the artist's work has risen to higher esteem and prices, the artist may want a new agreement that reflects that stature or the opportunity to find another gallery. Artists should not be locked into a contract that they have long outgrown. Some artist-dealer contracts have a termination clause, detailing the way in which the relationship will be severed.

- Nature of the agreement (exclusive or nonexclusive). A gallery may exclusively represent an artist's work in its entirety or for just a particular geographic area (Pacific Rim states or North America), leaving the artist free to contract with other galleries for territories not covered in the agreement. A gallery may represent an artist's paintings exclusively in one city, but not the artist's prints or sculpture. The artist may reserve the right to make studio sales or not pay a commission on sales at art fairs where the artist mans a booth. The agreement might also signify whether the artist's works are placed on consignment with the gallery or purchased outright.
- Commissions, usually ranging from 40 to 60 percent.
- Discounts for certain or all collectors. Some range as low as 5 percent and as high as 25 or even 50 percent in the case of a major museum that wishes to buy. The decision on discounts should be made by the artist.
- Pricing, which should be established by the artist in consultation with the gallery owner. There is no inherent value to artwork, only prices that collectors are willing to pay. Complicated equations have been offered to artists on how to fix the price of their work (based on the cost of materials, the number of hours spent creating the work multiplied by some hourly rate plus some amount representing return on investment), but the fact is that, at the start of their careers, artists will be paid less than their art is worth. When they become better known, they can raise their prices to well above what the equation would have them charge. The basis for setting prices is what other artists of similar experience and acclaim doing similar types of work are receiving for their art.
- Responsibilities of both artist and dealer, such as the types of promotional efforts that will be made for shows (who pays for flyers or newspaper and magazine advertisements), whether or not a catalogue accompanies a show (and who pays for it) and the requirement and cost of framing, shipping, and insuring artwork. In the past, dealers covered most of these expenses but not so much nowadays except for their most prestigious artists.
- Frequency and nature of exhibitions (one-person, group shows, once a year or less often, when in the year, how the work will be shown).

- Periodic accounting, detailing who bought which works and how much was paid for them. Artists should receive payment (less commission and any other expenses, such as framing or stipends) within thirty days, certainly no more than sixty to ninety days. Thirty states around the country—Alaska, Arizona, Arkansas, California, Colorado, Connecticut, Florida, Georgia, Idaho, Illinois, Iowa, Kentucky, Maryland, Massachusetts, Michigan, Minnesota, Missouri, Montana, New Hampshire, New Jersey, New Mexico, New York, North Carolina, Ohio, Oregon, Pennsylvania, Tennessee, Texas, Washington, and Wisconsin—and the District of Columbia have enacted artist-consignment laws that protect an artist's works from being seized by creditors in the event of a gallery going bankrupt. Even artists whose dealers are in states other than those covered by artist-consignment laws may receive many of the same protections by filing a UCC-1 form for works on consignment (available in the county clerk's office, requiring a nominal filing fee). The form stipulates that the artist has a prior lien on his or her own works if the gallery declares bankruptcy.
- An exact accounting of all works consigned to the gallery. Each work should have its own consignment sheet, listing the title, size, medium, and price. Too often, artists inquire about certain consigned works that their dealers claim they never received. A consignment sheet, signed or initialed by both artist and dealer, would eliminate the question of who is responsible for the particular work.

Although disagreements may come up, the relationship between artists and their dealers is not adversarial. Both sides want the artwork to look good and find buyers. A mutually beneficial relationship requires regular communication, on new work and life changes, on buyer interest and sales, and a commitment on both sides to work together. If problems begin to emerge in the relationship (there are not enough sales or promotion of the artist's work, or the gallery may not be reporting sales to the artist, for instance) and an artist decides to leave the dealer, the break should take place over time and in amicable manner. The gallery may still have a number of the artist's works, which the artist would want returned in good condition. Gradually, the artist should recall pieces "and try to get everything out of there before telling the dealer that this relationship isn't working out," said Joshua Kaufman, an attorney in Washington, D.C., who has represented many artists in their legal conflicts with galleries. "I've heard lots of horror stories about works kept in storage being lost or damaged as soon as the artist says he or she wants to leave."

Finding out who is a reputable dealer or gallery is no easy task. The Better Business Bureau will know only of complaints filed with the agency

(an unlikely place for dissatisfied artists or collectors to go). One might also contact local museum curators for a reference, but they may never have had dealings with the gallery. Word-of-mouth references are not always at hand. As they consider joining a gallery, artists should contact others represented by the gallery in order to learn whether or not the dealer keeps his or her promises, if payment is prompt, if work is promoted widely and effectively. Occasionally, another source of information about a gallery is the association to which it may belong.

There are dozens of these associations in the United States (some regional, others national), and the number is growing. Many differences exist between them, but they share a common belief with regard to prospective collectors. "The association assures that the highest levels of business practices and ethical standards have been set for the members," said Christopher Addison of the Addison-Ripley Gallery and a past president of the Washington Art Dealers Association. Noting that even though "nonmembers may be perfectly reputable," Sylvan Cole, president of the International Fine Print Dealers Association, added that "this organization represents print dealers you can trust and who are the best in the field."

Dealer and gallery associations represent the hopes and best interests of their members. Often, those interests are the same for collectors, such as the print disclosure laws that the International Fine Print Dealers Association lobbied to see enacted in eleven states around the country, requiring that dealers reveal all relevant information to would-be buyers about the limited-edition graphic prints they are selling. The Art Dealers Association of America was instrumental in creating an Art Advisory Panel at the Internal Revenue Service (IRS), which evaluates appraisals for charitable donations of art objects, and the association also helped to found the New York City–based International Foundation for Art Research, which tracks stolen and forged art and antiques around the world.

As with any trade association, these membership groups also attempt to promote and protect their members' profitability, which is where conflicts with collectors and artists may arise. "First and foremost, these organizations set standards, and their members by and large comply with these standards," Sylvan Cole said. "Not everyone lives up to these standards all the time, but the standards are there and that gives confidence to the collector that these are dealers you can trust."

GALLERY ARTISTS AND PRIVATE SALES

To some artists, having a dealer means that they never again need to concern themselves with the mechanics of selling works to collectors— someone else is in charge of that problem. Other artists, however, find that

collectors prefer to buy from them directly, instead of from their dealers, and beat a path to their studios. Frequently, those collectors believe that they can purchase artwork for less money than when a dealer is involved—the price may be halved, these buyers think, because there won't be a 50 percent gallery commission.

As a rule, artists should never undersell their dealers. "If you want to establish and maintain a good relationship with a dealer, you don't cut his throat," said Calvin J. Goodman, an artist's advisor and author of *The Art Marketing Handbook.* However, some artist-dealer issues are less clear-cut, especially when the artist also sells his or her work - directly.

For instance, dealers frequently, or even regularly, offer discounts off the stated price—usually 10 percent—to encourage potential buyers. Is it equally permissible for the artist to offer the same percentage discount?

Artists and their dealers tend to have opposing views on this. Painter William Beckman, noting that "dealers wouldn't have a job, wouldn't exist without artists," stated, "It is just as viable for the artist to sell work with a discount as the dealer." On the other hand, Gilbert Edelson, administrative vice president and counsel of the Art Dealers Association of America, said, "A discount by the artist undercuts the dealer, even if the discount and the final price is the same as what the collector would get at the gallery. Collectors talk to each other: 'Don't buy from the dealer. You'll get a better price from the artist.' This hurts the dealer, and eventually the artist, after the dealer decides he no longer wants to handle the artist because the artist has become his competitor. Artists should tell people who want to buy their work directly, 'I don't sell from my studio. You should go to my dealer.'"

In general, the only time that artists might sell work at a larger discount would be to their dealers—known as a "trade" discount, which may be as large as 40 or 50 percent, in effect the regular gallery price minus the regular dealer commission.

No less thorny is the question of whether or not an artist owes his or her dealer a commission on the sale of a work from his or her studio. For instance, a work is exhibited in the dealer's gallery and then returned to the artist; if someone who may have seen that work on display approaches the artist directly to purchase it, is the dealer owed a commission? Again, artists and dealers view this issue differently, although there is no unanimity of opinion on either side. "If the dealer can't sell it," Gregory Gillespie said, "I wouldn't owe him anything," while Alice Aycock stated, "I would owe the dealer a commission, but maybe not the full 50 percent. I would try to

figure out what the dealer has done and what I've done, basing the amount of the commission on that."

However, George Adams, co-owner of New York City's Frumkin/Adams Gallery, took the view that the dealer is owed the regularly agreed-upon commission because "the sale would not have been made but for the patronage of the gallery. A gallery provides all kinds of support services as well as a forum for presenting the artist's work, and the dealer would rightly expect that these costs would be paid for by the commission."

At times, an artist who is in a long-standing relationship with a gallery or dealer privately sells a work that was never displayed in the gallery, and the commission question arises again. In this instance, most artists tend to agree with Denver, Colorado, artists' advisor Sue Viders that "you shouldn't have to pay a commission on a sale when the dealer had nothing to do with it," although artists who receive a regular (often monthly) stipend from their dealers are more likely to feel an obligation to pay the commission. "I literally owe my dealer money because of the stipend he pays me," Gillespie said. "The dealer has to make up the money he has advanced me somewhere."

Dealers themselves, even those who do not pay stipends, consider that some commission may be due them. "The artist's name and reputation was presumably made by the dealer," Gilbert Edelson stated. "But for the dealer's efforts, no one would have tracked down the artist to buy from him or her directly."

The issue of whether or not to pay the dealer's commission, of course, only applies to artists who are not in "exclusive" relationships with their dealers—that is, they have not formally agreed to name the dealer as their sole agent for sales. In some instances, artists write into the consignment agreements with their dealers that collectors whom the artist has personally cultivated are an aspect of the market that fall outside the realm of exclusivity.

In general, it is wise for artists to discuss these and other issues with their dealers at the beginning of their relationship and as circumstances arise. As an example of an agreement that an artist and dealer might reach, the artist (who has the final word on the prices for his or her work) allows the gallery to discount works a certain percentage but requires that this discount be deducted entirely from the dealer's commission.

Some dealers do far more than others for the artists they represent, of course, while other artist-dealer relationships seem more adversarial. In order to minimize direct competition between the two, many dealers discourage their artists from selling privately in the same market area.

In an ideal and a practical sense, the two should be working toward the same goals; the payment of a commission tests this bond.

"Sales that the dealer may have helped to generate going to the artist leaves a bad taste in the dealer's mouth," Calvin Goodman said. "Artists need dealers; you don't want to jeopardize a situation that puts money in an artist's pocket. You don't want the dealer to find out that something has been taking place behind his back."

Sales and Rental Galleries

Artists generally try to put their work where art collectors go, which is why getting into a commercial gallery tends to be so important to many of them. However, it is never clear that *all* their potential collectors will go to that one gallery, and then there are those people who might become collectors if only they did go to art galleries. Many artists find that they cannot rely on one place to provide all their public exposure and all their sales, but must continually seek out new and different venues to show and sell their artwork. Kim Osgood of Portland, Oregon, has had good luck finding buyers for her monotypes at the Lisa Harris Gallery in Seattle, Washington, and the Margo Jacobsen Gallery in Portland, selling twenty or so (at $1,200 to $1,400 apiece) at one-person shows and one every month or so at the galleries between exhibitions. Those intervals can last up to two years, so it has proven quite welcome that, in the one year Kim Osgood has been exhibiting her artwork at the Seattle Art Museum's sales and rental gallery, eight works have been sold and some smaller amounts of money have shown up as rental income.

"There is a different pool of buyers—especially corporate collectors—at the Seattle Art Museum than you find at the Lisa Harris Gallery," Osgood said. "I get another chance to make a sale."

The museum's sales and rental gallery was established in 1970 for the twin purposes of helping to create opportunities for artists and create additional revenue for the institution. It has accomplished the second by achieving the first, since the gallery takes a 40 percent commission on sales (more than three hundred artworks are sold annually) and rentals, generating over $100,000 in income for the museum. The sales and rental gallery serves as a perquisite for museum membership, because only members may rent artworks or purchase them on a year-long installment plan (one needn't join the museum to purchase a work outright).

"There is a limited number of commercial galleries and nonprofit spaces in Seattle," said Barbara Shaiman, director of the museum's sales

and rental gallery, "and this represents a way for the museum to support local artists, and the local gallery community, too. The museum is easy to find, and we tell people about the area galleries." In fact, it was gallery owner Lisa Harris herself who originally contacted Shaiman about showing the work of Kim Osgood—the two galleries make a split of the commission from any sales of the artist's work. "A number of our regular clients were referred to us by the sales and rental gallery after they showed interest in an artist we represent," Harris noted, adding that she "may place a work at the sales and rental gallery that's been at our gallery for a while and hasn't sold."

Approximately 160 regional artists have consigned their work to the Seattle Art Museum's sales and rental gallery, and "almost all of them receive some money in the course of the year," Shaiman said, the majority of which is from rentals. Rather than purchasing pieces outright, a number of the museum's corporate members prefer to rent artwork for office decor, returning them after the three-month rental period in exchange for others. These companies may take twenty or more pieces at one time, paying the sales and rental gallery between 7 and 9 percent of the purchase price for the three months; that money is then paid to the various artists, less the gallery's commission. The amounts that artists receive is often low—Carl Kock of Chicago and Nina Weiss of Highland Park, Illinois, received checks for $20 and $35 per month, respectively, when their work was shown at the now-closed sales and rental gallery of the Art Institute of Chicago—but may add up over time.

The price range for works in museum sales and rental galleries is generally on the lower side—$600–$3,000 at Seattle, $500–$5,000 at the Delaware Art Museum, and $200–$600 at the Charles MacNider Museum of Art in Mason City, Iowa—and the majority of sales tend to be in the lower to middle area. A higher price point may work against an artist whose market is strong, making sales and rental galleries a more appropriate jumping-off place for emerging artists.

There are a number of benefits and a few drawbacks for artists in showing their work at a museum sales and rental gallery. Certainly, there is the opportunity for considerable exposure, since far more people visit art museums than art galleries, and a certain percentage may stop by the museum's gallery to see what's on view. Museums tend to be less intimidating to the general public than commercial art galleries, which attract a more select group of visitors. Most galleries don't have regular leasing agreements for the art they carry, which limits their ability to attract corporate clients (some of whom do eventually purchase the art they start out renting). In some cities, there may not even be many commercial art

galleries where area artists can show and sell their work, making the local museum the main cultural venue. In 2000, the sales and rental gallery of the Delaware Art Museum was voted Best Gallery by the readership of the *News-Journal,* the state's largest newspaper.

Additionally, although there is rarely any curatorial involvement in the selection of artists or the operation of sales and rental galleries (they are usually started and run by a museum volunteer committee with, perhaps, one paid employee), artists recognize the value of being associated with an art museum. "My work was shown in a prestigious museum," Nina Weiss said, "so I'm happy to keep it on my résumé."

However, it is for the very reason that some institutions do not wish to be associated with otherwise untested artists that they have closed their sales and rental galleries. "There is a belief at some museums that the artwork in the sales and rental gallery isn't at a professional level, that it's not in keeping with the rest of the museum," said Patty Howard, gallery manager at the Los Angeles County Museum of Art's sales and rental gallery. "Even here, we feel a little insecure." When the Art Institute of Chicago opened its gallery in the 1950s, "Chicago was a much more sleepy place in terms of an art community, and there was a real need for the museum to do something for artists," a spokeswoman for the museum said. However, as more galleries emerged and the museum sought to focus its attentions on internationally renowned artists rather than perform a favor for locals, justifying the continued presence of the sales and rental gallery became more difficult. The space was converted into an architectural studies center in 1990.

Sales and rental galleries also tread a thin line between cooperation and competition with commercial galleries. As part of a nonprofit institution, they do not charge any sales tax on artworks sold, which makes the same priced piece of art less expensive there than if purchased through a regular dealer. Francine Seders, a gallery owner in Seattle, noted that she has allowed but does not encourage artists she represents to also show their work at the museum, since, "in a small town like Seattle the rental-sales gallery becomes competition." One of her stable of artists, painter Juliana Heyne, had shown at the sales and rental gallery of the Seattle Art Museum but no longer does because the rental fees she receives "are very low, and the work is taken out of the market for months at a time." The museum allows renters to take the artwork for a three-month period, with an option to renew for another three months. As a result, the same piece may be rented several times by different clients for as long as six months apiece before they decide to either buy

or return it. By the time a previously new work is returned to Heyne, she added, "it may be three or four years old," and thereby less desirable both to her dealer and to collectors.

Except for an occasional feature article in a local newspaper, museum sales and rental galleries suffer from neglect from the media, and their shows—some galleries create thematic exhibitions and do not just place artwork on the walls or in bins—are rarely reviewed, perhaps also reflecting their lower status. Jennifer Zika, manager of the sales and rental gallery of the Portland Art Museum in Oregon, stated that local newspapers do not review her exhibitions, "because we don't do one-person shows, and we don't do one-person shows because we don't want to compete with the commercial galleries."

The quality of the operation of the sales and rental gallery is often uneven, reflecting the fact that some groups of volunteers may be very committed to the endeavor while others lose interest or do not follow through. Sales and rental galleries at the Fort Wayne Museum of Art in Indiana and the Springfield Museum of Fine Arts in Massachusetts never generated any revenues and were closed down; in both instances, it was difficult to find volunteers just to sit in the gallery during the hours it was open. Museum administration may also waver in its commitment to helping local artists, preferring a higher-revenue-producing museum shop, where note cards, T-shirts, posters, and books sell in greater volume, and opportunities for licensing images in the institution's collection. "In the last twenty years, museums have been pushed to generate more income and become more self-sufficient," said Sheila Perry, director of the Charles MacNider Museum of Art, which continues to operate a sales and rental gallery. "There is just not as much income to be made with a sales and rental gallery. The unit costs are high, the turnover is low, and it takes a lot more work to sell a unique work of art than a mass-produced poster."

The 1990s saw a number of museum sales and rental galleries fall by the wayside. Those that remained have created paid positions and generated, in some cases, significant revenues for their institutions. The sales and rental galleries of both the Albright-Knox Gallery of Art in Buffalo, New York, and the Delaware Art Museum both generate $30,000 annually for their respective institutions; the Portland Art Museum receives $100,000–$150,000 per year, while the gallery at the Los Angeles County Museum of Art produces a net income for the institution of between $125,000 and $175,000 annually, based on gross sales of $800,000. A similar amount is earned by the San Francisco Museum of Modern Art, whose

Artist Gallery had gross revenues in fiscal year 2001 of $1,883,740—of that amount, artists received commissions of $1,029,432.

Among the sales and rental galleries at museums are:

California
Laguna Art Museum
307 Cliff Drive
Laguna Beach, CA 92651-1530
(949) 494-8971, ext. 213
The museum no longer has a sales and rental gallery but continues to arrange rentals and sales of artists.

Los Angeles County Museum of Art
5905 Wilshire Boulevard
Los Angeles, CA 90028
(323) 857-6000

Delaware
Delaware Art Museum
2301 Kentmere Parkway
Wilmington, DE 19806
(302) 571-9590, ext. 550

Iowa
Charles H. MacNider Museum
303 Second Street, S.E.
Mason City, IA 50401-3925
(641) 421-3666

New York
Albany Institute of History and Art
Rice Gallery

135 Washington Avenue
Albany, NY 12210-2296
(518) 463-4478

Albright-Knox Art Gallery
1285 Elmwood Avenue
Buffalo, NY 14222
(716) 882-8700

Oregon
Portland Art Museum
1219 S.W. Park
Portland, OR 97205
(503) 226-2811

Pennsylvania
Philadelphia Museum of Art
Benjamin Franklin Parkway and 26th Street
Philadelphia, PA 19130
(215) 684-7965/7966

Washington
Seattle Art Museum
Rental/Sales Gallery
1334 First Avenue
Seattle, WA 98101
(206) 748-9282

In addition, a couple of artists' membership organizations—the Cambridge Art Association (25 Lowell Street, Cambridge, MA, 617-876-0246) and the Salem Art Association (600 Mission Street S.E., Salem, OR 97302, 503-581-2228)—also operate sales and rental services, charging a 50 percent commission.

Selling Art on the Web

A quick surf through the World Wide Web reveals a growing number of artists' home pages, featuring their art, information on the artists, prices, artist statements, and everything that the normal portfolio may contain and more. A Web site is now, it's exciting, it's on the cutting edge of something, but the question remains: Does any art actually get sold in this way? As yet, the Web as the new frontier of art sales has been more a matter of speculation than fact, and most of the reported sales have involved galleries with home pages and their regular clients buying artists they have collected in the past or seen during a visit to the galleries. "Ninety percent of my sales are on the Internet," said Jane Haslem, owner of the Jane Haslem Gallery in Washington, D.C., which has an address on ArtLine. "I used to have my gallery open all the time, but now I'm open only by appointment because so much of my business is through the Web."

Describing her Web site as a means of introducing artworks to a wider number of potential collectors, Haslem noted that most of her online buyers know her or the artists she represents. "It is rare that someone I don't know calls me and says, 'I saw an image on your home page, and I want to buy it,'" she said. "In most cases, someone who has been a customer in the past calls and says, 'I am looking at an image on your home page. Please tell me more about it and about the artist.' I will talk to that person and send a brochure about the artist. There will probably be more conversations and eventually, perhaps, a sale." The Web site does not replace the traditional brochure in her business, she added, but supplements it. "In a brochure, you can only show five or so images. On a Web site, I can do a complete retrospective, plus include everything else in my gallery's inventory."

Similarly, the Gomez Gallery in Baltimore, Maryland, has sold a number of works (including paintings that cost $2,500 and $3,500 apiece) through its Web site. Those buyers had discovered those particular artworks on the gallery's home page, although, according to gallery owner Walter Gomez, "they had bought from the gallery in the past. They had seen other pieces at the gallery and kept up with our Web site. As yet, we've had no bites from people who haven't bought from the gallery before."

While more and more galleries are going online, the jury is still out on the Internet's ultimate value. "Nobody's really selling anything of real value through the Web," said Sarah Hasted, director of Ricco/Maresca Gallery in

Washington, D.C., which has a home page because "it seems the thing to do." Komei Wachi, director of Gallery K in Washington, D.C., which has had a Web site on ArtLine for two years, also noted that "we haven't sold anything. With all these sites on the Internet, it seems like an inefficient way to show or sell anything."

Michael Thomas, assistant director of R. H. Love Contemporary art gallery in Chicago, Illinois, noted that "no one is going to buy an Edward Hopper based on seeing a picture on their computer screen, but for other artists it is going to happen; I'm just not sure when. In due time, as the demographics change and the users of the Internet become older, I think you're going to see a shift in the buying patterns among art collectors."

The Search for Art-Related Income

I N THE MINDS OF MANY PEOPLE, being an artist and working as an art teacher are the same, as it is thought that all but the relatively few successful artists support themselves by teaching. Most art students, especially those in MFA programs, hope to be hired by the same types of programs from which they are graduating or at least by another school. "My goal was to come to New York City and bum around for five years and then get a teaching job," said Harlan Mathieu, a printmaker and carpenter at the Metropolitan Museum of Art who received an MFA from the University of Iowa in 1981. "I did bum around for five years but never got a teaching job. My plan didn't work." Sheryl Hoffman, who received her MFA in sculpture from Ohio University in 1987, "waited and waited for a teaching job to come along, but you can't wait forever," so she went to work first in a sculpture foundry and later as a special-events coordinator in a natural history museum. Carl Hoffner, a printmaker who earned an MFA in 1979 from Syracuse University, "wanted badly to teach somewhere, but all I could get was some part-time work at a community

college. I never found a full-time job," although he did find a way to support himself from the sale of his art.

Teaching at the College Level

Anecdotal accounts mount up of dashed hopes for teaching careers and of artists patching together low-paying, part-time, no-benefits teaching jobs before a full-time opportunity appears. More likely, the artist finally gives up and looks for steady work in another field. Most MFA programs encourage false hopes by giving graduate students undergraduate courses to teach, such as foundation or introduction to this or that medium; schools save money by not having to hire full-time faculty, and graduate students start to develop a marketable skill while building up their teaching résumés and earning some money to pay for the cost of their education. Eventually, students graduate and begin to look for jobs, with the vast majority discovering that art schools and college art departments are unlikely to hire them.

The least likely to hire an artist to teach is the particular school that trained that individual. "We don't encourage hiring alums," said Dr. Leslie King-Hammond, dean of graduate studies at the Maryland Institute College of Art in Baltimore. "It's inbreeding. You don't strengthen your program by hiring people from your program." Relative to more seasoned art instructors, artists right out of art school are at a disadvantage for finding college-level teaching positions unless they have very specific, advanced skills (such as on a computer or in a sculpture medium, for instance) that a particular school requires. Yale University School of Art hires junior faculty (paying a starting salary of $44,000) who have five years of teaching experience beyond the teaching assistant level. As a result, few instructors are in their twenties when hired, and most are in their early thirties. Senior faculty hires at Yale (whose starting salary is in the low- to mid-$50,000 range) have had experience teaching graduate students and tend to be thirty-five years of age or older. Applicants for teaching positions there must also have an active presence in the art world—one-person and group exhibitions at galleries and museums (the more nationally prominent the better)—and an involvement with critical issues (writing in journals, lectures at schools, participation on a panel such as at the College Art Association). "It also helps if faculty here know the individual as a teacher or as an artist," said Barbara Shanley, assistant to the dean, who added that between fifty and four hundred résumés are submitted for every advertised job opening. Similar statistics and criteria are noted at many other highly selective art schools and university art departments.

Various art schools and departments may stress different qualifications for their faculty hires. Most schools want to see a portfolio (slides, generally) of recent work, but some also want to see slides of work accomplished by the applicant's students in order to identify the inspiration, influences, and technical skills that have been transmitted. Stephen Tarantal, dean of the College of Art and Design at the University of the Arts in Philadelphia, stated that he requests the syllabi for courses that applicants have taught as well as a written "philosophy of teaching." He evaluates letters of recommendation and may "call up and probe the letter writer further." However, "I don't typically look at student evaluations. Students generally don't have the background to judge a teacher's competence." Letters of recommendation are "artificial expressions of perfunctory praise," Dr. King-Hammond noted, adding that she prefers letters from people who know the applicant well, "and their letters speak to that—titles are unimportant."

Schools also have their own standards for judging the quality of an applicant's record of exhibitions. Most prefer that artists reveal a history of work being shown to ever wider and more discriminating audiences, from the local to regional to national and international, and, as Stephen Beal, provost at the California College of Arts and Crafts, said, "It's a bad sign if you only show in the galleries at the schools where you've taught." Some schools have a greater interest in seeing the degree to which there is a market for an applicant's work, while others are not as concerned with the number of shows at commercial art galleries—the issue is what a school or department is looking for to round out the areas of faculty competence. Installation or computer artists often have difficulty selling their work, yet their skills and teaching abilities may exactly suit a school's needs.

Who is hired varies from school to school. While the San Francisco Art Institute "prefers not to hire people just out of art school," according to Larry Thomas, dean of academic affairs, "we will if the individual is proficient in more than one area, such as teaching a drawing class and a film-making class. Younger artists tend to be more interdisciplinary than some of the older ones." Samuel Hope, executive director of the National Association of Schools of Art and Design, also noted that, "In most cases, high levels of specialization seem less and less attractive to schools." The curricula and emphases at art schools and in art departments are not static but change with the interests of the students. For example, if there is a greater interest in design and less in painting, the design department may get a new faculty member and the painting department will lose a position; in effect, the number of faculty remained the same but the position moved. Art teachers will be in a more favorable position to maintain their jobs if they have demonstrable skills in two or more areas of art-making.

Art schools and departments also look to reflect a range of ages, ethnicities, artistic styles, and points of view as well as a balance of male and female faculty for the purpose of offering diversity to their students. "If a department has a lot of retirements, leaving a lot of junior faculty," said Stephen Beal, "I may seek a senior faculty member with some administrative experience. If, on the other hand, a department is heavily laden with senior faculty, I'd prefer a younger person to fill a slot." That latter situation is more likely to be found at colleges and universities, where tenure is customary (in art as in all other departments) than at art schools, where use of a tenure system is rare. "Tenure keeps turnover down at universities," Hope said, "and because universities outnumber art schools a hundred to one, they are more likely to hire people right out of—or not long out of—an MFA program."

The hiring picture for art teachers gets cloudy because of the terms involved—one may be hired as an instructor, lecturer, visiting professor, or artist, assistant professor, associate professor, or full professor, for a full-time tenure track position or full-time nontenure track, or as a sabbatical replacement or part-time position—and each of these categories may have its own salary level and benefits (or no benefits). According to surveys conducted by the National Association of Schools of Art and Design, full-time salaries for instructors range from $12,000 to $42,000 (averaging in the mid- to high-$20,000s), for lecturers from $15,000 to $50,000 (averaging close to $30,000), visiting faculty from $14,000 to $88,000 (averaging in the low to mid-$30,000s), assistant professors from $15,000 to $68,000 (averaging $34,000–$35,000), associate professors from $21,000 to $70,000 (averaging in the low $40,000s), and full professors from $32,000 to $95,000 (averaging in the low $50,000s). The wide range reflects the size, wealth, and location of individual schools.

Full-time hires generally go through a lengthy committee review process, while department heads "have more autonomy to quickly hire faculty on a part-time basis," Beal said. Universities and art schools in rural areas and small cities have a higher percentage of full-time faculty because there are fewer artists ordinarily living in the area (less competition for jobs locally) and others are not likely to relocate for a part-time job. In larger cities, the ratio of full-time to part-time positions shifts dramatically. California College of Art and Crafts, for example, has sixty-five tenure track positions and hundreds of part-timers. "I don't hire full-time very often," Larry Thomas of the San Francisco Art Institute said, "not in the four years I've been here." The salary range per course taught there is $3,500–$5,500, requiring teachers to have another means of support. Many art teachers have part-time positions at two or more schools, piecing

together a livelihood—a style of existence that may not suit people with children or who are middle-aged and seeking security in their lives.

ART SCHOOL ADMINISTRATION

If faculty positions are difficult to obtain and retain, administrative and technical jobs in art schools are full-time and permanent, and they are predominantly filled by people with studio art backgrounds. "Ninety-nine percent of our administrators are artists," said Andrea Nasset, dean of the Minneapolis College of Art and Design, who herself has an MFA in painting and printmaking. That percentage includes clerical workers, support personnel in the shop and computer areas, admissions and financial aid offices, and all other departments. Admissions offices at art schools tend to hire their own graduates, and some employees there may be current students.

"There is a distinct desire not to hire alumni as faculty, but there is a preference for alumni in administrative positions," said Judy Nyland, head of placement at Pratt Institute, where she herself received an MFA in painting and printmaking in 1968. "Alumni understand how the place is run, how things are done." She noted that, in some school jobs, an additional degree may be required, such as counseling psychology for school counselor, accounting or a masters of business administration for the bursar, financial aid advisor, or registrar, and personnel administration for human resources or student affairs officer.

At the level of dean, positions are most often filled with artists who have both teaching and administrative experience (leading faculty committees, for instance). Wayne Morris, dean of Moore College of Art and Design in Philadelphia, is like many who never received special training in administration. After receiving an MFA in painting in 1970 from Indiana University, he "went to New York City. I took small part-time jobs—carpentry, office work, I drove people around—all while I was trying to paint." In 1973, he began a search for teaching jobs and was hired part-time by both Pratt Institute and Suffolk Community College. At about this time, he also was selected to teach a class at Moore, which developed into a full-time job. After a period of time, Morris took on administrative responsibilities, chairing two-dimensional fine arts for nine years. When the dean's position became vacant, "the faculty put me forward to take the job. They thought I'd represent them well."

The work involved in being a school dean—budgeting, staffing, developing, and approving curriculum, supervising employees, fund-raising and countless other office activities—was not taught to Morris (or to most other artists turned teachers turned administrators). "I guess you pick it up,"

Morris said. Arts administration certificate and degree programs teach most of these skills, but the programs are oriented principally to individuals looking to work in arts agencies, galleries, presenting arts organizations, and museums rather than in academic management. Both the National Association of Schools of Art and Design and Purdue University's Center of Philanthropy offer workshops on fund-raising, and Harvard University teaches an annual course for new college presidents on what their responsibilities will be and how to perform their duties. In addition, Morris noted, "most institutions have a fund-raising staff. Deans are not left alone with a tin cup and told, 'Go raise funds for your unit.' They get help from various quarters."

Still, most deans (other than those who move from one school to another) learn on the job. And, like all jobs that allow one to exercise greater power and that absorb more time, art school administration takes artists further away from working on their art. "The dean's position is more threatening to me as an artist than being an art teacher is," Morris said, "because it takes so much time. If you have a full-time job teaching, it's three days a week. As dean, I'm here four days a week, and deans don't get studio time, either. I never wanted a job that is all-consuming; when I get home these days, I can't just throw the switch and get into my own artwork, as I could when I was teaching full-time. Even though people say they want an art school dean to be an artist, being a dean is less being an artist than being a teacher was."

Lee Hall, a painter who was dean at the Rhode Island School of Design from 1974 to 1982, noted that she used to wake up every day at four in the morning in order to get some painting in before starting on the administrative work that consumed the rest of her day. She originally began teaching because "I liked university life and the freedom it offered." Increasingly, however, she became dissatisfied with university administration at the schools where she taught (Drew University, principally) and became involved in it through faculty committee work. The freedom she sought became a question of discipline—a tortuous effort to beat the sunrise and spend a few hours a day in front of a canvas. "Art schools should have artists in administration," Hall said. "You need a hands-on sense of the educational process and the value of it, but it tested every bit of my energy. I'll show you my battle scars."

OTHER TEACHING OPPORTUNITIES

Based on the number of advertisements for openings, the College Art Association has found an increase in nonuniversity teaching jobs for artists, such as at museums and nonprofit arts centers, as well as at less

prestigious institutions, including community colleges, summer retreats (art camps, cruise line art classes), senior citizen centers, Veterans Administration hospitals, and YMCAs. One finds these jobs through contacting the individual institutions, as each has its own availabilities and budgets. A museum or YMCA, for instance, may not have an existing position available but might be interested in a proposal for a class that the artist would run: artists could create part-time jobs for themselves.

Another growing area of hiring for art teachers, according to Tom Hatfield, director of the National Art Education Association, is the nation's public schools, where thirty-two state boards of education across the country now require high school students to take at least one arts course in order to graduate—a requirement that did not exist before 1980. In 1984, only one state required art. (It should be noted, however, that the state arts requirements do not necessarily specify visual arts; music and dance may be the chosen arts disciplines within a state or in various school districts.) In addition, 59 percent of the country's elementary schools have full-time or part-time art teachers, a substantial increase since the early 1980s. (Again, it should be noted that this statistic does not specifically mean there are art teachers for every one of those elementary schools, since some teachers are itinerant, going from one school to another, once a week or once a month.)

There are approximately 50,700 public school art teachers working in the nation's 15,000-plus school districts, with a turnover rate of between 2 and 5 percent, or between four hundred and one thousand jobs, a year. These jobs, however, are available only to those holding state teaching licenses or certification (or both). To learn about state requirements for public school teaching, one should contact the state department of education and its office of certification. In general, requirements include a bachelor's or master's level degree in education, completed pedagogical coursework and a class in the state's history, as well as direct teaching experience. Other requirements differ from state to state. South Carolina, for instance, requires its public school teachers to pass a National Teacher Examination created and administered by Educational Testing Service of Princeton, New Jersey, while other states have devised their own exams. One would have to contact school boards or school district superintendents about available positions. The National Art Education Association (1916 Association Drive, Reston, VA 20191, 703-860-8000, *www.naea-reston.org*) also publishes information on jobs and new arts initiatives around the United States in its newsletter. Salaries are based on teacher contracts with each town and vary depending upon the individual's educational background and experience (from lower to higher: a bachelor's degree,

bachelor's plus additional coursework, master's degree, master's plus additional coursework, Ph.D.—all of these plus years of teaching experience).

Private schools, which must be contacted individually, do not have the same requirements for teachers and may be worth pursuing, although one generally finds the salaries to be lower than at public schools. Charter schools are another form of public school, and state requirements for teaching again apply.

Most professional fine artists who teach will do so on the college level. It is rare, almost unheard of, for a major artist to have previously supported him- or herself as a public school (K–12) art teacher. Certainly, the environment in which one would teach on the public school level is quite different than at a liberal arts college or art school. In the elementary and high schools, the focus is product-oriented—creating something quickly in order to have something to show parents (this is especially true where an art class takes place once a week or once a month)—whereas in art schools the emphasis is on the process of art-making.

State Artist-in-Residence Programs

When Chelsea Smith, a painter in Bozeman, Montana, walks into a public school these days, "I am treated like a queen. The school has really worked hard to get me there, and everybody is excited." Smith is not a star athlete or spelling bee champion; rather, she is listed on the artists roster of the Montana Arts Council, which provides financial assistance to schools and nonprofit organizations around the state that want to bring in an artist for a short-term residency, working with students and helping teachers incorporate the arts into their curricula.

Part of the excitement derives from the fact that, in many of Montana's elementary schools, there are no full-time art teachers, and her two- to four-week presence represents the only prolonged exposure to art many of the students will experience. In addition, Smith knows from having worked as a full-time art teacher years before in Galesburg, Illinois, that "regular teachers have to maintain a professional persona, not getting too excited, keeping themselves in check. They have to follow certain procedures and meet certain expectations, but I get to be a little different, more funky, more of an artist, and people really respond to that."

While an artist in residence, Smith works with a variety of students on a large project, such as a mural or installation, which remains long after she has bid the school farewell. Over the course of a year, she will develop projects with a number of schools in the state, some of whom have brought

her in before and want her back. "There are a lot of repeat residencies at schools, and it's fun to grow with the kids," she said, but Smith also enjoys the flexibility of setting her own schedule, working for a few weeks at a time in a school, and then getting back to her own art career. Short-term stints in different schools are "invigorating. It takes me out of my studio and gives me a change." On more than one occasion, the schools where she has worked have recruited her for full-time art teaching, "but I just don't want to give up my freedom."

In the minds of many people, being an artist and working as an art teacher are the same thing, since teaching—particularly, college teaching—is the way that so many artists are able to support themselves. However, the odds of obtaining a full-time, tenured teaching position are slim, since between fifty and two hundred artists apply for every job opening at a college or university. There usually is less competition for art teaching jobs at most elementary and secondary public (and even private) schools; however, qualified applicants for public schools usually are required to have education degrees and state teaching certificates. The decision to earn these degrees and certificates tends to be a career switch, rather than a means of supporting one's artwork.

For artists such as Chelsea Smith and many others, full-time art teaching is not the goal. Occasional short-term stints as an artist in residence in public schools means extra money, excitement, and, to painter Rob Gartzka of Ludlow Falls, Ohio, who has done many residencies in area schools, "an excuse to get out of the studio and meet people." Actual instruction tends to be part-time—only a certain number of hours per week or full-time for just a few weeks—and may involve simply being seen in the act of creating art while providing a demonstration or explanation from time to time.

A large number of short-term teaching assignments are supported by the states. Every state arts agency maintains an arts in education program, providing cultural enrichment to nonprofit community centers, day care facilities, homeless shelters, hospitals, housing projects, libraries, prisons, schools, and summer camps—the vast majority tend to be K–12 schools. A primary element of these programs is the artist-in-residence component, which places artists (crafts, literary, performing, and visual) at one or another site. The actual length of a residency varies widely, from one forty-five-minute demonstration to projects that may take months or even two years to complete. The average residency in Ohio is four weeks, while in Arkansas it is two or three months. What the artist does during a residency is negotiated between the artist and the school, but a typical week consists of two or three days on site at four hours per day, earning between $30 and $40 per hour, although payment may be by the day or week or semester.

Most state arts agencies pay for artist residencies on a matching grant (dollar-for-dollar or two-dollars-for-one-dollar) basis with the sponsoring school or nonprofit organization. The amounts that the state provides may range from $5,000 (New Hampshire) and $7,000 (New York), to $15,000 (District of Columbia and Florida) and $20,000 (Louisiana and North Carolina). Combined with the matching grant portion, this can be a sizeable amount of money for an artist.

In order to be considered for a state artist-in-residence program, artists must be placed on a state arts agency artist roster, and it is from that list (and only that list) that schools and other nonprofit organizations make a selection. There is a three-stage process involved in obtaining a residency at a school: first, interested artists must complete an application, submitting a résumé, slides, or photographs of work, documentation of competence (reviews of exhibitions, articles in newspapers or magazines, letters of reference) as well as the specific activity one wishes to pursue during a residency. This proposal should note the age group (elementary school, high school, college age, senior citizens), target population (the disabled, for instance), and type of location (community center, museum, prison, public school) in which this residency might take place. The artist may be asked to indicate what he or she charges for this service.

Some states, such as Arizona and Tennessee, require all artists on their rosters to be state residents, while others do not. Although there is generally a preference for in-state artists (The Pennsylvania Council on the Arts notes that "Priority will be given to Pennsylvania artists"), the aim of the school or sponsoring organization is frequently to expose school children to other cultures or experimental art forms and bring in different viewpoints, such as an African-American or Native-American artist, into a predominantly white school. Many out-of-state and even some in-state artists may require additional money for lodging, meals, and transportation, which is added to the cost of their residency and split between the state arts agency and the school. As a cost-cutting measure, some schoolteachers will take the visiting artist in for the duration as a houseguest.

Most states have submission deadlines (others take applications throughout the year) and require that all of the artists on the roster reapply every two or three years. In most cases, artists already on the roster need not resubmit visual material; the reapplication is just to let the state know they are still interested in residencies.

Applications are reviewed by a committee that may be a peer review panel or an interdisciplinary panel, composed of artists, arts administrators, and educators, as well as people in other professions. This panel evaluates the artistic quality of the applicant. After being accepted by this first group,

the application is examined by a second committee, predominantly made up of educators, which judges the feasibility and interest of the proposal. At this stage, there is frequently a meeting between the artist and the second committee, in which the artist's ability to communicate his or her discipline and ideas is assessed. On occasion, an actual demonstration of what the artist would do is requested. Artists accepted by this second committee are placed on the agency's roster and undergo some training sessions for working in a classroom.

The third stage of the selection process is the application by the school or center to the arts agency for the artist's services. These applicants are evaluated in terms of their need, commitment to the program (making space available to the artist, making the artist's project or presence a part of the overall curriculum, for example), and ability to pay some portion of the cost of the artist's salary and materials.

Not everyone who is selected to be in the roster is chosen for a residency, but a large number will be. Between one-third and two-thirds of the 120 artists on the Ohio Arts Council roster are selected for residencies (in that state, artists are limited to four residencies per year), while approximately half of the two-hundred artists on the roster of the Arizona Arts Commission and three-quarters of the eighty artists at the Arkansas Arts Council are called upon.

Working in public schools offers clear rewards and some headaches for artists. Barbara Cade, a fiber artist in Hot Springs, Arkansas, who has taught at the university and community college level, as well as worked as an artist in residence in public schools in both Arkansas and Texas since 1985, noted that she preferred working with children to grown-ups. "Teaching adults is very different, and not as enjoyable," she said. "Children are very open to new things. You work with them on such an elemental level, which forces you to ask yourself very basic questions, and that's very stimulating for my own work as an artist." With the adults that she has taught at community colleges, however, "they have preconceptions about everything, and if what you're showing them doesn't fit into some category, they don't know what to make of it."

However, as opposed to teaching at the university level, where studio classes may last for several hours at a time and the students are all there by choice, artists in residence at K–12 schools generally teach in fifty-minute intervals, spending a certain percentage of the time engaged in discipline or, in the term schools use, "classroom management." Most states require a certified teacher to be in the classroom at the same time as the artist in residence (a school's liability insurance policy only provides coverage when a staff member is on hand), monitoring student behavior and freeing the

artist to just teach. In some settings, the class sizes may be halved (weeding out disruptive students), but other programs just set artists on their own in front of as many as thirty children. In addition, certain art materials may be deemed inappropriate for particular age groups, and the pacing of ideas and instruction undoubtedly will be slower than at a college or art school.

While the intellectual pace may be slower, the actual classroom experience of the artist in residence may be hectic. "With younger kids, you have to keep them moving because of their attention spans," said Rob Gartzka, who worked in short-term school residencies through the state's arts in education program between 1986 and 1999 (he eventually took a job as full-time art teacher at one of those schools). The pressure on him as an outside artist was considerable, he noted: "You only have two, maybe three weeks, and in that time you have to get on board, win everyone over, create something everyone can appreciate, and then you leave." Gartzka added that "you know the school had to come up with extra money to bring you there, and there is pressure to be worth it."

There may also develop tensions between regular teachers and the artists at the schools where they are in residence, especially when budgetary shortfalls require cutting curriculum and staff. Art classes are often the first programs to be eliminated, and some schools have filled in the gaps with less-expensive artists in residence—that is one of the reasons that many state arts in education programs often encourage longer residencies, some lasting an entire school year. Program guidelines in most states clearly state that money for artists in residencies cannot be "used for faculty salaries or to purchase equipment" not specific to the resident artist's project (Maine) or for "programs that appear to substitute for or replace art specialists" (New York), but corners sometimes get cut when school budgets are stressed. The artists may grumble that they are paid less than other teachers and have no benefits, while the art teachers are resentful that they may be replaced by low-wage part-timers.

On the other hand, artists in residence may find that they are freer to be artists rather than instructors imparting a body of knowledge. Diane Fishbein, a sculptor in Cincinnati, Ohio, who has taught for over twenty years at Thomas More College and Northern Kentucky University, as well as a number of short-term stints in the public schools through the Ohio Arts Council's artist-in-residence program, noted that as an artist in residence, "I am going in, making the kind of work I generally do, and describing the ideas that I am thinking about. In a college, on the other hand, I feel it's my responsibility to expose my students to the various artistic currents of the art world and to teach them the vocabulary of the art world. As a result, the work they create is more varied and really doesn't say anything about me as an artist."

There are limits to an artist's freedom within a school and, increasingly, these are set by principals and school superintendents who require that any outside art project be relevant to the curriculum. "Schools are so pressed for time these days that something that doesn't improve learning or teaching—that's just fun, for instance—doesn't make any sense," said Beck McLaughlin, education director for the Montana Arts Council. Artists often must demonstrate knowledge of school curriculum and devise projects that are both participatory and strongly related to what is being taught.

Residencies at schools and nonprofit organizations are not limited to artists on state arts agency rosters. A number of private organizations, such as Very Special Arts (John F. Kennedy Center for the Performing Arts, Washington, D.C. 20566, 202-628-2800, 800-933-8721, *www.vsarts.org*, with fifty-two affiliates around the United States) and Young Audiences (115 East 92nd Street, New York, NY 10128-1688, 212-831-8110, *www.youngaudiences.org*, with thirty-two affiliates around the United States), and many municipalities and museums also sponsor short-term residencies, as well as teaching opportunities for artists.

For more information on artist-in-residence programs, contact the National Assembly of State Arts Agencies (1010 Vermont Avenue, N.W., Washington, D.C. 20005, 202-347-6352, *www.nasaa.org*) or the National Endowment for the Arts (1100 Pennsylvania Avenue, N.W., Washington, D.C. 20506, 202-682-5426, *www.arts.gov*) for the kinds of programs offered in each state; and Americans for the Arts (100 Vermont Avenue, N.W., Washington, D.C. 20005, 202-371-2830, *www.artsusa.org*) for existing programs on the local level.

Federal and Privately Sponsored Residence Programs

States are not the only sponsors of artist-in-residence programs. The federal government is an active participant through the National Endowment for the Arts and, to a lesser degree, the Federal Bureau of Prisons (Artist-in-Residence Program, Education Division, 320 Fifth Street, N.W., Washington, D.C. 20534, 202-724-3022).

Private foundations have been moderately active in support of residencies. In general, they review artist-in-residence applications submitted by schools, community centers, or other nonprofit groups' programs involving already-identified applicants who have prepared a curriculum but need outside money for the residency to take place.

One private organization, COMPAS (308 Landmark Center, 75 West Fifth Street, Room 304, St. Paul, MN 55102, 651-292-3287, *www.compas.org*), has an Artists-in-the-Schools program that places visual artists in K–12 schools throughout Minnesota for one-week residencies. There are also a number of private groups that place writers in public schools, such as California Poets-in-the-Schools in San Francisco, Playwrights Theater of New Jersey, the Geraldine R. Dodge Foundation in Morristown, New Jersey, the New York City–based Teachers and Writers, the Missoula Writers Collaborative in Montana, Seattle Arts and Lectures, Houston Writers-in-the-Schools and Young Audiences (headquartered in New York City, with thirty-four affiliates across the United States). For all of these activities, there is a formal application, and artists who are approved to be in the program must undergo training, at the end of which they will be expected to provide lesson plans. The residencies are occasional and may range from one-hour classroom discussions to five- or ten-week sessions, paying between $30 and $70 per hour.

Very Special Arts programs, which serve people with mental and physical disabilities and are located in every state (the national office, from which addresses and telephone numbers of state branches are available, is located at the John F. Kennedy Center for the Performing Arts, Education Office, Washington, D.C. 20566, 202-628-2800 or 800-933-8721), also afford artists short- or long-term teaching opportunities. Similar to the state-sponsored artist residencies, each state Very Special Arts chapter maintains its own roster of artists, establishes its own guidelines for selecting artists, determines the length of residence (a one-day event, sixteen-week workshop or school year–length program, for example) and the amount of payment for artists. (It is to the state arts agencies' artist-in-residence programs, in fact, that the Very Special Arts affiliates turn to when seeking information or suggestions on developing arts activities, and there is occasional collaboration on specific projects.) Artists employed by Very Special Arts receive some training in how to work with people with particular disabilities, and that training is often conducted by artists themselves.

Artists do not apply directly to the state chapter but to an organization, such as a school or community center, which makes a formal application to the state Very Special Arts affiliate for funding. The ability of the state chapter to provide the requested funds is dependent on its ability to raise money, since each affiliate receives only $15,000 annually from the national Very Special Arts headquarters.

Hundreds of arts and crafts workshops take place throughout the year (most during the summer) in the United States, Canada, and Europe, the majority of which hire artists as resident faculty and teach amateurs and

aspiring artists in a particular medium or style. The best sources of information about workshops are the March issues of *American Artist* magazine and *Artist's Magazine* (see bibliography) and *The Guide to Art and Craft Workshops* (ShawGuides, Inc., P.O. Box 231295, New York, NY 10023 212-799-6464, *www.shawguides.com*, $16.95). The American Craft Council (72 Spring Street, New York, NY 10012, 212-274-0630, *www.craftcouncil.com*) will also provide to members a free computer search of artist-in-residence programs in the crafts area in which they are interested (nonmembers must pay a fee for this service).

There is no central source of information on college and university residencies, which last from one or two weeks to one or two semesters. These programs tend to pay considerably more than those sponsored by local and state arts agencies and often provide free or discounted room and board. One would have to contact the art departments at these institutions directly to find out whether or not they sponsor artists in residence and, if so, how the artists are selected. Cynthia Navaretta's *Whole Arts Directory*, published by Midmarch Associates (Box 3304, Grand Central Station, New York, NY 10163, 212-666-6990), includes a number of college-sponsored residencies.

Developing a Print Market

For centuries, buying art prints was a way for collectors to own and appreciate art at a low cost. Albrecht Dürer cranked out print after print of his woodcuts as a means of getting both his message of Protestantism and his artwork to the masses. He and fellow painters William Hogarth, Francisco Goya, Honoré Daumier, and Henri de Toulouse-Lautrec are perhaps better known for their prints than for their canvases. Very few people have ever seen the paintings of art deco innovator Erté, for instance, yet his renown as an artist rests on poster versions of his work that defined a movement.

Within the past thirty years, artists have recognized the benefits of producing their work in print versions, affording them far wider exposure to the public and additional income. During the 1980s, however, too many artists had that same idea, causing the art market to become glutted with print editions of all kinds and resulting in artists, galleries, and print publishers losing money. (The 1980s also saw the enactment of art print disclosure laws in various states around the country, in response to abusive sales practices, and an IRS crackdown on fraudulent art print tax shelters that aimed to capitalize on inflated losses.) An industry of art print discounters rose up, offering to take the excess inventory off the hands of

artists and galleries and selling the prints to furniture stores or anyone else for $5 or $10 apiece. The reputations of artists and of the entire print market were hurt in the process, and a greater wariness on the part of artists, collectors, and dealers concerning prints has emerged.

Print versions of artists' work are usually produced in one of three ways: the first is by artists publishing their own work, usually paying a print studio to create a photo-offset (photographically copying and transferring the image onto paper) or *giclee* (digitally scanned and inkjet-printed onto paper, canvas, or other flat surfaces) edition of their paintings, which the artists then seek to market; the second is a dealer or gallery sponsoring a print edition, either as an offset printing or with the artist actively involved in the process of creation; the third is a print publishing house that buys rights to produce an edition based on an artist's paintings, marketing these pieces either through a mail-order catalogue or through a chain of galleries.

SELF-PUBLISHING

In the early 1980s, Vivi Crandall of Casper, Wyoming, knew she needed to create print editions of her work. "The originals sold too quickly, and, by the time shows came, there was nothing to take," said her husband and business manager Gary Crandall. The artist agreed to have her work printed by a publisher "because, at that time, we didn't have the money or knowledge to do our own publishing." Her relationship with the publisher deteriorated after not being paid for print editions that sold out, and, instead of finding another publisher, she decided to publish and sell her own editions. Crandall's prints are sold through galleries (60 percent) and directly to a mailing list (40 percent). "The overhead is about $250,000," Gary Crandall noted, paying for a staff of seven who oversee telephone orders and marketing as well as framing, matting, and shipping for retail sales. Many artists might prefer to just paint, leaving all the business details and quarter-million-dollar expense of publishing and distributing print editions to a large publisher. "We wanted the freedom to put work out there even if we know it won't be a blockbuster," Crandall said, "and a number of publishers won't let you do that. Artists have told us that some big publishers want you to do the same images again and again. We also wanted a more direct relationship with our buyers."

Self-publishing requires greater knowledge of, and contact with, one's collectors. Anyone with two or three thousand dollars can pay a printer to create a basic edition of standard-sized prints, but it requires an understanding of one's market to sell them. "You need to know who are your typical buyers," said Ruby Reece, head of sales and marketing at Art Editions Publishing in Salt Lake City, Utah. "Are they male or female? What is their age group?

What are their likes and dislikes? From there, you need to go where your typical buyers go and really become your buyers for a while to learn why they buy." Reece noted that she frequently has this conversation with artists looking to self-publish editions of prints, because "so many artists have heard that they should do prints but don't have any idea if this is the right time to do them or what to do with them after they're printed." Ninety percent of Art Editions Publishing's clientele are self-publishing artists.

An edition of art prints should be a continuation of an artist's marketing efforts, not the opening gambit. There needs to be a supply of identifiable buyers who will—or are likely to—purchase a significant portion of an edition: artists should be able to see their way toward breaking even before they start the process. One way to do this is to make a "prepublication offer," said Sue Viders, artist consultant for Color Q, the Dayton, Ohio, printer, 70 percent of whose customers are self-publishing artists. "Have a private exhibit of your painting for past buyers and take orders there for prints of it." Artists can also print up postcards with the painting's image, costing between $100 and $200, to send to collectors on their mailing lists in order to solicit interest in prints.

Self-publishing artists need to determine how many prints must be sold at what price in order to cover their investment. Most artists spend between $2,000 and $3,000 for an edition of 16 × 20 inches or 18 × 24 inches in a quantity of four hundred or five hundred, with perhaps $200 in addition for the same image printed on postcards and flyers (just like car salesmen, printers look to sell artists extras). The price of individual prints may be determined by whether or not the prints are to be sold by a gallery charging, say, a 50 percent commission. Pricing a print in a limited edition is an area for which there are no rules. For some dealers and publishers, a print should cost 20 percent of the original; others put that price close to 5 percent. There certainly needs to be some relationship between the price of the original and that of the print. If the painting costs $200 and the print $100, there is little reason for anyone to buy a paper version of what, for only $100 more, they can acquire on canvas. Prints and paintings have separate audiences that sometimes overlap but usually do not. Those who buy a work on paper may aspire to own a canvas, but the print market has to be seen as distinct, and collectors need to be generated in their own right. If the print prices begin to seem too high for the market or the payback period too long, artists may have to consider limiting their expenses or decide how prepared they are to market an edition of prints at a particular time.

Although the prints of Daumier and Dürer are quite visually distinct from their paintings, most artists' prints are far closer in style to their one-of-a-kind works. In part, that is because collectors want artists to have

a specific look and subject matter—a niche. The most salable prints are those that reflect the way in which the artist's work is perceived by the buying public. Artists also need to have images that will reproduce well, which may require them to view their art in two different ways—this looks good as a painting but won't work as a print. The photo-offset process generally flattens images, for instance. A more limited palette, highlighting the use of primary colors will work better as a print than a full palette, because primary colors break down on the computer more easily for color separation. In many prints, the color black looks like a hole in the paper, and siennas look pale—not every time, but it is a recurrent problem in translating a painted image on canvas to one reproduced on paper.

"You spend a lot of time trying to get the color just right in the painting, but you never get the same color when it is printed," said Jim Hautman, a Minnesota artist who won the federal duck stamp competition in 1989 and 1994, adding that he has also learned not to add texture to a painting "since it just gets lost in the printing process anyway." In some cases, the point of the painting becomes the creation of an image that will reproduce well, which is not an art consideration but a marketing one. Not every artist will be able to accept these compromises.

Finding a suitable printer is vital, as most printers in the United States principally handle commercial jobs (brochures, for instance), which involve inks that fade and paper that quickly degrades. Commercial printers have told artists that they will use "premium grade" paper for their prints, but that is not the same as archival, acid-free, pH-neutral paper that won't develop dents through normal handling or brown in normal light. Artists should inquire as to the types of inks and papers used, whether or not the printer has worked with fine art and if the printer is able to work with original artwork (most commercial printers prefer slides or photographs). Fine art printers also generally have someone on staff who is able to advise artists on marketing strategies. *Decor: The Magazine of Fine Interior Accessories* (Commerce Publishing Company, 330 North Fourth Street, St. Louis, MO 63102-2036, $20 per year for twelve monthly issues), which sponsors the Art Buyers Caravan shows around the United States, has an annual "Sources" issue every July that lists many of the fine art print publishers and distributors in the country.

PRINTING PROCESSES: PHOTO OFFSET, INKJET, AND BEYOND

From a distance, it looked as though Roberta Wesley was making a very good living as a painter. The Madison, Alabama, artist averaged roughly $10,000 per month in sales, and there were always more buyers for her

paintings than paintings available, but still she was discontented. First, Wesley felt that she was "turning into a hack. Galleries want another painting just like the last one that sold, and I'd supply it, but I started to feel very unoriginal. I didn't start being an artist in order to paint the same picture day in and day out." Second, her earnings weren't as much as they might seem, when she counted in the 50 percent commission paid to one or another gallery owner, the costs of framing and shipping, and taxes. "After that, you find you aren't making a very good living," Wesley said.

As it turned out, there was one solution to both problems: Wesley began to create print editions of her work. A supply of multiples permitted the collectors who sought a specific type of work to purchase just what they wanted, and the second source of income provided "a more stable revenue stream." Within a few years, the sale of prints became her only source of income (providing Wesley more money than ever before), and she now either just keeps the original paintings or gives them to members of her family.

Solutions, of course, did create new problems for Wesley: What types of prints should she produce? What should they cost, and how many should be in an edition? At first, Wesley went strictly with photographic offsets (or photo-lithography), in which an image is photographed and transferred to a lithographic stone and printed in open editions. "There are a half-dozen of my images that I've reprinted over and over again," she said. "I may have sold more than ten thousand of some." Many other artists limit their edition sizes so that each print may be viewed as having greater value, since there is a potential scarcity in the supply, but as her offsets sell for $48 in galleries and shops, Wesley doubts that buyers are thinking about these works as investments. Additionally, since she is only paid $24 for each print sold by gallery owners (and only $12 if the work is sold through a distributor), Wesley needs high volume sales rather than limitations on her ability to earn a living.

Wesley has produced editions of her work as digital inkjet prints on canvas, sometimes called "canvas giclees," which sell for between $175 and $700, depending on their size and whether or not they are framed. More expensive to produce than the photographic offsets, she prints them as collectors ask for them, keeping her costs low and adding another source of income. "The giclees fill a price niche between the original paintings and the offsets," Wesley said, adding that they allow her to expand her print market to a different group of buyers.

A growing number of artists have taken a similar path, trying out multiples of their more popular images in one print medium or another. At times, artists find themselves offering a wide and complicated range of

works to meet various levels of prospective buyers. For instance, Mort Kunstler, a painter of historical scenes who lives in Long Island, New York, sells his original oil-on-canvas paintings for between $10,000 and $100,000, as well as signed and numbered 16″ × 30″ (picking one of many similar sizes) photographic offset prints for $200. These are limited editions of 950 (usually), along with another 100 artist proofs that sell for $350. At a smaller size of 11″ × 14″, called the Studio Collection, collectors may buy another limited edition offset version of the same image for $95, $150 for a proof. Yet another edition of the image may be purchased as a digital inkjet print on canvas at 11″ × 14″ (100 in an edition, selling for $250, $395 for a proof) or at 21″ × 33″ (100 in an edition, selling for between $525 and $575). Finally, there is a Masterpiece Collection, in which 25″ × 46″ digital prints in a limited edition of 35 may be bought for $3,500 apiece. All of these original paintings, paper, and canvas prints are sold through a constellation of galleries around the United States. Since the paintings are unaffordable to all but a few collectors, "the purpose of different types of prints is to have different products for different buyers," Kunstler said. "A lot of people are interested in my work, and I want them to have a choice."

Photographic offsets have a longer history than digital inkjet prints, and both artists and collectors tend to be more familiar with them. In some instances, print publishers such as Greenwich Workshop, Applejack, Mill Pond Press, or Wild Wings will pay for the production of an edition (usually limited), which are distributed to a network of galleries, and artists are paid a royalty for all sales. More artists look for fine art printers (they often advertise in art magazines or artists hear of them through word-of-mouth), producing editions of their work that they supply to their galleries or sell directly at arts and crafts shows. "I like to meet the customers of my work," said Judy Bolton Jarrett, a watercolor artist in Columbia, South Carolina, who exhibits her photographic offset prints at a variety of shows and art galleries, including the hometown gallery she owns.

Like Wesley, Jarrett had begun her career selling paintings, moving into prints later on and now only rarely selling a painting. "On occasion, I sell a small original to finance print costs," she said. Her first experience with prints was with print publishers, but she grew disappointed with the royalties (customarily, 15 percent of the retail price) and the loss of control over her career. "I like to choose the images I want to print, rather than have someone select the work they need for their market," she said. "Now, I self-publish, and I make more money."

Prices for prints vary based on the size of the actual print, how many will be printed in an edition, the number of color separations required, and the type of paper used (100 percent rag or poster paper, for instance).

Artists may also purchase "extras" to accompany their prints, such as postcard-sized copies of the same image and business cards that may or may not include the image. Color-Q, a printing company in Dayton, Ohio, offers three "Success Packages" of services, "targeted to first-time artists, helping them promote their work," said Vicki Hubbs, printing consultant at Color-Q. She added, "More established artists have also found these packages helpful."

At a print run of 100, Success Package One includes an edition of 16" × 20" prints, another 100 "miniprints" (8" × 10") of that image, 300 postcard-sized (5" × 7") images, and 400 2" × 31/2" business cards, all costing $1,736. On the other hand, artists ordering just the prints would pay $1,335, and Hubbs noted that most artists take that route, although the more customary print order is closer to 500. The physical print sizes increase with Success Packages Two (18" × 24") and Three (22" × 28"), as do their costs. Additional charges accrue for artists seeking the printer to supply parchment paper certificates of authenticity (either $60 or $90 for 100), 81/2" × 11" reference sheets (". . . proudly announces his new release . . .") on enamel paper ($364 for a black-and-white image, $550 for full-color, for 100), brochures that fold and contain up to 12 images ($878 for 100) and a news release ($224 for 100).

The possibilities for creating print editions from original artworks has grown in the past two decades, a result of new technology, and include photographic offsets on canvas and editions produced by computer inkjet printers. Inkjet prints, in which images are scanned into a computer, where they may be color-adjusted and even reworked, then printed onto watercolor paper and canvas, have caught the attention of a growing number of artists for their rich colors and closer resemblance to the originals. These digital prints "are so good they're scary," said Kunstler. "My main concern is that someone will think it's an original." In order to protect a less well-informed buyer, Kunstler makes his digital prints 10 percent smaller than the originals, and he also embosses the signature image, "but I still worry for the future. There is a lot of charlatans out there, and innocent people."

Digital inkjet prints were first produced in the late 1980s, exciting artists and adventurous collectors alike with their lush colors and ability to be printed on higher-quality papers and even canvas. "A watercolor on watercolor paper turned into a giclee on watercolor paper is almost indistinguishable from the original," said Henry Wilhelm, president of Wilhelm Imaging Research in Grinnell, Iowa, which has been testing the durability of inkjet prints. William Christenberry, a painter and photographer in Washington, D.C., who has used the inkjet process to create editions of his work for a number of years, stated that he is "very satisfied by the results

and very excited by the future and potential of the process. I like what I've seen of the dyes and how they saturate the papers. They have a very seductive quality on watercolor paper, and I can't use that kind of paper for my other printing."

However, many of the early experimenters with inkjet printing grew disappointed in how quickly colors faded and the substrate cracked, often within months. The major drawback for inkjet prints is fading, as pigments cannot be ground so finely as to fit through the small holes through which the inkjets spray colors onto the paper. The bright dyes used have not had a good "lightfastness," or durability, record. "The inks were designed for brilliant color reproduction with no concern for light permanence," Wilhelm said. "They were intended for offices, to create pie charts and handouts at meetings. They were not conceived by the manufacturers for creating fine art."

However, by 1996, manufacturers of inks, papers, and canvases began producing materials that, in the case of inks, were longer lasting and, with papers and canvases, were specially coated to receive these inks. The lifespan of digital prints is now rated up to 100 or 200 years, based on normal treatment of works on paper by collectors and museums, and the number of artists producing prints by ink-jets grew enormously. Early on, digital prints were only available at arts and crafts shows, but now they can be found in top Manhattan galleries and in the collections of major museums.

The interest in inkjet prints has led to a new crop of fine art printers specializing solely in this manner of printmaking, as well as older printers adding digital technology to their mix of services. Color-Q added digital printmaking for 2004, and Colson Prints, a forty-one-year-old company in Valdosta, Georgia, has seen its orders for digital prints from artists rise from 10 percent in 2000 to currently half its business. Mill Pond Press in Venice, Florida, which publishes and distributes prints to galleries around the United States, also publishes half of its editions as digital prints. Besides the original art look of the final print, inkjet prints are attractive to both artists and print publishers because the number printed may be more correctly aligned to the actual demand. Color-Q and Colson Prints do not permit artists to order fewer than one hundred photographic offset prints at a time, and price breaks are offered with larger offers, of five hundred, for instance. With digitally produced work, however, it is permissible to print just one at a time. Colson Prints also offers discounts for larger orders—one inkjet print on paper costs $170, or $150 if on canvas, while ten prints on either paper or canvas brings the price down to $105 each—but artists may be content to pay somewhat more to test collector interest, reordering others from the printer as demand warrants. Stephen Brown, owner of Proteus

Workshop in Sonoma, California, which exclusively produces digital prints for artists, stated that there is currently a 33 percent discount for artists ordering as many as three inkjet prints and there would be another price break for ten, "but no one has ever asked us to print that many." Both Colson and Proteus also charge a $250 "set-up" fee to cover the process of photographing the original artwork with a digital camera, creating a digital file, and making adjustments to the image within the computer through PhotoShop software. Brown noted that the set-up charge is less when the artist provides a slide, adding that the final print image is usually not quite as good, "but the difference is so small that most people probably wouldn't notice."

"The cost per unit is much higher" for a digital print than for a photographic offset, often by a factor of ten, said Linda Schaner, president of Mill Pond Press, "but you have to weigh that against the inventory issue." A good price break that leaves artists hunting to find room to store hundreds of unsold offset prints may not seem so worthwhile, at least in the short run.

Determining which images should be printed as an inkjet or as an offset is often difficult, based on a variety of considerations. Schaner noted that one factor is "how quickly we feel the image will sell. If we think there is a wide audience for the work, and that the sooner we can produce an edition and get it to market the better, we will likely go with an offset." Using similar logic, Judy Bolton Jarrett relies on photographic offsets to supply the numerous regional art galleries that exhibit her work. These offset prints sell from between $10 apiece for 5″ × 7″ holiday-oriented images to $95 for 18″ × 24″ images. "There is a market for people who want art, but don't want to spend a lot of money," she said.

However, producing an edition of prints need not become an either/or choice, and some artists publish both offsets and digital prints. Lucelle Raad, a painter in Sarasota, Florida, began publishing inkjet prints on canvas in 2002 after more than a dozen years of creating offset editions, selling both types of prints at galleries and trade shows. "Sales have doubled at the arts and crafts shows since I've started showing the giclees," she said. Raad added that these additional sales are not all digital prints. "The giclees attract people, who come to my booth and spend a longer period of time looking at my work. I think that what they end up buying is still the offsets, although I have sold some giclees."

The more popular and sought-after an artist's work is, the more likely that at least some collectors will be willing to spend more money. Another artist whose editions also are published as both photographic offsets (selling at $115 in galleries) and digital inkjet prints ($350), Phillip Philbeck of Casar, North Carolina, had long sought to appeal to the higher-priced print

market. Between 1992 and 2001, he had painted remarques (small, incidental paintings) on the bottom border of thirty offset prints in a given edition, and these prints were given the higher price of $350, "but I hated doing them," he said. "It came to seem like too much production work." The digital prints, however, which he began producing with his Winston-Salem publisher Salem Graphics, in 2002 and "look so much more like originals," enabled him "to get the same amount of money for my prints without having to do so much work."

Digital prints go by a variety of names, and the people who use a particular terminology sometimes have strong feelings about which words they want used. The commonly used term *giclee* was coined in the late 1980s by a California computer inkjet fine art printer, Jack Duganne, who said that he was "looking for a French or Italian word, because so many art techniques have foreign names." *Giclee* itself is a French word denoting something that was sprayed, and also street slang for "ejaculation" ("What, do I claim to know French?" Duganne said). More recently, the Giclee Printers Association trademarked the term TruGiclee to distinguish digital prints produced on specific materials using specific technology from those created by other means. (The association also trademarked the term "TruDecor" to refer to similar prints that do not involve the same archival printing surfaces.)

Other digital prints are identified in terms of the name of the manufacturer of the particular inkjet printer used, such as Iris prints or Epson prints (the Manhattan art gallery Pace Editions sells Iris prints, according to its director Kristin Heming), or by phrases that do not suggest that a computer was even involved. One increasingly hears the term "digital pigment prints" or just "pigment prints" to describe these artworks. Marc Glimscher, director of New York's Pace/Wildenstein gallery, referred to artist Chuck Close's "pure pigments on paper" and Lucas Samaras's "pure pigments on photographic paper" to denote editions based on a painting or a photograph. He noted that some print collectors "don't want to buy anything that sounds purely mechanical, as though the machine did it and not the artist." On the other hand, Pacifica, California, photographer Stephen Johnson, who has largely given up darkroom work, calls his images "pigment inkjet prints," not wanting to mask the technology involved in the production of his work: "I don't run away from the technology, I embrace it, and I think other people should, too."

Glimscher claimed that "people turn up their noses at the word *giclee*," since it "denotes that the work is a copy and that it was spit out of a computer." Distinctions are made for digital prints that are "original works of art"—that is, conceived largely in a computer—as opposed to inkjet prints

that are solely reproductions of, say, a painting or photograph. When painter Jim Dine goes to Adamson Editions in Washington, D.C., to produce an edition of digital prints, he creates a large-scale drawing on a wall that is photographed by a digital camera; working on a computer monitor, the artist makes changes in the design, adds other elements and decides which colors to use and their intensity. There is no other, complete original work from which his digital prints are made, David Adamson noted: "The original matrix exists only as a matrix to let the print live." Adamson's work with Chuck Close, on the other hand, is more akin to what he calls "facsimile work": "Chuck brings in a photograph, a daguerrotype, and says, 'I want that.'" The digital camera scans in the work and, after far less computer manipulation than for Dine, the inkjet printer produces the edition.

Dozens of museums in the United States and abroad have either mounted exhibitions of digital prints or purchased them for their permanent collections, including the Metropolitan Museum, the Guggenheim, the Boston Museum of Fine Arts, the Philadelphia Museum of Art, the Corcoran Museum in Washington, D.C., the Walker Art Center in Minneapolis, and the High Museum in Atlanta—the works bought or shown are more in the Jim Dine than the Chuck Close category. Marilyn Kushner, curator of prints and drawings at the Brooklyn Museum, who organized a "Digital Printmaking Now" exhibition in 2001, stated that her museum "only purchases original digital prints. We don't want to buy a digital print of an artwork that may be in some other museum's collection."

DEALERS AND GALLERIES AS PUBLISHERS

Printers are regularly approached by a variety of people and companies looking to create an edition of prints. There are the artists themselves, occasionally a parent of an artist, and sometimes an investor or a gallery or dealer acting as publisher. "Dealers and investors spend the same amounts on producing an edition of prints as an artist, but they go to greater lengths to market it," Cathy Georges, director of sales and marketing at Color-Q, said. Galleries, of course, have a ready exhibition space in which to present new work; their mailing lists are usually more extensive than that of an individual artist, and galleries are in a better position to get work shown in other art spaces as well (through trades with dealers elsewhere, for instance).

"The key is distribution," said Richard Solomon, president of New York City's Pace Editions. "You have to have some way for prospective buyers to be able to see these prints, or else you'll just have them on your hands forever." Pace Editions has an arrangement with approximately fifty galleries in the United States, and collectors around the country are notified of new

work and where it may be seen by mailers, the Web site, and the occasional telephone call.

Diane Villani, an independent print dealer and publisher in New York City, developed her customer base by forming a partnership with four other small print publishers (Graphic Studio in Florida, Landfall Press in Chicago, Riverhouse Editions in Steamboat Springs, Colorado, and Segura Publishing in Arizona), merging their mailing lists and arranging exhibitions of new work at various locations across the country. Villani has her own gallery but, when a publisher shows prints at other galleries, the commission is split between publisher and gallery, complicating the financial arrangements and the basis for pricing. "I discuss with the artists what their paintings and drawings sell for," she said. "If a drawing sells for $5,000, and it is as complete as a print, I may sell the print for $2,000." With production costs and dealer discounts and commissions, she hopes to break even when between 30 and 35 percent of the prints in an edition are sold.

Some galleries pay for the creation of offset reproductions of paintings, while others, such as Pace Editions and Diane Villani, publish original prints that the artist designed after going into a print studio. Villani selects artists—painters and sculptors, not professional printmakers—based on recommendations from other artists and peers (dealers and museum curators) as well as her own visits to gallery shows. She looks for artists who have a strong track record of exhibitions and sales. "As an independent publisher, I have to be able to sell the work to recoup my investment," she said. "I can't afford to publish unknown artists. Collectors ask me about the artist's bio—where does the artist show, what collections are the artist's works in."

Villani must rely on the strength of the artist's renown because most of them have never been represented in terms of print editions before. She noted that there is "not a lot of overlap of the print and painting collectors, but I believe that for the right artists the print market is there."

The sizes of limited editions for these artists are smaller—between fifteen and thirty for Villani, between ten and one hundred for Pace Editions—and the prices are considerably higher than for offset reproductions. Solomon noted that, based on the reputation of the artist, print prices range from $1,000 to $20,000. "The price has to do with what the public market has established for the particular artist," he said, adding that establishing a price for an unknown artist's work can be "totally arbitrary when there is no secondary market. Most artists' prints, most artists' paintings for that matter, don't have a secondary market." The works are produced in a medium not customary for the artist but are clearly identifiable in terms of content and style. "When Chuck Close, for instance, does a print for us, he

uses the same basic subject matter for the prints as for his paintings, although it's not a copy of a painting. But there has to be a family resemblance in order for it to be viable in the marketplace."

PRINT PUBLISHERS

"Artists come to us and we go out and look for them," said Jack Appleman, owner of Applejack Limited Editions in Vermont. "We" are the sales and marketing staff who attend a variety of large and small art shows around the United States. The same people are involved in reviewing portfolios that are sent to Applejack. Appleman noted that he prefers 35mm slides to photographs, "since we have a slide projector that can blow up an image to see detail; a 3 × 5-inch photograph is all you get."

Publishers have their own distinct "look" and subject matter, and they are interested in an artist whose work fits into their overall program. Applejack, for example, favors animal, floral, whimsical, and wildlife subject matter, presented in a colorful, realistic style. Artists who might consider submitting a portfolio to this or another publisher should review their catalogues for the degree to which there is a comfortable fit. A given portfolio might need to be edited to appeal to individual publishers, or one may need to keep searching for a more appropriate publisher.

"We look for technical skills, emotional content, a narrative quality to the work—that is, a story is being told," said Jennifer Oaks, creative director of the Greenwich Workshop in Connecticut. "We need a work that will connect with a large number of buyers, triggering the memory of an experience they've had." If the four-person selection committee at the Greenwich Workshop is interested in an artist's work, it may select an image from the portfolio for a print edition or ask to see more work. The form rejection letter, on the other hand, announces that the artist's work does not fit "our limited-edition print market."

When an artist is chosen by a publisher, this is generally the beginning of a long-term relationship, lasting not just for the marketing period of one print edition but over years. "We don't just try one thing and, if it doesn't work, pull it off the market and call it quits with the artist," Oaks said. "One print edition doesn't make or break a program. We invest in the publishing and promotion of an artist." Part of the contractual agreement between artist and publisher requires the artist to give the publisher the exclusive right to publish limited-edition prints over a specified period of time (for example, three to five years, subject to renewal). It is up to the artist to submit works to the publisher for possible print editions; they are paid, usually quarterly, on a royalty basis (sometimes receiving an advance against royalties) of between 10 and 20 percent. At Mill Pond Press in

Venice, Florida, the royalty is 10 to 18 percent, or 7 percent of net receipts. At Applejack, the amount of the royalty is based on "the prestige of the artists, their gallery and collector base, do they sell out their prints," Appleman said. That collector base is often established by the artist having previously self-published print editions over a period of at least two or three years. Some successful artists may receive guarantees of a certain level of payment regardless of sales.

Neither Applejack nor the Greenwich Workshop does any of the actual printing; instead, they send work out to various printers, who provide proofs for approval and then the final printing. Appleman stated that the average number of proofs used to create an edition is three, but some artists demand more. "I go through half a dozen proofs, making corrections in color and value, mostly, before I'm fully satisfied," said painter Howard Terpning, whose works have been printed by the Greenwich Workshop since 1981. Creative staff also evaluate each proof and are in direct contact with the actual printers.

Both Applejack and the Greenwich Workshop produce between eighty and one hundred editions per year, working with approximately thirty artists. Terpning usually has three to five editions made annually, averaging 1,000 prints per edition. Some very popular artists for the Greenwich Workshop—Bev Doolittle, for instance—have editions of 10,000 or more, but the average size has declined since the 1980s to the 750–950 range.

The downturn in the print market in the early 1990s led some print publishers to diversify and expand their services and offerings. The Greenwich Workshop created a fine art porcelain line of figurines (the Greenwich Workshop Collection), moving into the collectibles market, while Applejack developed a publishing subsidiary (Apple Press) that uses its same artists to illustrate children's books, art books, cookbooks and Bible stories. Both companies offer canvas reproductions of their artists' paintings, involving a three-dimensional process in which a mold is made from the original canvas and transferred to a cotton canvas (the reproductions not only look but feel like the original painting), and opportunities for licensing.

Licensing

"Licensing art images is the fastest-growing area in the licensing industry," said Charles Riotto, executive director of the New York–based Licensing Industry Merchandisers Association. "At our annual trade show, there used to be just a handful of people who handled artwork. Now, there are more

than a hundred. Licensees—manufacturers—like the idea of licensing a design because it's safer and less expensive than celebrities. A design won't end up in the newspapers for getting arrested after a fight in a bar."

Licensing agents take images to manufacturers, who may want to use them for paper products (greeting or note cards, posters, calendars, wallpaper, jigsaw puzzles, for instance) or fabric (T-shirts, neckties, duvet covers, curtains and drapes, tablecloths, napkins, gift bags, floor mats, upholstery, sheets and pillowcases, throw rugs, and blankets) or objects (plates, canisters, salt and pepper shakers, figurines, boxes, coasters, knives)—any surface, in short, where an image may be transferred. In some cases, the art may need to be modified for the use—dinnerware requires a rounded image, while sheets and wallpaper would call for repeated patterns—or just heavily cropped. Licensing is probably not an avenue for every artist. "The artist needs to be reasonably well known," said Marty Segelbaum, owner of MHS Marketing Consultants in Minneapolis, Minnesota, "in order to interest companies." Michael Stone, president of the New York City–based Bean Stalk Group, noted that companies want "very distinctive, relatively popular artwork with which their customers can identify."

Some artists do their own licensing, while most others rely on agents or their publishers to contact manufacturers and set terms. One of the ways to find a licensing agent is through the Licensing Industry Merchandisers Association (350 Fifth Avenue, Suite 2309, New York, NY 10118, 212-244-1944, *www.licensing.org*), which publishes a listing of its members (*The LIMA Licensing Resource Directory*, $250), noting the types of licensable properties in which the company or individual specializes. Artists may also choose to attend the annual LIMA trade show, which takes place in February in New York City in order to meet prospective licensing agents.

Michael Stone noted that there is no standard agreement for licensing images with manufacturers, but certain points should be part of any contract. They include: the length or term of the contract (two to three years is normal, with an option to renew); the right of the artist to approve everything pertaining to the use of the image (product, packaging, and marketing); the territory of the license (for example, the United States or United States and Canada, Europe, the world); exclusivity or nonexclusivity (may any other manufacturer produce a similar product with the same image?); a specific definition of which image is being licensed and for what purpose (such-and-such an image for a two-hundred-piece puzzle, for instance, which may allow another company to use the image for a five-hundred-piece puzzle but does not permit one company to claim rights to all uses of the image); and the manner of payment. Most licensing agreements are based on royalties, ranging from a low of 1 or 2 percent to a more

aggressive rate of 10 percent wholesale. (A powerhouse such as Disney gets a 15 percent royalty.) There may be advances against future royalties as well as minimum guarantees, terms assuring that the artist will receive at least a certain level of payment even if sales are lackluster. "Most companies prefer to pay up-front fees, because they won't have to pay as much with royalties," Stone said. "You don't want that."

When an artist's images become a sought-after licensable commodity, there may be concerns other than simple contractual arrangements and counting the money. The artist's reputation may be jeopardized by over-exposure or through an identity with inappropriate products or even through an identity with cheap merchandise in general. Norman Rockwell, the illustrator who died in 1978 at the age of eighty-four, became an even larger industry through licensing in death than he was in life. Apart from the artist's own drawings, oil sketches, watercolors, and finished oil paintings that continue to attract collectors willing to spend hundreds of thousands of dollars for major works, Rockwell's images are available on a myriad of items for which people spend tens of millions of dollars annually. This merchandise includes note cards, postcards, bookmarks, T-shirts and sweatshirts, coasters, posters, pencils and pencil cases, figurines, plates, rugs, snow globes, tote bags, iron-on transfers, Christmas cards and ornaments, lamps, clocks, jigsaw puzzles, candy bars, trouser suspenders, paper weights, coffee mugs and beer steins, calendars, pillows, playing cards, dolls, and architectural miniatures. The gift shop at the Norman Rockwell Museum in the artist's hometown of Stockbridge, Massachusetts, carries twelve hundred items, a fraction of the total. That sales shop, by the way, earns half of the museum's $2.2 million operating budget—an unusually high percentage as museum gift shops go.

Hundreds of companies market the Rockwelliana, and almost all of them need to receive permission, through a licensing agreement, from one or more of the four main copyright holders of the artist's works. They are the Norman Rockwell Family Trust (and the Norman Rockwell Estate Licensing Company, which owns publicity and endorsement rights for the artist's name as well as specific copyright to hundreds of sketches and paintings); Curtis Publishing Company in Indianapolis, Indiana (which owns the rights to the *Saturday Evening Post* covers, for which Rockwell is best remembered); Brown and Bigelow in St. Paul, Minnesota (the world's largest manufacturer of calendars, for which the artist created between 100 and 150 illustrations); and Hallmark in Kansas City, Missouri (for which Rockwell made illustrations for Christmas cards).

All these copyright holders receive between 5 and 10 percent royalties on sales of Rockwell-related items. Brown and Bigelow, for example, grosses

between $200,000 and $300,000 per year. Curtis Publishing takes in more than half a million dollars annually, according to Joan Durham, president of Curtis Archives, the company's licensing branch, while the Rockwell Estate Licensing Company receives "a little less" than half a million dollars, noted Harvey Gordon, a lawyer who handles the licensing agreements. The largest single area of revenues for the Estate Licensing Company is publicity rights for companies that want to use not only Rockwell images but also the artist's name to evoke a sense of high quality and attention to detail. In a few instances, companies buy only the rights to use the artist's name (and/or a photograph of Rockwell) without the artwork.

"Rockwell's name is used proverbially," Thomas Rockwell, one of the artist's three sons and sole trustee of the family trust, said. "When you say Norman Rockwell, the small town image comes to mind. The name itself has come to represent an idea that is simpler than the actual work."

The four main copyright holders frequently work with one another in setting up licensing agreements. Curtis Publishing occasionally acts as agent for Brown and Bigelow, finding potential licensees, and companies that want to use both a Rockwell *Saturday Evening Post* cover and the artist's name will have to negotiate with both Curtis Publishing and the Rockwell Estate Licensing Company.

Licensees generally pay the copyright holders a nonrefundable advance against royalties—between $2,000 and $5,000 for smaller production items, between $50,000 and $100,000 for merchandise that is to be marketed widely—that protects the copyright holders' interests should the item not sell or even be brought to market. "A company may not be able to sell as many items as projected, or there may be so many problems along the way of production that it drops the item altogether," Joan Durham said. "But, for us, that means giving an exclusive license to a very salable image and receiving no royalties back for it."

Copyright holders also generally license images for no longer than one year at a time, subject to "performance reviews" of the licensees, she stated. "We may need to renegotiate if the image isn't sold in sufficient quantity." With hundreds of companies continually seeking to use Rockwell's images, Curtis Publishing and the other copyright holders can afford to choose and strike hard bargains.

All of the copyright holders also keep in close touch with Thomas Rockwell—who is paid a percentage of royalties as a "sort of consultant" by Curtis Publishing—for approval of both the concept and prototype of proposed licensing items. A company may receive a license based on a concept for an item, but production may be canceled if a prototype fails to satisfy either the copyright holder of the Norman Rockwell image or Thomas

Rockwell himself. Poor reproduction quality is a commonly expressed concern. In general, it is Thomas Rockwell who vetoes something. Among the items and ideas he has disapproved in the concept stage are paper plates with Norman Rockwell's images in the center ("How would one of his paintings look underneath the remains of someone's three-bean salad?" he said) and a pizza chain's wish to substitute a pizza for the turkey in Rockwell's Thanksgiving-oriented *Freedom from Want* painting. "I try to limit cropping of the images and to have very few changes to the artwork," Thomas Rockwell stated. He did, however, approve trouser suspenders.

"It's a fine line that licensees have to walk," Joan Durham said. "We all want high-quality reproductions of the Rockwell images, and yet the items have to be affordable, because the people who want Rockwell items don't want to spend a lot of money." She added that the quality of the images used by Curtis Publishing's licensees is "basically OK."

Few artists in history other than Rockwell have ever had both an originals and a merchandise market at the same time, and both thriving. Analogous to Rockwell, perhaps, is Mary Anne Robertson "Grandma Moses" (1860–1961), whose original paintings are highly valued and hang in major museums and private collections—and whose images are also found on calendars, posters, ceramic plates, and greeting cards. Not dissimilar to the Norman Rockwell Estate Licensing Company, a separate enterprise called Grandma Moses Properties Company, which was created in the 1940s, handles the licensing of her images.

There is far less Grandma Moses than Norman Rockwell merchandise on the market, which is partly a reflection of relative demand and partly a matter of planning, according to her dealer, Jane Kallir of New York City's Galerie St. Etienne. "Toward the end of her life and after her death, Grandma Moses's celebrity status waned, and her status as a fine artist increased," Kallir said. "In this context, we didn't want the artist to seem totally exploited commercially, and, while we have allowed people to use her images on greeting cards and such, we have put more emphasis on exhibitions and seeing her work reproduced in books. Licenses are mostly restricted to fine arts areas."

She added that three criteria are used in determining the appropriateness of a potential licensee's concept: the first is the quality of the reproduction. "Grandma Moses is not as readily adapted to cheap reproductions as some other artists," Kallir stated. "You need more colors and tonalities than many companies may want to spend money for." A second criterion is the type of item on which an image is to be reproduced. A proposal to use a Grandma Moses image on a thimble was rejected, for example, because a thimble is so small that a reproduction would be unable to show much in

the image. Neckties have also been rejected because of the need to crop images severely. Kallir noted that the last criterion is "good taste, and that's a subjective issue. Grandma Moses was opposed to the sale of alcohol, so we wouldn't use one of her images on a liquor promotion, for instance."

Lawrence Cutler, president of Art Shows and Products, a New York City–based company that licenses the work of seventeen American illustrators—of whom the most sought-after is Maxfield Parrish (1870–1966)—also described the need to carefully monitor the items to which an artist's images are affixed. "We have maybe ten or fifteen licenses for Maxfield Parrish, and there is no clothing, no mugs or plates," he stated. "We've done licenses for posters, prints, note cards, postcards, calendars, date books, and many of those are mainly sold in museum shops. The family of Maxfield Parrish and I don't want to go the Norman Rockwell route."

Putting One's Art Talents to Work

I N TOO MANY ART SCHOOLS AND UNIVERSITY ART PROGRAMS, very little attention is paid to what students can do with their art training. As a result, students often maintain fuzzy hopes of getting a teaching job or finding a dealer to sell work. Neither prospect tends to pan out, at least right away, and, in the face of the problem of finding some means of support, most graduates begin the slow but inexorable drift away from the art career they had planned. Some artists who are versatile and not hindered by an absolutist temperament begin to look into art-related fields that may support or complement their gallery-oriented work.

Portraiture

There are many clients for artists skilled in portraiture. Spouses and parents want pictures of family members; universities, corporations, governments, and associations seek likenesses of their leaders. However, there is little public recognition of portrait artists outside of their clients and each other. Add to this the fact that the most famous portrait artists of the last fifty years have gained recognition only for works that were rejected by patrons.

Peter Hurd, Andrew Wyeth's brother-in-law, for instance, is remembered for painting President Lyndon Johnson's portrait because of the sitter's response ("the ugliest thing I ever saw"), and Graham Sutherland's portrait of Winston Churchill was actually never seen by the general public (it was destroyed by the prime minister's wife, who was just barely more incensed with it than her husband). Perhaps these rejections are signs of the artists' talents and insight, but they largely redefine fame as infamy.

For most artists who do likenesses, portraiture is a sideline that pays the bills until the fine art gallery pictures start selling. "It's a marvelous opportunity to sharpen one's drawing skills," Will Barnet said, "and it's a real challenge to capture someone on canvas."

Of course, certain artists who have done portraits are famous in a positive sense. Edgar Degas, better known for his paintings of domestic life and young ballet students, and John Singer Sargent, who also did watercolor landscapes, both used portraiture as a way to earn some badly needed money (it also brought Sargent entrée into the fashionable society he coveted). The sculptor Isamu Noguchi is another who made bronze busts and head figures in the image of paying clients early in his career, although he is best known for his large, abstract gallery pieces. Contemporary artists Will Barnet, David Hockney, Alex Katz, Alfred Leslie, Alice Neal, Philip Pearlstein, and Andy Warhol are among the many who have been induced to do a portrait when the money and sitter are right, but they have been sought out by art collectors who wanted a gallery fine artist to paint them; those sitters were not simply looking for a portrait of themselves but a connection with art history.

For other artists, portraiture is a full-time occupation that may involve not only people but also houses or pets as subjects, with final works created in a variety of drawing, painting, photographic, or sculpting media. Art dealers of all types may arrange for the artists whose works they sell to do a portrait of an interested client, but many of the artists who specialize in portraiture are represented by galleries catering to the portraiture market, including:

Portrait Brokers of America
26B Church Street
Birmingham, AL 35213
(205) 879-1222

Portraits, Inc.
985 Park Avenue
New York, NY 10028
(212) 879-5560

Portraits South
105 South Bloodworth Street
Raleigh, NC 27601
(919) 833-1630

Leon Loard Portraits
2781 Zelda Road
Montgomery, AL 36106
(334) 270-9900

The Portrait Source
300C North Main Street
Hendersonville, NC 28792
(800) 586-6575

Francesca Anderson Fine
Art/Portraits North
56 Adams Avenue
Lexington, MA 02173
(617) 862-0660

A Stroke of Genius
1482 Buckeye Lane
Palm Harbor, FL 34683
(727) 738-1688

The Portrait Group
1434 Churchill Place
Reston, VA 20194
(800) 234-4156

These galleries take from the client a 40 percent deposit that is kept in the event that the finished work is rejected. That 40 percent is also the customary amount of their commission, so the deposit ensures that the galleries lose nothing. Other, regular art galleries handling the work of figurative artists also arrange portrait commissions. Artists set the prices in most cases. Prices for portraits—of humans, pets, houses—are not likely to be lower when contracted directly with individual artists rather than through a dealer, because artists are unlikely to undercut their galleries (it makes for poor artist-dealer relations) and are quite happy to keep the extra 40 percent for themselves.

Artists working independently generally require a 15 to 25 percent deposit that will be kept if their work is rejected. Other costs are all negotiated with the patron separately. They can involve travel to sketch a subject (which may include accommodations, food, and the cost of renting a studio in another city), framing, shipping, the medium (bronze, pastels, and oil paint are the most common), whether or not there is more than one figure in the picture (a mother and daughter, for instance, or several animals), the type of pet in the painting (a horse may cost one amount, a parakeet another), the type of background (Portraits, Inc. charges an extra 30 percent for backgrounds that are not simply dark but include furniture or a landscape, for example), and the amount of the subject covered (head and shoulders, half-figure with or without hands, three-quarters or full-length).

Other than galleries, there are numerous ways to find potential portrait clients, according to Jennifer Williams, director of the American Society of Portrait Artists. One may set up an exhibition of portraits in one's home or studio or advertise in an upscale magazine (*Architectural Digest, Better Homes and Gardens, Veranda,* among others). An artist might also exhibit a portrait in a jewelry store because that type of business attracts wealthier people, she said. "It's a good idea to leave a brochure in the store and even give the store

a commission if a customer there calls about a portrait." She added that portrait artists should keep in contact with past clients, through postcards or letters, as most referrals are made by word of mouth. The fonder the memory of the artist, the more likely a client will spread favorable word. The American Society of Portrait Artists (P.O. Box 230216, Montgomery, AL 36123-0216, 205-270-9020 or 800-622-7672, *www.asaopa.org*) may also help to further an artist's career through its network of artists. Membership costs $65 annually and offers members a monthly newsletter, discounts on materials, answers to business and marketing questions, professional critiques, and listing at the society's Web site. A second association, Portrait Society of America (P.O. Box 11272, Tallahassee, FL 32302, 877-772-4321, *www.portraitsociety.org*), also offers opportunities for networking and general information about the field.

Daniel Greene, a pastel portrait artist who has been doing likenesses for the past thirty-five years, stated that some artists charge less for painting children because "portraits of children are usually paid for by an individual, such as a parent, whereas an adult may be the head of a corporation that is commissioning the painting. Corporations have more money than private individuals, and an artist may charge accordingly."

Greene, who holds portraiture workshops around the country, added that the prices artists charge for portraits range from $250 to $75,000, with the average being between $400 and $7,500. The more prestigious commissions and higher prices tend to come with a reputation based on past work. In addition, pictures of people usually cost more because they are intended to be lasting memorials and are to be shown in a prominent space.

The fees for painting a likeness of someone's house are often less than for pictures of individuals or animals, largely because of the way these house portraits are conceived or used. Interior decorators, landscapers, or architects, for example, may commission an artist to paint a customer's house as a memento of their own work, and they are unlikely to pay thousands of dollars. Homeowners sometimes also seek a painting of their property, and they may pay somewhat more.

Dena and Stewart Stewart of Miami Beach, Florida, who specialize in interior home murals and portraits of houses, find that Christmas is their busiest time; their prices range from $385 (for 11 X 14-inch portraits) to $485 (16 X 20-inch) and $585 (18 X 24-inch). The two create designs, in their folk art style, based on photographs that customers send them.

Every artist works differently on portraits, some staying in their studios and relying on photographs that a patron sends them, while others insist on site visits to sketch (and possibly to photograph) the subject who poses. Ariane Beigneux of Norwalk, Connecticut, who specializes in

children, noted that she does a "careful color sketch from life—the child has to sit for a few hours—and then I take maybe sixty photographs from different angles to capture expressions and poses. That gives me a lot of different attitudes and choices." Ellida Sutton Freyer of Chicago, who frequently does pets, on the other hand, takes a booth at an art fair or dog show to make quick sketches and occasionally travels to someone's house to make a sketch, "but it's hard to get animals to sit still and pose. It can be difficult following a cat all over the house."

As with everything else, portrait painting goes through various phases of taste, sometimes leaning more toward photographic realism and other times adopting a looser style. Patrons generally have a sense of what they are going to get, because either the artist or the gallery will have a brochure of previously painted portraits that indicate what the artist does and how. Sometimes, of course, the final work comes as a bit of a shock.

"I've had problems with paintings that, eventually, I had to redo," Everett Raymond Kinstler said. "I did one of then United Nations Secretary General Kurt Waldheim that he just didn't like. He didn't like my interpretation of him, and he made some recommendations. I saw his point in a few areas, but I could not, in my artistic sensibility, accept what he recommended that I do. But I agreed to do the painting over. He posed again and ended up liking the next one."

Daniel Greene suggested that artists show the work-in-progress to the sitter, because "customers like to see the work develop from white canvas to full color painting." Another advantage to this practice is that it keeps the final work from coming as a "shock" when clients finally see the finished painting. "It may be a good shock or a bad shock, but it is always startling," he said. "Many artists drape the work when the subject isn't posing or turn it to the wall, and all the sitter gets to see before the final viewing is the back of the canvas. When a subject gets to see the work-in-progress, that person is generally less prone to reject it at the end."

Rejection is a problem that doesn't exist in the same way in the fine arts realm of gallery exhibitions. "The reason I never wanted to do portraits as my full-time occupation," Will Barnet stated, "is that I don't want to work under anyone's judgment. I wouldn't want someone to tell me to make the nose a little different."

Most applied areas of fine art, and portraiture especially, require considerable skills and training in realist, figurative artwork, regardless of whether or not realism is one's preferred artistic style. When sculptor Eliot Goldfinger of New Rochelle, New York, graduated with a BFA from Pratt Institute in 1974, his main interest was abstract work. "I was influenced by David Smith and constructivist sculpture in general," he said. "I filled up my

parents' house and my apartment in Brooklyn with abstract sculpture. Now, whenever I visit my parents, I throw out two or three things."

However, while a student at Pratt, Goldfinger took an anatomy class that led him to an interest in figurative work, and it was through his skills in this realm that he landed a job in the art department at the Museum of Natural History in New York City, making anatomical models, mannequins, and figures in loincloths. One of the museum's trustees was Mary Lindsay, wife of former New York City Mayor John V. Lindsay, "who saw my work at the museum and liked it. I asked her if I could do a portrait of her husband and she said OK." That bronze portrait went directly into the collection of the Museum of the City of New York and helped lead to commissions for portraits of other New York City mayors (Abraham Beame, Edward I. Koch, and Robert Wagner).

As his involvement in portraiture and figurative work in general grew, Goldfinger recognized his need to develop his technical skills. He audited anatomy classes at Columbia University, studied at both the Art Students League and the National Academy of Design, and eventually began teaching a course on anatomy for artists at the New York Academy of Art, even writing a textbook on the subject that was published by Oxford University Press in 1991.

Indeed, portraiture has a long history in art, evident in monuments of powerful rulers in ancient Egypt as well as in earlier civilizations. The form was far enough advanced for Aristotle to separate portraiture into three categories—the idealized image, the exact likeness, and the caricature. The idealized form dominated the Middle Ages in Western Europe, but, by the Renaissance, portraits of specific popes, kings, and, increasingly, noblemen and simply wealthy individuals abounded. At times, the likeness of a patron might be included in a historical or religious scene; however, as secularism prevailed, the individual portrait became an area of art-making unto itself. As artists themselves became Romantic figures, self-portraits and portraits of other artists also became firmly established as serious art subjects. Perhaps the world's most famous work of art, Leonardo da Vinci's *Mona Lisa,* is a portrait of the wife of a wealthy Florentine merchant, reflecting the fact that a portrait can stand on its own as art and that the subject's importance is not a criterion for aesthetic value and appreciation.

Masaccio, Bellini, Dürer, van Eyck, Holbein, Rubens, Rembrandt, Reynolds, Romney, David, Stuart, West, Manet, Sargent, Cézanne, Braque, Picasso, Warhol, Katz, Leslie—the tradition of artists who have done portraits is long (almost as long as art itself). Yet, for artists and those who do portraiture occasionally or regularly, there is an odor attached to the word. John Singer Sargent referred to them as "putrids," and others bristle

if called portrait artists. The term "portrait painter" seems to carry a stigma of commercialism, of pleasing a patron and not oneself.

Portraiture has long been a lucrative occupation for artists, but many of them are embarrassed to admit that this is what they do (or this is who they are). Portrait artists may choose to say, for instance, "I am a sculptor, and I also do portraits from time to time," Raymond Kinstler, who has done numerous presidential and other portraits, said. "I'm a painter, and I do a lot of nonportrait work. I'm not a gun-for-hire. I'm in easel painting." Similarly, Daniel Greene, an artist whose portrait subjects include Eleanor Roosevelt and New York City Mayor Robert Wagner, stated, "I'm not a hired brush."

The issue seems to be whether one is known as a portrait painter or as an artist who also happens to do portraits. Aaron Schickler, who is best known for his portraits of former President Ronald Reagan and former First Lady Jacqueline Kennedy, eschewed the portrait painter label, noting, "I don't conceive of portrait painting as a separate identity. I am an artist." Allen Hirsch, who called himself "a fine artist basically, and faces are a big part of my work," distinguished between "portraitists," whom he described as "hacks trying to please a patron," and "portrait artists," such as Lucian Freud and Alberto Giacommetti, whose portraits are "pure expression. The artist finds a personal relevance as well as a stylistic connection to the subject."

The prestige of portrait artists is directly related to the renown of their subjects, and nowadays there is no greater prize in the United States than being commissioned to create the likeness of the president. For Kinstler, who painted official White House portraits of Presidents Gerald Ford and Ronald Reagan, the experience was one of "touching the history of this country. It's a singular privilege."

He not only has touched history but has become part of it. Kinstler has painted hundreds of portraits over the past forty years, including Miss Americas, actors, college presidents, business leaders and foundation directors as well as political figures, but his name is forever identified with the pictures of the two presidents.

The White House portrait commissions were also high points in his career and "generated a lot of good publicity for me. It was beyond my comprehension how my name traveled among so many people wanting a portrait." The same mixture of artistic recognition and marketability is true for William Draper, who painted sitting Presidents John F. Kennedy and Richard Nixon for the National Portrait Gallery of the Smithsonian Institution, and Aaron Schickler, who painted the official White House portraits of both John F. Kennedy (posthumous) and Jacqueline Kennedy. Add to this group the name of Herbert Abrams, who has painted the White

House portrait of President Jimmy Carter and portraits of President George Bush and former First Lady Barbara Bush.

"These are the commissions every portrait artist wants," Abrams said. "People think differently about an artist who has painted the president; it enhances my prestige. If I'm competing with other artists for a portrait commission, the fact that I was selected to paint Carter and now Bush often gives me the job."

Most portrait artists do some research for their major subjects, whether it be a conversation with the sitter, looking through photographs or even reading about the person. The White House sent Abrams a variety of official photographs of both George and Barbara Bush, and the artist added to his knowledge by touring the White House, asking staff there for information about what furniture and artworks the former president most enjoyed. These Abrams included in the official portrait.

Since 1960, Abrams has painted over two hundred portraits, many of doctors and corporate executives but also two Connecticut governors, three military generals, astronaut Edwin "Buzz" Aldrin, playwright Arthur Miller, former Reagan administration Treasury Secretary Donald Regan and a variety of other notable figures.

After the Jimmy Carter portrait, there was a greater demand for his work, and George Bush himself called Abrams's picture of Carter his favorite in the entire White House collection. With both presidential portraits, Abrams sent information about himself and his work—a small, self-produced catalogue with reproductions as well as biographical material—to the White House curator of collections. "I knew when Carter was in office that eventually there would need to be a portrait done," he stated, "so I mailed some material in to keep on file." Abrams's work greatly impressed then curator Clement Conger who, after the completion of the Carter portrait, commissioned the artist to paint Conger's own portrait for the State Department (where Conger was also a curator of collections).

Perhaps as many as ninety artists had expressed interest in doing the White House portrait of George Bush, submitting examples of their work to the curator of collections, Rex Scouten. Upon his own judgment and with the advice of Dr. Alan Fern, director of the National Portrait Gallery, the curator whittled down the stack to between fifteen and eighteen finalists, whose material was sent to Houston after President Bush left office.

Jimmy Carter started the tradition of assigning White House portraits after the presidents leave office, because these men have found themselves too busy for extended sittings during their terms. The money to pay for the portraits—usually, $25,000 apiece, not including costs of framing, travel, food, and other related expenses—comes from the White House Historical

Association, which was founded by First Lady Jacqueline Kennedy in 1961 and is a privately chartered organization that quietly solicits money for fine and decorative art acquisitions at the White House as well as any refurnishing. Prior to 1961, either the federal government or the president himself (sometimes friends of the president) paid for the portrait commissions.

Scouten noted that, during the Bush presidency and afterwards, he had been "lobbied by artists who want to do the portrait and by White House staff members who have somebody in mind for the job." Abrams had more than just President Bush's own admiration for his work to go on. In mid-1993, he met Laurie Firestone, who was Mrs. Bush's chief of staff during the Bush presidency, at the house of some mutual friends in Virginia. Firestone stated that she was a "great admirer of Herbert Abrams. I thought the Carter portrait, which I saw every day in the White House, was the best of the current presidents." She urged him to submit his portfolio to Rex Scouten, which Abrams did, and he also sent another copy of his portfolio to her.

Not long after meeting Abrams, Firestone talked with the Bushes and asked them if they had yet selected an artist to do their portrait, which they had not; "I told them, 'You really should take a look at Mr. Abrams's work,'" and she sent them his portfolio. She also put in a word on Abrams's behalf with Rex Scouten. "My part in all this was simply promoting one artist."

In January of 1994, Firestone arranged a meeting (which she attended) between Abrams and the Bushes at a suite they keep in New York City's Waldorf Towers, and there he made a formal presentation for the portrait commission. Soon after, the Bushes chose Abrams.

He flew down to Houston in order to meet George Bush for lunch at the club to which the former president belongs. "It's key to everything with me to have lunch with the person I'm going to be painting," Abrams said, "because it breaks the ice. There is a lot of unspoken tension involved in doing a portrait. I may be a little in awe of the sitter, and the sitter is also frequently ill at ease because he knows the painting will be up forever. Eating with someone helps to lower the tension—I don't know how, it just does—and the opportunity to just talk about anything also gets me and the sitter to relax together. One time, I met with the head of RCA, whom I was going to start painting, and he looked so stiff and guarded in his office. I looked around the room, which had a huge mahogany desk and beautiful decorations, and asked him, 'Just what do you do for a living, anyway?' The question took him by surprise; I don't think anyone ever asked him that before. It really loosened him up, and the portrait ended up going very well."

In advance of the portrait of President Carter, Abrams went to a Sunday school class that the former president taught as well as later

attending church with him. During the first sitting for the Carter portrait, the two men discussed Mozart, growing up on a farm, and the former president's passion for fly-fishing. At the luncheon in Houston, Abrams and George Bush talked about the Boston Red Sox ("Bush used to be a fan; I still am"), their similar experiences as pilots in World War II, about their interest in golf and tennis, and about their families.

Personal conversations win commissions and enable people who might otherwise think very differently to work together amicably. "He is so much more enjoyable in person than he came across on TV," said Jacob Collins, who painted a portrait of President Bush for the Union League Club in New York City. "The medium doesn't do him justice." Marc Mellon, a sculptor who created a bust of George Bush (now in the collection of the Smithsonian Institution) in 1982 when he was still vice president, recalled feeling quite nervous about the importance of this commission during the sittings, stating that both Bush and his wife chatted amiably with him now and then to break the tension. "I remember one time," he said, "Barbara Bush came into the room and said, 'I'm fixing lunch. It's nothing special, only chili but, if you'd like some, we'd love to have you eat with us.'"

Few artists start out as portrait painters, but almost all have received considerable attention for their realistic figurative work that was translatable into portraiture. There really aren't schools of portraiture, and most portrait artists did not study portraiture in school anyway. Instead, they tend to pick up techniques and ideas from observation and practice. Raymond Kinstler began his artistic career as a comic book illustrator, later graduating to paperback book covers before moving on to nonillustrative subjects and portraiture, while William Draper painted combat scenes as well as portraits of Admirals Halsey and Nimitz ("won me a lot of attention") for the military during World War II.

Jacob Collins was only in his mid-twenties when a member of the Union League Club saw Collins's student work—a nude—at the New York Academy of Art and arranged to have the young man commissioned by the club to paint the portrait of former Supreme Court Chief Justice Warren Burger in 1988. Five years later, the Union League Club selected Collins to do President George Bush.

Collins "kind of took art courses at Columbia University," where he graduated with a bachelor of arts degree in history in 1986, "but I didn't find them very interesting. The teaching was all very soft. No one was telling you that you did it wrong. The comments you received were more on your sensibilities, not your abilities: 'I like the way your red balances your green' or 'I like the way the paint moves across the canvas.' I liked to paint, but I knew I wouldn't learn anything there." He credited an

understanding of the human form to his instructors at the New York Academy of Art.

The Burger commission was a trial by fire for a young artist without much experience in portraiture. In all, it took two years for the painting to be completed and accepted, because the former chief justice repeatedly rejected the work, never explaining what he didn't like about it. "I sent the painting to the Union League Club, and they loved it, and some photographs of it to Burger," Collins said. "A few days later, the phone rang: 'This is Chief Justice Warren Burger. This picture doesn't look anything like me.'" Collins had to bring the work back into his studio and try again.

"In the year between when I first painted it and when I repainted it, my ideas had changed about what made a painting good," he stated. Collins applied more layers of paint—originally, the work had just one film of paint—and gave the canvas a more varied surface. Flesh colors were also enriched. He changed the expression on Burger's face but, more subtly, he gave the face greater structure. "It had been formless, soft, and weak," he said. "When I repainted it, the face adhered to a set of bones. If the head is volumetric, there is a believability that there is a soul inside, a personality. The artists who painted the most soul painted the solidest faces."

Between the Burger and Bush commissions, Collins had done a number of other portraits, such as a psychiatrist friend of his parents, some business executives and the stepmother of a friend, but nothing major. He devoted much of his time to painting landscapes, still lifes, nudes, and noncommissioned portraits as well as finding galleries in Houston and San Francisco that would represent him. Collins hadn't painted any other pieces for the Union League Club or portraits of club members, but club officials had not forgotten him. "The Union League really liked the Burger a lot," he said.

The institutions that hire portrait artists tend to have long memories, and word of mouth also goes quite far in this type of work. To a certain degree, these institutions want a continuity of style and prefer people they know (or believe they know) to others unfamiliar to them. Kinstler stated that it is not at all uncommon for "the successor to someone I painted fifteen years ago to call me up because he wants me to paint him, too."

As the overwhelming number of subjects of portraits are wealthy people, names of artists are often passed about between friends at social gatherings, perhaps at an art opening. Sometimes, one person will see a family member's portrait hung on the wall of a friend's house and ask who did it. Ambitious portrait artists tend to be social animals, attending parties where they might meet prospective patrons. "I think it helps to be personable and go to parties and get introduced," Marc Mellon stated. "There was a client of mine who called me up and said that he was having a party. There were going to be

some people there he'd like me to meet, was I free to come? I said, 'Yes I am,' without looking at my calendar. It's just good business sense."

Andy Warhol was well known for attending parties of the rich and famous, working the room and often coming away with the names of clients for portraits and other works. Other artists hold get-togethers in their studios. "I like to hold a big party in the spring and invite everyone I know," William Draper said. "I don't think of it as business, although I do deduct it."

Painting a major figure, and having that portrait exhibited for millions to see, easily elevates the artist in professional standing. Allen Hirsch, who was commissioned by the National Portrait Gallery in late 1992 to paint the newly elected President Bill Clinton, said that he "thought of the Clinton portrait as a career move. My name gets around; people saw me interviewed on the Today show. My prices for portraits have gone up 10 or 20 percent, and I've gotten a lot more commissions." Prior to the Clinton painting, which he developed from photographs (he never met the then-president-elect), his most significant portraits were of national leaders, such as Iran's Ayatollah Khomeini or India's Rajiv Gandhi, for *Time* magazine—all based on photographs.

Herbert Abrams's road to portraiture was not an easy one, although, as many artists, he evinced an ability at sketching early on. Born in 1921, he was one of ten children and experienced bitter poverty during the Great Depression. The family tried farming in Amherst, Massachusetts, losing their farm in a bank foreclosure before moving to Hartford, Connecticut, where his father, a machinist, was unable to find work. Abrams recalled helping his father peddle fruit on the streets of Hartford. A scholarship enabled him to attend Norwich Art School in Connecticut and, within a year, Pratt Institute in Brooklyn, New York, where he stayed for two years until he was drafted by the army. After his service as a pilot during World War II, with financial assistance from the GI Bill, he returned to finish his studies at Pratt and then took courses at the Art Students League, coming under the tutelage of Frank Vincent DuMond—who died in 1951 at the age of eighty-six. Abrams credits his understanding of the figure and his ability to do portraiture to DuMond's teaching.

Abrams wrote, in a tribute to his former teacher in a 1974 issue of *American Artist,* that:

> His approach to a head study, like his approach to any part of the figure, was first that it is simply a detail of the figure as a whole and cannot be thought of as an entity in itself. Every head being basically egg-shaped, he spoke at great length about eggs with their variety in shape and marvelous

structure: "Any point you touch on an egg has the strength of the keystone of an arch, yet the feeble pecking of the baby chick can break it from inside." Then he demonstrated how a good painting of a brown egg, which is nearly flesh-colored, solves most of the problems in painting a head. Based on this idea, his students learned to break down the shape of the head into planes—side, front and so on—with every part relating to every other part so that no feature was seen by itself. For example, "The two eyes are one thing," said DuMond. "They act so much together that if one is the slightest bit off, everyone speaks of "that fellow with the crooked eye."

After his final classes at the Art Students League in 1953, Abrams executed a portrait now and then, but his main interests were landscapes and still lifes. His work was exhibited at Grand Central Galleries in New York City and elsewhere. Abrams's chief source of income, however, was teaching art classes privately and at West Point. "I didn't want my life to depend on getting a likeness," he said, "because that requires you to flatter and please the sitter. What I wanted was something that pleased me, that I could be proud of artistically. After I had enough experience with the other type of painting, gaining confidence, I knew I was ready to do more portraiture."

His first major portrait, commissioned in 1962, was General William Westmoreland, who was later to direct U.S. military activities during the height of the Vietnam War. He painted another portrait of General Westmoreland in 1972 and a third in the late 1980s, which is in the now-retired general's private collection. The three portraits together tell a private story of a man learning how to untense himself: In the first painting, Westmoreland stands stiff at attention in full dress uniform; the second shows him in more casual battlefield attire, seated and not quite straight-backed but edging toward the viewer as though ready to pounce. The final portrait reveals a smiling, calmer man in an open-necked suburban-style shirt.

After the first two Westmoreland portraits, Abrams did more portraits for the military as well as for corporations, hospitals, and private individuals—almost all of the subjects shown with their faces at a three-quarters angle to the viewer. The 1982 White House painting of Jimmy Carter elevated Abrams into the first rank of portrait artists, increasing the demand—and prices—for his commissioned work and changing the direction of his career. By the mid-1980s, he left behind the landscapes and still lifes, and began concentrating on portraits.

Abrams's skill at still lifes, however, has continued to serve him; a number of his portraits, such as those of George and Barbara Bush, contain

objects that give a context to the sitter. Doctors, for instance, stand next to medical books or corporate executives have framed pictures of loved ones on their desks. Still, a large proportion of his paintings are the traditional "existential" portraits—alone and without props, the heavily chiaroscuroed subject with a dark, blank background, light reflecting off his (mostly) or her face. "DuMond used to say, 'What you're really painting is the action of light revealing form,'" Abrams said. "And it's true, the human eye turns toward the light like a moth. If there are too many light elements in the picture, you scatter the viewer's attention."

There is a hierarchy to presidential portraits, with the White House painting at the top, followed closely by that of the National Portrait Gallery, and below that by those various other governmental or private institutions. The value of such commissions to an artist's career are relative to the importance of the institutions, although any time a president of the United States will pose for a picture is a major event in itself. The largesse is usually spread around. While Kinstler was hired to paint President Ford nine times—for the White House, National Portrait Gallery, Union League Club, United States House of Representatives, Gerald Ford Museum, Yale Club, Yale Law School, the personal collection of Mr. and Mrs. Gerald Ford, and the collection of Ambassador and art collector Daniel Terra—there is generally a greater variety of portrait artists asked to paint the president. Ronald Sherr and Jacob Collins have painted portraits of Bush for the National Portrait Gallery and the Union League Club, respectively. Kinstler completed another for Yale University, and another had been commissioned for the Central Intelligence Agency, which Bush headed in the mid-1970s. Considering the fact that George Bush is a graduate of Phillips Academy, was once a member of Congress, chaired the Republican National Committee, served as ambassador to China and to the United Nations, established his own presidential archives and has homes in both Houston, Texas, and Kennebunkport, Maine, more portrait commissions are likely in the upcoming years.

The prestige attached to painting a portrait of a United States president is great, but so too are the feelings all citizens have toward a political figure whose actions affect their lives, artists included. While a number of portrait artists stated that they wouldn't do a likeness of Hitler or of some heinous contemporary dictator, most claim that they dissociate their feelings from the subject, concentrating instead on capturing the sitter's personality in the most positive light. Coining a term, Marc Mellon stated that "as a portrait artist, you must be something of an emotional empath. You have to identify something that your subject's most ardent fans see." Mellon identified himself as an "independent politically." Kinstler said that "I've voted

Democrat and I've voted Republican," while Jacob Collins claimed that "my politics are very fluid. I tend to change my ideas a lot." Allen Hirsch stated that he "didn't vote in the 1992 presidential election. I was confused about a number of things, and I wasn't registered anyway." Aaron Schickler and William Draper both noted that they "vote for the best candidate."

Perhaps not having a strongly identified allegiance to one party or ideology is wise for a portrait artist's career. Ronald Sherr, whose portrait of George Bush was painted at the former president's summer home in Kennebunkport for the National Portrait Gallery, also completed a portrait of Bush administration treasury secretary Nicholas Brady. However, he worked hard to line up a commission to paint liberal Democratic New Jersey ex-Governor Jim Florio shortly after completing the portrait of George Bush. "It's very important to do both Republicans and Democrats," Sherr said. "You certainly don't want to seem partisan. I had heard that I was under consideration to do a portrait of [Lloyd] Bentsen"—treasury secretary in the first Clinton administration—"but my name was suddenly taken off the list after someone said that I had done Brady. That's one of the reasons I wanted to do Florio, so that I don't seem to be on one side or the other."

The most controversial sitter Kinstler ever painted was Kurt Waldheim, the former United Nations secretary general and president of Austria, who at the time of the portrait was accused of covering up an extensive list of his own Nazi war crimes. While noting, "I talk all the time, because I like to keep my subject moving," the artist stated that the subject of World War II never came up. "My view is, you talk about the same things you would at a dinner party, that is, you use good taste. I won't talk about something controversial unless my subject brings it up." Kinstler most vividly recalls talking with Waldheim about a visit that he had made to Austria some years before, including a trip to the town in which Waldheim was born, and the people he met while there.

Abrams freely offered that he voted for Bill Clinton in the 1992 presidential election, but that political differences never arose in his conversations with George Bush and that "none of the people I've ever painted have asked me my politics. I would paint the devil himself; he'd make a marvelous subject."

He added that it does help him to "develop a strong attachment to the subject, and I did like Bush." Abrams stated that he has become friends with many of his sitters, including General Westmoreland, with whom he occasionally argued over the Vietnam War. "I was opposed to our involvement in Vietnam," he said. "I didn't think our government belonged there, and, obviously, Westmoreland did. He wasn't concerned that I would make him look like an ogre because we disagreed. Generally, I have a high regard for

people who have achieved prominence through ability and diligence, who have devoted their lives to certain ideas whether or not I agree with those ideas. I try to paint the person, not what the person thinks. It's not fair for me to pick on something I don't like and base a portrait on that."

Hirsch approaches portraiture with a scientific bent, attempting not only to "duplicate surface face topology" but to "read the personality by the facial forms." The right brain hemisphere, he noted, is the seat of logic, organization, and rationality, while the left hemisphere is the focus of creativity and empathy. As he looked through numerous photographs of Bill Clinton over the years, Hirsch saw that "the left eye was kind of crunched up. It was weaker than the right eye, while the right eye has more brilliance. I could tell he had a very good factual memory and excellent goal orientation, but his left side shows a weakness in intuitive capabilities."

Certainly, if portrait painting were solely a matter of achieving a likeness, any artist with basic technical skills could do the same work, arriving at the same outcome. It is what is personal to the artist—psychological insight, philosophical ideas about man or man's place in the world, stylistic idiosyncrasies and self-confidence in the face of a patron who may be sitting just a few yards away—that distinguishes one artwork from another. Those qualities, of course, are part of all highly regarded works of art, although it is the commercial aspect of portrait painting that brings out a defensiveness in the artists who do it.

In truth, portraiture in the twentieth century often looks to outsiders to be a commercial undertaking, involving a technical competency rather than pure artistry. There is a sameness in many, or most, commissioned portraits: university presidents, corporate executives, judges, and others are seated or standing, faces looking straight out or at three-quarters, usually dressed in dark clothes with a blank or darkened background. In a great many cases, the portrait is not commissioned out of any love for the subject but because everyone in that position has been painted before—the portrait is a requirement of the job. Wall space and the commissioning body's budget determine as many of the details as the artist does. A tacit requirement is that the artist's work fit into the style of what has been done before. Unless a strong stylist is hired—someone like Alex Katz or Andy Warhol, who are selected for "the style before the likeness," Katz said—there isn't much variation between one portrait and the next.

"I paint for two audiences," Daniel Greene said, "the people who will recognize the sitter, who may be friends and associates, and an artistic audience that responds to the artistic elements. Unfortunately, people who

understand those artistic elements tend not to visit the places where portraits are often displayed."

He noted that the public response to his portrait of Eleanor Roosevelt was mixed "exactly in proportion to the way people responded to Mrs. Roosevelt herself. People who loved her loved the painting, and people who hated her hated the painting, too."

The psychologist and essayist William James referred to the kind of success that brings one fame and recognition as the "bitch-goddess," a term with relevance to artists who may gain great prestige in a field that is not held in high regard among fine artists. Success in portraiture may also pigeonhole an artist who aspires to gain recognition in a variety of artistic subjects. Most of Sargent's quoted comments about portrait painting are negative, and Alex Katz has dampened enthusiasm for those who might commission him to do their portrait by "usually pricing them out. If they're still interested, I raise my price some more."

Referring gloomily to the portraits of John and Jacqueline Kennedy as "the thing for which I will be forever known," Aaron Schickler called those pictures "a big headache. I was doing fine with my own art before them, and I wish I had never done the portraits." He was undoubtedly speaking disingenuously, but the portraits of the Kennedys as well as of other notable figures (Ronald and Nancy Reagan, Gloria Vanderbilt and Barbara Walters, to name several) have eclipsed—or perhaps lessened the impact of—his other painting.

Jacob Collins too hopes to "concentrate on my entire body of work. I don't want to be enslaved to portrait painting." However, the accelerating number of calls for commissioned work that he has received since completing the Bush portrait—some paying as much as $50,000—may be difficult to turn away simply in order to create different works that do not sell for as much or even sell at all.

Painting or sculpting portraits may demonstrate an artist's grand insights, philosophy, and technical competence, but the actual job of it involves a lot of diplomacy and problems that are not part of any other type of art-making. Hurt feelings are an important concern, as even the most powerful people in the world worry about the size of their ears and noses. John Singer Sargent defined a portrait as "a picture of someone who has something wrong with his mouth." Even those portrait painters who insist on being called "artists," who care nothing about rejection, still try to overcome areas of possible embarrassment for their subjects through expressive gestures or informal poses or something else. Portraiture and fine art sometimes blend, sometimes coexist, sometimes take divergent paths. Art is usually seen as the expression of an artist's truth, while a portrait

must also take into account the subject's vanity and sense of self. Tom Loepp, a painter and portrait artist, noted that he regularly takes out double chins and smirks and will "go easy on the nose." Women, he said, "have more of a problem with their hair, while guys try to separate themselves from the portrait—'Oh, is that how I look?' Mothers may not like the way I do their children. They may be right and they may be wrong, but I make changes—it's a people thing."

The sitter and the artist may also find themselves not getting along for one reason or another. Jacob Collins noted that some subjects just don't like being posed, "Someone who has been garnering power all his life may not like being told how to hold his head, and the sitting gets a little tense." Painting or sculpting a very important subject may give the artist a case of stage fright, and some sitters may attempt to intimidate the artist. Probably every portrait artist has had to find ways to overcome anger and annoyance with sitters and concentrate on the visual forms. "If they're in a disagreeable mood," William Draper said, "I'll work on the hands." In some cases, the final portrait may reflect in a positive sense the tensions between artist and subject, seen in a particular intensity or ferocity in the sitter's expression.

"In posing, your subjects are doing something that isn't them, but you want them to relax and be themselves; it's a paradoxical situation," said Loepp, who has painted portraits of United States Supreme Court Chief Justice William Rehnquist and television personality Kathie Lee Gifford. "I do a lot of talking, and that gets them to talking, and through talking they begin to feel comfortable and relax." He spends two or three days, and sometimes as many as eight, with a subject, spending the first day mostly drawing in order that the individual "get used to the process." With children, however, "I go right for the painting, there's no drawing. The first day is the only day they're interested, and after that the rest is a war."

Another problem is keeping their subjects alert during extended periods of posing. Gilbert Stuart, renowned for his portraits of George Washington, wrote that "a vacuity spread over his countenance" as soon as Washington began to sit. Most portrait subjects are older people who may become sleepy if they are required to sit inactively for extended periods of time. Other subjects simply feel uncomfortable with someone looking directly and intently at them.

Marc Mellon found that the longer Bush posed the more preoccupied he seemed. "Sitting for a portrait may seem like downtime to busy people," he said. "Whatever needs to be done tends to filter up, and one sees a certain worry in the face. You see the weight the person feels he's carrying. A portrait artist has to be aware of this, because you're no longer seeing the public face but the private one, the one that Mrs. Bush may see when he

brushes his teeth in the morning. You have to find ways to get them back to being the person who is going to be portrayed."

For part of the time that George Bush was posing for Jacob Collins, the former president kept himself busy by talking about his experiences during World War II or dictating letters to a secretary, "most of them to friends who wanted him to visit or responses to people asking for something," the artist noted.

Often, the artist becomes chatty, looking to interest the sitter in some subject. William Draper has used limericks, while Daniel Greene places a large mirror behind himself in order that sitters can see the portrait progressing. "Seeing the image develop in the canvas keeps their attention and has a magical quality for them," Greene said. As a result, the subject takes an interest in the process of painting or in creating a likeness, offering comfortable ground for conversation. Greene did learn from doing a portrait of novelist Ayn Rand to "limit the involvement with the sitter. Explaining the painting process is one thing, but I don't want to debate every brushstroke. I also advise younger portrait artists to avoid soliciting the subject's approval during the process."

Talking and painting are not always talents that can be employed at the same time, although it is a skill most portrait artists must develop. It is probably most difficult for artists who complete their work in the presence of the sitter. "I prefer not to have any talking when I work," Allen Hirsch said. "Electricity builds up in the brain that gets interrupted by the conversation." Many portrait artists do sketches or rough out shapes and composition in paint with the sitter, saving the bulk of their work—or perhaps just the fine-tuning—for their studios. Abrams stated that he took approximately one hundred photographic transparencies of George Bush during the first of their three sittings (one-and-a-half hours each), and those images were later projected life-sized inside a dark box back at his studio where he is able to paint by studio light. He also used that first sitting to try out a variety of poses, take notes, and make a variety of sketches. At the second and third sittings, Abrams said, he used the majority of his time with the former president to "look at him and look at what I've got down on the canvas. For the third sitting, I don't think I even touched the painting, because I was more concerned with making sure I was on the right track with the picture. I can get much more of the actual painting done in the studio using transparencies."

Taking photographs has also served him well for subjects who were not good at posing. Abrams's most difficult subject was Howard Baker, former U.S. senator from Tennessee and briefly President Ronald Reagan's White House chief of staff. "He just couldn't sit still for a minute," he stated.

"I'd pose him carefully and, twenty seconds later, Baker was looking at something around the room. Fidgeting."

Courtroom and Forensic Art

Portraiture, of course, has a wider constituency than just the wealthy and powerful. Courtroom and police artists are frequently employed to capture the looks of the accused and suspected. Clearly, there are major differences between how courtroom and police artists and portraitists of notable individuals go about their work. Unable to pose their subjects, courtroom artists must work fast, often allowing only thirty seconds per portrait, while police artists have no one in front of them to draw and must create an image based on a witness's or victim's memory of an alleged criminal.

Another difference is that a courtroom artist does not have the luxury of a studio in which to spread out or a wide choice of media. "I work in pastel, because the picture has to be in color," said Christine Cornel, a painter who freelances courtroom portraits for television stations in Connecticut, New Jersey, New York, and Pennsylvania, wherever there is a newsworthy trial. "Charcoal is no good because TV stations need color. Some artists work in colored pencils, and I've even seen one or two use watercolors. They work tight and keep a bottle of water between their knees." An artist's supplies cannot overlap onto other seats, especially when the trial room is crowded and there may be other artists at work. Cornel added that, depending upon the length of the court session, she may have an additional hour to fill in the rest of the picture back at her studio, but more likely she must describe several figures—a witness giving testimony, the judge, lawyers, even jurors—in a compressed-space composition "in a snapshot period of time. It's like being a short-order food artist."

There is no association of courtroom artists (there aren't enough of them to establish a self-supporting group), no agents or recruiters who help them find work. One simply calls a television station's assignment editor in the news department—telephone calls seem to work better than letters, because they are more immediate—and asks for the opportunity to show one's portfolio. Cornel did a trial run for WCBS in New York City in order to show her abilities. Jane Rosenberg, a painter who has worked for WNBC in New York since the mid-1980s, developed her portfolio by making quick sketches at night court. Rosenberg already had some experience at a portrait gallery in Provincetown, Massachusetts, and in a shopping mall in Paramus, New Jersey.

Depending upon the television station and the importance of a particular trial, both Cornel and Rosenberg are paid between $250 and $400 per day (the station, not the artist, usually sets the rates). In smaller markets, rates are likely to be lower. Carrie Parks, a painter in Cataldo, Idaho, who sometimes takes a courtroom assignment from TV stations, stated that she is paid $30 per hour, "but that's portal-to-portal, meaning when I leave my front door until I return to my front door. I'm not going to travel all the way to a courthouse for a one-hour trial, then bring the sketch to a television station for just $30."

Dale Dyer, a painter in Brooklyn, New York, noted that courtroom art has been his most lucrative source of income, even though it is an erratic profession. "Someone suggested that courtroom work would be a good way to make a living," he said, "and it has taken care of me better than I thought it would." Dyer added that he enjoys "courtroom work a lot. It flies by so fast that it keeps you alert and thinking all the time: How am I going to draw all these people in such a short period of time? How do I capture the intensity of the courtroom in these people's faces?"

As with many other artists, Dyer has more than one source of income. His second job is doing book illustrations for Scholastic Books, a publisher of young adult fiction. Each job impinges on the time he can devote to the others. "When there is a court case to cover, I just have to drop everything else when I get the call," he said. "For the book illustrations, I have deadlines to meet. All of this can break up the time and continuity of a painting that I may be working on in the studio. When I finally get back to the studio, I sometimes have to remind myself what I was doing before."

There is an occasional expansion of this market. Cornel noted that she has provided courtroom sketches for both *Time* and *Newsweek* as well as for a cable channel. Since television stations may buy the use of the sketches but do not necessarily own them, Carrie Parks said they may be sold to judges and attorneys "who liked the way they looked on TV."

Competition for courtroom artist positions in major television markets is often fierce—the advent of TV cameras in the courtroom eliminated the need for many artists—and a new artist will start low on the list of those called to cover a trial. Over time, as other artists drop out, freelancers will move into the third, second, and first slots. Those artists may be called to work between one hundred and two hundred days per year. "You can't just sit back and wait for calls to come," Rosenberg said. "I used to worry that if I took a vacation or turned down an assignment, no one would ever call me again. I'm a little more secure now, but people will forget you very fast and you have to start all over again. You have to call the assignment editors more than they call you. It's also better not to call and ask, 'Is there

something you want me to do.' It's good to call them if you know of a trial, so you have to find out when and where a trial is going to be. If I'm at an arraignment, I'll take down names of other trials coming up and call my assignment editor about them."

There is no specialized training for courtroom artists, although a considerable amount of practice undoubtedly helps. In police work, forensic and composite art often calls for schooling or additional course work. Dave McNeil, a patrolman on the Stratford (Connecticut) Police Department who received a bachelor's degree from Southern Connecticut University with a major in painting, "knew I needed a steady job, and somebody suggested I become a police officer. I thought I might do it for five years." The dispatcher at the Stratford police station had long seen McNeil's drawings— he doodled on everything—and recommended that he take some courses at the Stuart Parks school in Cataldo, Idaho, toward combining his skills in art and police training.

Carrie Parks, who runs the program with her husband Rick, who was a visual information specialist at the Federal Bureau of Investigation for thirteen years, said that police artists "don't have to go through a police academy the way Dave McNeil did, but it's a good idea because of law enforcement's feeling about bringing in outsiders." She also added that it may help to know someone at a police station if one is not a police officer.

The courses her school offers are also taken by nonpolice-oriented artists, who work for insurance companies to create "demonstrative evidence," such as trial charts, floor plans, enlargements, graphs, and storyboards that are used in civil and criminal hearings. Besides teaching how to present this type of evidence, Parks describes ways of communicating with a jury through color and form. "This is an extremely good and lucrative field," she said. "Insurance companies are willing to spend thousands of dollars to win their cases, but it is also a competitive field. The artist also has the responsibility not to blow the case."

There are only two schools in which one may receive certificate training in forensic art: Stuart Parks (Skeel Gulch, Cataldo, ID 83810, 208-682-4564) and Scottsdale Artists' Schools (P.O. Box 8527, Scottsdale, AZ 85252-8527, 602-990-1422 or 800-333-5707). Among the skills taught at these two schools are how to pictorially age someone (such as a child, who has been missing for a long time); how to draw accessory items (such as beards, mustaches, more or less hair); facial reconstruction or proximation using clay on a skull (to identify someone who has been long dead); and how to build rapport with a witness or know if a witness is lying when involved in police work.

"Police academy training is helpful, because an artist can screw up a case in a number of ways," Parks said. "You can contaminate a witness or lead a witness if you're not careful in your wording. You don't ask, for instance, 'Did the man have brown hair?' because then you're putting words into the witness's mouth. Some artists get an ego problem when working with a witness, thinking, 'I can make this face look more realistic than the witness is describing.' You can end up with a great picture, but there is no such person."

While a personal connection with an insurance company, police department or law enforcement agency is helpful in seeking employment or freelance assignments, a credential in the field that may lead to a job in forensic art is certification by the International Association for Identification (P.O. Box 2423, Alameda, CA 94501-0247, 510-865-2174, e-mail: IAISECTY@aol.com). Certified artists, who need to be currently involved in the field, have been tested by a seven-member board of examiners; part of the test includes drawing a suspect based on a witness's account. The test costs $100, and certification is renewable every three years for $50.

Dave McNeil noted that some sketches he has created based on witness descriptions have looked exactly like the suspects and have led to their arrest and conviction. At other times, "if you have a lousy witness, you'll get a lousy sketch. It all depends on their ability to recall the suspect." His work in forensic art has also led to commissions for fine art, such as portrait commissions and a couple of record album covers. His initial interest in art has been reignited, and he has set up a studio in his apartment.

Religious and Liturgical Art

In centuries past, painting or sculpting religious subjects was the job description of artists in the Western world, and the majority of their patrons were, not surprisingly, officials of the Catholic Church. Nowadays, religion in art is more of an anomaly, perhaps permissible as a "postmodernist strategy," as one critic described an exhibition of Archie Rand's paintings, which over the years have increasingly contained elements of Jewish iconography.

If fewer artists now focus on biblical or religious themes than in the Middle Ages, an increasing number have entered the field over the past decade. Some of this artwork shows up in commercial art galleries, although dealers claim that the market for this art is limited, since deeply religious people tend not to be art buyers. In large measure, the growth of the market for this work has taken place outside of the commercial art gallery realm, with art and liturgical objects displayed in magazines of various religious

denominations (*Archives of Modern Christian Art, Catholic Liturgy, Modern Liturgy, Moment, Reform Judaism, Faith and Form,* among others) and sold through specialized mail-order companies, shows, and gift shops at individual churches, synagogues, and even some museums (such as the Billy Graham Center Museum in Wheaton, Illinois, and the Museum of Contemporary Religious Art of St. Louis University in Missouri) as well as in annual or biannual exhibitions held by artist associations specializing in art and religion.

This market for art with religious themes and objects used in church services is growing even in more secular realms. More and more galleries and retail shops around the United States—such as the Biblical Art Center in Dallas, Texas, and Genesis Gallery in Chicago, Illinois—feature or specialize in this type of work by contemporary American artists. One also sees galleries that for years featured the work only of Israeli artists now displaying artwork by contemporary American Jewish artists. In addition, many juried arts and crafts competitions now highlight work related to religious subjects and liturgical objects. The annual show of the Handweavers Guild of America, for instance, regularly includes a liturgical textiles section. "Lots of gift shops and crafts stores now stock menorahs for Hanukkah, for instance, or seder plates for Passover, or Jewish wedding gifts," said Bonnie Srolovitz, vice president of the American Guild of Judaic Art and co-owner of Presentations Gallery in New York City.

Many churches and synagogues around the country hold regular exhibitions or periodic sacred art shows, including Visions Gallery (which is housed in the Catholic Archdiocese building in Albany) and Trinity Episcopal Church in Detroit (which sponsors an annual juried sacred art show), and some have gift shops in which this artwork may be found. Some of these institutions also buy or commission liturgical objects that are used as part of religious ceremonies. Various church headquarters as well as the Interfaith Forum on Religious Art and Architecture maintain files on artists and craftspeople whose work is recommended for churches searching for stained glass windows, murals, and liturgical objects.

What's more, associations of artists and craftspeople who create devotional objects or artwork that contain religious elements—such as the American Guild of Judaic Art, Christians in the Visual Arts, Christians in the Arts Networking, Liturgical Art Guild of Ohio, Crosshatch, and Catholics in the 2000s—have become more visible, promoting themselves and their members' work. Christians in the Visual Arts, for instance, publishes a biannual directory of its members' work, which is sent to churches and others who request a copy, while the American Guild of Judaic Art periodically buys space in religious magazines for the full-color "showcase" of the members' work.

These religion-in-art groups usually hold conferences including shows of religious art, as well as publish newsletters for their members that offer information about upcoming shows elsewhere. These associations are also a good way to find out which galleries and shops feature art and objects with a religious orientation, since the names of these galleries (for those looking through gallery directories) usually don't indicate the types of objects sold.

"Artists whose main work is religious in subject matter may have to work a little harder at getting their work sold," David Abel Johnson, a painter and membership director of Christians in the Visual Arts, said. "Churches that sponsor sacred art exhibitions are not commercially aggressive or motivated. They don't put the collector together with the artist, and the buyer therefore has to take the initiative in contacting the artist, and that means fewer overall sales."

In general, the religious crafts—handmade kiddush cups, Torah mantles, Ark curtains, menorahs, mezuzahs, and other Judaica, as well as altar cloths, chalices, vestments, vessels, banners, and other liturgical objects used in Catholic and Protestant church services—have been prospering more than the religious fine arts. "There are Reform, Conservative, Reconstructionist, and Orthodox synagogues in this country—thousands of them—and they all need Judaica," said Dr. Jane Evans, chairman of the exhibition committee of the Union of American Hebrew Congregations. "There is enough work for a lot of artists to make a living."

However, the separation between fine arts and crafts that still exists in the art world has broken down in the marketing of religious art, and many shops and galleries tend to sell both types. Many artists and artisans also cross over on a regular basis, creating both liturgical pieces for a certain audience and more general, nonfunctional fine art works for other potential buyers.

Making a living strictly from the sale of liturgical objects is possible, although not necessarily an extravagant living, because of the limited budgets of churches and religious denominations (which set the rates). Lois Kramer, who creates Judaica objects in stoneware finished with acrylic paint, stated that she has to "sell in large quantities every year." Currently, she earns between $125 and $180 for figurative portraits of pre-Holocaust shtetl Jews, $180 for a small menorah and between $1,400 and $1,600 for a large menorah. She has also sold smaller pieces for $40.

Marian Slepian has bigger paydays from her cloisonné enamel Torah arks and breastplates, although she still wholesales mezuzahs to synagogue gift shops "as sort of a production item." Many of her commissions have come at the American Crafts Council show in Baltimore as well as the Union of American Hebrew Congregations convention.

"The nice thing about Judaica is that there is a real demand for it," said Lee Loebman, a painter who makes *ketubot* (formal written wedding documents outlining the obligations of the husband to the wife) for Jewish weddings. "It's not just decorative like art but has a utilitarian aspect. Jewish people need ketubot to get married, so you've got a captive audience." He made his first ketubah while still in the bachelor of fine arts program at the University of Illinois at Chicago. "My brother was getting married, and I decided to try my hand at designing one. The rabbi liked it so much that he started giving my name out to people looking to get married."

There is no easy way to drum up business in the liturgical field. Most clients come by word of mouth, which is a very passive form of marketing. It is difficult to know where one's next job is coming from, or when it will be coming at all. However, stained glass creator Karen Engelke of Schenectady, New York, stated, "word of mouth travels very well. In this area, there are a lot of older churches—many of them 100 or 150 years old—that are in need of renovation, and they look for modern stained glass. I don't exactly know how, but they find me."

Engelke charges between $100 and $400 per square foot, depending upon the complexity of the project, for her work in churches. Still, her main source of income is her job as director of the city's urban cultural park. "I do this job in order to live and the stained glass I do for my soul."

Rose Anne Chaseman has never needed to advertise her ketubot, because "people see them at weddings, and I just get calls after that. At a wedding, people see it for a long period of time when they're in a cheerful, festive mood. And, they only see yours; there are no others, so it's a good marketing tool."

Art and religion have had a rather uneasy relationship since the Renaissance, when artists began to pursue more secular subjects; the estrangement grew only more pronounced in the nineteenth century, when aesthetes replaced religion with art as the reigning belief system. In recent years, it seems that the two camps have become outright enemies, with members of certain religious groups attacking public funding for what they describe as immoral art and some artists depicting churchgoers as yahoos. "Religion doesn't play a large part in the life of intellectual people—it is not part of their intellectual identity," New York City art dealer John Post Lee stated.

Religious imagery and symbols in art are also more likely than almost any other subject matter to offend someone. In December 1993, Archie Rand filed suit against Brooklyn Union Gas after the company removed the artist's work from a show in its corporate offices. A number of employees of the gas company complained that Rand's painting, which is part of his

Kabbalah/Tarot series, was "offensive." The lawsuit was dropped after Brooklyn Union Gas agreed to allow the picture to be displayed until the end of the show, January 31, 1994.

Many artists whose work contains religious imagery or symbols complain that art dealers as much as the buyers of art refuse to handle their work. "One dealer told me to take out the Hebrew lettering," Frederick Terna, a painter of semiabstract images and an art consultant to the Union of American Hebrew Congregations, said. Edward Knippers, a figurative painter of biblical subjects and treasurer of Christians in the Visual Arts, stated, "One major Washington, D.C., dealer said to me, 'Ed, I've liked your work for years, but I don't want to mark my gallery with your subject matter.'" Knippers added that his problem is twofold, that his paintings are "too nude for churches and too religious for public spaces."

In "social conversations," Archie Rand claimed, "dealers and collectors have made it clear that they have no use for my art that includes the Jewish iconography." For years, Rand had two largely separate art careers—the first as a painter of general (or secular) subjects and the second accepting commissions for murals with liturgical themes in synagogues. By the mid-1980s, the two careers began to merge as his gallery art increasingly included Jewish symbols.

"There was always a tinge of Jewish identity in the earlier work," Rand stated, "but many people didn't notice. Now, I'm painting prayers as straight hang-in-your-house pictures. My newer art makes a secular statement about liturgical art." He stated that sales of his more recent work have declined somewhat, which his dealer, John Post Lee, conceded as well. As a result of such a potentially negative reception, many artists tend to tone down the overt religious elements in their artwork in order to have them displayed in galleries. Painter and printmaker Sandra Bowden, who is president of Christians in the Visual Arts, combines Hebrew letters in ways that form geometric patterns—"the subtler the better, in order to sell them in galleries." For his part, Terna stated, "I've sold things—I'm still selling things—but not as a Jewish artist, rather as an artist whose work happens to deal with some Jewish themes," and Edward Kellogg, a painter and member of Christians in the Visual Arts, said that "if you look at my paintings, they look like work along the lines of any landscapist in the realist tradition, concerned with composition, line, and color. The longer you look at them, the more you begin to see themes of evil and the curse, redemption, and affirmation, but you may have to know what to look for."

Away from the often aggressively secular art world, the issue of how much religious content to include in a work of art becomes much less

heated. Debates have raged within religious organizations as well as art groups over what is "Jewish" or "Christian" art, and no particular consensus has been reached other than the broad claim that the imagery reflects the Jewish or Christian experience. Still, there are Jewish members of Christians in the Visual Arts and Gentiles in the American Guild of Judaic Art, who joined one artist group or another based on an interest in certain visual subjects and how their work will be perceived or used. These artist groups exist to provide a mechanism for members to exhibit and sell their work rather than to winnow out those who are not true believers.

Specialty religious periodicals, mail-order liturgical and art companies, church and synagogue art shows and commissions, galleries and shops that feature or include religious themes and objects are the main outlets for artists looking to sell their work. Yet, most artists and artisans who support themselves from the sale of their "religious" work claim that word of mouth brings them most of their business. That may be both good and bad for artists. Certainly, a recommendation from a satisfied customer is better than any art dealer's sales pitch. However, as fiber artist Ina Golub noted, "you do get typecast, and it may be more difficult to break into a larger, more general market." Clergymen, for instance, may mention what they bought from whom to other clergymen, but it is unlikely that they will have these discussions with private collectors.

Still, for those whose names are passed from one buyer to the next, there may be numerous commissions and sales. Corinne Soikin Strauss, who creates hand-painted wall hangings and *chupas* (canopies used in Jewish weddings), noted that homeowners and corporate executives attend weddings where her chupas are used, "and they want one for their walls. My customers always seem to start out with the question, 'Who did that?'"

ARTISTS ASSOCIATIONS

There may be scores of visual artist groups and associations throughout the United States that focus on religious themes. The largest of these groups are:

American Guild of Judaic Art
15 Greenspring Valley Road
Owing Mills, MD 21117
www.jewishart.org

Catholics in the 2000s
Catholic Fine Arts Society

Sister Jean Dominici de Maria, O.P.
Maria Regina Hall
Molloy College
1000 Hempstead Avenue
Rockville Centre, NY 11570
(516) 678-5000, ext. 6487

Christians in the Arts
Networking
P.O. Box 242
Arlington, MA 02174-0003
(617) 646-1541

Christians in the Visual Arts
225 Grapevine Road
Wenham, MA 01984-1813
(978) 867-4124
www.civa.org

Grunewald Guild
Richard Caemmerer, Jr.
19003 River Road
Leavenworth, WA 98826
(509) 763-3693

Liturgical Art Guild
of Ohio
3322 Sciotangy Drive
Columbus, OH 43221

RELIGIOUS INSTITUTIONS

Churches of all denominations and synagogues commission artists to create new works, often liturgical (that is, specifically related to the religious service). As in the past, these works are usually intended to provide decoration for a church, and opportunities become available when new churches are built or old ones are refurbished. Most national headquarters of churches and other religious organizations have art and architecture committees in charge of selecting artists for churches that are being built or renovated. Among these are:

The Union of American Hebrew
Congregations
Department of Synagogue
Management
633 Third Avenue
New York, NY 10017-6778
(212) 650-4000

United Synagogue of Conservative
Judaism
155 Fifth Avenue
New York, NY 10010
(212) 533-7800

Evangelical Lutheran Church of
America
Division of Church Music and the
Arts

8765 West Higgins Road
Chicago, IL 60631
(312) 380-2700 or (800) 638-3522

Unitarian Universalist Association
Worship Resources Offices
Department of Ministry
25 Beacon Street
Boston, MA 02108
(617) 742-2100

United Church of Christ
United Church Board for Homeland
Ministries
Secretary for Church Building
132 West 31st Street
New York, NY 10001
(212) 683-5656

Presbyterian Church
Attention: Art Committee
100 Witherspoon Street
Louisville, KY 40202
(502) 580-1900

Episcopal Church
Attention: Director of the
Building Fund
815 Second Avenue

New York, NY 10017
(800) 334-7626

United Methodist Church
Fellowship of United Methodists
in Worship, Music and Other Arts
159 Ralph McGill Boulevard, N.E.
Suite 501-C
Atlanta, GA 30365
(404) 659-0002

The Interfaith Forum on Religious Art and Architecture, which is a department of the American Institute of Architects (1735 New York Avenue, N.W., Washington, D.C. 20006, 202-626-7305/7453), also maintains a slide registry of artists whose work might be applicable to churches and synagogues.

Both the Union of American Hebrew Congregations and the United Synagogue of Conservative Judaism hold biannual national juried exhibitions of artwork and liturgical objects. Within its offices, the Union of American Hebrew Congregations also has a changing exhibition series of objects and artwork by contemporary artists, curated by Dr. Jane Evans.

MAIL-ORDER COMPANIES

Religious institutions and individual collectors also learn about artists from mail-order companies specializing in religious art and liturgical objects, which send catalogues to prospective buyers. Galerie Robin takes two-dimensional art on a consignment basis, paying a 50 percent commission on sales, according to the company's owner, Shari Boraz. The company usually purchases three-dimensional pieces, although there are some consignments. Purchases, however, are likely to be at wholesale rather than retail prices, Boraz noted, "because this is a catalogue. I have to get a larger discount than 50 percent. It's more like 75 percent." Among the mail-order companies in this field:

BLD Limited
492B Cedar Lane
Teaneck, NJ 07666
(201) 287-0079 or
(800) 847-4207
www.bldfineart.com

GP Limited Editions, Ltd.
16 Court Street
Suite 2408
Brooklyn, NY 11241
(718) 237-9077
(800) 289-0844

Galerie Robin
636 Hanover Center Road
Hanover, NH 03755
(800) 635-8279

The Rosenthal Collection
4210 Howard Avenue
Kensington, MD 20895

(301) 493-5577 or
(800) 962-1545

The Treasured Collection
9 Candlelight Court
Potomac, MD 20854
(301) 986-8888 or
(800) 986-0370

RELIGIOUS PERIODICALS

Many artists and craftspeople advertise in religious magazines—their ads and those of the mail-order companies often are found side-by-side—and these publications also frequently include articles about religious or liturgical artwork. Among these periodicals are:

Archives of Modern Christian Art
College of Notre Dame
1500 Ralston Avenue
Belmont, CA 94002
(650) 508-3742

Faith and Form
1735 New York Avenue, N.W.
Washington, D.C. 20006

Ministry & Liturgy
160 East Virginia Street
Suite 290

San Jose, CA 95112-5876
(408) 286-8505

Moment
4710 41st Street, N.W.
Washington, D.C. 20016
(202) 364-3300 or (800) 777-1005

Reform Judaism
633 Third Avenue
New York, NY 10017-6778
(212) 650-4240

Letter Arts

Like Lee Loebman, Karen Ness, a painter in Munster, Indiana, began to design ketubot in college after being asked to make one (and the invitations) for her sister's wedding. A year-long stay on a kibbutz in Israel, where she made more ketubot, confirmed her interest in Judaica, and she began to design stationery, logos, and greeting cards with Hebrew and English

lettering on her return to the United States. She charges $975 for the basic execution of a ketubah, $200 more for a second language and between $100 and $1,000 more for gold leaf. She advertises her services in Jewish newspapers and synagogue newsletters and also rents a booth at Jewish fairs in order to drum up more business. Twice, in 1987 and 1995, she took a lettering master class with calligrapher Reggie Ezell, "which helped me to expand my horizons from almost exclusively doing work for Jewish weddings to also doing a variety of lettering jobs. I've even done covers for corporate annual reports."

Only a small percentage of art schools and college or university art departments offer courses in calligraphy or have faculty with experience in it. As a result, those interested in lettering must find instructors outside the academy. Julian Waters of Gaithersburg, Maryland, who was commissioned by the U.S. Postal Service to create the "Bill of Rights" stamp, attended art school for a time but left to study calligraphy—with his mother, as it turned out, as she herself had studied calligraphy at the Royal College of Art in London during the 1950s. She had an extensive collection of books on calligraphy, which Waters studied, and he also took master classes with other professional calligraphers. Georgia Deaver of San Francisco, who received her BFA from San Jose State University, was somewhat luckier in that her interest in calligraphy was encouraged at school. One of her graphic design instructors specialized in lettering and helped stoke her interest, and it was lettering that paid her way through school. "A company in San Jose that wrote out menus by hand for restaurants hired me to work freelance," she said. "One of my teachers at San Jose State happened to see my work and hired me to do some lettering. A number of the teachers there had their own graphic arts companies, and they hired me, too. Without ever advertising, my name had gotten around to the point that I was working full-time."

Deaver's specialty became calligraphy and illustration, designing restaurant logos and menus, wine labels, book titles, wedding invitations, and greeting cards: "I found there was a call for lettering—something with a hand feel to it, in between fine arts and graphic arts—and people were willing to pay for it."

One of the likeliest sources of information on calligraphers—who offers workshops, who is hiring them, where there are groups of them, who is doing what type of work—is the quarterly *Letter Arts Review* (212 Hillsboro Drive, Silver Spring, MD 20902, (336) 272-6193 or 800-348-7367, $42 per year, $12.50 for a single issue). Relevant associations of calligraphers include the American Institute of Graphic Arts (164 Fifth

Avenue, New York, NY 10010, 212-807-1990), Atypi (Parkstraat 29, 2514 JD, The Hague, The Netherlands, 011-31-70-365-7850), Type Directors Club (60 East 42nd Street, New York, NY 10165, 212-983-6042) and International Council of Graphic Design Associations (P.O. Box 398, London W11 4UH, England, 011-44-171-603-8494). Karyn Lynn Gilman, editor of *Letter Arts Review,* noted that hand-lettered wedding invitations and place cards are "bread-and-butter jobs. You know how many you can do in an hour and charge accordingly." Ness, for example, has prices for four categories of wedding invitations, each of which contains a water-color painting on the cards: an unfolded card that goes right into the envelope ($185 for the first 50), for a card with two languages ($250), for a card that is folded in half ($250) and for a folded card with two lan-guages ($295).

Seeking higher-level assignments, calligraphers send brochures or portfolios to design and advertising agencies as well as "network through typographers' groups, such as the American Institute of Graphic Artists," Gilman noted. John Stevens, a self-taught lettering artist in Winston-Salem, North Carolina, developed a client base by making "appointments with art directors in publishing, and just knocking on a lot of doors." As his portfolio grew, he began to rely on mailers to art, design, and creative directors, later advertising in *Showcase* and developing a site on the World Wide Web ("Most of the hits I'm getting are small jobs, a title for a book or a magazine artist," he noted, "sometimes, they're just referen-cing my portfolio"). Stevens and others have found that advances in digital technology have cut into some of the bread-and-butter hand-lettering jobs, requiring him to "maintain a steady stream of mailers to people I want to keep working for. In general, you have to hustle all the time. We're a nation of impulse buyers: something interesting comes across your desk and you want to do it, so I make sure my work is on their desks."

Combat Art

A number of very practical reasons led William Phillips, an artist in Ashland, Oregon, to contribute paintings to the U.S. Air Force's art collection. The Air Force permits selected artists to visit its bases and climb into its aircraft as part of research for the art they will donate to the military, and Phillips' specialty is aviation art. Many of his paintings are reproduced as print editions by Greenwich Workshop. Beyond the oppor-tunity to learn more about airplanes, he has gained customers, since some

of the members of Air Force squadrons he has met have bought his originals.

Moving beyond the practical, however, Phillips lights up when he talks about visiting an Air Force base, especially when describing taking a ride in a fighter jet: "Every time you get into a high-performance aircraft, you face danger. For the pilots, it's all pretty routine, but the maneuvers they go through as they practice dog fights and avoiding surface-to-air missiles really pick the adrenaline level up. It's not like sitting in my studio. And, when you put on that flight suit"

The Air Force has a collection of more than 8,800 artworks—mostly sketches and paintings—that pictorially tells its story. These works have been donated by civilian artists who, just like Phillips, have been allowed to spend a week or two on a military base or in the field of battle, meeting the servicemen and women, learning about what they do and how they live, as well as seeing the aircraft they fly.

Each of the five branches of the armed forces (Air Force, Army, Coast Guard, Marine Corps, and Navy) has an art collection, continually added to by art programs (which are not well publicized) that similarly bring civilian artists into the action. The Navy's collection is currently the largest, with approximately 17,000 works, followed by the Army's 15,000; the Marines have 8,000 artworks and the Coast Guard 5,000. A large percentage of the Army's and Navy's art consists of combat art, created during wartime by enlisted soldiers, but the rest was donated. All five services maintain an active exhibition schedule for their art collections, arranging for shows of various pieces at large and small museums around the country.

A strong mix of reasons lead artists to donate their time, energy, and artwork to one or another branch of the military. Money tends not to be a major incentive: The military doesn't commission artists or pay them for their work, only offering them round-trip transportation, officers' quarters, and food (artists receive a temporary rank as captain or colonel or major, depending upon the particular service—"I couldn't give orders to anybody, but I could get first in line at mess time," said Charles Waterhouse, a civilian combat artist for the Marine Corps in Lakewood, New Jersey).

In addition to donating the original paintings to the U.S. government, artists must transfer copyright as well. The reason is that the military is asked periodically to provide images from its art collections to publishers and television stations and wants a free hand to do so without seeking permission from the artists. Retaining ownership of the copyright would not likely benefit the artists anyway, since there is not much of a civilian

market for scenes of military life and combat. Karen Loew, a New York City artist who has painted works for the Coast Guard, noted that this subject matter is "most attractive to people who've been in the service or served on the ship you've painted or who have been where you've been." However, members of the armed forces are not high on the pay scale, and their ability to support an artist who sought to specialize in military scenes is not great. "I don't think anyone could paint Coast Guard scenes full-time," she added.

Certainly, there is a market for aviation art and battlefield art, and some of the collectors of this genre are well aware of who has donated works to the military art programs. Harley Copic, a full-time graphic designer for the *Toledo Blade* newspaper in Ohio and part-time painter, stated that he has received "quite handsome" prices for his paintings of military life from aviation art collectors, who sometimes first saw his work in exhibits at the Smithsonian Institution's Air and Space Museum. Since the early 1970s, Copic has donated nineteen artworks to the Air Force. Most art buyers in this realm, however, gravitate toward historical imagery, such as aircraft of World War I and II and Civil War battles. There may not be as much allure or humanity in present-day "smart bombs" and global positioning systems for them.

On the other hand, the career of Rick Herter, an advertising illustrator in Kalamazoo, Michigan, has decidedly benefited from his volunteering for the Air Force, since a number of his clients are in the aerospace industry, such as Boeing, Pratt & Whitney, and Rolls Royce. Herter's visits to Air Force bases are a form of research "and build credibility for my corporate work," he said. "I sometimes know more about how tactics, engines, and how the planes are used by the military than my clients do." Boeing also commissioned him to create a series of paintings of its Apache helicopters, which were then given by the Seattle-based company to the defense ministries of some of the nations to which Boeing sold the aircraft (Egypt, Israel, Kuwait, the Netherlands, and Singapore)—"a high-end gift of appreciation," Herter said.

For some artists, a sense of paying a debt of gratitude to the United States impels them to donate their time and artwork to the military. Karen Loew's father had served in the Navy during World War II, "and I believe he smiles down from heaven on his daughter sailing with the Coasties." Other artists noted the attractiveness of having their work in the permanent collection of the United States as an incentive ("I will be gone, but my paintings will be around to tell the story of the Air Force for hundreds of years," Herter said), but almost all spoke of the adventure

of temporarily joining the military. The small cots, cramped cockpits, military food, and efforts to overcome seasickness might be wearying over the long run, but the abbreviated term of civilian artists drapes it all in adventure.

"Vietnam was on everyone's mind—there was a lot of controversy about it," said Howard Terpning, a painter in Tucson, Arizona, who had served in the Marine Corps during World War II but came back to the service as a civilian combat artist for six weeks between 1967 and 1968. "It was an opportunity to see first-hand what was going on. I was able to experience one of life's adventures that most other people wouldn't be able to experience." While traveling with various regiments around South Vietnam, "Major" Terpning took a number of photographs ("There was no way I could do any sketching") of scenes of combat that formed the basis of six paintings he completed back at his studio at home and that were donated to the Marine Corps.

Artists brought in for short stints in the military are not told what or how to paint; they are not asked to be propagandists for the military or a war effort, and some of the artworks submitted focus on quite nonheroic scenes, including bored soldiers drifting off to sleep and medics tending to the wounded. The artwork that the military accepts into its collections is expected to be appropriate and useful in telling the story of the particular branch of the armed forces; that is, the picture reflects something actually done by that military service. Accuracy is certainly important, since these images are used to present an historical record. "I was given complete freedom," Charles Waterhouse said. "Of course, I had to make sure it's the right color coat, but I didn't have to count the number of buttons." John Dyer, curator of art at the U.S. Marine Corps Museum, noted, "We don't tell artists to include more marines in their paintings. Our only guideline is, Don't draw anything you haven't experienced yourself." Another recommendation is that artists not paint formal portraits but scenes of military life. An implicit (but not iron-bound) requirement is that the finished artwork be submitted to the service within two to eight weeks of returning to civilian life—"we want to put out the work while the news is still hot, so to speak," Dyer said.

Although they may be called combat artists, it is extremely rare that a civilian artist is ever placed in harm's way. The Air Force artists who were sent to the Persian Gulf as part of Operation Iraqi Freedom, for instance, "were stationed primarily at bases in Kuwait," said Rusty Kirk, curator of the Air Force's art program. "They may fly on a support or resupply mission, but not a combat mission." The only known fatality of a civilian

combat artist in a theater of war was McClelland Barclay (1891–1943), whose Navy transport ship was hit by a torpedo en route to paint a naval officer's portrait during World War II.

All five services have budgets for their art programs, not to pay for the art they acquire (although the Coast Guard offers a small honorarium) but to cover the transportation and incidental expenses of the artists they bring in. The programs are also ongoing, only limited from one year to the next by their budgets. "You don't need a war to hire an artist," Gale Munru, head curator of the Navy's art collection, said. "There are plenty of peacetime assignments, such as a fleet exercise or the celebration of an anniversary." She noted that her program receives many inquiries from artists, but "we're very selective and like to use the same artists we've used before. They have a track record. We know how they work, and they know how we work. It helps that they know how to fit in with the military system." Having served in the military tends also to give artists a leg up in the selection process, because they presumably understand how the system works. Still, new artists are regularly accepted into these programs, after having submitted their portfolios and being approved by a selection committee.

Artists looking to participate in a military art program, or just to donate a completed work to an armed services art collection, may contact the various branches directly:

Air Force Art Program Office (AFAPO)
1720 Air Force Pentagon
Washington, D.C. 20330
(703) 697-6629
www.afapo.hq.af.mil

U.S. Army Center of Military History
Attention: DAMH-MDC, Renee Klish, art curator
103 Third Avenue, Building 35
Ft. McNair,
D.C. 20319-5058
(202) 761-5396
www.army.mil/cmh-pg/

Coast Guard Art Program (COGAP)
Attention: Angela McArdle,
Community Relations Branch
Commandant G-IPA-3
2100 Second Street, S.W.
Washington, D.C. 20593
(202) 267-0933
www.uscg.mil/hq/g-cp/comrel/art-work/artist.html

U.S. Marine Corps Museum
Attention: John Dyer, curator of art
2014 Anderson Avenue
Quantico, VA 22134-5002
(202) 433-2820
http://hqinet001.hqmc.usmc.mil/HD/Historical/Art_Collection.htm

Navy Art Collection
805 Kidder Breese Street, S.E.
Washington Navy Yard

Washington, D.C. 20374-5060
(202) 433-3815
www.history.navy.mil

 Some membership organizations of artists assist the military in the process of building their collections and finding suitable combat artists. The Salmagundi Club (47 Fifth Avenue, New York, NY 10003, 212-255-7740) is the principal sponsor of the Coast Guard Art Program, having established the collection in the early 1980s. One need not be a member of the Salmagundi Club to participate in the art program. Much of the collection of the Air Force is attributable to the work of the New York City–based Society of Illustrators (128 East 63rd Street, New York, NY 10021, 212-838-2560, 800-746-8738, *www.societyillustrators.org*), the Society of Illustrators of Los Angeles (P.O. Box 3661, Glendale, CA 91221–0601, 818-551-1760, *www.si-la.org*), San Francisco Society of Illustrators (493 8th Avenue, San Francisco, CA 94118, 415-221-6840, *www.sfsi-art.com*), Midwest Air Force Artists and Southwest Air Force Artists, all of which have located member artists to donate their time and work. Contact information for these last two groups is available through Air Force Art Program Office, although artists wishing to take part in the Air Force program who are not members of these groups may submit portfolios of their work to the Air Force directly.

 In summary, with any type of bill-paying second career that artists may choose, there may be a conflict between how artists are seen by the larger public and how they see themselves. Carpenters who are really printmakers, textile designers who are in truth painters, toy-model makers whose sculpture few have ever seen—there are thousands of artists who psychologically identify themselves as artists and become quite defensive when asked about what they actually do for a living. Finding a way to answer the basic introductory question, "What do you do?" in an unselfconscious, nonargumentative way is a key element in the maturation process of artists. To say, "I am an artist," may lead to the question of the type of art one creates, but it also may strike some people as pompous, as "artist" is a highly value-laden term in our society. It is probably wiser to say specifically, "I am a painter or sculptor or mixed-media artist," or something that invites further inquiry. That is especially important if the person to whom one is speaking may turn into a

potential collector. To others who may be possible employers or job contacts, it may be wiser for artists to simply introduce themselves in terms of their jobs. At other times, one may prefer to say, "I'm a painter, and I'm working at the museum of art right now," which acknowledges the economic truth that painting doesn't provide an income at present but it is one's intention that it will someday.

Art-Related Employment Requiring Additional Study

THE PROBLEM WITH HAVING MORE THAN ONE INTEREST OR APTITUDE is the necessity of making a choice in terms of developing a career. The novelist Walker Percy applied his interest to becoming a doctor, later pursuing his literary endeavors, while sculptors Herbert Ferber and Seymour Lipton were full-time practicing dentists before making sculpture their life's work. When a choice must be made, the arts are likely to lose because there is less money and security in this field. It is rare that those with a creative aptitude actively maintain artistic interests over the years and even more rare that the art will eventually become the main career as happened with Percy, Ferber, and Lipton. At times, however, different interests may be combined to form a viable cross-disciplinary art career. In the sciences, there is medical illustration and art conservation.

Medical Illustration

Some artist-scientists go back and forth in their interests over the course of a lifetime. Painter John Cody had a double major—art and zoology—when he graduated from Johns Hopkins University in 1949, which he described as a "terrible time for someone like me to be studying art. Everyone wanted to teach me to be an abstract expressionist. What I really wanted to do when I graduated was to paint moths." Not a fit subject for a budding Willem de Kooning, but Cody was hired by the ornithologist William Beebe to be the staff artist on a six-month expedition to Trinidad in order to study the wildlife. (Cody had originally written Beebe to solicit a recommendation for a Guggenheim Fellowship he was seeking to paint a certain moth species— he did not get the fellowship, but Beebe was sufficiently impressed by the sample artwork to hire him.) After that, Cody worked for five years as a medical illustrator at the University of Arkansas Medical School before deciding to become a doctor himself. In 1986, Dr. Cody retired to paint moths and other subjects.

Medical illustration is not solely the domain of two-dimensional artists, nor are all practitioners medical personnel. Jim Jackson, who studied sculpture at Pratt Institute, earning a BFA in 1968, worked at various art-related jobs (in museum education departments and as a public school teacher, among others). In the midst of them, he began to perform volunteer work as a telephone counselor for sexuality questions. As part of his training, he took a course. "The nurse who was running the program couldn't find models of sexual anatomy, and I said I would make some," Jackson said. "I designed and made them in my studio. The nurse used the models to describe exercises used in sex therapy and birth control." In time, he began to produce a line of these sex organ models (cross-section and cutaway types), which he sold to publishers, medical schools and other buyers for $100–$500 per model, and this became his livelihood.

Few medical illustrators born before 1960 entered the arts with this particular field in mind. "I never knew the field existed," said Timothy Phelps, who received his BFA in 1975 from Wittenberg College in Springfield, Ohio, and currently teaches medical illustration at Johns Hopkins School of Medicine. Sharon Weilbacher, a painter in New Orleans, who received her BFA in 1960 from the University of Colorado, "graduated thinking, 'Well, what could I do with art?'" Weilbacher's mother had an answer, since a college roommate of hers had become a medical illustrator. "I always liked science," Sharon Weilbacher said, "and I thought, 'Gee, that sounds interesting.'" She eventually illustrated medical texts at the medical school of Tulane University.

Nowadays, medical illustration is a better-recognized field, for which a number of schools in North America have established specific training in bachelor's, master's, and certificate programs.

Graduate Program in Medical Illustration
School of Graduate Studies
The Medical College of Georgia
Augusta, GA 30912-0300
(706) 721-3266
www.mcg.edu/medart
Two-year MS program.

Department of Biomedical Visualization
College of Associated Health Professions
University of Illinois at Chicago
1919 West Taylor Street
Room 213
Chicago, IL 60612
(312) 996-7337
www.uic.edu/ahs/sbhis/bvis/index.htm
Two-year MA-MS program.

Department of Art as Applied to Medicine
The Johns Hopkins School of Medicine
1830 East Monument Street
Suite 7000
Baltimore, MD 21205-2100
(410) 955-1085
www.hopkinsmedicine.org/medart
Two-year MA program.

MFA Program in Medical and Biological Illustration
School of Art and Design
The University of Michigan
2000 Bonisteel Boulevard

Room 1075
Ann Arbor, MI 48109-2069
(313) 747-1669
www.art-design.umich.edu
Five-semester MFA program.

Biomedical Communication Graduate Program
Department of Biomedical Communications
The University of Texas Southwestern Medical Center at Dallas
Graduate Program/Exchange Park
5323 Hines Boulevard
Dallas, TX 75235-8881
(214) 648-4699
www.swmed.edu/medillus
Two-year MA program.

University of Toronto Division of Biomedical Communications
Department of Surgery
Faculty of Medicine
Medical Sciences Building
Room 2356
One King's College Circle
Toronto, Ontario M5S 1A8
Canada
(416) 978-2659
www.bmc.med.toronto.ca/BMC
Two-year MScBMC program.

Cleveland Institute of Art
11141 East Boulevard
Cleveland, OH 44106

(216) 421-7422
www.cia.edu
MFA program with a major in
medical illustration.

McDaniel College
2 College Hill
Westminster, MD 21157-4390
(410) 848-7000 or (410) 857-2595
www.wmdc.edu/academic/art/
medillus.shtml
MFA program in medical illustration.

Rochester Institute of Technology
School of Art and Design/School for
American Crafts
73 Lomb Memorial Drive
Rochester, NY 14623-5603
(716) 475-2646
www.rit.edu
BFA program with a major in
medical illustration.

Other college and university art departments and art schools have also increased their offerings in anatomy, which help prepare students who may go on to a medical illustration specialty. Artists otherwise need an extensive science background, including general biology or zoology, vertebrate and comparative anatomy, embryology, physiology, chemistry, and histology—in effect, premed training, which was part of the reason that John Cody decided to attend medical school.

In order to prepare himself for the University of Michigan's MFA program in medical and biological illustration, Phelps returned to Wittenberg for a year and also attended Earlham College for another year to study a broad spectrum of sciences. Most students in these master's-level programs have either a fine arts major with a science minor or a science major with a fine arts minor. A portfolio review is part of the admissions process, and these programs offer both art and theory courses (design and color theory, computer graphics and multimedia, photography, media production, three-dimensional models, surgical illustration, illustration techniques, anatomical and histological drawing, management and business practices) as well as medical science classes (gross, neuro- and microanatomy, pathology, human physiology, and embryology).

The number of graduates from these programs is limited, and most of them are hired for full-time positions right out of school by other medical schools, hospitals, dental schools, schools of veterinary medicine, clinics, and medical publishers. Salaries range from $35,000 to $75,000 per year. Other medical illustrators, looking for full-time or freelance work, find employment through the Association of Medical Illustrators (1819 Peachtree Street, N.E., Atlanta, GA 30309, 404-350-7900, *www.medical-illustrators.org*), which lists jobs in its newsletter and through its job hotline. The association's directory (*The Medical Illustration Sourcebook*),

in which members may buy space, is distributed to seven thousand advertising agencies, book publishers, medical schools, museums, physicians, and zoos through North America (a black-and-white advertisement costs $950, color costs $1,200), and individual illustrators may attach their own portfolio page to the association's Web site. Nonmembers may also receive some of the same services, but at nonmember rates ($10 per month for use of the hotline instead of as a free benefit, for instance). Membership costs $50 per year for students, $160 for associate members and $180 for professional members; certification, which some employers may require, costs an additional $100. Certification involves oral and written tests as well as a portfolio review.

Freelance medical illustrators may choose to place ads in the *Sourcebook* or the *Black Book* (see "Directories" in chapter 9) or create brochures that show their specialties—cardiac or ophthalmology, for instance. They could mail to many of the same agencies, doctors, publishers, schools, museums, and zoos to which the *Sourcebook* is sent. For his freelance work, Phelps charges $65 per hour (the same rate that Johns Hopkins University School of Medicine charges publishers and others who come to the department of art for medical illustrations).

Scientific Illustration

Medical illustration is but one facet of the world of natural-science illustration. Artists frequently are used by science and nature magazines, textbook publishers, museums, pesticide companies, zoos, universities, and various other businesses and employers to create accurate images of living creatures and scientific specimens. Paleontologists, for instance, hire two- and three-dimensional artists to show what a dinosaur might have looked like—images that a camera could not capture. In other cases, artists may be used in place of photography for tasks such as depicting insects, flowers or wild flowers because of their ability to isolate objects or reveal an underlying structure.

"I use photographs. For a picture of a crayfish, I had five photographs taken with five different light sources," said Carolyn Gast, a biological illustrator in Arlington, Virginia. "With all the photographs, I can see all the details and put them in one drawing. No photograph can focus on every area, but a drawing can."

Gast drew images of insects, large and small animals, and fish for several decades at the Smithsonian Institution in Washington, D.C., the leading taxonomic institution in the world. She had studied art at Boston University but went to work for the federal government in this most exacting area of

the arts. "A bad drawing can confuse generations of scientists," she said. "It's my job to do a highly accurate, meticulous rendering."

This is a very research-oriented art field. Gast noted that she frequently made her sketches while looking into a microscope, and Doug Allen, a wildlife artist in Neshanic Station, New Jersey, goes out into the woods and prairies to make pencil and oil sketches, as well as take photographs of the animals whose images he renders. "It's hard to get animals to pose," he said. "You have to spend time with them where they are and get to know them."

This kind of art is not for every artist, as it requires intense discipline and allows a minimum of self-expression. In some instances, artists have scientists as supervisors; most of the time, their work is judged solely on the basis of accuracy. In this realm alone can one be deemed "wrong."

"You have to train yourself to think with your eye instead of your brain," Elaine Hodges, a biological illustrator in Eugene, Oregon, said. "With butterflies, for instance, a lot of artists think the wings are shaped a certain way when they're not. You can't have any preconceived notions." Neither Hodges, who studied at Pratt Institute in Brooklyn and worked as a (human) portraitist, nor Gast had any formal scientific training—and none is universally required by the companies, publishers, and institutions that hire artists full-time or as freelancers to create scientific illustrations. However, employers increasingly look for artists with experience in this field, and a growing number of artists have pursued certificate and degree programs to gain background and specific skills. Among these programs are:

Arizona
The Scottsdale Artist's School
3720 North Marshall Way
Scottsdale, AZ 85251
(602) 990-1422
(800) 333-5705
www.scottsdaleartschool.org
One-week workshops.

California
California Academy of Sciences
Adult Education
Golden Gate Park
San Francisco, CA 94118
(415) 750-7100
www.calacademy.org
Nondegree courses.

University of California
Science Illustration
Science Communication
Program
San Cruz, CA 95064
(408) 459-4475
http://scicom.uscs.edu/illus/
default.html
Year-long graduate certificate
program.

Yosemite Association
P.O. Box 230
El Portal, CA 95318
(209) 379-232
www.yosemite.org
Three-day seminars.

District of Columbia
Guild of Natural Science Illustrators
P.O. Box 652
Ben Franklin Station
Washington, D.C. 20044
(301) 309-1514
www.gnsi.org
Spring, summer, and fall workshops.

Smithsonian Institution
National Museum of Natural History
Office of Education
Intern Program
Washington, D.C. 20560
(207) 357-3045
www.mnh.si.edu/edu_resources.html
Internships.

Georgia
Medical College of Georgia
Medical Illustration Graduate Program
Augusta, GA 30912-0300
(706) 721-3266
www.mcg.edu/SAH/Medill
Two-year MS degree in medical illustration.

University of Georgia
Interdisciplinary Studies Program
Dean's Office, Arts and Sciences
Athens, GA 30602
(706) 542-0012
www.franklin.uga.edu
BFA in scientific illustration.

Illinois
Northern Illinois University
DeKalb, IL 60115-2857

(815) 753-0446
www.niu.edu
Scientific illustration emphasis within a BFA program.

University of Illinois at Chicago
Graduate Program in Biomedical Visualization
School of Biomedical and Health Information Sciences
College of Associated Health Professions
1919 West Taylor
Chicago, IL 60612-7249
(312) 996-7337
www.uic.edu/ahs/sbhis/bvis
Two-year master of association medical sciences degree program.

Iowa
Iowa State University
Biological/Premedical Illustration Program
201 Bessey Hall
Ames, IA 50011-1020
(515) 294-1064
www.bpmi.iastate.edu
BA in biological/premedical illustration.

Maine
Humboldt Field Research Institute
Eagle Hill Field Seminars
Dyer Bay Road
P.O. Box 9
Steuben, ME 04680-0009
(207) 546-2821
www.eaglhill.us
Week-long training seminars.

Maryland
Johns Hopkins School of Medicine
Department of Art as Applied
to Medicine
1830 East Monument Street
Suite 7000
Baltimore, MD 21205
(301) 955-3213
www.jhu.edu/medart
Master's degree in medical
and biological illustration.

Michigan
University of Michigan
School of Art and Design
MFA Program in Medical and
Biological Illustration
2000 Bonisteel Avenue
Ann Arbor, MI 48109-2069
(313) 647-1669
www.umich.edu/~medill/
MFA in medical and biological
illustration.

Nebraska
University of Nebraska
Lincoln, NE 68588
(402) 472-7211
www.unl.edu
Three-credit course in scientific
illustration.

New Jersey
Fairleigh Dickinson University
Maxwell Becton College of
Liberal Arts
Department of Fine Arts
Montoss Avenue
Rutherford, NJ 07070
(201) 460-5215/5213
www.fdu.edu

BA with secondary area of concen-
tration in biological illustration.

New York
Cornell University
Cornell Plantations
Education Program
One Plantations Road
Ithaca, NY 14850-2799
(607) 255-3020
www.plantations.cornell.edu
Nondegree adult education courses
in botanical illustration.

Cornell University
School of Continuing Education
B 20 Day Hall
Ithaca, NY 14853-2801
(607) 255-4987
www.sce.cornell.edu
Six-week courses in natural-science
illustration.

Cornell University
Shoals Marine Laboratory
G-14-J Stimson Hall
Ithaca, NY 14853
(607) 255-3717
www.sml.cornell.edu
Two-credit courses in biological
illustration.

New York Botanical Garden
Continuing Education
200th Street and Southern Boulevard
Bronx, NY 10458-5126
(718) 817-8747
(800) 322-6924
www.nybg.org/edu/conted
Certificate program in botanical
illustration.

Pennsylvania
Beaver College
Department of Fine Arts
450 South Easton Road
Glenside, PA 19038
(215) 572-2900
www.upenn.edu/gsfa
BA in scientific illustration.

Rhode Island
Rhode Island School of Design
Continuing Education
Two College Street
Providence, RI 20903-2787
(401) 454-6200
www.risd.edu/conted.cfm
Certificate program in natural-
science illustration.

Texas
Pan American University
Art Department
Edinburg, TX 78539
(512) 381-3480
www.panam.edu
BFA in biological illustration,
with minor in biology.

University of Texas
Southwestern Medical Center
Department of Biomedical
Communications
5323 Harry Hines Boulevard
Dallas, TX 75235
(214) 648-4699
www.swmed.edu/medillus/
program1.htm
MA in biomedical communications.

Utah
Four Corners School of Outdoor
Education

P.O. Box 1029
Monticello, UT 84535
(801) 587-2156
(800) 525-4456
www.fourcornersschool.org
Four- and ten-day educational field
programs.

Washington
University of Washington—
Extension
Certificate Program in Scientific
Illustration
5001 25th Avenue, N.E.
Seattle, WA 98105-4190
(206) 543-2320
(800) 543-232
www.outreach.washington.edu/ext/
certificates/sci/sci_brd.asp
Nine-month noncredit
program.

Canada
University of Toronto
Faculty of Medicine
Division of Biomedical
Communications
Department of Surgery
Room 2356, Medical Sciences
Building
One King's College Circle
Toronto, Ontario M5S 1A8
Canada
(416) 978-2659
http://www.bmc.med.utoronto.ca/
BMC/
Two-year MScBMC program.

England
Old Manor House Studio
The Old Manor House
Market Overton

Oakham, LE 157PW
England
011-01-572-767-270
Courses in botanical painting.

University of Sheffield
Division of Adult Continuing
Education

196-198, West Street
Sheffield, S10 4ET
England
011-01-14-222-7000
www.shef.ac.uk
Two-year certificate program in
botanical illustration.

Some biological illustrators specialize in particular areas—invertebrates or ornithology, for instance—while most are generalists. Allen largely concentrated on bears, bison, elk, and moose, although he has been called to render some species of wildlife exclusive to Africa. "No one is going to pay me to go to Africa to track down some rare animal, and publishers generally don't give that many days to finish the work," he said. As a result, Allen has created his own personal research library, collecting photographs of, and articles about, wildlife all over the world, and he also looks up various species at New York City's Museum of Natural History. "Sometimes, I just can't find any photographs to go on, but I can discover when animals are in the same family as others. They're often close in anatomy."

There are many ways in which scientific illustrators find employment. One method is submitting a portfolio to the art directors of magazines and book publishers of scientific and wildlife topics. Natural history museums and science departments within universities also use illustrators for their displays and texts. Taking a portfolio to individual scientists is a viable route, as textbook writers frequently make arrangements for specific illustrators with their publishers. Needing to publish or perish, academicians generate a significant quantity of illustration opportunities. Where biological illustration specifically differs from medical illustration is in the payment; "scientists don't make as much money as doctors," Hodges said. Compensation is generally in the $25-per-hour range.

Organizations of artists working in these fields also offer opportunities to learn of jobs and to showcase members' work. Among the main associations are the Guild of Natural Science Illustrators (P.O. Box 652, Ben Franklin Station, Washington, D.C. 20044, 301-309-1514, *www.gnsi.org*), American Society of Botanical Artists (P.O. Box 943, Wading River, NY 11792, 516-429-6428), Society of Animal Artists (47 Fifth Avenue, New York, NY 10003, 212-741-2779), and the Wildlife Artist Association (5042 Casitas Pass Road, Ventura, CA 93001, 805-649-3914). They all stage juried

exhibitions, usually held at natural history museums, which enable prospective employers to see work in this field. The Guild of Natural Science Illustrators also publishes a directory, *Creative Source Directory,* in which artists may buy advertising space to display their work to employers.

Art Conservation

While medical illustration provides art for scientists, art conservation enlists science in the service of art. Conservators stabilize objects, counteracting chemical and physical deterioration, and work either privately or in institutions (historical societies, libraries, museums) that have collections of paintings, works on paper, textiles, sculpture, furniture, rare books, archaeological or ethnographic materials. In most cases, conservators specialize in one area. Roy Perkinson, for instance, whose artwork is painting, became a conservator of works on paper at the Boston Museum of Fine Arts because the man who taught him was a paper conservator at the museum. "My introduction to art conservation was through him," he said.

Perkinson fell into conservation while pursuing other avenues in the art world. While in the process of earning a master's degree in art history at Boston University, he became "fascinated with how certain pieces in the Boston Museum of Fine Arts' collection were made—Degas's monotypes in particular. I was interested in the methods, effects, and materials, and I asked the paper conservator, F. W. Dolloff, about these Degas." The conversations lasted for a period of time and, when Perkinson received his degree, Dolloff offered him a job as his assistant. In addition to on-the-job training, Perkinson also took courses at the Winterthur Museum in Wilmington, Delaware, the Buffalo Art Conservation Program at the State University of New York and the Institute of Fine Arts of New York University.

Sandy Webber, a paintings conservator at the Williamstown Regional Conservation Center in Massachusetts, drifted into this field after receiving her BFA from the Massachusetts College of Art and working for an antiques dealer. She began learning this business—how to run a show, where to attend auctions and other sales events—but also developed an interest in repairing the pieces that were in bad shape. "One of the people I was working with said, 'Why don't you look into art conservation?' and a light went on in my head," Webber said. She returned to school to study chemistry in order to apply to a three-year internship program in art conservation at the Fogg Art Museum at Harvard University.

Another whose conservation career was not part of the original plan is Ross Merrill, paintings conservator at the National Gallery of the Smithsonian Institution in Washington, D.C. "My childhood ambition was to paint, but I never had an idea how to earn a living," he said. "I assumed that, if you paint well, the world will beat a path to your door." He took museum jobs in his native Texas, first as a registrar at the Fort Worth Museum of Modern Art and then at the Kimbell Art Museum, where he worked as a preparator, inventorying the collection. "Once the paintings in the collection had been inventoried," he said, "they had to be taken out of the frames, photographed, and put back into frames. The problem was, a lot of the paintings had not been properly framed in the first place: there was no matting, the backing was flaking off, the frames themselves were falling apart. The museum director was aware that I was a painter and made my own frames, so he let me make and repair the frames for these paintings." At the time, the Kimbell was discovering that many works in its collection were over-attributed and "not of first-rate quality. They wouldn't be hung in a good museum, anyway. There was only one art restorer at the time in all of Texas and no frame restorers. The works would have to be sent to New York for repair, and the paintings weren't worth spending that kind of money on."

As Merrill began to sideline in frame repair, he was also asked to do restoration work on canvases themselves. "Someone who knew I painted and fixed frames and worked for the museum asked me to fix a painting with a hole in it," he said. There was almost no competition in all of Texas, and so more freelance repair and conservation jobs came his way (from insurance companies, collectors, dealers, and even the Amon Carter Museum in Fort Worth), including one to restore a picture in the Kimbell's collection itself. Eventually, Merrill decided that he enjoyed conservation work but "that if I was going to devote my limited time to this, I should really learn what I'm doing." He undertook a three-year program of conservation training at Oberlin College, and a new career was born.

There are a number of schools offering undergraduate and (mostly) graduate programs in art conservation. Most of the graduate programs require applicants to have a background in studio art, science (chemistry, especially), and art history; foreign language skills are helpful, too, when researching works produced in other countries. The University of Delaware offers a bachelor of arts degree in an interdepartmental program of art history, studio art, and chemistry that is geared to the graduate program at the nearby Winterthur Museum. Studio skills are not neglected; all three are equally important. "You need exceptionally good manual skills and a good ability at matching colors," Sandy Webber said. "If you're not adept at that, it doesn't

really matter what else you can do." These graduate programs also favor students who have some experience in the field, such as working for a private conservator or in a museum or regional conservation center. The Williamstown Regional Conservation Center, for instance, has a year-long pre-program internship in which students are given a modest stipend and the opportunity to gain experience in the field of art conservation. Only students planning on a career in conservation are admitted to a preprogram internship.

The schools in North America offering art conservation programs are the following:

California
Getty Conservation Institute
1200 Getty Center Drive
Suite 700
Los Angeles, CA 90049-1684
(310) 440-7325
www.getty.edu
Courses in art conservation.

Colorado
Rocky Mountain Conservation Center
University of Denver
2420 South University Boulevard
Denver, CO 80208
(303) 733-2712
www.du.edu/rmcc
Courses in art conservation.

Delaware
University of Delaware and Henry Francis du Pont Winterthur Museum Art Conservation Program
303 Old College
Newark, DE 19716
(302) 831-2479
http://seurat.art.udel.edu/artcons
Graduate degree program.

District of Columbia
Smithsonian Institution

Conservation Analytical
Laboratory
Training Program
Washington, D.C. 20560
(301) 238-3700
www.si.edu/scmre
Internships, courses, graduate and postgraduate programs in art conservation.

Illinois
Campbell Center for Historic Preservation Studies
203 Seminary Street
Mt. Carroll, IL 61053
(815) 244-1173
www.campbellcenter.org
Courses and workshops in art conservation.

Maryland
Johns Hopkins University
Department of Materials Science and Engineering
Maryland Hall, Room 102
Baltimore, MD 21218
(410) 516-8165
www.pha.jhu.edu/groups/mrsec
Doctoral program in conservation science.

Massachusetts
Harvard University Art Museums
Strauss Center for Conservation
32 Quincy Street
Cambridge, MA 02138
(617) 495-2392
www.artmuseums.harvard.edu/strauss
Graduate and postgraduate
internships.

New York
Columbia University
Graduate School of Architecture,
Planning and Preservation
400 Avery Hall
New York, NY 10027
(212) 854-3518
www.arch.columbia.edu
Graduate program.

New York University
Institute of Fine Arts Conservation
Center
14 East 78th Street
New York, NY 10021
(212) 772-5800
www.nyu.edu/gsas/dept/fineart
Graduate program.

State University College
at Buffalo
Art Conservation Department
230 Rockwell Hall
1300 Elmwood Avenue
Buffalo, NY 14222
(716) 878-5025
*www.buffalostate.edu/depts/
artconservation*
Graduate program.

Pennsylvania
University of Pennsylvania

Graduate Program in Historic
Preservation
Architectural Conservation
Laboratory
115 Meyerson Hall
Philadelphia, PA 19104-6311
(215) 898-3169
www.upenn.edu/gsfa/hspv
Graduate program.

Texas
University of Texas at Austin
Graduate School of Library and
Information Science
Preservation and Conservation
Studies
SZB 564
Austin, TX 78712-1276
(512) 471-8290
*http://sentra.ischool.utexas.edu/
programs/pcs*
Graduate program in the conser-
vation of books and archival material.

Canada
Canada Conservation Institute
Training and Information Division
Department of Communications
1030 Innes Road
Ottawa, Ontario K1A 0C8
Canada
(613) 998-3721
www.cci-icc.gc.ca
Graduate and postgraduate programs.

Queens University
Art Conservation Programme
Kingston, Ontario K7L 3N6
Canada
(613) 545-2156
www.queens.ca
Courses and workshops.

Conservation, as any other type of art-related employment, may be beneficial or detrimental to one's art-making. Webber noted the positive influence of seeing up close how artists achieved certain effects. "I cleaned a painting that had been done in gouache on canvas," she said. "I was fascinated by the matte paint on the canvas, how it gave a very soft focus to the image, and I used that on a series of acrylics on canvas I made." On the other hand, her co-worker at Williamstown, Tom Branchick, another paintings conservator, who had received a BFA from Cranbrook Academy before pursuing a graduate program in conservation, noted, "Conservation and painting didn't complement each other. I gave up the painting." Both Perkinson and Merrill stated that being surrounded by important, famous works of art was "overwhelming," and Perkinson viewed conservation as "a reason for artistic paralysis. You think, 'What else could possibly be done?' It takes a while to get beyond that, to make peace with these great works in my mind." Mark Bockrath, a paintings conservator and art instructor at the Pennsylvania Academy of Art in Philadelphia, said, "I try not to look too closely at other artists' pastels when I'm doing pastels," but it is difficult for him to do his job well if he doesn't look closely at the art. "It's just hard for me to do my own work without thinking about other artists." On the upside, Merrill noted that "one can learn a lot of technical things you don't learn in art school: how to structure a picture, how an artist achieved a particular visual effect, how an artist uses light, color, contrasts, texture, materials. But you don't want to be Winslow Homer in the 1990s."

Many conservators in museums also freelance their services, often prompted by directors of these institutions, who encourage trustees and potential donors to bring their objects to the museums for treatment. Whether within the museum or outside, conservators generally charge hourly rates ranging from $50 to $125, with $65–$85 being the average.

The main organizations for conservators are:

American Institute for
Conservation of Historic and
Artistic Works
1717 K Street, N.W.
Suite 301
Washington, D.C. 20006
(202) 452-9545
www.aic.stanford.edu/aic/

Canadian Association for
Conservation of Cultural Property

P.O. Box/CP 9195 Terminal
Ottawa, Ontario K1G 3T9
Canada
(819) 684-7460
www.cac-accr.ca

International Centre for the
Study of the Preservation
and Restoration of Cultural
Property
Via di San Michele 13

00153 Rome
Italy
39-6-585-531
www.whc.unesco.org

International Institute for
Conservation of Historic
and Artistic Works
6 Buckingham Street
London WC2N 6BA
England
44-171-839-5975
www.iiconservation.org

National Institute for the
Conservation of Cultural
Property, Inc.
3299 K Street, N.W.
Suite 602

Washington, D.C. 20007
(202) 625-1495
www.nic.org

Society of American Archivists
600 South Federal Street
Suite 504
Chicago, IL 60605
(312) 922-0140
www.archivists.org

United Kingdom Institute for
Conservation
6 Whitehorse Mews
Westminster Bridge Road
London SE1 7QD
England
011-44-171-620-3371
www.ukic.org

The American Institute for Conservation of Historic and Artistic Works sponsors workshops and an annual conference, publishes a membership directory as well as a scholarly journal three times per year and a newsletter six times per year, and offers referrals to those seeking a conservator for hire or freelance work. Other than working either for an institution or privately, a growing number of conservators work for regional conservation organizations, which provide these services to museums unable to afford full-time conservation departments. These regional centers are supported by partnerships of museums and historical associations in their area:

California
Balboa Art Conservation Center
P.O. Box 3755
San Diego, CA 92163-1755
(619) 236-9702
www.rap-arcc.org

Bay Area Art Conservation Group
1124 Clelia Court

Petaluma, CA 94954-5617
(707) 763-8694
http://palimpsest.stanford.edu/
baacg/

Western Association for Art
Conservation
P.O. Box 98
Gratan, CA 95494

(707) 829-7085
http://palimpsest.stanford.edu/waac

Colorado
Rocky Mountain Conservation
Center
2420 South University Boulevard
Denver, CO 80208
(303) 733-2712
www.du.edu/rmcc

District of Columbia
Washington Conservation Guild
P.O. Box 23364
Washington, D.C. 20026
(301) 238-3700
www.palimpsest.stanford.edu/wcg

Georgia
Atlanta Art Conservation Center
6000 Peachtree Road
Atlanta, GA 30341
(404) 733-4589
www.woodruffcenter.org

Southeast Regional Conservation
Association
330 Capitol Avenue
Atlanta, GA 30334
(404) 656-3554

Illinois
Chicago Area Conservation Group
2600 Keslinger Road
Geneva, IL 60134
(630) 232-1708

Indiana
Midwest Regional Conservation
Guild
Indiana University Art Museum

Conservation Department
Bloomington, IN 47405
(812) 855-9382
www.indiana.edu

Louisiana
New Orleans Conservation Guild
3301 Chartres Street
New Orleans, LA 70117-6201
(504) 994-7900
www.art-restoration.com

Massachusetts
Northeast Document Conservation
Center
100 Brickstone Square
Andover, MA 01810-1494
(508) 470-1010
www.nedcc.org

Strauss Center for Conservation
Harvard University Art Museums
32 Quincy Street
Cambridge, MA 02138
(617) 495-2392
www.artmuseums.harvard.edu

Textile Conservation Center
American Textile History Museum
491 Dutton Street
Lowell, MA 01854
(508) 441-1198
*www.athm.org/textile_ conservation_
center.htm*

Williamstown Art Conservation
Center
225 South Street
Williamstown, MA 01267
(413) 458-5741
www.williamstownart.org

Minnesota
Upper Midwest Conservation
Association
2400 Third Avenue South
Minneapolis, MN 55404
(612) 870-3120
www.preserveart.org

Nebraska
Gerald R. Ford Conservation Center
1326 South 32nd Street
Omaha, NE 68105
(402) 595-1180
www.nebraskahistory.org/fordcenter

New York
Cathedral Church of St. John the
Divine
Textile Conservation Laboratory
1047 Amsterdam Avenue
New York, NY 10025
(212) 316-7523
www.stjohndivine.org

Image Permanence Institute
Rochester Institute of Technology
70 Lomb Memorial Drive
Rochester, NY 14623-5604
(716) 475-5199
www.rit.edu

New York Association for
Conservation
345 Eighth Avenue
New York, NY 10011

New York Conservation Foundation
275 Madison Avenue
New York, NY 10016
(212) 714-0620
www.nycf.org

New York State Office of Parks,
Recreation and Historic
Preservation
Collections Care Center
Peebles Island
P.O. Box 219
Waterford, NY 12188
(518) 237-8643
www.oprhp.state.ny.us

Textile Conservation Workshop
3 Main Street
South Salem, NY 10590
(914) 763-5805
*www.rap-arcc.org/welcome/
tcwsite2.htm*

Ohio
Intermuseum Conservation
Association
Allen Art Building
Oberlin, OH 44074
(440) 775-7331
www.ica-artconservation.org

Pennsylvania
Conservation Center for Art and
Historic Artifacts
264 South 23rd Street
Philadelphia, PA 19103
(215) 545-0613
www.ccaha.org

Texas
Harry Ransom Humanities
Research Center
Conservation Department
Box 7219
Austin, TX 78713-7219
(512) 471-9117
www.hrc.utexas.edu

Virginia

Virginia Conservation
Association
P.O. Box 4314
Richmond, VA 23220
(804) 358-7545

Washington

Conservation Associates of the
Pacific Northwest
P.O. Box 2756
Olympia, WA 98507-2756
(360) 754-2093

Art Therapy

When Don Seiden, a sculptor and instructor at the School of the Art Institute of Chicago, began offering a course in art therapy in 1970, the field (even the term "art therapy") was largely unknown, and "the art department was scared of it," he said. "People in the department thought it would distract students from other, traditional areas, and they also felt psychology was inherently invasive. The belief was, artists are by nature a little crazy and they would lose the art if they got interested in therapy." Eventually, Seiden moved his course out of the art department and into art education, where it continues to be taught.

The fear of psychology has largely left art schools, where the general education programs usually offer one or more courses in the subject, and psychologists are often on staff to counsel students with personal problems. Certificate and degree programs in art therapy, however, are offered not through art schools but at other institutions, and many artists who become interested in the use of art in therapeutic settings pursue such studies outside of art school.

Seiden's interest developed from one of his first jobs after art school, working at a psychiatric hospital in Chicago, "where I saw that, through the process of making art, I could motivate patients to gain control over their lives. I achieved results that no one else could." Dale Schwartz, a painter and the founder of the New England Art Therapy Institute in Sunderland, Massachusetts, discovered the therapeutic use of art as a counselor at a camp for the mentally retarded, while Robert Ault found that creating art helped give voice to the feelings of children with speech impediments at the Institute of Logopedics in Wichita, Kansas. He taught there through a two-year fellowship sponsored by Wichita State University, where he was earning an MFA in painting.

"I've always painted and exhibited my work," Ault said, "but I found that it was just as stimulating to work with a live medium—people—to capture thoughts, memories, and feelings." His interest in art therapy led Ault to undergo additional schooling, in this case, two years of psychotherapy

training at Menninger's Psychiatric Hospital in Topeka, Kansas, with another two years of supervision while he began to see patients. In 1978, he opened his own art academy, while continuing his art therapy practice on the side. At times, one job overlaps the other. "A lot of people come to learn art in order to change their lives," he said. "I call them 'unidentified patients.' They are chronically but not clinically depressed and so are not in the pipeline of psychiatry. When you work with them and help them develop the skills to express themselves with, they begin to take ownership of something that's theirs. They see that their lives have value, and that's health producing."

Art therapy has a wide range of clients, from the severely traumatized to artists who have reached an impasse with their work. "Artists who come to my workshops may move into greater freedom of expression; it creates breakthroughs," Dale Schwartz said. Most patients, however, have severe mental handicaps, physical defects, have suffered some catastrophic event or, in the case of children, do not have the language or cognitive skills to employ traditional talk therapy. A background in art is necessary for art therapists because patients need to be taught basic skills in order to express themselves adequately. "Each person who comes into the field of art therapy must be reasonably competent in a broad variety of media," according to Carole Busch, a spokesperson for the American Art Therapy Association. Degree and certificate courses in art therapy generally include art studio experience in ceramics, drawing, painting, and sculpture as well as art history classes, in addition to extensive coursework in psychology.

"You have to experience the process of creating in order to understand the trials and tribulations of creativity," said Simone Alter-Muri, director of the art therapy program at Springfield College in Massachusetts. "You also need to know the properties of the materials you're working with, because you don't want something to blow up." A knowledge of various media is important, because different art materials will be used for specific patients, depending upon their age, diagnosis, physical capabilities, and the particular problem being addressed therapeutically. Technically advanced art-making skills, such as lithography or metal welding, are not likely to be used or taught, and carving tools would be avoided as a potential danger to the patient or others. "The emphasis is not on technical skills; the therapeutic relationship with the patient is paramount. I offer technical assistance when it helps in the process of creation."

Art therapists work in a variety of settings—in private practice, prisons, nursing homes, schools, and hospitals, usually—offering counseling to individuals or groups. Private practitioners charge between $70 and $100 for hour-long sessions or earn between $35,000 and $45,000 when employed full-time at a hospital, Busch noted.

Many, if not most, art therapists belong to either the Society for the Arts in Healthcare (45 Lyme Road, Suite 304, Hanover, NH 03755-1223, 603-643-2325) or the American Art Therapy Association (1202 Allanson Road, Mundelein, IL 60060-3808, 847-949-6064, *www.arttherapy.org*), both of which publish information-filled newsletters, hold conferences and workshops, have job information hotlines, sponsor research, offer referrals, and establish educational requirements and ethical guidelines for their members. One may also receive information on the field by contacting the National Coalition of Arts Therapies Associations (2000 Century Plaza, Suite 108, Columbia, MD 21044, 410-997-4040, *www.ncata.com,* e-mail: *ADTA@aol.com*) or its member organizations: American Association for Music Therapy (One Station Plaza, Ossining, NY 10562, 914-944-9260), American Dance Therapy Association (2000 Century Plaza, Suite 108, Columbia, MD 21044, 410-997-4040, e-mail: *ADTA@aol.com*), American Society of Group Psychotherapy and Psychodrama (c/o International Meeting Managers, Inc., 4550 Post Oak Place, Suite 248, Houston, TX 77027, 713-963-8372, e-mail: *74117.511@compuserv.com*), National Association for Drama Therapy (15245 Shady Grove Road, Suite 130, Rockville, MD 20850, 301-258-9210, e-mail: *nadt@mgmtsol.com*), and the National Association for Poetry Therapy (P.O. Box 551, Port Washington, NY 11050, 516-944-9791).

There are a number of graduate-level programs in the United States and Canada, offering master's-level training (MA or MS) in art therapy (those approved by the American Art Therapy Association are asterisked):

*Adler School of Professional
Psychology*
65 East Wacker Place
Suite 2100
Chicago, IL 60601-7203
(312) 201-5900, ext. 220
www.adler.edu

**Albertus Magnus College*
Master of Arts in Art Therapy
Program
700 Prospect Street
New Haven, CT 06511
(203) 773-6998
www.albertus.edu

**College of New Rochelle*
Graduate Art Programs
29 Castle Place
New Rochelle, NY 10805
(914) 654-5280
www.cnr.edu

**Concordia University*
Department of Art Education and
Art Therapy
1455 de Maisonneuve Boulevard West
Montreal, Quebec H3G 1M8
Canada
(514) 848-4643
http://art-therapy.concordia.com

*Drexel University
Hahnemann Creative Arts in
Therapy Program
245 North 15th Street
Philadelphia, PA 19102-1192
(215) 762-6925
www.drexel.edu/gradprogs/Creative
Arts/Arttherapy

*Eastern Virginia Medical School
Graduate Art Therapy Program
P.O. Box 1980
Norfolk, VA 23501
(757) 446-5895
www.evms.edu/hilthprof/art-
therapy.html

*Emporia State University
Division of Psychology and Special
Education
1200 Commercial Street
Emporia, KS 66801
(316) 341-5809
www.emporia.edu/physpe/
arttherapy/athp.html

*Florida State University
Department of Art Education
123 Milton Carothers Hall
Tallahassee, FL 32306-3014
(904) 644-5473
www.fsu.edu

*George Washington University
Art Therapy Programs
2129 G Street, N.W.
Building L
Washington, D.C. 20052
(202) 994-6285
www.gwu.edu/~artx

*Hofstra University
Art Therapy Programs
Department of Counseling,
Research, Special Education and
Rehabilitation
212 Mason Hall
124 Hofstra University
Hempstead, NY 11550-1090
(516) 463-5752
www.hofstra.edu

*Illinois State University
Art Department
Campus Box 5620
Normal, IL 61761
(309) 438-8948
www.ils.edu

*Lesley College
Expressive Therapies Graduate
Program
29 Everett Street
Cambridge, MA 02138
(617) 349-8436
www.lesley.edu

*Loyola Marymount University
Clinical Art Therapy
Graduate Department of Marital
and Family Therapy
7900 Loyola Boulevard
Los Angeles, CA 90045-8215
(310) 338-4562
www.lmu.edu/mft

*Long Island University
Art Department
720 Northern Boulevard
Brookville, NY 11548
(516) 299-2464
www.liu.edu/~svpa/art

*Marylhurst College
Graduate Program in Art Therapy
Marylhurst, OR 97036
(503) 699-6244
www.marylhurst.edu

*Marywood College
2300 Adams Avenue
Scranton, PA 18509
(717) 348-6278
www.marywood.edu

*Mount Mary College
2900 North Menomonee River
Parkway
Milwaukee, WI 53222
(414) 256-1215
www.mtmary.edu

Naropa Institute
Transpersonal Counseling
Psychology
2130 Arapahoe Avenue
Boulder, CO 80302
(303) 546-3545
www.naropa.edu

*Nazareth College
Graduate Art Therapy
4245 East Avenue
Rochester, NY 14618-3790
(716) 586-2525
www.naz.edu/dept.art

*New York University
Art Therapy Program
34 Stuyvesant Street
New York, NY 10003
(212) 998-5727
www.nyu.edu

*Notre Dame de Namur
University
1500 Ralston Avenue
Belmont, CA 94002
(650) 508-3556
www.ndnu.edu

Phillips Graduate Institute
5445 Balboa Boulevard
Encino, CA 91316-1509
(818) 386-5611
www.pgi.edu

*Pratt Institute
Art Therapy and Creativity
Development
Art Therapy Special
Education
200 Willoughby Avenue
Brooklyn, NY 11205
(718) 636-3428
www.pratt.edu

*St. Louis Institute of Art
Psychotherapy
308A North Euclid
St. Louis, MO 63108
(314) 367-8550

*School of the Art Institute
of Chicago
Department of Art Education
and Art Therapy
112 South Michigan Avenue
Chicago, IL 60603
(312) 345-3516
www.artic.edu

*Seton Hill College
Office of Graduate Studies
Greensburg, PA 15601

(412) 830-1047
www.setonhill.edu

Sonoma State University
Psychology Department
Rohnert Park, CA 94928-3609
(707) 664-2682
(707) 539-9245
www.sonoma.edu/Exed/mapsych/
art_therapy

*Southern Illinois University
at Edwardsville
Graduate Studies in Art Therapy
Box 1764
Edwardsville, IL 62026-1764
(618) 692-3183
www.siue.edu/Art/AREAS/art-therapy

*Southwestern College
RR 20, Box 29D
P.O. Box 4788
Santa Fe, NM 87502-4788
(505) 471-5756
www.swc.edu

*Springfield College
Art Department
263 Alden Street
Springfield, MA 01109
(413) 748-3752
www.spfldcol.edu

*University of Illinois at Chicago
Art Therapy Graduate Program
M/C 036
929 West Harrison Street
Chicago, IL 60607
(312) 996-5728
www.uic.edu

*University of Louisville
Expressive Therapies Program
Gardiner Hall 331
Louisville, KY 40292
(502) 852-5265
www.louisville.edu/edu/ecpy/et/et.html

University of New Mexico
Art Education/Art Therapy
Albuquerque, NM 87131-1236
(505) 277-4112
www.unm.edu/~arted

University of Wisconsin-Superior
Program in Visual Arts
1800 Grand Avenue
Superior, WI 54880
(715) 394-8391
www.uwsuper.edu

*Ursuline College
2550 Lander Road
Pepper Pike, OH 44124
(216) 646-8139
www.ursuline.edu

Vermont College of the Union
Institute
Graduate Art Therapy
Program
36 College Street
Montpelier, VT 05602
(802) 828-8500
www.tui.edu.VC

*Wayne State University
Art Therapy Program
163 Community Arts Building
Detroit, MI 48202
(313) 577-0490
www.wayne.edu

Some institutes and schools in North America also offer certificate programs in art therapy, based on attendance at workshops or the completion of course work:

Adler School of Professional Psychology
65 East Wacker Place
Suite 2100
Chicago, IL 60601-7203
(312) 201-5900, ext. 220
www.adler.edu

Antioch University Seattle
Art Therapy Program
2326 Sixth Avenue
Seattle, WA 98121-1814
(206) 268-4818
www.antiochsea.edu

Art Therapy Institute
8340 Meadow Road
Dallas, TX 75231-3751
(214) 696-4278
www.arttherapy-institute.com

British Columbia School of Art Therapy
1931 Lee Avenue
Victoria, British Columbia V8R 4W9
Canada
(604) 598-6434

Caldwell College
Art Therapy Programs
9 Ryerson Avenue
Caldwell, NJ 07006
(973) 618-3511
www.caldwell.edu

Center for the Creative Arts Therapies
Box 9296

Santa Rosa, CA 95405-1296
(707) 538-7848
www.creativearttherapies.org

Centre de Ressourcement par les Arts et la Nature
1412 rue Simard
Sherbrooke, Quebec J1J 3K4
Canada
(819) 822-1217
www.reseauproteus.net

Marylhurst College
Graduate Program in Art Therapy
Marylhurst, OR 97036
(503) 699-6244
www.marylhurst.edu

Nazareth College of Rochester
4245 East Avenue
Rochester, NY 14618-3790
(585) 389-2535
www.naz.edu/dept/art_ therapy/ index.html

New England Art Therapy Institute
216-T South Silver Lane
Sunderland, MA 01375-9473
(413) 665-4880
http://users.rcn.com/cccneati

New School for Social Research Art Therapy
66 West 12th Street
New York, NY 10011

(212) 431-6845
www.newschool.edu

Notre Dame de Namur University
Art Therapy Program
1500 Ralston Avenue
Belmont, CA 94002
(650) 508-3556
www.ndnu.edu

Phillips Graduate Institute
5445 Balboa Boulevard
Encino, CA 91316-1509
(818) 386-5611
www.pgi.edu

Seton Hill College
Office of Graduate Studies
Greensburg, PA 15601
(724) 838-4283 or
(800) 826-6234
www.setonhill.edu

Sonoma State University
Psychology Department
1801 East Cotati Avenue
Rohnert Park, CA 94928-3609
(707) 664-2682
www.sonoma.edu/Exed/mapsych/
art_ therapy

Southwestern College
Art Therapy Program
P.O. Box 4788
Santa Fe, NM 87502-4788
(505) 471-5756 or (877) 471-5756
www.swc.edu

Toronto Art Therapy Institute
216 St. Clair Avenue West
Toronto, Ontario M4V 1R2

Canada
(416) 924-6221
www.tati.on.ca

University of California
San Diego Extension
9500 Gilman Drive 0172C
La Jolla, CA 92093-0172
(858) 882-8033
www.extension.ucsd.edu

University of Houston-Clear Lake
2700 Bay Area Boulevard
MC 354
Houston, TX 77058
(713) 283-3031
(713) 283-3315
www.cl.uh.edu

University of Oklahoma
College of Continuing Education
1700 Asp Avenue
Room 202
Norman, OK 73072-6400
(405) 325-4414 or (800) 522-0772,
ext. 5101
www.occe.ou.edu

University of Western Ontario
Continuing Education
London, Ontario N6A 5B8
Canada
(519) 661-3633
www.uwo.ca/cstudies

Ursuline College
Art Therapy Department
2550 Lander Road
Pepper Pike, OH 44124
(440) 646-8139
www.ursuline.edu

Several foreign programs grant certificates, diplomas, or master's-level degrees in art therapy:

Diorama Arts-London
Diorama Arts Centre
37 Euston Centre
Regents Place
London NW1 3JG
England
011-44-027-916-5467
www.diorama-arts.org.uk
Certificate in art and psychotherapy.

Edinburgh University Settlement
School of Art Therapy
Wilkie House
37 Guthrie Street
Edinburgh EM1 1JG
United Kingdom
011-0131-650-6311
www.biad.uce.ac.uk
Postgraduate diploma in art therapy.

Goldsmith College-University of London
Art Psychotherapy Unit
23 St. James
New Cross, London SE14 6AD
England
011-44-171-919-7230
www.baat.org/training.html
Postgraduate diploma in art therapy.

Instituto Sedes Sapientiae
Art Therapy Department
1484 Perdizes
Sao Paolo 05015-900
Brazil
011-3866-2730
www.sedes.org
Certificate of completion.

University of Sydney
Behavioural Sciences
Cumberland College
P.O. Box 170
Lidcombe, NSW, 2141
Australia
011-61-2-646-6283
www.sid.cam.ac.uk
MA in behavioral sciences.

There are also a number of undergraduate degree programs in art therapy in the United States, offering BA, BFA, and BS degrees (the type of degree is determined by whether the program is directed by a psychology department or art department):

Albertus Magnus College
Psychology Department
Art Therapy Program
700 Prospect Street
New Haven, CT 06511
www.albertus.edu

Alverno College
P.O. Box 343922
Milwaukee, WI 53234-3922
(414) 382-6146
www.alverno.edu

Anna Maria College
50 Sunset Lane
Paxton, MA 01612-1198
(508) 849-3442
www.annamaria.edu

Arcadia University
Fine Arts Department
450 South Easton Road
Glenside, PA 19038
(215) 572-2900/2995
www.arcadia.edu

Barat College
Psychology Department
700 East Westleigh Road
Lake Forest, IL 60045
(847) 547-6359
www.barat.edu

Bowling Green State University
School of Art
Bowling Green, OH 43403
(419) 372-2786
www.bgsu.edu/departments/art

Brescia College
717 Frederica Street
Owensboro, KY 42301
(502) 686-9526
www.brescia.edu

Caldwell College
9 Ryerson Avenue
Caldwell, NJ 07006
(201) 228-4424, ext. 511
www.caldwell.edu

Capital University
2199 East Main Street
Columbus, OH 43209
(614) 236-6328

www.capital.edu/acad/as/arther/index.
schtml

College of New Rochelle
Art Department
29 Castle Place
New Rochelle, NY 10805
(914) 654-5856
www.cnr.edu

College of Santa Fe
1600 St. Michael's Drive
Santa Fe, NM 87505
(505) 473-6394/6590
www.csf.edu

Converse College
Art Therapy Department
580 East Main Street
Spartanburg, SC 29302
(864) 596-9178/9181
www.converse.edu

Edgewood College
855 Woodrow Street
Madison, WI 53711
(608) 257-4861, ext. 2219
www.edgewood.edu

Long Island University
Art Therapy Program
720 Northern Boulevard
Brookville, NY 11548
(516) 299-2944
www.liu.edu/~supa/art

Marian College
3200 Cold Springs Road
Indianapolis, IN 46222
(317) 621-7653
www.marian.edu

Marywood University
2300 Adams Avenue
Scranton, PA 18509-1598
(570) 348-6278
www.marywood.edu

Mercyhurst College
Glenwood Hills
Erie, PA 16546
(814) 824-2212
www.mercyhurst.edu

Mount Mary College
2900 North Menomonee River
Parkway
Milwaukee, WI 53222
(414) 256-1215
www.mtmary.edu

Our Lady of the Elms College
Art Therapy
291 Springfield Street
Chicopee, MA 01033-2839
(413) 594-2761
www.elms.edu

Pittsburg State University
Department of Art
1701 South Broadway
Pittsburg, KS 66762
(316) 235-4310
www.pittstate.edu/art

Russell Sage College
Creative Arts Therapy
45 Ferry Street
Troy, NY 12180
(518) 270-2248
www.sage.edu

St. Joseph College
1678 Asylum Avenue

West Hartford,
CT 06117-2791
(860) 232-4571, ext. 302
www.sjc.edu

St. Thomas Aquinas College
125 Route 340
Sparkill, NY 10976-1050
(845) 398-4166
(845) 362-8595
www.stac.edu

School of Visual Arts
209 East 23rd Street
New York, NY 10010
(212) 592-2610
www.sva.edu

Seton Hill College
Greensburg, PA 15601
(724) 830-1047 or (800) 826-6234
www.setonhill.edu

Springfield College
Art Department
263 Alden Street
Springfield, MA 01109
(413) 748-3752
www.spfldcol.edu

Spring Hill College
Department of Fine and Performing
Arts
4000 Dauphin Street
Mobile, AL 36608
(334) 380-3855
www.springhill.edu

University of the Arts
Philadelphia College of Art
and Design
320 South Broad Street

Philadelphia, PA 19102
(215) 875-4880
www.uarts.edu

University of Indianapolis
1400 East Hanna Avenue
Indianapolis, IN 46227
(317) 788-3253
www.uindy.edu

University of Tampa
Department of Art

401 West Kennedy Boulevard
Tampa, FL 33606-1490
(813) 253-3333, ext. 3368
www.utampa.edu

University of Wisconsin-Superior
Program in Visual Arts
1800 Grand Avenue
Superior, WI 54880
(715) 394-8391
www.uwsuper.edu

Architecture

In almost every master's of architecture program in the United States, some students come from a studio art background, which may offer them advantages over their classmates who studied other fields. "They know how to draw, and they have a trained eye, which often has to be developed by the other students in the program," said Cynthia Weese, dean of the school of architecture at Washington University in St. Louis, Missouri. Karen Van Lengen, chair of the department of architecture and environment design at Parsons School of Design in New York City, noted that fine artists have the ability to express themselves in visual terms, while other students in the program—who came out of the humanities, for instance—"struggle for a period of time." Further, Gabriel Feld, who heads the Rhode Island School of Design's department of architecture, stated that "people with backgrounds in the humanities take time to get accustomed to the studio experience. For fine artists, that's all second nature."

There is a long tradition of fine artists moving into architecture, the most notable examples being Michelangelo and Le Corbusier. Charles Édouard Jeanneret, known as Le Corbusier, had trained as a painter but crossed over to architecture early in his career, whereas Michelangelo devoted the last three decades of his long life to architecture. In the sixteenth century, it was not viewed as absurd to ask Michelangelo, trained primarily as a sculptor, to paint the ceiling of the Sistine Chapel and design St. Peter's basilica: creative talents were not thought to be confined to one specific area.

More in the Le Corbusier mold is Aaron Brode, who entered the master's of architecture program at the Rhode Island School of Design (RISD) a year after receiving a BFA in sculpture from the Tyler School of Art in Philadelphia. He noted that his move was occasioned by thinking about his work in a larger context. "Instead of picturing the sculpture in the building or in front of the building, I found myself thinking more about the building itself," he said. Between the time he left Tyler and enrolled at RISD, Brode earned two commissions, one from the National Hockey League to design a trophy for a World Cup competition and the other a public art piece for a new building at Temple University in Philadelphia, but his interest in studying architecture overcame this initial success as a sculptor. "I had planned on being an architect since I was in high school. In fact, I had only taken an art class in high school, because I had exhausted all the architecture courses there. I hadn't been introduced to art before, and it really appealed to me, so I decided to apply to art school."

An advantage Brode found he had over some of his other architecture classmates who had not gone to art school was that "model-making came more naturally to me than for other students." Because he had prepared himself in high school for architecture training, he had also studied algebra, calculus, trigonometry, and physics, which are common problem-solving tools for the field, and he needed only a brief refreshing in these areas to stay current with course requirements. Many studio art graduates in architecture programs do not have that background. "A major problem for the BFA's is their background in physics and math, and most have to do remedial work in these areas," said Robert Beckley, dean of the college of architecture and urban planning at the University of Michigan.

In some ways, architecture is a natural extension of the fine arts. Art students are trained in analysis (taking things apart) and synthesis (putting them back together), as well as the form, scale, and relationships of objects, and have a "sensibility for the kinds of materials that architects work with," Feld said. Many art students also learn some of the history of architecture as part of their BFA training. Certainly, architecture seems more like a profession than fine art: architects need to be licensed by the states, maintain rigorous standards, and are part of a well-organized field. Architects also have greater chances than fine artists of finding employment and earning a living wage right out of school. Historically, architecture has been defined as a combination of science and art, but the more recent description includes science, art, and business. Those who are likely to find success in the field of architecture must understand costs, how to work with clients and contractors, and how to adapt to changing situations.

In other respects, fine artists may find that different styles of work and ways of thinking take time to learn when entering an architecture program. "Studio artists are trained to work alone and think for themselves," Van Lengen said, "but in architecture you work in collaboration with others. It's a public rather than a private art, and some fine artists struggle with that." Brode himself noted that his understanding of drawing changed through studying architecture, discovering that a drawing "is not just description— a symbolic or representational language—but the thing you are making. What you make on paper is the real thing."

The American Institute of Architects (1735 New York Avenue, N.W., Washington, D.C. 20006, 202-626-7300, *www.aiaonline.com*) is the largest organization of architects in the United States, offering conferences, workshops, job referrals, and a newsletter. Another group is the American Society of Registered Architects (1245 South Highland Avenue, Lombard, IL 60148, 708-932-4622), which also sponsors seminars and has a placement service. The American Society of Landscape Architecture (4401 Connecticut Avenue, N.W., Washington, D.C. 20008, 202-686-2752) has some overlapping membership with the other two groups, and it also holds conferences, publishes a newsletter, and offers a job referral service for members. The National Architecture Accrediting Board, which is associated with the American Institute of Architects, accredits bachelor's- and master's-level architecture programs around the country, which currently include:

Alabama
Auburn University
College of Architecture, Design and Construction
202 Dudley Commons
Auburn University, AL 36849-5313
(334) 844-4524
www.auburn.edu/academic/architecture/arch
Bachelor of architecture degree awarded.

Tuskegee University
Department of Architecture
College of Engineering, Architecture and Physical Sciences
Tuskegee, AL 36088
(334) 727-8329

www.tusk.edu/colleges/CEAPS/index.html
Bachelor of architecture degree awarded.

Arizona
University of Arizona
College of Architecture
Tucson, AZ 85721
(520) 621-6754
www.architecture.arizona.edu
Bachelor of architecture degree awarded.

Arizona State University
School of Architecture
Tempe, AZ 85287-1605
(480) 965-3536

www.asu.edu/caed/Architecture/ind
Master of architecture degree
awarded.

Frank Lloyd Wright School
of Architecture
Taliesin West
Scottsdale, AZ 85261-4430
(480) 860-2700
www.taliesin.edu
Master of architecture degree
awarded.

Arkansas
University of Arkansas
School of Architecture
100 Vol Walker Hall
Fayetteville, AR 72701
(501) 575-4945
www.uark.edu/~archhome/school.html
Bachelor of architecture degree
awarded.

California
University of California
at Berkeley
Department of Architecture
232 Wurster Hall
Berkeley, CA 94720
(510) 642-4942
www.ced.berkeley.edu:80/arch
Master of architecture degree
awarded.

University of California at Los
Angeles
Department of Architecture and
Urban Design
405 Hilgard Avenue
Los Angeles, CA 90095-1467
(310) 825-7857

www.aud.ucla.edu
Master of architecture degree
awarded.

California College of Arts
and Crafts
School of Architectural Studies
450 Irwin Street
San Francisco, CA 94107
(415) 703-9516
www.ccac-art.edu
Bachelor of architecture degree
awarded.

California Polytechnic State
University at San Luis Obispo
Architecture Department
San Luis Obispo, CA 93407
(805) 756-1316
www.calpoly.edu/~arch
Bachelor of architecture degree
awarded.

California State Polytechnic
University at Pomona
Department of Architecture
3801 West Temple Avenue
Pomona, CA 91768-4048
(805) 869-2683
www.csupomona.edu/~arch
Bachelor and master of architecture
degrees awarded.

NewSchool of Architecture
1249 F Street
San Diego, CA 92101-6634
(619) 235-4100
www.newschoolarch.edu
Bachelor and master of architecture
degrees awarded.

University of Southern California
School of Architecture
Los Angeles, CA 90089-0291
(213) 740-2723
www.usc.edu/dept/architecture
Bachelor and master of architecture
degrees awarded.

Southern California Institute
of Architecture
5454 Beethoven Street
Los Angeles, CA 90066
(310) 574-1123
www.sciarc.edu
Bachelor and master of architecture
degrees awarded.

Woodbury University
Department of Architecture
7500 Glenoaks Boulevard
Burbank, California 91510-7846
(818) 767-0888
www.woodbury.edu
Bachelor of architecture degree
awarded.

Colorado
University of Colorado at Denver
College of Architecture and
Planning
Campus Box 126
P.O. Box 173364
Denver, CO 80217-3364
(303) 556-3382
www.cudenver.edu/public/AandP
Master of architecture degree
awarded.

Connecticut
University of Hartford
220 Bloomfield Avenue

West Hartford, CT 06117
(860) 768-4366
http://uhaweb.hartford.edu/
wardweb/descaet.htm

Yale University
School of Architecture
180 York Street
P.O. Box 208242
New Haven, CT 06520
(203) 432-2288
www.architecture.yale.edu
Master of architecture degree
awarded.

District of Columbia
Catholic University of America
School of Architecture and Planning
620 Michigan Avenue, N.E.
Washington, D.C. 20064
(202) 319-5188
www.cua.edu/www/apu/index.htm
Bachelor and master of architecture
degrees awarded.

Howard University
School of Architecture and
Planning
2366 Sixth Street, N.W.
Washington, D.C. 20059
(202) 806-7420
www.imappl.org/CEACS/Departments/
Architecture/index.htm
Bachelor of architecture degree
awarded.

University of the District of
Columbia
Department of Architecture, Design
and Planning
Carnegie Building

800 Mount Vernon Place, N.W.
Washington, D.C. 20001
(202) 274-6800
www.universityofdc.org
Bachelor of architecture degree
awarded.

Florida
University of Florida
Department of Architecture
P.O. Box 115702
Gainesville, FL 32611-5702
(352) 392-0205
www.arch.ufl.edu
Master of architecture degree
awarded.

Florida A&M University
School of Architecture
Tallahassee, FL 32307
(850) 599-3244
www.168.223.36.3/acad/college/soa
Bachelor and master of architecture
degrees awarded.

Florida Atlantic University
77 Glades Road
P.O. Box 3091
Boca Raton, FL 33431-0991
(954) 762-5654
www.fau.edu/dividept/cupa
Bachelor of architecture degree
awarded.

Florida International University
11200 S.W. 8th Street
Miami, FL 33199
(305) 348-3181
www.fiu.edu/index.htm
Master of architecture degree
awarded.

University of Miami
School of Architecture
P.O. Box 249178
Coral Gables, FL 33124
(305) 284-5000
www.arc.miami.edu
Bachelor and master of architecture
degrees awarded.

University of South Florida
School of Architecture and
Community Design
3702 Spectrum Boulevard
Suite 180
Tampa, FL 33612-9421
(813) 974-4031
www.arch.usf.edu
Master of architecture degree
awarded.

Georgia
Georgia Institute of Technology
College of Architecture
Atlanta, GA 30332-0155
(404) 894-3880
www.arch.gatech.edu
Master of architecture degree
awarded.

Savannah College of Art and Design
Department of Architecture
201 West Chalton Street
Savannah, GA 31401
(912) 238-2487
www.scad.edu
Bachelor of architecture degree
awarded.

Southern Polytechnic State
University
School of Architecture

1100 South Marietta Parkway
Marietta, GA 30060-2896
(770) 528-7253
www2.spsu.edu.architecture
Bachelor of architecture degree
awarded.

Hawaii
University of Hawaii at Manoa
School of Architecture
2410 Campus Road
Honolulu, HI 96822
(808) 956-3469
http://web1arch.hawaii.edu
Bachelor and master of architecture
degrees awarded.

Idaho
University of Idaho
Department of Architecture
Moscow, ID 83844-2451
(208) 885-6781
www.aa.uidaho.edu/arch
Master of architecture degree
awarded.

Illinois
Judson College
1151 North State Street
Elgin, IL 60123
(847) 695-2500
www.judson-il.edu/depts/dada
Master of architecture degree
awarded.

University of Illinois at Chicago
School of Architecture
M/C 030
845 West Harrison Street
Chicago, IL 60607-7024
(312) 996-3335

www.uic.edu:80/depts/arch/
homepage.html
Bachelor and master of architecture
degrees awarded.

University of Illinois at Urbana-
Champaign
School of Architecture
611 Taft Drive
Champaign, IL 61820-6921
(217) 333-1330
www.arch.uiuc.edu
Master of architecture degree
awarded.

Illinois Institute of Technology
College of Architecture
S.R. Crown Hall
3360 South State Street
Chicago, IL 60616
(312) 567-3230
www.iit.edu/~arch
Bachelor and master of architecture
degrees awarded.

Indiana
Ball State University
College of Architecture and Planning
Muncie, IN 47306-0305
(765) 285-5861
www.bsu.edu/cap
Bachelor of architecture degree
awarded.

University of Notre Dame
School of Architecture
Notre Dame, IN 46556
(219) 631-6137
www.nd.edu/~arch
Bachelor and master of architecture
degrees awarded.

Iowa

Iowa State University
Department of Architecture
156 College of Design
Ames, IA 50011-3093
(515) 294-4717
www.arch.iastate.edu
Bachelor and master of architecture
degrees awarded.

Kansas

University of Kansas
School of Architecture and Urban
Design
Lawrence, KS 66045
(785) 864-4281
http://afce.ukans.edu/scharch/
scharch.htm
Bachelor and master of architecture
degrees awarded.

Kansas State University
College of Architecture, Planning
and Design
Manhattan, KS 66506-2901
(785) 532-5953
http://aalto.arch.ksu.edu
Bachelor of architecture degree
awarded.

Kentucky

University of Kentucky
College of Architecture
Pence Hall
Lexington, KY 40506-0041
(606) 257-7617
www.iky.edu/Architecture
Bachelor of architecture degree
awarded.

Louisiana

Louisiana State University
College of Design
Baton Rouge, LA 70803
(225) 388-6885
www.cadgis.lsu.edu/design/index.html
Bachelor and master of architecture
degrees awarded.

Louisiana Tech University
School of Architecture
P.O. Box 3147
Ruston, LA 71272
(318) 257-2816
www.LaTech.edu/tech/arch
Bachelor of architecture degree
awarded.

Southern University and A&M
College
School of Architecture
Baton Rouge, LA 70813
(225) 771-3015
www.subr.edu
Bachelor of architecture degree
awarded.

University of Southwestern
Louisiana
School of Architecture
Lafayette, LA 70504-3850
(337) 482-6225
http://arts.louisiana.edu/depts/
architecture
Bachelor of architecture degree
awarded.

Tulane University
School of Architecture
Richardson Memorial Hall
New Orleans, LA 70118-5671

(504) 865-5389
www.tulane.edu/~tsahme
Bachelor and master of architecture
degrees awarded.

Maryland
University of Maryland
School of Architecture
College Park, MD 20742-1411
(301) 405-6284
www.inform.umd.edu/arch
Master of architecture degree
awarded.

Morgan State University
Institute of Architecture and
Planning
Baltimore, MD 21239
(410) 885-3225
www.morgan.edu/acadmic/schools/
archit/archit.htm
Master of architecture degree
awarded.

Massachusetts
Boston Architectural Center
320 Newbury Street
Boston, MA 02115
(617) 585-0226
www.the-bac.edu
Bachelor and master of architecture
degree awarded.

Harvard University
Department of Architecture
48 Quincy Street
Cambridge, MA 02138
(617) 495-2591
www.gsd.harvard.edu
Master of architecture degree
awarded.

Massachusetts Institute
of Technology
Department of Architecture
77 Massachusetts Avenue
Cambridge, MA 02139
(617) 253-7791
http://sap.mit.edu
Master of architecture degree
awarded.

Northeastern University
Department of Architecture
151 Ryder Hall
Boston, MA 02115
(617) 373-4637
www.architecture.neu.edu
Master of architecture degree
awarded.

University of Massachusetts
Amherst, MA 01003
(413) 545-6957
www.umass.edu
Master of architecture degree
awarded.

Wentworth Institute
of Technology
Department of Architecture
550 Huntington Avenue
Boston, MA 02115-5998
(617) 989-4450
www.wit.edu
Bachelor of architecture degree
awarded.

Michigan
Andrews University
Division of Architecture
Berrien Springs, MI 49104-0450
(269) 471-6003

www.andrews.edu/ARCH
Bachelor of architecture degree
awarded.

University of Detroit at Mercy
School of Architecture
P.O. Box 19900
Detroit, MI 48219-0900
(313) 993-1532
www.udmercy.edu
Bachelor and master of architecture
degree awarded.

Lawrence Technological University
College of Architecture and Design
21000 West Ten Mile Road
Southfield, MI 48075
(248) 204-2805
www.ltu.edu/architecture
Master of architecture degree
awarded.

University of Michigan
College of Architecture and Urban
Planning
Ann Arbor, MI 48109-2069
(734) 763-1300
www.caup.umich.edu
Master of architecture degree
awarded.

Minnesota
University of Minnesota
Department of Architecture
89 Church Street, S.E.
Minneapolis, MN 55455
(612) 624-7866
http://gumby.arch.umn.edu
Bachelor and master of architecture
degrees awarded.

Mississippi
Mississippi State University
School of Architecture
P.O. Drawer AQ
Mississippi State, MS 39762
(601) 325-2202
www.sarc.msstate.edu
Bachelor of architecture degree
awarded.

Missouri
Drury College
Hammons School of Architecture
Springfield, MO 65802
(417) 873-7288
http://hsa.drury.edu
Bachelor of architecture degree
awarded.

Washington University
School of Architecture
One Brookings Drive
St. Louis, MO 63130
(314) 935-6200
www.arch.wustl.edu
Master of architecture degree
awarded.

Montana
Montana State University
School of Architecture
Bozeman, MT 59717
(406) 994-4256
www.montana.edu/wwwarch
Master of architecture degree
awarded.

Nebraska
University of Nebraska
College of Architecture
Lincoln, NE 68588-0106

(402) 472-9212
www.uni.edu/archcoll.index.htm
Master of architecture degree
awarded.

Nevada
University of Nevada at Las Vegas
School of Architecture
4505 Maryland Parkway
Las Vegas, NV 89154-4018
(702) 895-3031
www.nscee.edu/univ/Colleges/
Fine_Arts/Architecture
Master of architecture degree
awarded.

New Jersey
New Jersey Institute of Technology
School of Architecture
University Heights
Newark, NJ 07102
(973) 596-3079
www.njit.edu/Directory/Academic/SOA
Bachelor and master of architecture
degrees awarded.

Princeton University
School of Architecture
Princeton, NJ 08544
(609) 258-3741
www.princeton.edu:80/~soa
Master of architecture degree
awarded.

New Mexico
University of New Mexico
School of Architecture and Planning
2414 Central Southeast
Albuquerque, NM 87131
(505) 277-3133

www.unm.edu/~saap
Master of architecture degree
awarded.

New York
City College of the City University
of New York
School of Architecture and
Environmental Studies
138th Street at Convent Avenue
Shepard Hall 103
New York, NY 10031
(212) 650-7118
www.ccny.cuny.edu
Bachelor of architecture degree
awarded.

Columbia University
Graduate School of Architecture,
Planning and Preservation
New York, NY 10027
(212) 854-3510
www.arch.columbia.edu
Master of architecture degree
awarded.

Cooper Union
Irwin S. Chanin School of
Architecture
New York, NY 10003-7183
(212) 353-4220
www.cooper.edu/architecture/arch.
text.html
Bachelor of architecture degree
awarded.

Cornell University
Department of Architecture
143 East Sibley
Ithaca, NY 14853-6701

(607) 255-5236
www.aap.cornell.edu/index.html
Bachelor of architecture degree
awarded.

New York Institute of Technology
School of Architecture and Design
Old Westbury, NY 11568
(516) 686-7593
www.nyit.edu
Bachelor of architecture degree
awarded.

Parsons School of Design
Department of Architecture and
Environmental Design
66 Fifth Avenue
New York, NY 10011
(212) 229-8955
www.parsons.edu
Master of architecture degree
awarded.

Pratt Institute
School of Architecture
200 Willoughby Avenue
Brooklyn, NY 11205
(718) 399-4308
www.pratt.edu/arch/index.html
Bachelor and master of architecture
degrees awarded.

Rensselaer Polytechnic Institute
School of Architecture
110 Eighth Street
Troy, NY 12180-3590
(518) 276-6460
www.rpi.edu/dept/arch
Bachelor and master of architecture
degrees awarded.

State University of New York at
Buffalo
School of Architecture
and Planning
112 Hayes Hall
3435 Main Street
Buffalo, NY 14214-3087
(716) 829-3483, ext. 104
www.ap.buffalo.edu
Master of architecture degree
awarded.

Syracuse University
School of Architecture
103 Slocum Hall
Syracuse, NY 13244-1250
(315) 443-2256
http://mirror.syr.edu/soa.html
Bachelor and master of architecture
degrees awarded.

North Carolina
University of North Carolina at
Charlotte
College of Architecture
Charlotte, NC 28223
(704) 547-2358
www.coa.uncc.edu
Bachelor and master of architecture
degrees awairded.

North Carolina State University
Department of Architecture
Box 7701
Raleigh, NC 27695-7701
(919) 515-8350
www.ncsu.edu/design
Bachelor and master of architecture
degrees awarded.

North Dakota
North Dakota State University
Department of Architecture and
Landscape Architecture
SU Station, P.O. Box 5285
Fargo, ND 58105
(701) 237-8614
www.ndsu.nodak.edu/arch
Bachelor of architecture degree
awarded.

Ohio
University of Cincinnati
School of Architecture and Interior
Design
Cincinnati, OH 45221-0016
(513) 556-6426
www.daap.uc.edu
Bachelor and master of architecture
degree awarded.

Kent State University
School of Architecture and
Environmental Design
Kent, OH 44242
(330) 672-2917
www.saed.kent.edu/SAED
Bachelor of architecture degree
awarded.

Miami University
Department of Architecture
205 Presser Hall
Oxford, OH 45056
(513) 529-1964
www.muohio.edu
Master of architecture degree
awarded.

Ohio State University
Austin E. Knowlton School of
Architecture

Columbus, OH 43210
(614) 292-1012
www.arch.ohio-state.edu
Master of architecture degree
awarded.

Oklahoma
University of Oklahoma
Division of Architecture
Norman, OK 73019-0265
(405) 325-3990
www.arch.ou.edu
Bachelor and master of architecture
degrees awarded.

Oklahoma State University
School of Architecture
Stillwater, OK 74078-0185
(405) 744-6043
http://masters.ceat.okstate.edu
Bachelor of architecture degree
awarded.

Oregon
University of Oregon
Department of Architecture
School of Architecture and the
Applied Arts
1206 University of Oregon
Eugene, OR 97403
(541) 346-3656
*http://architecture.uoregon.edu/
windex.html*
Bachelor and master of architecture
degrees awarded.

Pennsylvania
Carnegie Mellon University
Department of Architecture
201 College of Fine Arts
Pittsburgh, PA 15213-3890
(412) 268-2355

www.arc.cmu.edu
Bachelor of architecture degree
awarded.

Drexel University
Department of Architecture
Philadelphia, PA 19104
(215) 895-2409
*www.coda.drexel.edu/departments/
architecture*
Bachelor of architecture degree
awarded.

University of Pennsylvania
Department of Architecture
207 Meyerson Hall
Philadelphia, PA 19104-6311
(215) 898-5728
www.upenn.edu/gsfa
Master of architecture degree
awarded.

Pennsylvania State University
College of Arts and Architecture
206 Engineering Unit C
University Park, PA 16802-1425
(814) 865-9535
www.arch.psu.edu
Bachelor of architecture degree
awarded.

Philadelphia College of Textiles
and Science
School of Architecture and Design
School House Lane and Henry
Avenue
Philadelphia, PA 19144-5497
(215) 951-2896
www.philacol.edu/archdes.ad.htm
Bachelor of architecture degree
awarded.

Temple University
Architecture Program
Twelfth and Norris Streets
Philadelphia, PA 19122
(215) 204-8813
www.temple.edu/architecture
Bachelor of architecture degree
awarded.

Puerto Rico
Polytechnic University of Puerto ico
Architecture Program
Hato Rey, PR 00918
(787) 754-8000
www.pupr.edu
Bachelor of architecture degree
awarded.

University of Puerto Rico
School of Architecture
P.O. Box 21909
San Juan, PR 00931-1909
(787) 250-8581
www.upr.edu
Master of architecture degree
awarded.

Rhode Island
Rhode Island School of Design
Department of Architecture
2 College Street
Providence, RI 02903
(401) 454-6281
www.risd.edu
Bachelor and master of architecture
degrees awarded.

Roger Williams University
School of Architecture
One Old Ferry Road
Bristol, RI 02809

(401) 254-3605
www.rwu.edu
Bachelor of architecture degree awarded.

South Carolina
Clemson University
College of Architecture, Arts and Humanities
Clemson, SC 29634-0501
(864) 656-3084
http://hubcap.clemson.edu/aah
Master of architecture degree awarded.

Tennessee
University of Tennessee at Knoxville
College of Architecture and Planning
Knoxville, TN 37996-2400
(865) 974-5265
www.arch.utk.edu
Bachelor and master of architecture degrees awarded.

Texas
University of Houston
College of Architecture
Houston, TX 77204-4431
(713) 743-2400
www.arch.uh.edu
Bachelor and master of architecture degrees awarded.

Prairie View A & M University
Department of Architecture
P.O. Box 397
Prairie View, TX 77446-0397
(936) 857-2014
www.pvamu.edu
Bachelor and master of architecture degrees awarded.

Rice University
School of Architecture
6100 Main Street
Houston, TX 77005-1892
(713) 527-4044
www.arch.rice.edu
Bachelor and master of architecture degrees awarded.

University of Texas at Arlington
School of Architecture
Box 19108
Arlington, TX 76019
(817) 272-2801
www.uta.edu/architecture
Master of architecture degree awarded.

University of Texas at Austin
School of Architecture
Goldsmith Hall 2.308
Austin, TX 78712
(512) 471-1922
www.ar.utexas.edu
Bachelor and master of architecture degrees awarded.

Texas A & M University
Department of Architecture
College Station, TX 77843-3137
(979) 845-0129
http://archone.tamu.edu
Master of architecture degree awarded.

Texas Tech University
College of Architecture
P.O. Box 42091
Lubbock, TX 79409-2091
(806) 742-3136

www.ttu.edu/~arch
Bachelor and master of architecture
degrees awarded.

Utah
University of Utah
Graduate School of Architecture
Salt Lake City, UT 84112
(801) 581-8254
www.arch.utah.edu
Master of architecture degree
awarded.

Vermont
Norwich University
Division of Architecture
and Art
Northfield, VT 05663
(802) 485-2620
www.norwich.edu
Bachelor and master of architecture
degrees awarded.

Virginia
Hampton University
Department of Architecture
Hampton, VA 23668
(757) 727-5440
www.hampton.edu
Bachelor of architecture degree
awarded.

University of Virginia
School of Architecture
Campbell Hall
Charlottesville, VA 22903
(434) 924-3715
www.virginia.edu/~arch
Master of architecture degree
awarded.

Virginia Polytechnic Institute
and State University
College of Architecture and Urban
Studies
Blacksburg, VA 24061-0205
(540) 231-6416
www.caus.vt.edu
Bachelor and master of architecture
degrees awarded.

Washington
University of Washington
Department of Architecture
Box 355720
Seattle, WA 98185-5720
(206) 685-8454
*www.arch.washington.edu/HTML/
ARCH*
Master of architecture degree
awarded.

Washington State University
School of Architecture
P.O. Box 64220
Pullman, WA 99164-2220
(509) 335-5539
www.arch.wsu.edu
Bachelor and master of architecture
degrees awarded.

Wisconsin
University of Wisconsin at
Milwaukee
Department of Architecture
P.O. Box 413
Milwaukee, WI 53201
(414) 229-4016
www.sarup.uwm.edu
Master of architecture degree
awarded.

One may receive more complete information about bachelor's- and master's-level architecture programs from the Association of Collegiate Schools of Architecture (1735 New York Avenue, N.W., Washington, D.C. 20006, 202-785-2324, *www.acsa-arch.org*).

The National Council of Architecture Registration Boards administers tests in all fifty states for architects wishing to be licensed. Thirty states around the country require that architects have degrees from schools accredited by the National Architectural Accrediting Board for licensing, and the specific level of one's degree (bachelor or master of architecture) is not a criterion. In the other states, working as an intern for a licensed architect for a certain number of years is a sufficient education.

Interior Design

Just as in architecture, the field of interior design attracts a certain number of people with studio art training. "It's an advantage to have a fine arts background," said Sally Levine, director of the interior design program at the Boston Architectural Center in Massachusetts. "Those people are already comfortable working in the visual domain and can visualize conceptually. They also have a wealth of visual experience to draw upon."

Interior design exists as a field between architecture and interior decoration: designers may devote a considerable amount of their attention to furniture and wall coverings for homeowners, as do interior decorators, but their reach also extends to mapping the physical layout of interior spaces for homes as well as for businesses, churches, hospitals, and institutions. They may design a kitchen or casework, for instance, which a decorator is unlikely to do. Levine noted that the transition from studio art to interior design is often fluid, as two-, three-, and four-dimensional skills are involved. In the two-dimensional area, for instance, one may become involved in the composition of a facade, wallpaper patterns, textures, color, and lighting. Three-dimensionally, "you are creating space with other objects, such as furniture. You may arrange a collection as a composition," she said. In the fourth dimension (time), "moving through an interior creates a cinematic unfolding of events."

A number of international membership organizations provide information, additional education, and certification for interior designers, including:

American Society of Interior Design
608 Massachusetts Avenue, N.E.
Washington, D.C. 20002
(202) 546-3480
www.asid.org
There are two additional Web sites
for members only, providing job
listings and workshops.

Interior Designers of Canada
65 Wellesley Street East
Suite 303
Toronto, Ontario M4Y 1H6
Canada
(416) 964-0906
www.interiordesigncanada.org

International Federation of Interior
Designers
P.O. Box 19126
1000 GC
Amsterdam, The Netherlands
31-20-627-6820

International Interior Design
Association
341 Merchandise Mart
Chicago, IL 60654-1194
(312) 467-1950
www.iida.org

A number of schools in the United States and Canada offer master's-level degrees in interior design (designating them MA, MFA, MID, or MS), with a core curriculum that emphasizes research methods, building construction and support systems, theory and principles of design, art and architecture history, building codes, and the performance of materials. The schools include:

Alabama
University of Alabama
Department of Clothing, Textiles
and Interior Design
College of Human Environmental
Sciences
Box 870158
Tuscaloosa, AL 35487-0158
(205) 348-8135
www.ua.edu

Arizona
Arizona State University
School of Design
College of Architecture and
Environmental Design
Tempe, AZ 85287-2105

(602) 965-8684
www.asu.edu

California
Academy of Art College
Graduate School
79 New Montgomery Street
San Francisco, CA 94105
(415) 263-4181
www.academyart.edu

California State University
at Long Beach
Department of Family and
Consumer Sciences
College of Health and Human
Services

1250 Bellflower Boulevard
Long Beach, CA 90840-0501
(562) 985-4484
www.sculb.edu

San Diego State University
Interior and Environmental Design
College of Professional Studies and
Fine Arts
San Diego, CA 92182-0214
(619) 594-6511
www.sdsu.edu

San Francisco State University
Consumer and Family Studies
Department
College of Health and Human
Services
1600 Holloway Avenue
San Francisco, CA 94312
(415) 338-1750
www.sfsu.edu

Colorado
Colorado State University
Department of Design,
Merchandising and Consumer
Science
150 Aylesworth, S.E.
Fort Collins, CO 80523-1575
(970) 491-5141
www.colostate.edu

District of Columbia
Mount Vernon College
Interior Design Program
School of Arts and Design
2100 Foxhall Road, N.W.
Washington, D.C. 20007
(202) 625-4551
www.gwu.edu/~art

Florida
Florida State University
Department of Interior Design
School of Visual Arts and Dance
105 Fine Arts Annex
Tallahassee, FL 32306-2051
(850) 644-1436
www.fsu.edu

University of Florida
Department of Interior Design
College of Architecture
P.O. Box 115705
Gainesville, FL 32611-5705
(352) 392-0252
www.arch.ufl.edu/interior

Georgia
Georgia State University
Interior Design Program
College of Art and Design
University Plaza
Atlanta, GA 30303-3083
(404) 651-0494
www.gsu.edu

Savannah College of Art and Design
Department of Interior Design
School of Building Arts
342 Bull Street
P.O. Box 3146
Savannah, GA 31401-3146
(912) 238-2409
www.scad.edu

University of Georgia
Department of Art and Interior
Design
School of Arts
Visual Arts Building
Athens, GA 30602-4102

(706) 542-1511
www.uga.edu

Illinois

Columbia College
The Graduate School
Department of Art and Design
600 South Michigan Avenue
Chicago, IL 60605-1996
(312) 663-1600
www.colum.edu/undergraduate/
artanddesign

Illinois State University
Department of Family and
Consumer Sciences
College of Applied Science and
Technology
Turner Hall
Normal, IL 61790-5060
(309) 438-5802
www.cast.ilstu.edu/fcs/Courses

Indiana

Indiana State University
Department of Family and
Consumer Sciences
Terre Haute, IN 47809
(812) 237-3311
http://www.baby.indstate.edu/artsci/
heco/

Indiana University
Department of Apparel,
Merchandising and Interior Design
A.M.I.D.
Memorial Hall East 232
Bloomington, IN 47405-2201
(812) 855-6425
www.indiana.edu/%7Eamid/
masters/id1.html

Iowa

Iowa State University
Interior Design Program
Department of Art and Design
158 College of Design
Ames, IA 50011-3092
(515) 294-8898
www.design.iastate.edu

Kansas

Kansas State University
Department of Clothing, Textiles
and Interior Design
College of Human Ecology
225 Justin Hall
Manhattan, KS 66506-1405
(785) 532-1318
www.humec.ksu.edu

Kentucky

University of Kentucky
Department of Interior Design,
Merchandising and Textiles
College of Human Environmental
Sciences
113 Funkhouser Building
Lexington, KY 40506-0054
(606) 257-3106
www.uky.edu

Louisiana

Louisiana Tech University
Interior Design Program
School of Architecture
P.O. Box 3175 T.S.
Ruston, LA 71272-0001
(318) 257-2816
www.vm.cc.LaTech.edu

Massachusetts

Boston Architectural Center
School of Interior Design

320 Newbury Street
Boston, MA 02115-2703
(617) 585-0219
www.the-bac.edu

University of Massachusetts
Design Area
Art Department
361 Fine Arts Center
Amherst, MA 01003
(413) 545-6937
www.art.umass.edu

Michigan
Eastern Michigan University
Interior Design Program
202 Roosevelt Hall
Ypsilanti, MI 48197
(313) 487-0652
www.emich.edu

Michigan State University
Department of Human
Environments and Design
204 Human Ecology Building
East Lansing, MI 48824-1030
(517) 353-3052
www.pilot.msu.edu

Minnesota
Minnesota State University at
Mankato
Interior Design Program
Design and Human Environment
MSU Box 44
Mankato, MN 56002-8400
(507) 389-6385
www.mnsu.edu

University of Minnesota
Interior Design Program
Department of Design, Housing
and Apparel

College of Human Ecology
240 McNeal Hall
1985 Buford Avenue
St. Paul, MN 55108-6136
(612) 624-6232
www.umn.edu

Missouri
University of Missouri at Columbia
Department of Environmental Design
College of Human Environmental
Sciences
137 Stanley Hall
Columbia, MO 65211
(573) 882-7224
http://www.missouri.edu

New York
Bard Graduate Center for Studies
in the Decorative Arts, Design
and Culture
Student Academic Services
18 West 86th Street
New York, NY 10024
(212) 501-3056
www.bgc.bard.edu

Cornell University
Department of Design and
Environmental Analysis
New York State College of Human
Ecology
Martha Van Rensselaer Hall
Ithaca, NY 14853-4401
(607) 255-1950
www.dea.human.cornell.edu

New York School of Interior Design
170 East 70th Street
New York, NY 10021-5110
(212) 427-1500
www.nyssid.edu

Pratt Institute
Department of Interior Design
School of Art and Design
200 Willoughby Avenue
Brooklyn, NY 11205-3897
(718) 636-3630
www.pratt.edu

Syracuse University
Department of Interior Design
College of Visual and Performing Arts
334 Smith Hall
Syracuse, NY 13244-1180
(315) 443-2455
www.vpa.syr.edu

North Carolina
East Carolina University
Environmental Design Program
School of Art
Greenville, NC 27858-4353
(919) 328-6267
www.ecu.edu

University of North Carolina at
Greensboro
Department of Housing and Interior
Design
School of Human Environmental
Sciences
259 Stone Building
Greensboro, NC 27412-5001
(336) 334-5320
http://www.uncg.edu/hid/

Ohio
Ohio State University
Department of Industrial, Interior
and Visual Design
Hopkins Hall
128 North Oval Mall
Columbus, OH 43210-1318

(614) 292-6746
www.osu.edu

Oklahoma
Oklahoma State University
Department of Design, Housing and
Merchandising
431 Human Environmental Sciences
Stillwater, OK 74078-6142
(405) 744-5035
www.okstate.edu

Oregon
Oregon State University
Department of Apparel, Interior
Design, Housing and Merchandising
College of Human Economics
224 Milam Hall
Corvallis, OR 97331-5101
(541) 737-3796
www.orst.edu

University of Oregon
Interior Architecture Program
College of Architecture and Applied
Arts
Eugene, OR 97403
(503) 346-3656
www.uoregon.edu

Pennsylvania
Drexel University
Department of Design
College of Design Arts
32nd and Chestnut Streets
Philadelphia, PA 19104
(215) 895-4943
www.drexel.edu

South Carolina
Winthrop University
Department of Art and Design

School of Visual and Performing
Arts
140 McLauren Hall
Rock Hill, SC 29733
(803) 323-2126
www.winthrop.edu/artdesign

Tennessee
Memphis State University
Interior Design Program
Department of Art
College of Communication and Fine
Arts
Jones Hall, Room 201
Memphis, TN 38152-6715
(901) 678-2071
www.cc.memphis.edu

Texas
Texas Tech University
Department of Merchandising,
Environmental Design and
Consumer Economics
College of Human Sciences
P.O. Box 41162
Lubbock, TX 79409-1162
(806) 742-3050
www.ttacs.ttu.edu

University of North Texas
Interior Design Program
School of Visual Arts
P.O. Box 5098
Denton, TX 76203-5098
(940) 565-4010
www.unt.edu/pais/insert/uintd.htm

Virginia
Marymount University
Interior Design Department
School of Arts and Sciences

2807 North Glebe Road
Arlington, VA 22207-4299
(703) 284-1671
www.marymount.edu

Virginia Commonwealth University
Department of Interior Design
School of the Arts
325 North Harrison Street
P.O. Box 2519
Richmond, VA 23284-2519
(804) 828-1713
www.vcu.edu

Virginia Polytechnic Institute and
State University
Department of Housing, Interior
Design and Residential
Management
College of Human Resources
240 Wallace Hall
Blacksburg, VA 24061-0424
(540) 231-3295
www.vt.edu

Washington
Washington State University at
Pullman
Department of Apparel,
Merchandising and Interior Design
College of Agriculture and Home
Economics
Room 202, White Hall
Pullman, WA 99164-2020
(509) 358-4543
www.wsu.edu

Washington State University
at Spokane
601 West First Avenue
Spokane, WA 99201-3899

(509) 358-4543
www.wsu.edu

Wisconsin
University of Wisconsin at Madison
Department of Environment,
Textiles and Design
College of Family Residences and
Consumer Sciences
1300 Linden Drive
Madison, WI 53706
(608) 262-2651
http://sohe.wisc.edu/depts/etd_letd.
htm

Canada
University of Manitoba
Department of Interior Design
Room 216
Architecture II Building
Winnipeg, Manitoba R3T 2N2
Canada
(204) 474-9566
www.arch.unmanitoba.ca

For more information on master's-level programs in interior design, contact the Interior Design Educators Council (9202 North Meridian Street, Suite 200, Indianapolis, IN 46260-1810, 317-816-6261, www.idec.org). There are currently 127 colleges and universities in the United States and Canada offering undergraduate programs in interior design, and one may request a list of these schools and information about their programs from the Foundation for Interior Design Education Research (FIDER, 60 Monroe Center, N.W., Suite 300, Grand Rapids, MI 49503-2920, 616-458-0400, www.fider.org).

CHAPTER SEVEN ————————————————

Making a Living as a Printmaker or Sculptor

S OMETIMES, IT IS THE MINOR, incidental things one learns at school
that prove most useful in one's career: Seniors in BFA programs
and MFA candidates usually create a final exhibition, requiring
them to quickly learn about how to move artwork properly, how to dis-
play it attractively, perhaps how to frame pieces or build cases or
pedestals for them.

The art they created as students may be far removed from the type or
style of work they create in the years that follow, but those quickly-learned
skills at the time of their school show enabled these artists to find jobs as
framers, art handlers, exhibition designers or in some other related field.
Additionally, a rigorous training in the technical aspects of artmaking not
only better enables artists to express their own ideas and visions; it also
may allow them to help others achieve their goals, such as in the hands-on
fields of printmaking and sculpture foundry work.

— 220

Supporting Oneself as a Printmaker

As with everything else in the art world, there is no one way to making a living primarily through the sale of prints, as various artists discover and develop their audience in diverse ways. Mary Tikeman, an etcher in Northampton, Massachusetts, began her career by entering national print competitions. Many print collectors attend these shows, and the prizewinners often gain a slew of buyers whose interest may last for years. "I started getting a lot of attention after I won prizes at the National Arts Club and the Print Club in Philadelphia," she said. "I could print up an edition and know that there was a waiting market for them." Finding other printmakers is not all that difficult, since there are a number of printmakers' organizations that hold meetings, demonstrations, and workshops; publish newsletters; and sponsor exhibitions, some of which may travel to different venues. With some organizations, membership is by jury, while others allow anyone to join. In North America, they include the following:

Baren Woodcut Forum
440 S.W. 198th Street
Aloha, OR 97007
www.barenforum.org

Boston Printmakers
c/o Emmanuel College
400 The Fenway
Boston, MA 02115
www.bostonprintmakers.org
$25 annual membership

California Society of Printmakers
2434 East 23rd Street
Oakland, CA 94601
Messages: (415) 905-4296
www.caprintmakers.org
$40 annual membership

Northwest Print Council
c/o Portland Art Museum
922 S.W. Main
Portland, OR 97205

(503) 525-9259
www.northwestprintcouncil.org
$45 annual membership

Nova Scotia Printmakers Association
2565 Kline Street
Halifax, Nova Scotia B3L 2X6
Canada
$15 (Canadian) annual membership

Pittsburgh Print Group
c/o Pittsburgh Center for the Arts
6300 Fifth Avenue
Pittsburgh, PA 15232
www.pittsburghprintgroup.org
$30 annual membership

Conseil quebecois de l'estampe
811 rue Ontario est
Montreal, Quebec J0T 2No
Canada
$50 (Canadian) annual membership

Florida Printmakers
P.O. Box 1181
Tarpon Springs, FL 34688
$15 annual membership

Honolulu Printmakers
1111 Victoria Street
Honolulu, HI 96814
(808) 536-5507
www.honoluluprintmakers.org
$20 annual membership

Maryland Printmakers
8915 Montgomery Avenue
Chevy Chase, MD 20815
www.marylandprintmakers.org
$30 annual membership

Manitoba Printmakers' Association
11 Martha Street
Winnipeg, Manitoba R3B 1A2
Canada
(204) 779-6243
www.printmakers.mb.ca

Mid-America Print Council
School of Arts & Letters
Indiana University Southeast
New Albany, IN 47150
(715) 824-5403
$15 annual membership

Monotype Guild of New England
110 Homestead Lane
Teaticket, MA 02536
(509) 495-0870
www.mgne.org

New York Society of Etchers
120 West 86th Street
New York, NY 10024
www.nysetchers.org

The Print Center
1614 Latimer Street
Philadelphia, PA 19103
(215) 735-6090
www.printcenter.org

The Print Consortium
6121 N.W. 77th Street
Kansas City, MO 64151
www.printexhibits.com

Printmakers Association of
Washington
Arts House
P.O. Box 78
6 Roe Street
Northbridge, WA 90030

Printmaking Council of New Jersey
440 River Road
Somerville, NJ 08876
(980) 725-2110
www.printnj.org

Printmakers Council of Prince
Edward Island
RR#4 Breadalbane
Prince Edward Island CoA 1E0
Canada
(902) 621-0361

Printmakers of Cape Cod
Box 945
South Orleans, MA 02662

Society of American Graphic
Artists
SAGA Artist Printmakers
32 Union Square
New York, NY 10003
(212) 260-5706
$35 annual membership

Southern Graphics Council
Lamar Dodd School
Visual Arts Building
University of Georgia

Athens, GA 30602
www.utc.edu/-utesgc
$20 annual membership

One may also contact the American Print Alliance (302 Larkspur Turn, Peachtree City, GA 30269, 770-486-6680, *www.printalliance.org*), a nonprofit consortium of printmakers' councils that publishes the biannual journal *Contemporary Impressions* as well as a *Guide to Print Workshops in Canada and the United States* ($20 in the United States, $28 for shipments to Canada).

Galleries also showed an interest in Tikeman's work, starting with Associated American Artists in New York City in the early 1980s and growing thereafter. She tried to have a sizable number of galleries, between fifteen and twenty around the United States, representing her work in order to create a volume of sales. "If you have a popular painting, you sell it once and that's the end. With prints, you can sell the same work again and again if the image is popular." Selling art is a fickle activity, and there are "spurts of selling by some galleries and no activity at others. I have to keep finding new places to show, and I try to keep in touch with my galleries, so they'll remember to display my work." Finding a gallery or print dealer is relatively uncomplicated. The membership directories of the International Fine Print Dealers Association (15 Gramercy Park South, Suite 7A, New York, NY, 10003; *www.printdealers.com/index.cfm*) and the Art Dealers Association of America (575 Madison Avenue, New York, NY 10022; 212-940-8590; *www.artdealers.org*) provide selective lists.

After years of entering lots of shows in order to gain exposure and prizes, Tikeman cut back, strategically aiming for only the most prestigious events or entering "if the juror is someone I want to have see my work—a museum curator, for instance". Finding the appropriate shows to enter is a job in itself, as there are thousands of juried shows that take place around the country during the year. The September issue of *Sunshine Artist (www.sunshineartist.com)* lists the top 200 shows, based on 1–10 ratings by readers, and the magazine also publishes *The Audit Book & Show Guide* ($54, includes U.S. shipping costs), which provides a quick overview, historical trends, and contact information for the more than 5,000 shows in the U.S. and Canada.

Yet another source of information is *The Harris List* (P.O. Box 142, LaVeta, CO 81055, 719-742-3146, $55), published annually and focusing on 180 mostly high-end arts and crafts shows. The publisher, Dr. Larry Harris, also works privately with individual artists and craftspeople, helping them select the most appropriate shows to enter by examining their slides, product line and show track record.

While Tikeman researches juried shows and galleries, lithographer Enid Mark of Wallingford, Pennsylvania, looks for libraries with special collections, because these are the principal buyers of her work. She creates editions of artist books (usually fifty or sixty in an edition, each selling for $1,000), in which her imagery accompanies the poetry of various women, such as Elizabeth Bishop, Edna St. Vincent Millay, Sylvia Plath, and Adrienne Rich. "Making money depends on the kinds of works you produce," Mark said. "One-of-a-kind artist books are very labor-intensive; you sell one, and that's that. I don't know how anyone makes money on those kinds of books."

The two-pronged approach of producing books in editions and combining her images with well-established text expands her market from just the buyers of art to collectors of rare books and even college women's studies programs. "Libraries and special collectors are more likely to find money in their budgets to make purchases than are institutions that just buy art, because my books are not just images," she said, adding that institutional book collectors tend to "want things in depth. Once they buy one book, they'll buy others. The key is to get them started."

To that end, Mark seeks out directories of special collectors all over the world, many of which are cross-referenced for poetry, history, fine art, print publishing and other categories. One of the most thorough sources is R. R. Bowker's *Subject Collections: A Guide to Special Book Collections and Subject Emphases as Reported by University, College, Public, and Special Libraries and Museums in the United States and Canada.*

She also visits special collections (frequently lugging books with her) and researches bibliophile clubs and book centers around the United States because these represent active book collectors. Mark creates a prospectus for each edition, describing the book (paper and typography, printing and binding methods, size, text and artwork), which she sends to previous and potential buyers, following up with telephone calls several weeks later. "Perseverance is a very important part of selling," she said. Mark also needs and has a strong sense of confidence in her ability to find buyers for her books. Her up-front expenses—between $6,000 and $10,000 for the printer, $100 and $150 per book for binding and purchasing the right to use copyrighted material—require her to sell half of an edition in order to break even.

Carl Hoffner of Fayetteville, New York, started out as a painter, switching to lithographic printmaking in part because of "the challenge of the medium" and in part because "it's easier to sell one inexpensive print and sell a lot of them than to sell one expensive painting." He initially bought a $2,000 lithography press and read the instruction book to produce his early print editions. Hoffner's work is sold in galleries around the United States, Europe, Australia and Asia.

At festivals and shows, Hoffner set up a booth with his artwork, greeting people and discussing his work with them up to twelve hours per day. "It's hard work to do these shows," he said. "It takes a lot of stamina to stand around talking to people and being friendly, listening to them and seeming interested in what they have to say." Sales skills are rarely taught in art schools; Hoffner learned by doing and by listening to audiotapes that describe how to sell to people while driving to one fair or another.

For years, he set up a booth (the booth fees averaged $250–$400) at between eighteen and twenty-four fairs and festivals per year, using the remainder of his time to print, frame, mat and ship his work as well as keep up with the paperwork of applying for admission to all these shows. "It's easy to be successful at an artist fair," Hoffner said. "There are going to be 200,000 to 500,000 people walking right past you, and a percentage of them are going to stop by and buy something. They're all looking for something for their homes. You simply have to identify what their needs are and satisfy them."

After many years, Hoffner built up a list of 2,000 to 3,000 customers, to whom he sent an eight-page catalogue, advertising more than a dozen works. The other side of volume sales is productivity, and Hoffner created sixteen new print editions annually with 170 prints per edition, in order to satisfy mailing list collectors, galleries, and thousands of walk-ins at the fairs and festivals. He currently keeps buyers abreast of his work through his Web site, *www.hoffnerart.com.*

By the mid-1990s, Hoffner decided to concentrate on the high-end shows, such as the annual Art Expo in New York City. "I worked for a year and a half to make the work for the New York Art Expo," he said, producing eighteen editions of 110 prints each. "The cost of doing that show and the cost of printing the work for the show came to $50,000. It's like betting your house: the 10 x 10-foot booth was $4,000 alone, and then there's the hotel and food costs, but the years of doing the festivals had taught me to have confidence and to invest in myself." The show turned out to be a positive experience, as Hoffner sold almost 60 percent of his work from his booth. By the end of 1995, he had sold 90 percent of his work. The next year, he said, he did "even better."

Selling prints in large enough volume to make a living is a problem in itself, but one soon realizes that printmaking itself is an expensive activity, requiring machinery, inks, paper, printing plates, chemicals and other sundry accessories that may run into thousands (or tens of thousands) of dollars. One way to gain use of printing presses is teaching in an art school or college art department. "The major benefit of working here, other than getting a salary, is access to a well-equipped studio space," said Carmon Colangelo, director of the Lamar Dodd School of Art at the University of

Georgia in Athens. He noted that he creates print editions of 30 x 40 inches in quantities of between ten and forty at the undergraduate and graduate studios, and this work is "considered part of my teaching and research as an artist. It would cost me $4,000–$5,000 to do an edition if I went to an outside studio," although he added that outside studios don't require artists to help mix colors and clean up after they are done as a college facility does.

Employment opportunities for printmakers in art schools and university art departments are slightly better than for painters and sculptors, because there are fewer printmakers trained in a variety of printmaking media and practices with whom to compete. However, one should keep in mind that, although there are fewer applications for every advertised teaching position in printmaking, there are also fewer jobs on the whole. Another option to gain use of printing presses is working in a print studio.

Working in a Print Studio

Kelly Driscoll, a printmaker in Brooklyn, New York, has worked in offices where the day ends at five o'clock and then she begins her second shift as an artist. However, she prefers working part-time as a master printer at the Printmaking Workshop in New York City, because the work she does and the work she wants to do blend together more easily. "In a printmaking studio, you see art, talk about art, work with artists, hear about opportunities for artists, and get a network going," she said. Certainly, few printmakers can afford to purchase printing presses designed for full-sheet sizes, and only those who have a sizable, reliable market will be able to use a print studio without also working in it, either as an employee or as a print instructor at an art school or university. Print studios have the facilities and equipment for employees and instructors to pursue their own work after hours, usually free of charge or at significantly discounted rates. The technical skills developed by printmakers who have worked in a print studio may lead to college-level teaching. For example, of the eighty-one University of Wisconsin graduate students who had worked as assistants at Tandem Press in Madison between 1987 and 1997, twenty-one responded to a survey: fourteen were teaching (twelve on the college level, two at public schools), while the others were either working as full-time artists or printers.

Some print studios are, in fact, associated with art schools. Tandem Press is affiliated with the University of Wisconsin, employing approximately ten students (mostly MFA candidates, occasionally a BFA senior) as part-time assistants. GraphicStudio/USF in Sarasota, Florida, is connected to the fine art department of the University of South Florida, and

MLK Studio in New York has had a longtime association with Pratt Institute. Tamarind Institute in Albuquerque, New Mexico, is both a professional print studio and a school, offering a two-year certificate program in printmaking. Every year, eight students (four from other countries) are selected by Tamarind to take part in a professional printer training program, learning the theory, chemistry, and processes of lithography, applying them to real-life projects. During the first year, students work with graduate students at the University of New Mexico on their print projects; in the second year, students enter the professional studio, working with artists. During the first year, students pay $650 per semester, $700 per month living expenses, and $850 or so in materials fees. They also take courses in the history of printmaking, marketing, contracts and other legal issues, grant writing, and how to set up and run a print studio. Only two of the eight are invited to continue into the second year. The others, according to Tamarind director Marjorie Devon, go on to teach printmaking on the college level or open their own print studios and workshops. "Some of the six"—who don't continue into the second year—"simply wash-out; they don't want to work with other artists," she said. "It takes a distinctly flexible and agreeable person, who is willing to subvert his own ego in order to help others achieve their goals. We often joke around here that printers ought to go to acting class, in order to learn how to deal with people."

Being an artist and working with artists are related but still quite distinct activities that not everyone can do equally well. Tim Sheefley, a printmaker and owner of Corridor Press in Oneonta, New York, noted that when he entered Tamarind's program in 1978, he had to "struggle with the question: Am I going to be a printmaker or learn to be a printer? Going in, you think you are an artist, but Tamarind doesn't really want you to be an artist. That can be a little tough to take."

Working for other artists requires a certain temperament and personality. Sheefley said that "for some reason or other, I've never had difficulties working with people whose artwork I don't like." He also said that his own interests have been stimulated by other artists' work but that there has never been a direct influence on the art he continues to produce. Driscoll, on the other hand, stated that printing can be "very difficult if you don't appreciate someone else's style or manner of work." On the most basic level, working for others is an interruption of an artist's own work. "When you're around someone else's work all the time," she said, "it's very easy to be influenced by it. Sometimes, it makes me have to stop my own work, because I'm so mentally preoccupied with another person's project."

The most difficult clients for Muhammed Khalil, a printmaker and owner of MLK Studio, are "those artists who don't know anything about technique. They say, 'Why can't you just do something?' Those who know something about printmaking will listen to me." He said that it has been difficult for him to be predominantly known as a printer. For the directors of New York City's Pace Gallery, for whom he has been hired to print work by gallery artists, "it is easier for them to deal with me as a printer than as an artist. They prefer to give orders than to listen to them."

Printing for other artists is as lucrative, as the artists are well known. Khalil, who has printed editions for Louise Nevelson, Jim Dine, and Cy Twombly, noted that "if you want to make good money, find a big-name artist. "Whenever you make prints for big-name artists, you get to keep one or two prints, and that's where the big money is. A print by Jim Dine goes for $30,000." Otherwise, Khalil charges $75 per hour, and the cost of creating an edition is dependent upon the number of prints produced, size of the sheet, overall complexity of the project (for instance, black-and-white or various colors), and who is paying. When artists are self-publishing, Sheefley stated, the jobs are less expensive, sometimes as low as $500. When a dealer is footing the bill, artists are more adventurous, and the costs may reach $12,000. Some printers charge by the day or by the project, negotiating with the artist or dealer.

At some print studios, especially those outside major urban areas, printers are hired full- or part-time. In larger cities, where there is more competition among printers and a good supply of people with printing skills, studios usually take on printers only as freelancers, paying them between $12 and $20 per hour. Attrition among full-time employees at print studios is not high (they tend to stay on for years). However, these studios do offer full-time positions to the freelancers with whom they have developed a relationship, and the salaries improve with that change in status. Tandem Press pays full-time associate printers $25,000–$40,000; $40,000–$50,000 for master printers.

There is no directory of print studios in the United States. However, the bimonthly *On Paper* (formerly known as the *Print Collector's Newsletter*, Fanning Publishing Co., Inc., 39 East 78th Street, New York, NY 10021, 212-988-5959, $60) is a journal of the print world, listing new editions—and where they were printed—and containing advertisements from various print studios in the back.

Supporting Oneself as a Sculptor

Barnett Newman was not being nice when he said that a sculpture is something "I bump into when stepping back to look at a painting." A sculpture is

a physical impediment in a way that paintings usually are not, and he reflected the position—subordinate to two-dimensional artwork—that sculpture occupies in the minds of many people. Sculptors also find far fewer galleries that are interested in or physically capable of showing sculpture, and the expense of buying tools and materials, as well as casting pieces to be produced in editions, would make many people look to another line of work.

As with every other art medium, getting exposure for one's work and attempting to generate sales are critical to establishing a career. Jill Burkee of New York City first began to show her work from her home to friends and business associates of her parents, developing a network of collectors who gave her names, addresses, and telephone numbers of other potential buyers they knew. After a while, hundreds of people were on her list. Dan Ostermiller, Richard MacDonald, and Glenna Goodacre, on the other hand, entered juried competitions, "because you find collectors and dealers through these shows," Ostermiller said. "I did one show a month in the first few years of my career, learning about which shows to enter or to not bother with from other artists. After ten years of this, I had a number of regular collectors, and most of my sales were coming through dealers, so I could weed out a lot of the shows. Now, I do just a couple of shows per year."

Earlier in his career, Ostermiller, who lives in Loveland, Colorado, pursued dealers, but now he is pursued by them. "Getting rejected is a very useful part of the process," he said, "because it forces you to look at your work and at yourself, and ask, What am I doing wrong?" The years of doing show after show, meeting collectors and gallery owners, helped him to better identify his audience and refine his artwork. His criteria for dealers are: that they are "financially sound," which can be judged by talking to other artists and "personally seeing how they live and do business"; that they are able to show sculpture properly ("I can't stand to go into a gallery where sculpture is crowded together, where the ceiling is too low"); and that the "dealers who represent my work also handle work by deceased artists." That last criterion reflects his view that buyers of work by deceased artists "have more money and have better, more important collections."

A rule of thumb among gallery owners is that a large sculpture, prominently and publicly displayed, draws people in, but there should also be a number of small pieces on hand that collectors will actually buy. Ostermiller's work comes in two sizes, monumental or life-sized (selling for $30,000–$200,000, created in editions of between three and twenty) and half-sized or "garden-sized" (four feet tall, selling for $3,500–$6,000, in editions of twenty to thirty). Pricing a sculpture can be an agonizing experience, especially for someone early in a career, because the time and expense to produce the work may be significant, but there is no equation to calculate value.

"Sculpture isn't priced on the cost of producing it," Burkee said. "You price things by building a career"—that is, the price reflects demand. Ostermiller added that, adding up the expense of creating an edition and a dealer commission, he usually breaks even when one-third of an edition is sold, "but that doesn't include my sculpting time."

Most artists start showing their work in smaller, local shows and eventually move to larger, regional and national ones. Richard MacDonald of Monterey, California, however, started big and has only grown. After a career as an illustrator, he inaugurated a career as a sculptor by renting a booth at Art Expo in Los Angeles in 1988. He had created only three sculpture editions at the time, and the cost of fabricating the works and participating in the event was $10,000, but he emerged with a profit and a plan for a new career. According to his son, Richard MacDonald Jr., his father "first sold on his own, and dealers saw that. They approached him and now have forty galleries around the country selling his work." The artist continues to rent a booth at New York's Art Expo, but participating in the show now costs $100,000 ($30,000 to crate and ship pieces; $20,000 for advertising in art, business, and hotel magazines, the costs of a booth rental, sculpture fabrication, and the expense of food, transportation, and lodging for a staff that includes his two children, a bookkeeper, floor assistant, and sales help).

"The yearly advertising budget is in the six-figure range," MacDonald Jr. said. It includes marketing brochures for all galleries handling the artist's work, photographs of each piece, cards with a history on the back for each piece, letters for galleries to send out to prospective buyers (the artist employs an in-house writer) and videos on the artist and his manner of working to show to collectors. The galleries with which MacDonald works are referred to as "subscribing galleries," as they sign on to purchase—rather than take on consignment—a minimum of ten sculptures. When a gallery expresses interest in representing MacDonald's work, "someone from our staff flies out to visit the gallery, in order to make sure it is compatible with the work," MacDonald Jr. said. "Is the gallery large enough for sculpture? Will the work be given its own space? We don't want my father's work mixed in with other sculpture." When an agreement to sell to the gallery is made, a sales training seminar is conducted for gallery staff, describing how to present and light the work, how orders should be filled and what should be said about each piece (a mock sales presentation takes place).

Glenna Goodacre, a sculptor in Santa Fe, New Mexico, said that she was "conscious of the need to build a good résumé" as a way to help her sell work, and she began entering juried competitions, such as those of the National Academy of Design and the National Sculpture Society. "Getting into these shows brought me to the attention of buyers and dealers," she

said. "Becoming a member, then a fellow, of these organizations elevated my status as a sculptor and increased the number of people who wanted to buy or represent my work." Another way she built exposure was doing occasional portraits, since those clients tend to be wealthy and likely prospects to purchase her fine artwork.

"I'm a firm believer in the gallery system," Goodacre said. "If you're not in the public eye, you're forgotten, and galleries keep your work on view." However, she has made her own work quite visible by entering and winning a number of public art competitions, the most notable being the Women's Vietnam Memorial in Washington, D.C., which has given her national renown. That prestige brings more people to galleries to purchase her work, a bonus that creates a dilemma, since during the time (months or longer) that it takes to design, fabricate, and install a monument, "I have little or nothing to send to galleries," she said. Her solution has been to increase "the size of my editions to cover the problem, and I also go back to older works and make new castings in order to supply dealers."

Public Works of Art

It is not always easy for sculptors to go back and forth between their gallery pieces and those created for public sites. Paper (requests for proposals, financial documentation, a portfolio, further correspondence) may be measurable by the yard, and the entire process often takes years. "The [Franklin Delano] Roosevelt Memorial took almost twenty years from when people first talked to me until it was finally completed," Neil Estern, one of five sculptors for the project, noted, citing the debates in Congress concerning whether and how much to pay for it. "With so many public works, you don't know if anything is going to come of it. I was commissioned to do a sculpture for a Holocaust memorial in New York City but, after I had submitted a design, several conservative rabbis objected to it, other rabbis approved it; the controversy effectively killed the project." He added that, "in spite of the difficulties, politics, and inevitable delays, public art can be very challenging, stimulating, and meaningful for the artist as well as for the general public."

The terms "public art" and "monument" are synonymous—the one a newer way of saying the other—yet they are often perceived as different: monuments are traditionally buildings, sculptures, or towers erected as memorials to great events or individuals, whereas the most notable public works of art these days often resemble the artists' gallery work but on a larger, outdoor scale. That characterization may apply to sculptor George Segal, but he noted a distinction between public artwork and

gallery art. "Most artists strive in their work toward expressing personal feelings—that's the modern approach to art," he said. "In public works of art, you are touching on the public psyche. In a democracy, a large group of ordinary people are involved in what you're doing and expressing, and that influenced my work a lot." Segal was one of five sculptors involved in the Roosevelt Memorial, along with Estern, Robert Graham, Tom Hardy, and Leonard Baskin. "I'm the son of a very poor immigrant. My father's admiration for Roosevelt had been so strong, and that colored my work a lot."

Fine art and democracy are not always easy companions, and some artists may chafe under the varying viewpoints of a sponsoring committee, elected officials and members of the general public, all of whom claim the right to express themselves on art and the expenditure of tax dollars. The difference between public and gallery art is most evident in the various stages of applying for and completing a commission. "I've always enjoyed working with people," Jill Burkee said. "My work is in response to someone else's desires. Not so much my private sculpture, but my public pieces are the outcome of a relationship."

Thirty-three states—Alaska, Arkansas, Arizona, California, Colorado, Connecticut, Florida, Hawaii, Illinois, Iowa, Maine, Michigan, Minnesota, Montana, Nebraska, New Hampshire, New Jersey, New Mexico, New York, North Carolina, Ohio, Oregon, Rhode Island, South Carolina, South Dakota, Tennessee, Texas, Utah, Vermont, Virginia, Washington, Wisconsin, and Wyoming—as well as the District of Columbia and the territory of Guam, have either a mandatory or voluntary percent-for-art program that devotes between one-half of 1 percent and 1 percent of all building or renovation expenditures to the purchase of artworks. Almost all of that money is used for public artworks, typically a sculpture placed in an atrium or outside a building, although murals also have been commissioned. The Veterans Administration and the General Services Administration (both federal agencies) as well as scores of cities across the United States have their own percent-for-art programs. Even where the programs are mandatory, there are limitations and exceptions. Vermont, for example, will allocate only up to $50,000 for any one percent-for-art project, while Ohio's mandatory per-cent-for-art law applies only to construction projects costing more than $4 million. States and the federal government often do not purchase public art for border crossing stations or for prisons. Most of these commissions are not limited to residents of the particular city or state. Burkee, who was selected to create a public artwork to satisfy Hawaii's percent-for-art statute, noted that the first time she looked at the building in Honolulu was when "I went to do the installation."

One can learn of opportunities through Web sites, such as:

www.nasaa-arts.org/aoa/aoa_contents.shtml
www.artopportunitiesmonthly.com ($25 annual subscription)
www.artdeadline.com ($24 annual subscription)

Other sources of information on public art commissions are *Sculpture Magazine* (c/o International Sculpture Center, 14 Fairground Road, Hamilton, NJ 08619-3447, 609-689-1051, *www.sculpture.org*, $50 for ten issues per year), which lists commissions in its "Opportunities" section as well as its quarterly *Insider Newsletter; Public Art Review* (2324 University Avenue West, Suite 102, St. Paul, MN 55114, 612-641-1128, *www.publicartreview.org*, $17 for two semi-annual issues); *Sculpture Review* (c/o National Sculpture Society, 56 Ludlow Street, New York, NY 10002, 212-529-1763, *www.sculpturereview.com*, $24 for four quarterly issues plus a bimonthly *NSS News Bulletin*), which contains information on grants, competitions, and available commissions); and Americans for the Arts' *Public Art Directory* ($21 prepaid, 800-321-4510, ext. 241), which is updated periodically. Obviously, the *Public Art Directory* will not list new commissions, and those listed in both *Sculpture Review* and *Sculpture Magazine* are frequently out of date by the time readers receive the publications. *The Artist's Resource Handbook* (by Daniel Grant, published by Allworth Press, 10 East 23rd Street, New York, NY 10010, 212-777-8395, $18.95) also has an extensive listing of federal, local, and state governments, as well as private agencies that currently commission public art or have done so in the past. Most of these commissioning bodies have slide registries to which artists may submit images of their work. Artists interested in pursuing public art should not overlook these registries, since agencies will look through them for suitable artists when planning a major construction or renovation project.

Estern noted that he has been fortunate in knowing powerful and influential people through cultural and civic groups in Brooklyn, New York, where he lives. In the 1960s, the sculptor was approached by the borough president of Brooklyn after a mutual friend suggested that Estern's bust of the then-recently assassinated President John F. Kennedy be installed in Grand Army Plaza. Other public works that he created of notable figures— among them, a full figure of New York Mayor Fiorella La Guardia and relief portraits of the architects of Prospect Park and Central Park, Frederick Law Olmsted, and Calvin Vaux—were commissioned from recommendations. After a time, it is no longer who-you-know but who-knows-of-you that paves the way to public art commissions. "I don't go looking for who is commissioning a public art project," Goodacre said. "Offers come to me, or I'm sent a prospectus and am invited to apply."

Working as a Sculpture Foundry Technician

Graduates of art schools assume (or hope) that their careers will grow and develop from what they learned in school, but it is not always immediately clear which learning they can specifically apply. An artist may labor for months on a senior-year exhibition, but it is the knowledge he or she gained from installing the show that results in a job at a gallery or museum. A chemistry course within a school's general education program may spark an interest in art conservation or lead to the creation of homemade art supplies.

Sheryl Hoffman's main interest at Cleveland State University (where she earned a BFA) and at Ohio State University in Columbus (where she received an MFA) was her sculpture, but the process of creating her mixed-media pieces required her to learn welding and various casting techniques (plaster, sand, and wax), which enabled her to find work in sculpture foundries after graduation. "While I was waiting for a teaching job to come along, I took up casting because I knew how to do this," she said. For eight years, she worked at several different Ohio-based foundries—Studio Foundry in Cleveland and David R. Kahn in Athens, among others—working with artists in their studios to create rubber molds of their work; then at the foundry making waxes and the investment that resulted in editions of their artwork. During those years, she earned between $20,000 and $30,000, depending upon how many jobs came in.

There may be two or three thousand foundries in the United States, although only a fraction of them are involved with the creation of fine artwork, that is, using the lost wax (*cire perdue*) method of casting. Most others produce industrial, utilitarian objects (grillwork and railings, for example) or plaques, emblems, medals, and building reliefs, which require little experience or training and pay accordingly. "It's not necessary to have an art degree if all you do is pour metal," said Terry Feathers, customer service representative for Sheldow Bronze Corporation in Kingwood, West Virginia. The company employs four artists among its 150 employees to sculpt bas-reliefs, emblems, medals, and plaques as well as draw flat reliefs and generate designs on a computer.

At some foundries, there is a prejudice against those with fine art backgrounds. "We work with artists," said Domenico Ranieri, owner of Ranieri Sculpture Casting in New York City. "We don't hire them." Michael Petrucci, president of Fine Arts Sculpture Centre in Clarkston, Michigan, noted that the "problem" with artists as employees is that "they tend to be creative. In

this job, you need to follow someone else's work, and you don't want them to put their own touches on things. We don't want creative work here." Working with other artists' designs may be difficult for those people who are bursting with enthusiasm about creating their own work: selflessness is not the first attribute ascribed to artists, but art foundry work requires patience, maturity, and tolerance as well as technical skills. Dick Tuna, owner of Mesa Bronze Foundry in Center Point, Texas, noted that he has had to rein in employees with art backgrounds who "want to correct an artist's work." Bill Gold, owner of Excalibur (foundry) in Brooklyn, New York, said that he "once had an employee who was an artist. He worked on one piece that came in, making one copy—it was very good. I told him it was an order for eight copies and he had to make seven more. He told me, 'I'm an artist. I don't do production work.' I had to let him go."

The complaint against artists by another foundry owner, Wally Shoop Sr. of American Bronze Casting in Osceola, Wisconsin, was that "foundries know they will be temporary; one year is about as long as artists tend to stay. Who wants to train people who are just going to leave?" That view of artists also extends to most people with college degrees. Phyllis Broges, a sculptor and owner of Mystic River Foundry in Mystic, Connecticut, said, "I prefer not to hire college graduates. They think they know everything (I have to teach them everything), and then they leave." Among Mystic River Foundry's three employees in molding are a former garage mechanic, a newspaper delivery person, and a recent high school graduate.

The salaries that both American Bronze Casting and Mystic River Foundry offer are also commensurate with unskilled labor—$7.50 and $7 per hour, respectively, with no benefits. After several years, one's pay may increase to $12–$15 per hour. Salaries in the Southeast and Southwest are generally lower than in other areas of the country.

A distinct benefit of working in a foundry for a sculptor is access to tools and equipment, which some owners will allow their employees to use on their own time for free or at a greatly discounted rate. The difference between whether one does or does not continue to be a sculptor is often access to a large space and equipment; certainly, one's skills will be enhanced by an ongoing exposure to the processes involved. Different foundries, of course, use specific processes, and artists should look for those that correspond to their particular interests and experience. Both the National Sculpture Society (56 Ludlow Street, New York, NY 10012, 212-529-1763) and the International Sculpture Center (14 Fairgrounds Road, Hamilton, NJ 08619-3447, 609-689-1051) publish regularly updated books that list foundries around the United States. Neither book is inclusive of every foundry, and they offer different yet complementary information. It would be advisable to get both. The National

Sculpture Society's $10 *Sculptors' Supply Index* lists foundries by state and notes what each produces, as well as names suppliers for a range of tools and materials. The International Sculpture Center's $12.50 *Foundry Guide and Directory,* on the other hand, groups foundries alphabetically, and it also describes the types of sculpture processes used at each foundry, how many artists are employed and whether or not employees are permitted to use foundry tools. One might also examine the Design-Production Link database at the Industrial Technology Assistance Corporation (253 Broadway, Suite 302, New York, NY 10007, 212-240-6879, *www.itac.org*), which includes design and production services available to manufacturers.

Training is part of employment situations at most foundries, especially those that do not require or desire college degrees or an artistic background. Some foundry owners hire technicians with experience in other foundries. A form of postgraduate training for sculptors is the Johnson Atelier Technical Institute in Mercerville, New Jersey, a two-year program costing $4,000 per year, for which students receive between $4.00 and $7.76 per hour, depending upon ability and experience. Students learn a wide variety of casting processes, as well as patination and conservation, during the first year and are allowed to work on projects with professional artists during the second. One also learns that foundry work is unrelentingly hard, sometimes hazardous work. Sheryl Hoffman noted that, after eight years of foundry work, she "couldn't breathe anymore because of all the silica, and I couldn't lift another hundred-pound bag. I decided to go into another line of work"—in her case, coordinating special events at the Cleveland Museum of Natural History.

Carpentry

Art in the twentieth century has become very much a conceptual affair, full of isms and theories that have taken precedence over traditional technical skills. One thinks of mechanics, rather than artists, as being good with their hands, but there are many categories of temporary and full-time employment involving creative manual skills to which artists have applied themselves.

Carpentry tends to be a field that some artists fall into because of a natural aptitude. Richard Converse of Conway, Massachusetts, for example, learned carpentry over the years by doing it. A sculpture major at Antioch College, he later received a master's degree in landscape architecture from the University of Massachusetts at Amherst as a means of earning a living. "Landscape architecture is art in its own way," he said. "You get to manipulate and design things." Converse also applied his skills related to reinforced concrete sculpture in designing and building fountains, bird baths, and more decorative

objects for gardens as part of his landscaping work. In the early 1980s, he became a partner in the general contracting firm, Apple Corps, building homes, one of which was felicitously chronicled in Tracy Kidder's best-selling book, *House,* resulting in considerable notoriety and requests for his carpentry services. "I never set out to be a carpenter, but it was something I could also do," he said, "and I guess it has now become what I principally do."

Bob Guest, on the other hand, joined another Pratt Institute sculptor to form a partnership of carpenters right out of school in 1979. Their first client was Pratt itself, which hired them to build benches and tables in the registrar's office, and they eventually branched out to general contracting work and kitchen cabinetry for homeowners. "I didn't have a lot of experience in carpentry," he said. "I worked in the shop at school and thought, 'I could do this.' Early on, it was all 'learn while you earn,' but life is a catch-22 otherwise"—that is, not being hired without experience and not gaining any experience without a job.

Six years after graduating from Pratt, Guest and his wife, an exhibit designer, formed their own exhibition building firm, R. H. Guest, which builds pedestals, archival display cases, light boxes, and other exhibition props for museums. Among their clients are the Brooklyn Museum, the Metropolitan Museum of Art, and the American Museum of Natural History. For some exhibitions, "I do some design and building, but it's mostly just building," he said, "and I put most of my creative energy into the detail elements."

There are a variety of employment avenues for artistic people with carpentry skills. Some may become full-time tradesmen, advertising their services—and charging on a per-hour ($20–$25) or per-job basis—or working for a licensed and insured carpenter or contractor as an assistant (paying $10–$15 per hour). Carpenters and general contractors are found locally through the Yellow Pages and by word of mouth. The United Brotherhood of Carpenters has a number of apprentice programs for carpenters, millwrights (building, designing, or repairing machinery), cabinetmakers, pile drivers, floor coverers, and remodelers run jointly by the national and local union offices. Approximately fifty thousand people are involved in the four-year-long apprenticeship program annually. Union locals set up their own schools, and apprentices take 160 hours of courses and perform 5,600 hours of site work over the four-year period. Apprentices are paid between 50 and 70 percent of a journeyman's normal scale, with a raise every six or twelve months. (A journeyman is someone qualified to work in a particular carpentry field.)

In the arts, there are numerous opportunities to find full- and part-time as well as temporary employment related to carpentry. Harlan Mathieu, a printmaker, moved from general carpentry jobs around New York City to working for R. H. Guest for six years, then taking a job in the carpentry shop under the

auspices of the registrar at the Metropolitan Museum of Art, creating "the con-text for exhibits." Mathieu noted that "you find a lot of artists building cases and pedestals, building walls and doing installations in museums, because there is a lot of fine detail work involved. Artists will see if something is off by a sixteenth of an inch, whereas most professional carpenters will think every-thing looks basically OK, and museums know that." The Metropolitan employs four full-time installers, and each department within the institution may hire others for special exhibits and specialized reinstallations. Most other museums in New York and elsewhere have no carpenters on staff, except per-haps for crating and shipping, and bring in people on a temporary basis.

An industry of exhibit builders and designers has developed to service museums (and galleries), with individual carpenters themselves hiring artists and carpenters either full-time or on an as-needed basis. "We keep a core of three scenic artists on staff," said Adam Levinson, owner of Showman Fabrication in Brooklyn, New York, "but we may bring in a dozen different peo-ple for a few weeks or a few months. It fluctuates depending on the amount of work we have." He noted, for instance, that nine sculptors were hired for nine months to build a South American rainforest set for the American Museum of Natural History, while others were brought in to paint a fake brick and granite background for the set of a cable news service of the National Broadcasting Company. Temporaries are paid within the range of $12–$20 per hour, while the full-time scenic artists receive $20 per hour plus benefits.

Companies of this type are often listed in the Yellow Pages under "Exhibits," although a more comprehensive information source is the American Association of Museums' *Official Museum Directory* (especially the second volume, *Products and Services*), which costs $110 and may be purchased by calling (toll-free) 800-473-7020, *www.officialmuseumdir.com.* Employers in this field may also be located through the magazine *Exhibit Builder* (P.O. Box 4144, Woodland Hills, CA 91365, 818-225-0100, 800-356-4451), which costs $25 for seven issues per year (single copies are available for $5).

Theater Props

Theater companies and producers also need and use freelancers as well as full- and part-time carpenters and scenic artists, generally paying $10 to $13 per hour to start in nonunion shops, $20 to $22 starting salary for union positions. One of the largest directories of carpenters, costumers, craftsmen, light specialists, prop-makers, scene shops, sound technicians, and production

houses is *The New York Theatrical Sourcebook* (163 Amsterdam Avenue, New York, NY 10023-5001, 212-496-1310, 800-247-6553, *www.sourcebk.com*), costing $40. Another source of employment opportunities is the Web site *www.theatrejobs.com*. There are a number of New York City–based groups, which one may contact for additional employment leads. Among these are:

Actors' Equity Association
165 West 46th Street
New York, NY 10036
(212) 869-8530
www.actorsequity.org

Advertising Photographers of America
27 West 20th Street
Suite 601
New York, NY 10011
(212) 807-0399
www.apanational.org

Alliance for the Arts
330 West 42nd Street
Suite 1701
New York, NY 10036
(212) 947-6340
www.allianceforarts.org
Publishes *NYC Culture Guide and Calendar,* listing museums, exhibition and performance spaces theaters, and other cultural sites.

Alliance of Resident Theatres/ART/New York
575 Eighth Avenue
Suite 175
New York, NY 10018
(212) 244-6667
www.offbroadwayonline.com
Serves not-for-profit professional theaters.

American Theatre Wing
250 West 57th Street
New York, NY 10107
(212) 765-0606
www.americantheatrewing.org
Seminars for the theater community.

Dance Theatre Workshop
219 West 19th Street
New York, NY 10011
(212) 691-6500
www.dtw.org
Publishes the *Poor Dancer's Almanac.*

Director's Guild of America
110 West 57th Street
New York, NY 10019
(212) 581-0370
www.dga.org

Entertainment Services and Technology Association
875 Avenue of the Americas
Suite 2302
New York, NY 10001
(212) 244-1505
www.esta.org
Trade association of dealers, manufacturers, distributors, production and service companies supplying the theater industry.

International Alliance of Theatrical Stage Employees
1515 Broadway
Suite 601
New York, NY 10036
(212) 730-1770
www.iatse.com
Union representing stagehands and motion picture operators.

League of American Theatres and Producers
226 West 47th Street
New York, NY 10036
(212) 764-1122
www.broadway.org

Painters Forum
P.O. Box 8601
New York, NY 10128
(212) 427-9782
www.rottentomatoes.com
Information for scenic artists.

Performing Arts Resources, Inc.
88 East Third Street
New York, NY 10003
(212) 673-6343
Job referrals for production personnel.

Puppetry Guild of Greater New York
P.O. Box 177
New York, NY 10116
(212) 388-8732
www.puppeteers.org

Society of Stage Directors and Choreographers
1501 Broadway
New York, NY 10036
(212) 502-1147
www.solofoundation.org

Stage Manager's Association
P.O. Box 2234
Times Square Station
New York, NY 10108-2020
(212) 691-5633
www.stagemanagers.org
Publishes *The Stage Manager's Directory.*

Theatre Communications Group
355 Lexington Avenue
New York, NY 10017
(212) 697-5230
www.tcg.org
Publishes a directory of member theaters.

United Scenic Artists
16 West 61st Street
New York, NY 10023
(212) 581-0300
www.usa829.org

United States Institute for Theatre Technology
6443 Ridings Road
Syracuse, NY 13206-1111
(315) 463-6463 or (800) 93-USITT
www.usitt.org
Information referral service.

Outside of New York City, one may also contact the following groups:

Central Opera Service
c/o Opera America
1156 15th Street, N.W.
Suite 819
Washington, D.C. 20005
(202) 293-4466
www.operaamerica.org

Costume Society of America
55 Edgewater Drive
P.O. Box 73

Earleville, MD 21919
(410) 275-2329
(800) CSA-9447
www.costumesocietyamerica.com

National Association of Display
Industries
3595 Sheridan Street
Hollywood, Fl 33021
(954) 893-7225
www.nadi-global.com

Trade association of companies that market visual merchandising material, store fixtures, mannequins, and other decorative materials; sponsors two trade shows annually.

National Costumers Association,
Inc.
3038 Hayes Avenue
Fremont, OH 43420
(317) 873-0942
(800) NCA-1321
www.costumers.org
Publishes Costumer Magazine.

Puppeteers of America, Inc.
5 Cricklewood Path

Pasadena, CA 91107
(818) 797-5748
www.puppeteers.org
Sponsors seminars, festivals, and workshops.

Set Decorators Society of America
940 North Mansfield Avenue
Hollywood, CA 90038
(323) 462-3060
www.setdecorators.org

"There are tons of people with fine arts backgrounds working in the theater," said Tony Ruse of the Sourcebook Press. "It's actually rare to see people with technical degrees in stage or lighting design." Sometimes, working in the theater becomes a fine artist's career; at other times, artists become interested in theater work not as a source of long-term employment but as a result of knowing people in other areas of the arts with whom they look to collaborate.

Frame-Making

Artists often learn how to make frames for their two-dimensional work at art school, but Bob Kulicke found what he learned "was totally wrong. The Tyler School of Art taught that if you have a green painting, you want a

green frame or it's total contrast. What nonsense, but I started to think, 'What could be a more wonderful way to support your painting than frame-making?'" Kulicke pursued his study of both painting and frame-making, taking classes in the late 1940s at the Académie Léger in Paris and apprenticing himself to a frame-maker at the school for two years.

When Kulicke returned to the United States in 1950, he became friends with a number of the central artists of the abstract expressionist movement, supporting himself by making frames. In time, the world came around to the style of frames that Kulicke began making for the new style of art gaining ascendancy in the art world—moving away from the heavily carved thick wood frames to unadorned welded aluminum ones that mirrored Bauhaus architectural designs of a generation earlier. "All my frames were based on Mies van der Rohe's 1928 Barcelona chair," he said. Kulicke moved from constructing frames individually to producing them in quantity, and his renown peaked in 1960 when New York's Museum of Modern Art purchased hundreds of his frames for a reinstallation of its permanent collection.

Frame-making offers a form of entrée to the art world, as clients (collectors, dealers, museums) may be the very people an artist looks to meet. For instance, New York art dealer Andre Emmerich visited the studio of painter Miles Karpilow, whom he had met through purchasing some of his frames, in order to view his art. Karpilow also met other artists at their studios when delivering newly framed paintings. Yet another benefit of framing artwork for him was "just seeing artists' work up close, without the gloss of a museum or gallery or a piece of glass to separate you from the canvas. It's an education to look that closely at how other artists approach a subject that I've been thinking about as well."

An organization of frame-makers (Professional Picture Framers Association, 4305 Sarellen Road, Richmond, VA 23231, 804-226-0430, *www.ppfa.com*) offers those in the field a variety of services, including discounts on continuing education, bankcard processing, health and liability insurance, travel and accommodations, member directory, a monthly newsletter and a help-line for answers to technical questions and the names of potential suppliers. The group also certifies picture framers (a process costing $225 for members, $325 for nonmembers); association officers claim that certification helps one's chances for employment within an institution, such as a museum.

8

Careers in the Art World

"IT'S CHALLENGING TO PURSUE TWO CAREERS," SAID MARY DELMONICO. "I'm primarily an installation artist, and then there is my job here, which is pretty demanding." "Here" is the Whitney Museum of American Art, where Delmonico is head of publications and one of the many artists on the museum's staff. In fact, there are so many artist-employees that the museum holds an annual staff art exhibition in the conference rooms, and trustees are invited to the reception. "At least one sale I know of took place," she said. The museum is also a congenial employer to Delmonico, allowing her to take time off in order to install her work at group and one-person shows.

The Museum as Employer

Museums regularly hire fine artists in a variety of capacities. According to the Whitney's personnel director, Martha Koletara, artists may be found working as art handlers, associate curators, collection cataloguers, dock attendants, film projectionists, gallery assistants, grant writers, lecturers, librarians, outside storage managers, production managers, receptionists, registrars, research assistants, sales supervisors, and security

guards: salaries range from the low $20,000s on up. Clearly, many of the jobs are physically taxing, neither glamorous nor conducive to upward mobility, but they all offer a connection to art and the art world, from which other opportunities may arise.

George Schneider, a painter and retired senior lecturer in the education department at the Art Institute of Chicago, noted that his own work benefited from seeing so much art around him and by talking with other staff. "From the preparators, I learned how to better mount and present my work," he said. "From the conservators, I learned how to protect my work and use materials more carefully. From the designers, I've seen how to create new exhibitions. From all the art, I've gotten lots of new ideas."

Schneider was recommended for the job at the museum by a fellow art student at the School of the Art Institute who was already working there. Kimberly Schell, a painter who "wanted to work in a museum in some way, wanted my foot in the door," found that the best point of entry was a sales job—first part-time, then full-time—in the gift shop of the High Art Museum in Atlanta, Georgia. Eventually, she rose to the position of registrar. The High Art Museum, like the Art Institute of Chicago, the Whitney and other museums around the United States, has staged exhibits of artwork by staff members.

Increasingly, administrative and curatorial staff at museums require master's- or doctoral-level degrees in art history, although knowledge of a particular area may help the job searches of those without such degrees. May Casselberry, a printmaker and librarian at the Whitney, earned a master of library sciences degree from Columbia University, doing her thesis on artists' books—a focus that proved attractive to the museum. Lora Urbanelli, a painter and curator of prints, drawings and photographs at the Museum of Art at the Rhode Island School of Design in Providence, received a master's degree in museum studies from Syracuse University in 1982. Almost immediately, she applied and was hired as a curatorial assistant at the Yale Art Gallery in New Haven, Connecticut. "Just having a museum studies degree would not have been enough to get me the job at Yale," she said. "The degree is too practical and not concerned with art history enough." Fortunately, she wrote her master's thesis on an art historical subject that "serendipitously happened to be the subject of an upcoming exhibit at the Yale Art Gallery. That's what got me the job."

Specialized knowledge and being in the right place at the right time are helpful in getting hired by museums. Mark Pascale, who received an MFA in printmaking from Ohio State University, taught at the School of the Art Institute of Chicago and used the museum's study room for lectures, eventually becoming familiar with the associate curator of prints and drawings

who ran that room. In the early 1980s, the museum acquired the collection of the renowned print studio United Limited Art Editions, and curators began to tap Pascale for his knowledge of printmaking. "They asked me about techniques, papers, procedures, texture, and process," he said, "as few curators knew much about the making of art."

Eventually, Pascale became a regular resource for the curators of prints and drawings whenever a technical question arose. By the late 1980s, he was helping curators with a catalogue raisonné of Whistler's lithographs, checking entries for technical correctness. Not long after, he was hired by the museum to run the museum's study room as an associate curator of prints and drawings. "I was not given to understand that I need additional degrees," he said. "I did, though, take a writing class, because I would be doing some academic writing."

Robert Storr is another artist whose primary asset to the museum world is knowledge about art. The former head curator of painting and sculpture at the Museum of Modern Art in New York City, he received an MFA in painting from the School of the Art Institute of Chicago and worked as an installer for the art collection of the McCrory Corporation. He gained art world attention not from his artwork but from his influential position at MOMA and his art criticism, which has been extensively published.

Storr's literary career began oddly: "I wrote a letter to the *Voice's* then chief art critic, Peter Schjeldahl, objecting to some things he wrote in a review about Philip Guston, an artist I admire very much. He wrote back, taking exception to my objections; we exchanged a few more letters, and finally he told me, 'You know, you're pretty good at this. Why don't you write about art professionally.' He then recommended me to Betsy Baker, the editor of *Art in America,* and I started writing for the magazine after that."

Writing freelance art criticism is generally more of a supplement to an income than an income in itself, as a number of artists and others have found. *Art New England,* for instance, currently pays $15 for reviews, while *Art in America* offers $75 for short write-ups. Larger newspapers will pay $100–$200 for reviews, sometimes more, but they don't publish many reviews and usually have a staff critic or a string of longtime freelancers for these tasks. Storr noted, "I set out to be a painter, and I learned how to live very cheaply"—a must in this kind of work. Artists Fairfield Porter, Peter Halley, and Donald Judd all wrote reviews in the early stages of their careers, which did not make them rich but at least paid them to look at contemporary art, meet artists and dealers, and gain a certain name recognition with the art world. Clement Greenberg and Harold Rosenberg both had aspirations to be painters but found their calling as critics. It was Storr's reviews and essays that brought him to the attention of the Museum of

Modern Art. Generalizing on his own experience, Storr said, "It is very difficult to work your way up the ladder in a museum without an academic background. You have to work freelance in the art world, show you know things, advocate artists in a contemporary context, and then, perhaps, the museum world will see you have something they need."

Art Appraisal

There are numerous ways in which artists may earn money through art, among which are making it, conserving it, curating it, teaching and assisting others to make it, and framing it. Some also sell it as gallery owners, and others appraise it. "We've had a number of fine artists come through our program to work in the appraisal field," said Lisa Koenigsberg, director of New York University's Appraisal Studies in Fine and Decorative Arts. "They have a sensitivity to technique, method, and materials that puts them a step ahead of people from other backgrounds." Maria Siskind of Williamstown, Massachusetts, who received a BFA in sculpture from the Maine College of Art in 1988 and has taken appraisal courses at New York University, noted that her understanding of "process and what makes a work of art a success" has helped her recognize when a piece has "intrinsic value, which is the first step toward determining its value in monetary terms."

There are various reasons that art appraisers are hired by individuals and institutions: a collector may wish to purchase an object at an auction or from a dealer but wants to be certain that the price named is not out of line; another person may want to sell a piece and need to know a reasonable price to ask or expect. "A lot of people find an appraiser after they've been rummaging through their attic and come across something that's old," said Victor Wiener, executive director of the Appraisers Association of America. "They bring in things they think are priceless. Mostly, the object has more sentimental than cash value, but it's always funny to see how sentimentality goes right out the window when someone finds out that something is really valuable. They'll be willing to sell it right then and there."

Property insurance is another reason for hiring an appraiser. Insurers often require an appraisal for coverage of expensive objects, such as art and antiques, in a fine arts rider to a homeowners policy, and most insurers will demand that an appraiser who is considered an expert in the particular area make an evaluation. More often, the tax code brings art owners and appraisers together, for example, as the fair market value for a donation to a nonprofit charitable institution (such as a library or museum) needs to be determined in order to calculate a deduction. Since 1985, donors to charitable institutions

have been required to include a valid appraisal on their tax returns if, when the gift is an object, it is valued at $5,000 or more, or over $10,000 when it is a closely held stock. The appraiser must submit some form of written documentation to show on what basis the evaluation is made. Appraisers are also needed in the probate process, evaluating the value of pieces belonging to a deceased person for estate tax purposes (inheritance taxes currently range from 14 to 33 percent). The number of art appraisals submitted with tax forms has grown so large in the postwar era (along with questions about those appraisals' reliability) that, in 1969, the IRS established an Art Advisory Panel to examine the valuations that taxpayers claimed. A new specialty emerged.

In general, appraisers look at price records, at auctions, and in galleries for the particular object or for similar objects as well as examine the work's condition, inherent quality (is it a good painting by the artist? are the colors attractive?), and even its size. "The work of some artists is far more valuable at one size than at another," said Lewis Shepard, an art dealer and appraiser in Worcester, Massachusetts, who has worked for individuals and museums up and down the East Coast. He noted that Thomas Cole (1801–1848), an American landscape painter associated with the Hudson River school, "did some very nice small sketches, but he is really known for his large landscapes, and the difference in price between the large works and the small ones is enormous. On the other hand, someone like Cornelisz van Haarlem"—a seventeenth-century Dutch painter—"is best known for his smaller works, which are far more valuable than his larger pieces."

There are two main membership associations of appraisers in this country:

Appraisers Association of America
386 Park Avenue South
Suite 2000
New York, NY 10016
(212) 889-5404
www.appraisersassoc.org
Nine hundred members.

Appraisers Society of America
P.O. Box 17265
Washington, D.C. 20041-0265
(703) 476-2228 or (800) 292-8258
www.appraisers.org
Six thousand members.

Only real estate appraisers are licensed by the states. All other appraisers rely on their reputations or on membership in one group or the other. "If you are an accredited member of ASA, it tells people you know what you're doing," said Donna Reid, membership director of the Appraisers Society of America. Both associations require members to have worked in the appraisal field for a certain number of years, pass examinations that they administer, and submit two or more appraisals for review. Completion of a

degree or certificate program exempts individuals from certain exams and experience in the field, which are usually qualifications for membership in these groups. Members agree to abide by a code of ethical conduct, and they may be expelled from either association if an ethics panel within the group responding to a complaint concludes that they acted unprofessionally.

A handful of universities around the United States offer certificate and degree programs in appraisal studies, all of them including or emphasizing art and antique valuations (the general category is personal property appraisal). New York University's School of Continuing Education (Division of Arts, Sciences, and Humanities, 48 Cooper Square, Room 203, New York, NY 10003, 212-998-7137) is affiliated with the Appraisers Association of America and offers the most extensive course listings in art and antiques valuations as part of a certificate program. A number of schools are affiliated with the American Society of Appraisers, some offering certificate programs:

Embry-Riddle Aeronautical University
600 South Clyde Morris Boulevard
Daytona, FL 32114
(751) 258-3658
www.cts.db.erau.edu

George Washington University
Appraisal Studies Program
2020 K Street, N.W.
Washington, D.C. 20006
(202) 572-5697 or (800) JOIN-GWU
www.gwu.edu

Rhode Island School of Design
Two College Street
Providence, RI 02903
(401) 454-6499 or (800) 364-RISD
www.risd.edu

Stetson University
421 North Woodland Boulevard
Deland, FL 32723
(386) 822-7100 or (800) 688-0101
www.stetson.edu

Telcordia Learning Center
6200 Route 53
Lisle, IL 60532
(630) 960-6137
www.800teachme.com

University of California at Irvine
Irvine, CA 92697
(949) 824-5990
www.unex.uci.edu

University of Missouri at Kansas City
Continuing Education Division of the College of Arts and Sciences
4949 Cherry
Kansas City, MO 64110
(573) 882-3598 or (800) 545-2604
www.missouri.edu

University of Tennessee at Knoxville
Knoxville, TN 37996
(865) 974-1000/0150
www.utk.edu

And two offering degrees:

Lindenwood University
Valuation for the Sciences Program
209 South Kings Highway
St. Charles, MO 63301
(314) 916-1924
www.appraisers.org/college/
opinions/Education.pdf
BS and MA degrees awarded.

Regis University
School for Professional Studies
3333 Regis Boulevard
Denver, CO 80221
(303) 458-4993
www.regis.edu
BS degree awarded. This is an individualized major, in which students design a course of study relative to their interests.

Certificate programs, with classes of two, four, six, or eight sessions over the course of a weekend or a series of Mondays (for instance), usually attract people already involved in the field. The degree programs, on the other hand, are a top-to-bottom education in the work of appraisers and the tools they use, covering all areas of potential valuation, with the opportunity to specialize.

There are an estimated 125,000 appraisers of all types in the country. Many appraisers are listed in the Yellow Pages, although most hold other jobs and pursue appraising as a moonlighting activity. Dealers or museum curators of the type of object one wishes to have appraised may know the best people to call, or they may take the job themselves.

Most appraisers work on an hourly basis, charging between $40 and $200 an hour, and they may require at least two hours' minimum payment. Travel time and research may lead to additional charges. It is considered strictly unethical for an appraiser's fees to be based on an object's value, because that practice may lead to inflated valuations. Most appraisers are generalists, known as estate appraisers, who will give ballpark estimates on everything in one's home—typically used in valuing estates. Those who specialize in a particular area, such as antiques or coins, or who are experts in a more narrowly defined field, such as Japanese prints, are on the higher end of the fee structure. At times, estate appraisers may call in specialists for valuations of specific objects.

Maria Siskind "knew a little bit about appraising from having grown up with my mother," who was herself an appraiser of antiques and furniture. "After graduating, I worked for a law firm doing property appraisals for probate and estates with heirs. After a while, I started working with my mother, but I knew I needed more formal training in this if I was going to do it right."

When Richard-Raymond Alasko of Chicago received his MFA in painting from the University of Notre Dame in 1969, however, there were no courses in appraisal studies, and he had to learn by doing. When he earned his art degree, Alasko looked and found art teaching jobs in the Midwest. "I had no plans to be an appraiser and had no interest in that area," he said, but while teaching at Loyola University in Chicago, a friend asked him to fill in and give a lecture at an appraisers' conference on a work of art that had gone up and then down in value. Within two weeks of that talk, he was asked to join the Appraisers Society of America and to consider working in the field. In time, he did become a full-time appraiser, working for individuals and insurance companies and even as a consultant to the IRS. He has also taught classes in art appraisal, helping to eliminate some of the misconceptions common when he initially entered the field. "People believed that, if you know about art and art history, you know what things are worth," he said. "It's not really true, but maybe understanding how art is made helps me see things about the complexity and structure, the use of materials and colors—qualities that are part of a work's inherent value."

Alasko found that, as an artist, he has benefited from his examination of top-quality works of art, finding that "great works truly inspire me to work at a very high level." A number of the appraisal certificate and degree programs (especially New York University's) specifically teach the business of art, including how art is priced and marketed. No subject is probably as taboo at art schools as the question of what art is worth. Students are often taught precious little about how to sell their art, let alone how objects should be priced, and the entire art market tends to remain a mystery until students become graduates and realize that they suddenly need to think about it. Maria Siskind noted that some of the courses she has taken have helped her to better understand how to present her own artwork to potential collectors. For her, the dilemma to being both an artist and an art appraiser becomes most obvious when different aesthetics collide: "I'll look at some piece of art and think, 'This is really worth money? Someone would actually pay for this?' Some stuff I have to appraise really turns my stomach."

Arts Administration

"I was a sculptor for ten years, but I had to give it up for this job"—a not uncommon refrain in the arts, because most people with artistic aspirations need to find another way to support themselves; many jobs are all-consuming, leaving little time and energy for after hours art-making.

But the job in this case is executive director of the International Sculpture Center in Washington, D.C., and Jeanne Pond, who holds that position, has turned her energies from developing her own career to assisting other sculptors develop theirs.

The directors of many arts groups and service organizations are artists who have taken on a new role, some receiving training beforehand, while others have learned on the job. Kathy Edwards, a printmaker and director of the Print Center in Philadelphia, learned how to manage a nonprofit organization by watching and helping her boss when she was the executive assistant to the director of Philadelphia's Rosenbach Museum and Library. "I helped the director raise money and manage the institution," she said. "It really pays to be someone's assistant, because you can do a lot and learn a lot."

Many artists-turned-arts-administrators developed fund-raising, marketing, management, and leadership skills in this way, including B. J. Larson, David Bancroft, and Jennifer Dowley. Larson received an MFA in ceramic sculpture from the School of the Boston Museum of Fine Arts in 1986 and held various odd jobs after graduating, such as foundry technician, home health aide and title examiner for a law firm. "I decided I wanted the work I did to correspond to my art training," she said, taking a job as a receptionist at the New England Foundation for the Arts in 1988. "I took on extra duties and responsibilities whenever I could, and NEFA had a philosophy of promoting from within," she said. In time, Larson became visual arts director at the regional arts agency.

David Bancroft, who received a degree in painting from Catholic University in 1973, worked his way through college as a clerk-typist at the National Endowment for the Arts, where he is now a museum specialist. "I took a typing test for the Civil Service in 1969," he said, "and afterward I got three phone calls—all to be a typist. One was from the Department of the Army, one was from the Department of the Navy, and one was from the NEA." Bancroft was referred to as a "floater," going from office to office within the arts endowment wherever a typist was needed. "Being a floater, I got to know everybody and to know something about everyone's job here," he said. "When I graduated, I was offered a job in the visual arts program, helping to administer all the applications and grants. I never thought about arts administration as a career, but here I am."

Jennifer Dowley, originally a theater artist who is now the director of museums and visual arts at the NEA, also started her career at the bottom, assisting the membership director at the Boston Ballet, then moving on to be an assistant at the Artists Foundation in Boston. "I think of some of these jobs as semi-volunteer work, because the pay was so low," she said. Like

Larson, Dowley took on additional responsibilities, compiling all the available sources of funding for artists and arts groups into a book (*Money to Work: Grants for Visual Artists*) that the Artists Foundation published, and which became quite popular and widely imitated. When a higher-level position opened up at the foundation's fellowship program, she was selected, "which I liked a lot, because I got to work with artists." From there, she was hired by the Cambridge (Massachusetts) Arts Council as director of the Arts on the Line program, which commissions murals and other public art for the area's subway system, and afterward spent nine years as director of Headlands Center for the Arts, an artist community in Sausalito, California. One benefit of being an artist heading an arts organization is an understanding of, and sensitivity to, the needs of other artists. "I made a point of hiring artists for almost all jobs there, including janitors, business managers, secretaries, program officers, fund-raisers—they were all artists," she said. "I also made studio space available to them, because I wanted to keep that part of their lives going."

Starting at the bottom, or just rising to fill a management need in an agency or organization, is certainly one means of learning the basics about nonprofit arts or other groups. "It's just as good to work your way up from the mail room," said Dan Martin, director of the master of arts management program at Carnegie-Mellon University. "However, you can learn in one or two years in a graduate school arts management program what it takes you four or five or ten years on the job. You also learn proper techniques in school, whereas what you learn on the job may not be efficient."

The types of inefficiencies he has found most prevalent in the operation of arts organizations are a lack of planning ("where you're going, and how you're going to get there"), shoddy grant-writing and fund-raising techniques, poor marketing strategies ("not understanding the marketplace, not reaching the target audience and then not communicating with the audience") and bad personnel practices ("people get used up; no one stays around long enough to correct problems—they just perpetuate them"). Arts management programs have much in common with regular business administration schools, but the focus is on the nonprofit world. A lot of attention is given to fund-raising techniques, stretching a budget to accommodate a variety of services and generally "taking a for-profit mentality to the nonprofit world," said Edna Neivert, director of outreach at the Pittsburgh (Pennsylvania) Center for the Arts, who received her master's degree in arts administration in 1996. "To cover expenses, you have to create revenue-generating avenues. You don't just drive an organization into the ground and then tell the public to ante up."

The people who enroll in an arts management program are also look-ing for a means of working within the arts. "I was uninterested in living the artist lifestyle," said Sydney Kamlager, managing director of Social and Public Art Research Center in Los Angeles, who studied photography and ceramics in college. Her mother is a theater actress who remarried a painter. "I know all too well what it is like not to have much money, to have to move around a lot. It often seemed that the rewards aren't equitable to what you have to put in." She earned an arts administration degree in 1996 as a way of fixing her life in the arts in a remunerative way. Dan Martin noted that salaries for graduates range from $20,000 to $70,000, most aver-aging $35,000–$45,000.

"I would not have advertised toilet paper," said Lara Culley, an account executive at LaPlaca Cohen Advertising in New York City, who earned an arts administration degree in 1995. LaPlaca Cohen specializes in developing marketing and media campaigns for museum clients, and among Culley's accounts are the Art Institute of Chicago, the Philadelphia Museum of Art, Harvard Art Museum, and the National Gallery of Art. "The whole reason I do this is the art museums. I want to get people to take part in the art experience." Her own art interests and the training she received in arts administration enabled her to "understand the sensitivi-ties that museums have with regard to advertising. You can't redesign the packaging in an art museum. You can't alter the artwork or what the gallery looks like. With consumer products, you can change the look, the name, the packaging, but art museums are different. You also have to try constantly to figure out how to produce something while spending as little money as possible."

Certainly, an arts management degree does not preclude entering the corporate world, as many of the courses train students in the same basic skills as those taught in regular business administration programs, such as financial analysis and management, strategic planning and policy making, accounting, marketing, and communications, organizational structure and behavior, human resources, and labor relations. For example, Gretchen Thomas, a theater major at Skidmore College whose plan was to be a regional theater manager, joined Motorola in the department of corporate communications not long after graduating from Carnegie-Mellon's arts management program. Still, most students entering and leaving these pro-grams look to work within the arts.

There are thirty-three graduate-level arts administration (two-year) pro-grams in the United States and Canada approved by the Association of Arts Administration Educators (c/o American University, Department of Performing Arts, 4400 Massachusetts Avenue, N.W., Washington, D.C.

20016-8053, 202-885-3420, *http://www.artsnet.org/aaae*). Another six approved programs are found in London (England), Scotland (United Kingdom), Salzburg (Austria), Queensland (Australia), Barcelona (Spain), and Utrecht (The Netherlands). Degree requirements differ from one program to another, and a student's prior experience and training may count for credit at certain schools. The degrees themselves also differ from school to school, some offering an MA, others awarding an MBA, MS, MFA, or MAM (there are also doctoral programs). The focus of some programs is on the visual arts, while others are oriented toward the performing arts. A valuable source of additional information on these programs (application procedures, degree and thesis requirements, internship opportunities) may be found in the *Guide to Arts Administration Training and Research* ($12.95), which is published by the Association. The graduate-level arts administration programs are:

Alabama
University of Alabama
Department of Theatre and Dance
Theatre Management/Arts
Administration
P.O. Box 870239
Tuscaloosa, AL 35487-0239
(205) 348-3850
www.as.ua.edu/theatre

California
Golden Gate University
Arts Administration Program
536 Mission Street
San Francisco, CA 94105
(415) 442-6515
http://Internet.ggu.edu/~asmith

Connecticut
Yale University
Yale School of Drama
Theatre Management Department
222 York Street
New Haven, CT 06520
(203) 432-1591
www.yale.edu/drama

District of Columbia
American University
College of Arts and Sciences
Department of Performing Arts
4400 Massachusetts Avenue, N.W.
Washington, D.C. 20016-8053
(202) 885-3420
www.american.edu

Florida
Florida State University
Arts Administration Center
126 Caruthers Hall
Tallahassee, FL 32306-4480
(850) 644-5475
www.fsu.edu/~svad/ArtEd.pages/artedhome.html

or

School of Music
Housewright Music Building
Tallahassee, FL 32306-1180
(850) 644-3424
www.music.fsu.edu/artadmin.htm

or

School of Theatre
Fine Arts Building
Tallahassee, FL 32306-1160
(850) 644-5557
www.fsu.edu/~theatre

Illinois
Columbia College Chicago
Arts, Entertainment and Media
Management Department
600 South Michigan Avenue
Chicago, IL 60605
(312) 663-1600
www.colum.edu/graduate/
artsentertainment.html

School of the Art Institute of
Chicago
37 South Wabash
Chicago, IL 60603
(312) 899-1232
www.artic.edu/saic

University of Illinois
at Springfield
School of Public Affairs and
Administration
Springfield, IL 62794-9243
(217) 786-7373
http://www.uis.edu/ ~cam

Indiana
Indiana University
Arts Administration Program
Merrill Hall
Bloomington, IN 47405
(812) 855-0282
www.indiana.edu/ ~artsadm

Louisiana
University of New Orleans
College of Liberal Arts
Arts Administration
New Orleans, LA 70148
(504) 286-6574
www.uno.edu

Maryland
Goucher College
Welch Center for Graduate and
Professional Studies
1921 Dulaney Valley Road
Baltimore, MD 21204-2794
(410) 337-6200
(800) 697-4646
www.goucher.edu/moaa

University of Maryland
Department of Theatre
Theatre Management Program
College Park, MD 20742-1215
(301) 405-6692
www.theatre.umd.edu

Massachusetts
Boston University
Metropolitan College
Arts Administration Program
808 Commonwealth Avenue
Boston, MA 02215
(617) 353-4064
http://bumetb.bu.edu/

Michigan
Wayne State University
Theatre Management Program
Department of Theatre
4841 Cass Avenue
Detroit, MI 48202
(313) 577-3508
www.theatre.wayne.edu

Minnesota
Saint Mary's University of
Minnesota
c/o The Minneapolis College of Art
and Design
Arts Administration Program
2801 Stevens Avenue
South Minneapolis, MN 55404-4343
(612) 874-3700
www.smumn.edu/academics/
mplsgrad/artsadm.html

New York
Brooklyn College of the City
University of New York
Performing Arts Management
Department of Theatre
Brooklyn, NY 11210
(718) 951-5989
www.brooklyn.cuny.edu

Columbia University/Teachers
College
Department of the Arts and
Humanities
Program in Arts Administration
Box 78 Teachers College
525 West 120th Street
New York, NY 10027
(212) 678-3271
www.tc.columbia.edu/academic/arad

New York University
School of Education
Department of Music and
Performing Arts Professions
Performing Arts Management
Program
Suite 675
Education Building
35 West Fourth Street

New York, NY 10012-1172
(212) 998-5505
www.nyu.edu

or

School of Education
Department of Art and Art
Professions
Visual Arts Administration Program
34 Stuyvesant Street
New York, NY 10003
(212) 998-5700
http://www.nyu.edu/education/art/
visartadmin

State University of New York at
Binghamton
School of Management
MBA in Arts Administration
Program
Binghamton, NY 13902-6015
(607) 777-2630
www.binghamton.edu

Ohio
University of Akron
School of Dance, Theatre and Arts
Administration
College of Fine and Applied Arts
Arts Administration Program
Akron, OH 44325-1005
(330) 972-7890
www.uakron.edu/dtaa

University of Cincinnati
College-Conservatory of Music
Arts Administration Program
Cincinnati, OH 45221-0003
(513) 556-4383
www.ccm.uc.edu

Oregon
University of Oregon
School of Architecture and Applied
Arts
Arts and Administration Program
Eugene, OR 97403-5230
(541) 346-3639
www.uoregon.edu

Pennsylvania
Carnegie Mellon University
H. John Heinz III School of Public
Policy and Management
Masters of Arts Management
Program
5000 Forbes Avenue
Pittsburgh, PA 15213-3890
(412) 268-7036
http://www.artsnet.org/mam

Drexel University
Department of Performing Arts
Arts Administration Program
2018 MacAlister Hall
Philadelphia, PA 19104
(215) 895-2452
www.drexel.edu/depts/artsadm

Texas
Southern Methodist University
Meadows School of the Arts
Center for Arts Administration
P.O. Box 750356
Dallas, TX 75275-0356
(214) 768-3425
www.smu.edu/~artsadmin/

Texas Tech University
Department of Theatre and Dance
Box 42061
Lubbock, TX 79409-3601

(806) 742-3601
www.theatre.ttu.edu

Virginia
Shenandoah University
Arts Management and Arts
Administration Program
146 University Drive
Winchester, VA 22601
(540) 665-1290
www.su.edu/conservatory

Virginia Tech
School of the Arts
Arts Administration or Stage
Management
PAB 203
Blacksburg, VA 24061-0141
(540) 231-5335
www.sota.vt.edu

Wisconsin
University of Wisconsin
Graduate School of Business
Bolz Center for Arts
Administration
975 University Avenue
Madison, WI 53706
(608) 263-4161
http://www.wisc.edu/bolz

Canada
L'Ecole des Hautes Etudes
Commerciale
3000 Chemin de la Cote-Sainte-
Catherine
Montreal, Quebec H3T 2A7
Canada
(514) 340-6151
www.hec.ca/programmes/dessgoc

York University
Schulich School of Business
Program in Arts and Media
Administration
4700 Keele Street

Toronto, Ontario M3J 1P3
Canada
(416) 736-5088
www.ssb.yorku.ca

Working within, or directing, an arts agency or organization is not an easy life for an artist. The nonprofit world usually is not as lucrative as the corporate sphere, although responsibilities and the necessary skills are comparable, and the hours are often long, which makes it difficult to find time for creating one's own art. "I made a choice," Kathy Edwards said. "I can't run a small nonprofit organization and be an artist at the same time." Another problem for her was the conflict of interest in being a printmaker leading an organization that promotes the work of printmakers. "If my work is in a show we put together," she said, "that means I've chosen myself over someone else. But my job is to support other artists and their work. You shouldn't use your context to help yourself." A somewhat more basic problem confronted David Bancroft, especially when he worked in the arts endowment's visual arts program. "Here I was surrounded by art all the time, but I'm not doing it," he said. "Any number of times, I would wonder, 'Why is this person getting a grant? My work is so much better.'" Moving to the museums program helped him overcome that particular problem.

Careers in Design

"A FINE ART BACKGROUND IS AN IDEAL TRAINING FOR WEB SITE DESIGN," said H. K. Dunston, a producer at Concrete Media in New York City. "Studio artists simply have to be willing to work within the constraints of the Web and a corporation." Beyond designing Web sites, this proviso is true of all areas of design: deadlines must be met, a chain of different people have to approve of this or that, changes may need to be made—and that is just for one job. The next job may involve a whole new set of deadlines, middle managers, and changes. We are a far cry from the Romantic image of the artist, laboring alone for as long as it takes to produce something whose only true judges are time and the Muse who inspired the effort. In the field of design, inspiration and artistic talents are commodities, the artistic temperament replaced by an ability to synthesize other people's needs and ideas into clear visual imagery. Not every fine artist can work this way, and not every artist wants to use his or her artistic skills in the commercial realm, fearing that this kind of employment will subtly (or not so subtly) change the character of the art or make the fine art seem like just more work. In order for a job in design to be artistically and financially successful, the employee should have a keen interest in the particular area, not just seeing it as something to be done grudgingly for money. "You need to be into it," Dunston said, "and you have to work with clients' needs. People who can do both of those things can do OK."

Moving into the Design Field

Approximately half of the members of the Graphic Artists Guild, a nation-wide membership organization of artists involved in the commercial arts, are illustrators, according to Paul Basista, the group's executive director. Many of these illustrators either specifically pursued a fine arts program in school or have a background as gallery artists. He viewed the difference between gallery (he does not use the term *fine*) and graphic artists not as a distinction of quality or aesthetic value but of marketing. "Gallery artists essentially act as entrepreneurs, initiating a project on speculation in the hope that some gallery will exhibit it and some collector will buy it," he said. "Graphic artists, on the other hand, are commissioned to do a specific work and are promised payment before the work begins." (That payment consists of a one-third down payment on the signing of a contract, one-third when the sketches are approved, and the final third when the work is completed and approved.)

Gallery-oriented artists may first need to make some adjustments in their thinking about commercial art before trying to establish a career within this field. "On occasion, I get a call from a gallery artist, saying 'I am a fine artist, but I'm willing to do some illustration to make some money,'" said Vicki Morgan, an illustration representative. "That whole approach gives people in my industry the creeps. The gallery artist assumes that the *fine* in *fine art* means 'quality,' where it actually means 'gallery.' There is something disparaging in this that the illustration world hears." Morgan teaches workshops at New York City's School of Visual Arts on how artists may develop a career in illustration; the first step in this process of "applying your talent to a new career" involves "getting your head into the industry. You need to see yourself not as an artist but as a shop." Among the ways she suggested to make this attitudinal shift is by taking courses in illustration, which allow an artist to start building a targeted portfolio, read books that describe the business of art (such as Steven Heller's *The Business of Illustration* and the Graphic Artists Guild's *Pricing and Ethical Guidelines*), and join organizations, such as the Graphic Artists Guild, that enable artists to learn about trends and business practices as well as meet others in the field and become part of a network. The shift in thinking also involves understanding what it is to work for an art director, taking instructions and making changes ("some artists are better at giving instructions than taking them," Morgan said), as well as how to maintain one's own artistic integrity while working with and for other people.

"I used to make awful fun of commercial art for being so corny, so visually unstimulating," said illustrator Randall Enos of Westport, Connecticut. That was when he attended the School of the Museum of Fine Arts in Boston and "lived in the pages of *ARTnews*." He planned to move to Greenwich Village in New York City when he finished school, but a job offer came up that he couldn't refuse. He met through his wife's family the head of the cartooning department of the Famous Artists Schools (located in Westport), who offered him a full-time job teaching cartooning. "The lure of living in Westport and working in an art school was too great," Enos said. "I couldn't resist." He dropped out of art school and began a career in which he has seen his illustrations in such publications as *Atlantic Monthly, National Lampoon, Newsweek, Playboy,* as well as the *New York Times, Wall Street Journal,* and the *Washington Post.*

The illustration career did not materialize overnight. Enos worked for eight years at Famous Artists Schools, starting in 1956, and learned about cartooning ("which I discovered was more serious than I had thought") and other areas of the applied arts from his fellow artists and teachers. A reeducation is required for many fine artists to turn their talents to commercial areas, which often involves going back to school. Mark Rosenthal, who received an MFA in painting from the State University of New York at New Paltz in 1978, was working at the checkout counter of an art supply store in New York City when he decided to enroll in a night class at the School of Visual Arts called "Design and Personality," taught by the illustrator Milton Glaser. "I was getting fed up with the fine art world, and I knew I needed something else," he said. Although his fine art painting was abstract expressionist in style, Rosenthal was able to switch gears to work in a more narrative mode, impressing Glaser who hired him out of the class to work in his studio "to do design work—book covers, product packages—drawings he didn't want to do."

Rosenthal stayed for five years, learning "how things are done, from concept through stages to completion: the sketch, the finish, all the mental processes of attacking a problem." Both he and Enos had begun to take on freelance assignments during their respective employments, and when they left the two were self-supporting.

There was still much to learn. "Illustration is an idea business," Enos said. "You have to work with metaphors and symbols, reading an article over and over again in order to come up with the right image. A lot of people think—I used to think—that art directors give you the idea, but that's not true. You have to come up with your own ideas, and do it fast." As a way of creating his own look, Enos began to work in linoleum cuts, a fine art technique that he largely had to teach himself, finding ways of working in

this medium "at top speed, so I don't miss any deadlines." Rosenthal had entered the art world as an oil painter, "but doing an oil painting for illustration just didn't make sense because it takes so long. I can do a number of watercolors in the same time as one oil painting." He began to try his hand at watercolors while still in Glaser's studio (where he largely worked in ink) and then on his own after he left that job.

As with everything in the arts, there is no one way in which careers are built. It is common that illustrators and graphic designers find full-time jobs within companies before they attempt to establish freelance careers. Full-time jobs often allow younger artists a variety of experiences, exposure to new and different technology, and the opportunity to meet other prospective employers and artists—all the while receiving a steady paycheck. "Most of the people who come to us are young, fresh out of school, and their lack of confidence tells them they need experience in a job for a number of years," said Caroline Dacey, placement director of Freelance Advancers, a New York City employment agency for designers, graphic artists, and illustrators. "Those with more confidence tend to be willing to try freelancing." A job also may reveal how a business works, a subject not often taught in art schools. Roz Goldfarb, who received an MFA in sculpture from Pratt Institute and, ten years later, started her own employment agency for graphic artists in New York City, said that "you need to learn what is a bottom line, and what it takes to make something financially viable. You need to learn what clients want and how to satisfy them."

There are a number of employment agencies for artists, a large percentage of which are listed in the *Workbook Illustration* directory (see page 265 for address) while others may be found in the Yellow Pages. Most of the jobs that agencies list are in computer graphics, art direction, and desktop publishing, with some for illustrators. Computer skills tend to be a given. Artists should have fluency in Photoshop (a computer design program that creates images one sees on the Web, taking digitally coded art and converting it into the proper file format), FreeHand (for laying out type and images), Quark (page layout and prepress production), and Illustrator (for drawing and making image maps). "The world has been recreated by technology," said William L. Ayers Jr., president of the Ayers Group, an employment consulting agency in New York. "The keystroke is almost as important as the brushstroke."

In some cases, the keystroke may replace the brushstroke in the work of artists who learn these skills. Jeff Gervasi, a 1996 School of Visual Arts BFA (painting) who directs photo shoots for Macy's, found that the knowledge he gained in Photoshop shortly after graduating helped him win a commission to paint a mural for a New York City office building. "I went to

the building and took photographs of the walls that would be painted," he said. "Then, I took my paintings and, using Photoshop, scanned the images onto the photographs of the walls to show what my work would look like installed. The owner of the building liked my presentation and commissioned me to create three fifteen-foot paintings."

ART DIRECTION

Gervasi noted that being an art director in general has had "a wholesome effect" on his fine art career. "I've learned to organize myself in a businesslike manner, targeting certain areas, putting my work out there in a professional manner." In days past, art directors were seasoned illustrators hired by an agency or company. Increasingly, such positions have become close to entry-level jobs for those with art, design, and computer skills, and the average age of many art directors is the mid-twenties. For example, Michael Perna, who earned his BFA in painting and sculpture in 1995 from the School of Visual Arts, was hired as an assistant art director at Doremus Advertising a year after graduating, earning in the low $30,000s. A year after that, he became one of the agency's art directors, raising his salary to $40,000. Perna had taken a couple of courses in computer graphics during his sophomore year and, during his junior year, began to work part-time for a design firm in New Jersey, at first putting layouts together for the designer and later becoming the designer himself.

"I stayed in that job for six months after I graduated," he said, "but I really wanted a full-time job in New York. It was hard to look for a job while working in New Jersey, and I also had a lot of responsibilities—I couldn't just take time off to look for a job." He quit and freelanced page layouts and typography for publishing and design firms for a period of months until he was hired (through a recruiting firm) at Doremus.

When Steven Morris graduated from the School of Visual Arts in 1994 with a BFA in painting, he first worked as an art handler for a gallery but began to teach himself the computer. Within a small period of time, he was hired by a publisher of design and photography annuals, doing computer pasteup, "scanning for placement mostly, to make it easier for people actually doing the design." There is considerable volatility in these jobs, and many people do not stay very long. Morris moved to another design firm, where he began to use Photoshop with animation. "Within three months, I moved into an art director position, with a number of people under me," he said. Subsequently, his career has been one of lateral moves as art director to larger and better-paying companies. The next position up is often creative director, where the jobholders are more

likely to be in their thirties or older and have had a number of years of rising responsibility.

WEB DESIGN

A number of artists who have gained computer design skills have also gone on to become Web designers. Many art schools and art departments, which have been stressing computer literacy for both their fine and applied art students over the past decade, offer a course in how to design a site for the World Wide Web, and internships at Web design companies may also be arranged by the school. Although Web design is a career (albeit a new one) for many artists, it is not a major at any school because the skills involved are relatively easy and quick to learn and because this area of design is only one application of a larger body of computer art training. Web designers have all learned Photoshop, FreeHand, and Illustrator. From these, one learns how to format images and how to relate text and images in the smallest number of files (for ease of use). An additional method of learning how to design a Web site is by looking at sites themselves, clicking "show source" under the file menu to see how the text and design are written up, and then experimenting with designs on one's own using the 216 available colors. Jane Mount was a painter in Hunter College's MFA program (in New York City) when she began to teach herself HTML (hypertext markup language) in the school's computer lab. While looking through various Web sites, she came upon one that struck her as "particularly well-designed, an online magazine called *Word.com.* I sent them an e-mail, telling them I liked the design and asked if I could do work for them, and they hired me to be their art director." Mount later moved into Web design and is currently the executive design director of a New York City–based Web design firm. She also teaches a course at Parsons School of Design in Web design.

"It helps to be an artist to do Web design," said Michael Merrill, a painter and design director at Concrete Media in New York City, "because you need to know the fundamentals of color, layout and design, hierarchies and structure. Those without art backgrounds tend to get caught up in the technology. Their sites have a lot of gadgets, but they don't communicate as well as they should." There may also be drawbacks to being both a fine artist and Web designer at the same time. Merrill noted that his artwork has "definitely been affected by what I do on the computer. There is a lot more repetition in my paintings, with repeating lines and color fields." Mount also noted the problem of influence in her two careers. "In design, you want to make things easy to see and highly

understandable," she said. "People should be able to grasp everything very quickly. A painting, on the other hand, is more emotional and not all that thought-out; you want people to look at it for a while to try to understand what is going on and how things do or don't fit together. I've noticed in some of my paintings that I'm explaining more, taking out some of the complexity, which I don't like."

Salaries for full-time Web designers in companies range widely from $20,000 to $80,000, depending upon experience and the needs of the clients, although the average is $40,000 to $50,000. Freelance rates are determined by the hour ($25 and up, usually) or by the job. Joe Johnson, a freelancer who received a BFA in sculpture from Kendall College and taught himself Web design while still in school, created a college student site for the automobile maker Chrysler, charging $36 per hour for a job that required thirty-two hours. As might be expected, employment opportunities are listed under various Web sites (the most plentiful source is *Communication Arts* magazine's, *www.comarts.com*), and one responds to job advertisements by e-mail.

Illustration

Artists who have studied applied arts at an art school or university have an advantage over those who pursued the fine arts side in that the goal of the applied arts program is a professional-looking portfolio that is ready to be taken to art directors. Fine art graduates may have their own portfolio, but it tends to be oriented toward galleries. One can still take these portfolios to show art directors, Sam Modenstein, director of career planning at the School of Visual Arts, noted. "The employer needs enough insight to see the potential of someone without a standard portfolio and say, 'Hey, you've really got a great eye. You're really great with color. You really could do this work.' Not every employer is that insightful."

Fine art graduates do not come away from art school with less talent for illustration than applied art graduates—they all took the same courses in two- and three-dimensional design, drawing, color theory, and composition—but without the specific training. As a result, these artists need to learn in a hurry. One of the first issues is in what market of illustration the artist wants to work, for instance, advertising (the highest paying area), editorial (offering the greatest opportunity for exposure), corporate (art for annual reports, sales and marketing pamphlets, for instance), book covers, children's books, and educational books. "If your portfolio doesn't show jobs that you've done for clients, put in work that you would

like to get," Morgan said. "If you want to do book covers, find a book and give yourself the assignment of illustrating a cover for it. If you want to do corporate work, get an annual report from IBM and do an illustration for it. You need to work up a number of samples." It would be useful for an artist preparing a portfolio to have someone look at it in order to ensure that it is presentable, is easy to follow, and suggests accomplished work. Morgan noted that she does portfolio reviews on a consultant basis, and one may otherwise ask an art school career office administrator or faculty member to make an evaluation.

Beyond knowing the type of work they want to do, artists should also carefully identify the specific clientele who would want and be willing to pay for it. An artist interested in creating covers for science fiction novels, for instance, should look for the publishers of these books. Those seeking jobs in advertising illustration would want to look through directories of advertising agencies. In effect, artists need to create their own lists of would-be employers. Then they should submit portfolios to art directors (which was more effective in the past when there were fewer illustrators competing for jobs and art directors had more time to meet them and review their work) and mail a postcard, flyer, or brochure to them. Basista noted that whatever is mailed should be a strong image presented in an original manner, because "art directors get hundreds of cards every day, and most of them don't get looked at. You want to send something that stands out from the crowd." Among the innovative approaches he has seen are a T-shirt featuring an image by the artist (as well as the artist's name and telephone number) and a cigar box with the artist's image inside to be seen when one picks up the lid. "One artist sent out a blank pad of paper with an image and the artist's name and number in one corner," he said. "Most people don't want to throw out blank paper—they can always use—so this artist found a way to keep his name in front of the art director for a long time, which is what you want." Gimmicks aside, artists need to recognize the need to make their work eye-catching in a very crowded field.

Promoting one's work needs to be an ongoing activity, with mailers sent out regularly (quarterly, in some instances), especially to clients for whom one would like to work and for whom one's work is appropriate. Artists should establish an advertising and promotion budget, Basista said, of between 10 and 30 percent of their gross revenues. That sounds like a lot of money, but "if you earn $100,000 one year and decide to save that money instead of spending 10–30 percent on advertising, you won't make $100,000 again."

DIRECTORIES

Illustration directories are one of the most expensive means of advertising and promotion; most are sent free to art directors and other prospective buyers of talent. Considering the cost of advertising in many of these books (between $1,500 and $7,000, depending upon the size of the ad one takes out), one should have a career reasonably well established before buying ad space so that one's investment will be repaid. There are many more directories than listed here. Some, such as *California Image, Rocky Mountain Creative Sourcebook, Philadelphia Creative Directory,* and *Texas Creative Sourcebook,* are regional, while others are narrowly focused (*Klik, Madison Avenue Handbook, Rx Plus,* and *Stock Photo Deskbook*). Among the more general, national directories are:

Alternate Pick
1133 Broadway
New York, NY 10010
(212) 675-4176
www.Altpick.com
Annual directory for the editorial, entertainment, and music industries. Listings cost $2,500 for one page, $4,800 for a two-page spread. A page from each advertiser also appears on *Alternative Pick*'s Web site as well as on CD-ROM.

American Showcase Illustration
584 Broadway
New York, NY 10012
(212) 941-2496 or (800) 894-7469
www.showcase.com
Two-volume national sourcebook in commercial illustration (also available on CD-ROM), published each January. Listings cost between $2,550 and $7,700, depending upon the size of the ad, whether it is in color or black-and-white, a single or double-page spread and when the ad is placed.

ASMP Membership Directory
150 North Second Street
Philadelphia, PA 19016
(215) 451-2767
www.asmp.org
Listings of the more than 5,000 general and associate member photographers, published annually. Membership costs between $125 and $275 per year.

Creative Black Book Illustration
Black Book Marketing Group
10 Astor Place
New York, NY 10003
(212) 539-9800
(800) 841-1246
www.blackbook.com
An international portfolio of commercial artists and illustrators, published each September.

Single-page advertisements (black-and-white or color) cost $3,000; a two-page spread costs $2,700 per page. Advertisers receive 2,000 reprints for every page.

Digital Directory
301 Cathedral Parkway
New York, NY 10026
(212) 864-8872
www.digitaldirectory.com
A showcase of photographers, designers, and illustrators, published each January on CD-ROM. List for free, linking one's Web site to the directory.

Graphic Artists Guild Directory of Illustration
Serbin Communications
511 Olive Street
Santa Barbara, CA 93101
(805) 963-0439
(800) 876-6425
www.gag.org
www.serbin.com
A national sourcebook published annually in November. Full-page advertisements cost $2,395 ($2,275 for Graphic Artists Guild members), with five separate images permissible on a page. Advertisers receive 1,000 reprints plus a 500-name credit at a mailing list company.

RSVP: The Directory of Illustration and Design

P.O. Box 050314
Brooklyn, NY 11205
(718) 857-9267
www.rsvpdirectory.com
A national collection of promotional pieces from illustrators and designers, published annually and distributed internationally. Full-page color advertisements cost $1,450; full-page black-and-white ads cost $1,100. Discounts available for previous advertisers (subtract $100), full payment ($100), reserving an ad space by February of the preceding year ($100), and membership in a professional graphic artists organization ($75).

Workbook Illustration
Scott and Daughters Publishing, Inc.
940 North Highland Avenue
Los Angeles, CA 90038
(213) 856-0008
(800) 547-2688
There are four separate directories, one for illustrators, one for photographers, a calendar, and a workbook that comes in East, West, South, and Midwest editions. Designers, illustrators, and photographers may be listed for free in all regional workbooks. Full-page illustrations cost $3,600 per page, with 10 percent discounts for paying in full and for membership in a professional graphic artists organization.

The costs increase for artists as they advertise in more than one directory in order to reach the widest possible market. Besides being prepared to shoulder those costs, an artist must produce work at a high level—one should not place an ad in a directory if still developing a style. "Directories stay around for a long time," Basista said. "If it's not really a good page, if you're not showing top-notch work—work that is as good as anyone else's found in the directory—then an ad can kill a career. You won't get calls this year and, when art directors look at older directories, you won't get calls next year either, or the year after that, and so on."

AGENTS

"When you're new to the business, you have more time to find your own style, get feedback, develop accounts, negotiate contracts, collect receipts— that's all stuff you should learn," said Gerald Rapp, an illustrators' representative. "It's when you have too much of that stuff to do that you need a rep." An agent's job is to find work for the artists he or she represents, negotiating the particulars of a job (payment, schedule, rights) with an art director or some other employer, billing the client and ensuring that the artists are paid. Ideally, the agent keeps artists as busy as they want to be, their minds free of the business side of things, while providing a steady stream of income.

There is no one kind of agent and no one place to find them. Some agents, such as Rapp, claim that they don't want to be found at all. "I get five hundred people a year coming to me, wanting me to be their rep," he said. "I just don't tend to want people I haven't heard of before. I take people I seek out or who are referred to me by an art director. If I see something I like in a magazine, I may seek out the artist." Other agents, such as Greg Lhotsky, are more willing to be approached by artists seeking representation. "I look at everything that is dropped off," Lhotsky said. "You never know when the next Richard Avedon is going to walk through the door with a portfolio." He also stays on the lookout for new talent by visiting schools, attending at shows of illustration, occasionally visiting fine art galleries, as well as perusing magazines. "I spend an inordinate amount of time looking at magazines sideways, looking at picture credits." Agents who are very well established in their field are unlikely to want to represent an artist right out of school, while agents who are just starting their careers are more likely to go to art schools and work with less experienced artists.

For many agents, a major criterion is that the artists already have a viable career that the reps can enhance. They want busy artists rather than just good ones. "I look for illustrators who have developed a market, who

have a serious following," Lhotsky said. "I look at the types and stature of clients they have and at the economics: What are they billing? Can this person afford to have an agent?" In many instances, agents look for artists in directories, identifying those who are not currently represented. Artists who can afford the thousands of dollars for an advertisement are thought of as serious and economically viable.

Two organizations of illustration agents exist—the Society of Photographers and Artists Representatives (SPAR, 60 East 42nd Street, New York, NY 10165, 212-779-7469) and Chicago Artists Representatives (312-409-6211)—that represent a small percentage of all agents. Membership in either group does not signify that an agent is more successful, more ethical, or held in higher esteem than nonmembers, since these groups primarily serve the educational and networking needs of those who join. Directories, such as the *Workbook,* the *Graphic Artists Guild Directory of Illustration,* and *American Showcase,* contain far more complete listings of agents. Inclusion in a directory list, however, is not a basis for selecting or even approaching an agent. "Looking for an agent is like looking for a relationship or a marriage," said Lhotsky, who is president of SPAR. "You want someone with whom you feel personally comfortable, someone you feel will act in your best interests. I tell artists to meet the rep in the rep's office, another time in the artist's studio, and then at a restaurant or some other neutral territory to see how you get along. It's like the three-date rule in dating."

Artists should also research the agents they are considering, determining if their style of art fits into the area in which the agent concentrates, although an artist would not want to compete with other artists represented by the agent working in a very similar style. "For agents working with a variety of talent, you want to be the thing they don't already have," Basista said. "Some agents take a Darwinian attitude. They'll have six cartoonists and pay attention to the one who gets the most work." Artists should also discuss the agents' honesty and competence with their current and former clients: Have they done what they've promised? Do they get artists enough work? Are the contracts negotiated properly? Is payment on time? (Current directories and those of a few years back will list the artists that an agent represents, and the names often change over time. It may be useful to talk with artists who left an agent about why they did so.) "Artists stay with me an average of fifteen years," Rapp said. "That's longer than most marriages." When there is significant turnover in the talent pool, prospective artists would want to know why. Agents expect that artists will research them and may be interviewing other representatives as well. "The last thing I want is a letter from an artist starting 'Dear Sir' or 'To whom it may concern,'" Vicki Morgan said. "They should want what I can do for them specifically."

Most self-supporting illustrators choose not to have an agent. Terry Brown, director of the Society of Illustrators, estimated that, of the artists participating in its annual show, "maybe 20 percent have reps." Basista noted that, based on a survey conducted by the Graphic Artists Guild, 63 percent of all illustrators do their own marketing, negotiating, and billing. Of the other 37 percent, only 7 percent claimed that they were satisfied with their agents, which Basista attributed to "unrealistic expectations." Artists who concentrate in advertising, book and corporate illustration, which are the highest-paying areas in illustration, are more likely to have agents than those working in less lucrative fields, such as editorial (which, however, has the advantage of providing greater public exposure for artists). Artists have less incentive to split a $500 fee with their agents than they would a $10,000 payment, and agents are unlikely to rustle up low-paying jobs in general.

"The value of an agent is that this person can market work to a wide variety of people you might not be able to get to otherwise," Lhotsky said, adding that agents frequently charge higher fees for their artists than those artists would ask for themselves. "Anyone without an agent doesn't have a handle on what they're worth. Artists tend to just think about their own work, but it's my job as an agent to think about other people's work and what they're getting for it."

Having an agent is not a telltale sign of success, however, as many illustrators complain that they don't get enough work. The strength of an agent is that individual's relationship with various art directors, but, Lhotsky conceded, "some art directors prefer not to use a rep," and instead maintain a direct relationship with the artists they hire. Publishers of the *Workbook* surveyed art directors on how and why they hire artists, finding that the reputation of, or relationship with, an agent was low on the list of reasons. Higher up were such reasons as, they had used the artist before, the artist was recommended by someone they knew and trusted (another art director or artist) and they saw the artist's work in a directory. Doreen Minuto, an illustrator in Deer Park, New York, decided to forgo her agent and deal directly with art directors because "I wanted more control over my career. With my agent, I only got certain types of jobs. When I left the agent, I got other types of jobs, too." The trade-off appears not all to her benefit, since marketing her work ("dropping off jobs, making phone calls, billing") takes up a third of her time—and a larger percentage of her income than what she paid her agent—but she claimed to "enjoy the business part of the job. I think I come out ahead this way." Other artists who have given up their agents found that they needed to hire assistants to handle mundane office work, whom they have to pay whether or not there is work.

Artists on their own, and even those represented by an agent, should be knowledgeable about contractual issues when hired by an art director. The Graphic Artists Guild's periodically updated *Handbook Pricing and Ethical Guidelines* details industry prices, standard business practices, terms and rights to be negotiated, and payment schedules.

Some artists simply resent paying an agent 25 percent when the rep seems to do little else but take orders that come in over the telephone. When illustrators with agents take out an advertisement in a directory, they usually pay 75 percent of the cost (the agent pays the rest—the percentage is based on the commission), yet the ad lists only the agent's telephone number. "The rep may not get you any work, but the rep has that ad forever," said Joe Safferson, account executive at *American Showcase.* "If you split up with your agent, that ad still has the agent's name on it, and you have to start from scratch again."

An agreement that an illustrator signs with an agent generally includes the following points:

- Exclusivity: The agent may represent the artist in all work worldwide, or in certain types of work (advertising, for instance) within a particular geographical area (such as North America). Some illustrators have more than one agent, while others use a rep for one area and otherwise market their own work.
- Term: An agreement lasts for a specific period of time, after which it is renewed or renegotiated, or the relationship will no longer continue. A termination clause is often part of these contracts, specifying how the relationship will be ended ("30 days after written notice" is common) and how long commissions will continue to be paid to the agent after the relationship has been severed (the Graphic Artists Guild recommends up to 90 days, while SPAR prefers 180 days plus one month for every year that the agent has represented the illustrator). Because an artist is unlikely to want to pay commissions to a former agent while beginning a relationship with a new representative, Basista noted, artists "may negotiate a lump-sum payment to the first agent to clear the board."
- Commissions: The standard rate is 25 percent, although many agents take a 30 or even 35 percent commission with their newest artists for the first year or two as "there is a lot of work at the beginning to get an artist known," Lhotsky said. Agents may also charge 30 percent when they pay for messenger services, any travel or materials, or when they pay more than 25 percent of the cost of advertisements in directories. Another concern that may arise are commissions for what are called "house accounts." The agent may now want to take a percentage of the money paid to an artist by a particular client, even though the artist

and client had established a working relationship before the agent became part of the picture. This issue needs to be negotiated and often results in the artist paying none or a reduced commission to the agent.

- Billing and payment: In some arrangements, the artist bills the client and pays the agent a commission, but most of the time the agent bills the client and pays the artist. There are a variety of timetables by which artists are paid, and these must be negotiated with every different agent. Some agents pay their artists as soon as they bill the client for the job, while others pay as soon as they receive a check from the client. Yet others pay their artists once a month or quarterly. An obvious concern for illustrators who are paid quarterly is that the agent may be drawing interest from their money while waiting the ninety days to pay them. In addition, some artists may find that ninety days is a long period to go between pay periods.

- Other contractual points may be a periodic accounting by the agent to the artist, the right to inspect the books, the right to refuse jobs, and mediation or arbitration of disputes.

A number of service membership organizations offer information and direct counseling to artists in the commercial art realm, as well as the opportunity to meet others and network. They include:

American Institute of Graphic Arts
164 Fifth Avenue
New York, NY 10010
(212) 807-1990
www.aiga.org
Seminars and conferences,
newsletter, exhibitions.

*American Society of Media
Photographers*
150 North Second Street
Philadelphia, PA 19016
(215) 451-ASMP
www.asmp.org
Newsletter, advocacy,
workshops.

Graphic Artists Guild
90 John Street
Suite 403

New York, NY 10038
(212) 791-3400
www.gag.org
Guild chapters located in
Albany, New York (518-251-3015),
Atlanta, Georgia (404-297-8435),
Boston, Massachusetts
(781-455-0363), Chicago,
Illinois (773-761-7292),
District of Columbia
(301-530-6971), Indianapolis,
Indiana (317-925-3275),
New York, New York
(212-791-0334), Portland, Oregon
(503-245-9832), San Francisco,
California (510-839-4236),
and Seattle, Washington
(206-471-0820).
Workshops newsletter,
advocacy.

Society of Illustrators
128 East 63rd Street
New York, NY 10021
(212) 838-2560
(800) 746-8738
www.societyillustrators.org
Newsletter, exhibitions, conference.

A Foot in Two Careers

"You can't dabble in illustration," Vicki Morgan, the illustrators' rep, said. "You have to be committed to this work and not just do it when you need some money. You're competing for every job against very talented illustrators who do nothing but illustration all day." Quite true, but Morgan and many other agents represent some artists who both do illustration and exhibit their fine artwork in galleries. It is not an easy balance to maintain, because there is often a drop-everything aspect to commercial illustration assignments that may prove disruptive to the process of creating fine art, but trade-offs are a regular feature of artists' lives.

"Sure, you have to be dedicated to illustration, and I don't want to disappoint my agent or some art director by turning down jobs or sending them in late," said painter Tom Christopher of South Salem, New York. "But, if you don't have work in front of you every minute—and most illustrators don't—then you can do other things." His other thing is creating paintings that are exhibited at the David Findlay Gallery in New York City. He has one-person shows there every other year, a schedule that gives him sufficient time to build up enough works to exhibit, and it helps that he is by nature prolific. "When you have your foot in two careers, you can survive when one side goes down."

Christopher received a BFA in painting in 1979 from Art Center College in Pasadena, California, and promptly moved cross-country to live and work in Manhattan's Lower East Side, where many young artists were congregating. While attempting to show and sell his work in galleries, Christopher also began to develop a commercial art portfolio. He painted pictures of tools, which he had reproduced onto postcards and then sent them to magazine art directors (whose names he found by looking through magazines at newsstands), and he also worked for the local television station WCBS as a courtroom artist. Based on a review of his quick-study courtroom work, the National Hockey League commissioned him to travel

with, first, the Philadelphia Flyers and later the Soviet Red Army team, creating candid portraits for a publication the league produced. Through his postcards, he was able to generate assignments and a self-supporting career as an illustrator.

Most artists aren't as able to nurture both fledgling fine art and commercial art careers at the same time. Because of the need to support themselves, artists generally involve themselves in, say, illustration and then branch out in the fine art realm. Bruce Wolfe of Piedmont, California, dropped out of art school in 1963 in order to work at the San Francisco branch of Foote, Cone and Belding advertising agency, where he eventually became an art director, staying for ten years ("long enough to vest, then I split") before going out as a freelance illustrator. As an art director, he had come into contact with other area and regional art directors socially or professionally and could call them for work. "I also knew what to charge for my work because I had spent money on illustrators," he said.

It was through people he knew that Wolfe also began to sell his paintings and sculpture, receiving commissions for sculpted portraits and, later, monumental pieces. Three galleries in California—in Carmel, Mendocino, and San Francisco—currently exhibit his paintings. There is an easy back-and-forth flow from illustration to fine art, in his mind, because "the who you-are kind of style in your work doesn't change that much. It's what you paint and why you paint that changes."

Another illustrator who moved into the fine art world, Dahl Taylor of Albany, New York, attended the Art Institute of Boston as a painting major but left to work as a staff artist for several daily newspapers. For them, he created editorial illustrations, courtroom sketches, and covers for special sections, as well as the layout and design for sales and marketing flyers. After a few years, Taylor moved on to an advertising agency and, in 1980, went on his own as a freelance illustrator.

"I left my job one day at a time," he said, "going from five days a week to four days, then from four days to three, then three to two, then one. Because I wanted to work freelance, I began to build a portfolio of the stuff I liked to do, which takes a while because in a local market like Albany you have to do all kinds of things, some far less interesting than others. I put lettering on trucks, I did ads for newspapers, I did brochures. After a while, I could start developing my own style, winnowing out the other stuff."

During these years, Taylor also tried to create at least two paintings per year in order that this part of his art training didn't get lost. After a number of years, he had a body of work, which was exhibited at the Rice Gallery of the Albany Institute. His paintings sold, and he also began to receive commissions for portraits and other types of work. "More and more of my

income, almost half, comes from fine art now," he said. Working in both fine and commercial spheres has its benefits and drawbacks. "As an illustrator, I have experience as a custom artist, so commissions don't pose a substantially different problem for me. When I'm making a picture to sell at a gallery, I approach it the same way as I do my illustrations, gathering references and working at the same pace." In certain respects, his commercial artwork has affected positively the fine art. "Being an illustrator enhanced my skills as a picture-maker. I can build a picture."

The problem, Taylor noted, is that his success as an illustrator may have also hindered him as a fine artist, because "you need to be fast and successful each time out. If you're not absolutely successful, art directors won't call you back. That has tightened me as a fine artist, because I know I don't take risks as much as I want."

There may also be a problem of perception for artists working in both the fine art and illustration areas. "Art directors look down on gallery artists as people who have no work experience and no sense of deadlines," Taylor said, and the fine art world sometimes attaches a stigma to those who work regularly in commercial art. "It doesn't matter to our collectors what else Tom [Christopher] does if they like the work. He could be a garbage collector," said Lindsay Findlay, director of David Findlay Gallery. However, she added that "we wouldn't promote the fact that he does illustration. We never mention it to people when talking about him." For his part, Christopher said that "I call my illustration jobs commissions because it sounds more art world."

Perceptions are not always the reality, and the stigma may be more assumed than real. Some fine art collectors first learned of Christopher's art (in both realms) from the "Absolut Christopher" advertisement for Absolut vodka, a long-running promotional campaign that features fine artists lending their styles to a commercial venue. Some art directors show a special interest in illustrators who are also gallery artists, believing the association with the high-toned world of fine art will rub off on their products. Commercial illustration and advertising must make their points quickly, and the split-second identification of art with a product or service telegraphs a sense of high quality, cachet, uniqueness, and creativity as well as a higher price tag. Advertising frequently appropriates fine art imagery: the point is to exalt, frequently with a tinge of irony, a product or subject matter by raising it to the level of art. For instance, Rice-a-Roni used a section of Vermeer's *A Girl Asleep* to point out that "Before Savory Classics, dinner could be a real snore," and van Gogh's *Sunflowers* was pictured next to a package of Flora margarine in an ad that stated "Very tasty if you've got the bread." Art is often used to add a touch of class to a product. Neiman

Marcus has classified its bed-and-bath accessories in ads under the heading "Interiors as Art"; an expensive timepiece by the Movado company is billed as "The Museum Watch," and Belgium's General Bank announces that "Talent knows no frontiers" while displaying a large detail from a painting by one of that nation's most famous artists, Peter Paul Rubens. Porcher, a French company that makes bathroom fixtures, took a portion of a Matisse painting entitled *Large Reclining Nude* to promote "Form. As Only the French Can Express It." In the past, advertising's use of fine art has focused on appropriating styles and specific imagery of well-known, long-dead masters (Botticelli, Leonardo da Vinci, Magritte, Michelangelo, and Grant Wood, to name a few), reflecting perhaps what the public views as art. Fewer images of the postwar world are as universally known. Increasingly, however, contemporary fine art styles (if not the particular works themselves) have found their way into advertising, suggesting that art directors are more open to gallery artists in the commercial arena and that the public's conception of art is not limited to the long ago.

As do all other illustrators, both Christopher and Taylor are reluctant to turn down assignments that come in, out of the fear that art directors may never want to use them again and because it reflects poorly on their agents, who have spent years promoting them to art directors. As a result, they simply have to put in far longer days than their colleagues who pursue only one artistic career. "In all, I work fifty-five to sixty hours a week," Taylor said. "It would be closer to forty if I just did illustration." His dual career is satisfactory to his agent, Vicki Morgan. "My agreement with her is, if I can handle whatever comes down the pike, then I can do whatever else I want." Morgan may be one of the more understanding reps in this area, as she herself was a painting student at Cooper Union, where she took courses at night while working during the day at J. Walter Thompson advertising agency. She eventually took a job working for an illustrators' representative, later setting up as a rep on her own. "I said to myself at the time, and I say this to lots of young artists, 'What is the business of your talent? How can you make your talent earn money for you?'" Morgan said. "I found that being a rep was what I could do best. I understand what my artists want, and I know how to get it for them."

From Commercial to Fine Art

The aim of this book has been to describe some of the collateral fields of employment for which a studio art background is relevant and valuable, to answer the assumed question, What can someone do with a fine arts training?

The movement isn't all one-way, however—away from fine art into something else—for some people in the commercial arts or in art-related fields are able to become full-time fine artists. Take both Barbara Kruger and Camille Przewodek, for instance. Their commercial work was quite related to their fine art, making the transition one of changing audiences rather than of style or technique. Kruger worked for four years full-time and eleven years freelance at Condé Nast Publications as a magazine designer and picture editor on *Mademoiselle* and *House and Garden,* "taking a photographic image and putting words on top of it. It didn't matter that the words I put were meaningless: it was someone else's job to supply the final words."

Although she had pursued painting for a number of years, Kruger had not attended art school and "didn't know a bunch of people who could help me." Finding a place in the art world was a daunting challenge, she noted, since presenting work to dealers was a "humiliating experience" in general and, during the 1960s and early 1970s, "the art world was not all that welcoming to women artists." The 1970s was not all that welcoming to painting either, and "I felt alienated from it." With artistic skills and some on-the-job training, however, Kruger developed a career as a commercial artist, but that also was not fulfilling for her and she did not feel wholly competent in her work. "I just didn't feel I had the wherewithal to be a designer," she said. "I'm not that good at solving problems in terms of visual imagery, and I felt that the intimacy between a designer and client that should be there wasn't there."

Over the years that she was a designer, Kruger began to build up a body of work based not on the painting she had previously done but on her work at Condé Nast. These large-scale word-and-photographic image pieces "objectified my experience of the world, transforming my job as a designer into my work as an artist. The two are related on a visual level, not on an ideational level." Kruger began to meet other artists, many of them younger than herself, with whom she exhibited her work in galleries off the beaten track. Her work attracted considerable attention, and it was eventually shown at alternative spaces in New York City (the Kitchen, Franklin Furnace) and, later, at galleries and museums. By then, art-making was her full-time occupation.

Commercial art to Kruger was "a job, and I needed some way of making a living." Early in her career, Przewodek, of Petaluma, California, also thought about being a gallery artist but "decided that the gallery scene was too pretentious." She also wanted a way to make money. After earning a BFA in fine art in 1972 at Wayne State University, she took another BFA in illustration in 1983 at the Academy of Art College in San Francisco. To her

instructors at the college, she did not seem a good fit in the illustration field, because her style was loose and colorfully impressionistic. "I was told in art school to reduce the amount of fine art in my portfolio," she said. "I was told that I'd never get any jobs in advertising, maybe in editorial," but those fears were misplaced. Over the years, she has produced work for Alfa Romeo, Chevron, Del Monte, Northwest Air, and RCA Records, among others. "My work looks painterly. I do a landscape with a car in it—the car happens to be an Alfa Romeo."

A fine art temperament often accompanies fine art, and some artists who try to maintain a presence in both fine art and illustration find that it is not easy to go back and forth from one realm to the other. "I juggled both balls for a while," said former illustrator and now gallery artist Skip Loepke, "but it was hard to do both. The more enjoyment I got out of my own work, the more I hated the compromises I had to make in my illustration. Fine art made me feel more intensely the lack of freedom in illustration, and I felt as though my illustration work wasn't really so good anymore. It wasn't my work, it wasn't my idea. I was just solving some art director's problems." Przewodek also increasingly began to chafe under the demands of commercial work; "I don't want to be told 'Do this' by clients," and she started looking for ways to develop a presence in the fine art realm. Not only did she submit her commercial work to annual exhibitions of illustration (New York Society of Illustrators, San Francisco Society of Illustrators, Illustration West), but she also sent other pieces to fine art competitions, such as those held by the New York Pastel Society and the Provincetown Art Association and Museum in Massachusetts. She joined a number of groups, among them the American Academy of Women Artists and Plein-Art Painters of America, in order to have her work shown in their annual exhibitions. She opened her studio to the public (one open-studio event resulted in $8,000 in sales) and convinced a local company that produces a community telephone directory to put her work on the cover. "I selectively called people who could do something for me," she said. One call, for instance, resulted in having her work displayed in department store windows. She also persuaded a collector to introduce her to a dealer, who began exhibiting her work.

Applying her commercial art sense of building a clientele to the fine arts realm, Przewodek also started to advertise in art magazines (*American Art Review* and *Southwest Art,* principally), as well as—and later instead of—illustration directories, spending between $5,000 and $6,000 per year. "Most fine artists don't have an advertising budget," she said. "I ask artists who are having trouble selling their work, 'What is

your vision of where you want to be in five to ten years?' and 'What is your advertising budget?'"

Planning ahead in uncharted territory is not easy. Another illustrator, Thomas Blackshear, spent a long time trying to find a way to make fine art his main occupation. Certainly, he enjoyed considerable success in illustration, with such clients as Anheuser-Busch, Walt Disney, Coca-Cola, Coors, Embassy Pictures, Milton Bradley, National Geographic, and Universal Studios, and he did not want to have to start again at the bottom, this time as a fine artist. However, after fifteen years of nonstop illustration work, "I got to the point with illustration where I was basically sick of it," he said. "I loved doing the artwork, but the process of doing a job, getting paid, doing a job, getting paid was wearing me out. I never had time to do anything else and, if you tell people you're taking time off to do your own work, you may not get another job for months." It was at this point that he decided to branch out into another area, creating collectibles.

Beginning in the late 1980s, Blackshear created portraits of noted African-Americans for a "Black Heritage" series of stamps for the U.S. Postal Service. Seventeen of these portraits, which the Postal Service later published in a commemorative book entitled *I Have a Dream*, were exhibited in 1992 at the Smithsonian Institution, and this show traveled to a number of cities around the country. Also in the late 1980s, he created images of characters from the films *Star Wars* and *The Wizard of Oz* and the television series *Star Trek* for collector plates for the Hamilton Collection, as well as sculpted a series of figurines for Hallmark. For a distributor of religious imagery, the MasterPeace Collection of DaySpring, Blackshear produced scenes from the Bible; in addition, he created figurines of black people in exotic dress for an "Ebony Visions" series for Willits Designs. When Greenwich Workshop took him on as one of their artists, he was able to add the limited-edition print market to the mix.

"All of these different areas started to pull together, as people from different areas began to hear of me," he said. "They knew my name and wanted to collect more of my work." He established the Blackshear Gallery near his home in Colorado Springs, Colorado, selling prints, figurines, plates, stamps, and original paintings, advertising the gallery in various publications. "The problem with being an illustrator was that I never had time to paint, and that means I never had enough originals to sell. With figurines and prints, I get royalties, which affords me the time to do more painting. I don't have to keep looking for the next job."

Przewodek continues to take a few illustration jobs per year; developing a presence in the fine art world did not require her to reject

commercial illustration. Howardena Pindell, on the other hand, had pursued her art while working for almost thirteen years as associate curator of prints and drawings at New York's Museum of Modern Art, but it wasn't until she left that job for a teaching position at the State University of New York at Stony Brook that her work received major recognition. "Some dealers thought I had too good of a job to be a serious artist as well," she said. "People wanted me to either leave the museum or devote all my time to the museum. Some dealers hinted that they might exhibit my work if the museum bought some of the art they showed. For years, I felt like I was swimming upstream." Being a woman and African American, she felt, also worked against her chances of finding a gallery.

This was quite frustrating to Pindell, who identified herself as an artist rather than as a museum curator. "I always felt like an artist; all my associates were artists. I lived in a loft. I didn't socialize with other museum people—there were almost no other curators of color. It was a godsend that I had my art and that I was highly productive." Her frustration reached a head in 1979; she quit the museum and was almost immediately hired by SUNY–Stony Brook as an associate professor of studio art (two years later, she received tenure). The change in jobs, coupled with a growing desire within the arts community to become more inclusive of women artists as well as artists of different races, sparked a reevaluation of her work. "The same people who, the year before, had told me they weren't sure if they would exhibit my work now told me how much better my work had become—it was the same work they had already seen," she said. "People could see my work now through new eyes instead of having other filters in the way."

Every job has its drawbacks. Whereas Pindell, a Manhattan resident, spent only twenty minutes getting to and from the Museum of Modern Art, her commute to Stony Brook is three hours each way. The trade-off is acceptable to her, however, as "a university wants diversity—it states that publicly—whereas the museum is basically an all-male white club," she said.

Too often, young artists maintain illusory notions about the art world, that they are destined to starve in obscurity, that successful gallery artists are mysteriously discovered, that success means getting one's picture on the cover of *ARTnews,* that the only paying job for which they are qualified is

teaching. Much of what contributes to success as an artist—defining success as the ability to support oneself as an artist—is the willingness to hang in there, finding ways to both earn a living and build a presence in the art world. When it comes, success is likely to look different than one's plans when just graduating from school. An artist's ambition and maturity are tested in ways unlike that of other professionals in our society, but the rewards are considerable.

The Art World and Minority Artists

S MANY PEOPLE ARE AWARE, THE WORLD IS NOT ENTIRELY FAIR TO ARTISTS, and it is even less so to artists who are members of minority groups. Relatively few art and crafts galleries and museums in the United States show the work of Latino, African-American, Asian-American, or other minority artists, creating a problem of invisibility that suggests that non-Caucasian artists and their work do not exist. Sande Webster, owner of a gallery in Philadelphia that predominantly exhibits African-American artists, said that a lot of museums and nonprofit art spaces want to show the work of black artists during February, Black History Month, "and they call me about which artists they should show. But, when I ask about showing some of these artists during other months of the year, they tell me they're all booked up."

Sometimes, certain assumptions are also made about nonwhite artists and craftspeople concerning the type of work they do. Webster noted that these museums and galleries are reluctant to show African-American artists whose work is not political in nature, untrained ("outsider art"), or somehow reflecting the fact that the artist is black, "because they don't get credit for using African Americans in that case." Fay Torres-Yap, a sculptor and furniture maker in New York City, noted, "There is an expectation that, because you're Asian, you have to have Asian themes in your work, or that

it look like something from the Ming Dynasty. Being stereotyped is a huge problem."

Only a few galleries have opened their doors to non-Caucasian artists. An affirmative action effort on the part of arts and crafts shows and fairs would be even more difficult to achieve, because jurying for these events usually is blind; that is, the individuals making the selections "won't be familiar with the maker unless they happen to know the work," said Carmine Branagan, executive director of the American Crafts Council. Noting that there haven't been any surveys of the exhibitors at arts and crafts shows that acknowledge their ethnic or racial background, she called for "a wider and more aggressive mentoring program for young and minority artists on the part of organizations and also the arts and crafts schools. It's not a matter of intentionally keeping people out, I don't think, but there is a need to find ways to bring people in."

African-American Artists

"I've heard gallery owners say, 'He's my black artist,' as though that's a wonderful badge of honor," said David Driskell, a painter and African-American art curator and historian. In the early 1990s, Dean Mitchell, a painter in Overland Park, Kansas, was recruited by the print publisher, Greenwich Workshop, to create images that would be turned into limited edition prints but found that the many members of the dealer base were reluctant to promote or even carry his work. "Greenwich Workshop holds annual presentations for the galleries that carry its prints, and artists are brought out to meet people," he said. "Their eyes rolled when they saw me and my work. I was told by a number of them, 'We don't have any black customers.'"

Those African-American artists who receive recognition are frequently identified in terms of their race, rather than the quality of their work. "For my whole career, I have been 'Benny Andrews, the black artist,'" said painter Benny Andrews. "Everything that a black artist does gets talked about in terms of social issues and economics by critics." He noted that, years ago, he made two paintings of nudes: "One was a white couple, and everyone said it was Adam and Eve, and the other was a black couple, and people said, 'What are those black people doing under that apple tree?'" He added that, for those artists whose work isn't "specifically about the black experience— say, your work is abstract—they ignore you. It's very easy for a black artist to fall through the cracks."

The opportunities for African-American artists are far better now than just a generation ago. Jean-Michel Basquiat emerged directly into the

mainstream art world, meeting almost immediately with critical praise and buyers, as have Lorna Simpson, Carrie Mae Weems, and a growing number of others—some claim that race has accelerated their careers. In most cases, the buyers of the work of these and other artists are white, but what has benefited more black artists is the growth in collecting by people within the African-American community who view the work as good art, a deserving cause, and/or an undervalued commodity.

"We're catering to a new industry," George R. N'Namdi, owner of art galleries in Chicago and Detroit that predominantly feature African-American artists, said. "First-generation African-American art buyers, people who have money but who came from people who either didn't have any money or were comfortable but didn't think about spending any extra money on things like art. Now, more of these people have disposable income, and we're trying to get them to buy art."

Many of the white collectors of African-American artwork regularly purchase American art and have broadened their interest to include an overlooked area, while black collectors "almost exclusively buy the work of African-American artists," said Halley K. Harrisburg, director of the Michael Rosenfeld Gallery in New York City, a white-owned gallery that shows a mix of historical and contemporary black art. "For many, it is a personal mission: They want to expose their children to art by African-Americans that was unavailable to them."

An example of this is Thomas Burrelle, chairman and chief executive officer of Burrelle Communications in Chicago, who stated that he has bought between fifty and sixty works by mostly contemporary artists from various galleries "to support African-American art. I also believe that African-American artists are undervalued and not exhibited enough." Several works from his collection—including paintings by Norman Lewis (1909–81) and Romare Bearden (1914–88)—have been loaned to museums and galleries for exhibitions. He declined to say how much he has spent on his collection or its current value, but noted that the insurance appraisal on almost all of the works has increased between three and ten times.

Similarly, Bruce Gordon, president of retail markets for Verizon in New York City, said, "As an African American, I wanted to invest in my own culture. I like art, first of all, and I had an interest and reasonable resources to invest." He noted that he is "not on a mission, I'm not trying to accomplish something, but when I meet other African Americans who should be interested in the art of their own culture but don't know how to gain access to it, I introduce them to what I collect." Perhaps more of a missionary in this pursuit is Ragan Henry, a part owner of Allur

Communications in Philadelphia and a board member of a special committee on African-American art at the Philadelphia Museum of Art. "I feel a need to get more people to see African-American art, because that will help spur more collecting by African Americans," he said. "If no one sees it or reads about it in art history books, people tend to not think it exists, or they denigrate it as not being very important or valuable when they do see it." Towards this end, he has prompted the Philadelphia Museum to make more acquisitions in this area. He noted an "increased willingness to raise money to buy more works by African American artists on the part of Anne d'Harnoncourt [director of the museum]. However, I also see some curatorial resistance about buying black artists' work, especially when it is a matter of spending $300,000 as opposed to $3,000."

Both Harriet Kelley of San Antonio, Texas, and Paul R. Jones of Atlanta became trustees of the San Antonio Museum of Art and the High Museum, respectively, serving on the acquisitions committees very much with an eye toward prompting these institutions to collect African-American art. Jones noted that, when he started collecting African-American art in the mid-1960s, "I couldn't go to a museum to hear a lecture on it, and I couldn't go to galleries to see it." As a result, Jones purchased from black artists directly, visiting their studios. Later, he began lending and donating pieces from his collection to museums, most recently placing a sizeable number with the University of Delaware. "My goals are to make sure that African-American art is on exhibit at all times and that African-American art is weaved into the story of art history."

Kelley and her husband, Harmon, also began donating works from their collection, first to the San Antonio museum and later (in a larger quantity) to the Smithsonian Institution for its planned African-American Museum. "When my husband and I were growing up, there were no pieces by African Americans in museums, and parents didn't encourage their children to pursue art," she said. "They wanted their children to be able to make a living, which is why my husband and I were science majors." Years later, Dr. and Mrs. Harmon Kelley were in a position to buy art, inspired in 1986 by a nationally traveling exhibition entitled "Hidden Heritage," which tracked the accomplishments of African-American artists in the nineteenth and twentieth centuries. "You get a few dollars extra, and you get things you want," she said, "but then you get tired of that. You have a desire to leave a legacy: this collection is what we give back."

At first, the Kelleys relied on art consultants to help them make selections, but eventually they began browsing the growing number of art galleries specializing in African-American art to train their own eyes and make their own purchases.

What has helped focus the attention of the African-American commu-nity are shows, such as the National Black Arts Festival in Atlanta (236 Forsyth Street, Atlanta, GA 30303, 404-730-7315, *www.nbaf.org*), consisting of hundreds of African-American artists as exhibitors, and the increasing number of galleries that predominantly show the work of black artists. The largest grouping of these galleries is the National Black Fine Art Show (6417 Little Leigh Court, Cabin John, MD 20818, 301-263-9314), which takes place every February in New York City and has between forty and fifty gallery exhibitors. The catalog for this show, which lists all of the partici-pating dealers, is $10.00. Another source of information is the *Guide to African-American Galleries* (Hampton University Museum, Hampton, VA 23668, 757-727-5308, $15).

Black-owned galleries are no more likely to take on an African-American artist on the basis of race than a white-owned gallery automatic-ally will represent a white artist; these galleries are deluged by portfolios in the mail and artists in person who want to be represented. Like all other gal-leries, they take on new artists based on the artists' record of sales and exhi-bitions, the compatibility of an artist's work (size, medium, price, style) with that already represented by the gallery, and recommendations from others (artists, dealers, critics, curators) whom they know and trust. Throughout the art world, getting into the galleries that actually sell work is often a matter of who-you-know and how-you-know-them, and African-American artists may be at a disadvantage in the mainstream art world if they are not part of a white social network. "A lot of what goes on in the art world is word-of-mouth stuff behind the scenes, in clubs, and other places that artists meet," David Driskell said. "Black artists can do everything per-fectly well, but they may not get invited to all the same places as other artists." The value of black-owned galleries to African-American artists is that part of their mission is "to discover and promote the work of black artists. Young and emerging black artists at least can get a hearing."

These galleries also reach out to the African-American community, giv-ing talks and teaching classes about art in order to "get people to realize that it's alright to collect art," said Sherry Washington, a gallery owner in Detroit. She has arranged for both Benny Andrews and Richard Mayhew to speak at public schools and community groups, allowing people to see a black artist (perhaps for the first time). Part of her outreach includes being a member of both the Friends of African and African-American Art com-mittee of the Detroit Institute of Art (in order to encourage the acquisition of more artwork by black artists by the museum) and the predominantly white Detroit Athletic Club (to encourage potential white collectors to buy African-American art).

African-American artists might also do much of the same type of outreach. "African-American society is very naive about the importance of the arts," said painter Richard Mayhew, "and the educational system doesn't speak of African-American artists. I make it a point to speak to many groups at civic and community centers about what the arts contribute to society and how African-American artists have contributed to art."

Many African-American artists also seek to show their work at the galleries and museums of black colleges, of which there are over one hundred in the United States. The United Negro College Fund (8260 Willow Oaks Corporate Drive, Fairfax, VA 22031, 703-205-3400, *http://uncf.org*) has information on, and gives money to, thirty-nine of these schools. Other sources of information include *Black American Colleges and Universities* (Gale Research) and *America's Black and Tribal Colleges* (Sandcastle Publications). Additionally, a growing number of museums specifically exhibit the work of contemporary and historical black artists, and one may learn about them through the African-American Museum Association (P.O. Box 427, Wilberforce, OH 45384, 937-376-4611), which is an affiliate of the Washington, D.C.–based American Association of Museums.

The *African-American Information Directory* (Gale Research) lists a large number of black professional associations, which may offer project grants and fellowships to students and artists, as well as other resources.

Unfortunately, few African-American artists are supported solely through sales to black collectors. Galleries and museums that primarily show African-American artists' work are often a means of getting into the larger art world rather than an end in itself. Howardena Pindell, a New York City artist, noted that she creates "smaller works for people with smaller budgets," as a way of developing collectors in the African-American community. However, according to Dean Mitchell, "once you get past $3,000, you lose a lot of black people. I've never sold anything to anyone who is black for $30,000."

Some artists reject the idea of predominantly African-American art galleries as ghettoizing artists altogether. "The art world, like the rest of the world, is multi-racial," said Washington, D.C., painter Sam Gilliam. "An African-American art gallery is a kind of gimmick, but it is wrong to try to create a second nation in America." Similarly, Dan Concholar, a painter and the director of the Art Information Center in New York City, noted, "It is important to communicate with the black community, but it's foolish to ignore the mainstream power of the art world."

Having a mixed audience can be challenging for artists. Among Pindell's criteria for working with an art gallery is that "the dealer must be comfortable with all kinds of people, since my buyers are black and white;

and the dealer must be comfortable with a black artist who has been suc-cessful—I don't want someone who will try to put me down."

It is not uncommon that African-American artists worry about how "black" the content of their art is. Bill Hodges, a black gallery owner in New York City, stated that some black "artists won't go into abstraction, because of a fear of turning off African-American collectors: African Americans tend to buy representational pictures." Approximately half of Mitchell's sales are for landscapes and still lifes, and the rest are figurative paintings, most of which are black subjects; prior to 1990, the majority of the figures were white. "When I was teaching at the Kansas City Art Institute, I had an African-American student who told me that he was trying to capture skin tone. He went to the museum in town and looked around but couldn't find any representations of black people, and he came to me and said, 'May I see the work you've done, so I can learn how to do it?' I was embarrassed, because I hardly had any images of black people. At that point, I largely stopped painting white people and made a commitment to portray black people." These black figurative works he is able to sell through his white-owned gallery (Bryant Galleries) in New Orleans, "because blacks and whites are all around you—they are in context down there. Otherwise, the only way I can sell my black figurative work is when I make them small—5″ × 7″ or 3″ × 2″. White people don't feel so threatened by these images if they are smaller."

Native-American Artists

"It's a plus in this day and age to be a Native-American artist, because there are collectors just of Native-American art," said Joanne Swanson, a painter and enrolled member of a federally recognized Alaskan tribe. In another day and age, there was far less value in proclaiming oneself a Native American or American Indian, reflecting the low regard with which European settlers held native peoples whose lands they coveted (and forcibly took). Nowadays, as more than $1 billion in American-Indian art-work and crafts objects is estimated to be sold annually and a number of tribes have entered the lucrative gaming industry, more and more people are claiming Native-American ancestry.

The majority of American-Indian art sells in Arizona, New Mexico, and throughout the southwest—at roadside stands, art galleries, and special fairs often called "Indian Markets"—although buyers may also find works sold through the online auction company e-Bay, as well as on other Web sites, Native American and otherwise. The strength of this market has led

to instances of fraud, such as mass-produced items, sometimes imported from abroad and sold as American Indian–made, and to individual artists who proclaim themselves Native American but cannot produce any proof of that assertion.

"We get reports of people claiming to be Seminoles all the time, selling their copies of Seminole designs, when they don't have a speck of Seminole blood in them," a spokeswoman for the Seminole Tribe of Florida in Hollywood said. "We call them members of the Wannabe tribe." To be an enrolled member of the Seminoles, one must have no less than a 25 percent Seminole bloodline.

Numerous claims of misrepresented American-Indian art and other objects led Congress to pass the Indian Arts and Crafts Act of 1990, a truth-in-advertising statute that stipulated stiff penalties (up to $1 million in fines and five years in prison for the first offense) for the creators and sellers of this material who knowingly make false claims about the heritage of those who made the artwork. Under the law, "someone who claims to be an American Indian must be an enrolled member" of one of the 557 federally recognized tribes in the United States, according to Meredith Z. Stanton, chairman of the Indian Arts and Crafts Board in Washington, D.C. The tribes themselves, as legally established sovereign nations, determine qualifications for enrollment, and the federal government is bound to support their decisions with both criminal and civil prosecutions.

The law has helped to rid the market of many artworks and objects that were not created by an actual Native American, Stanton stated, as have advertisements in southwestern magazines and brochures ("Know the Law," "How to File a Complaint Under the Law") that the Indian Arts and Crafts Board has published. "Consumers are asking for information in writing" before they make purchases, she noted, "and the complaints we've received have increased in quantity and quality."

With all the reports of fraud that led up to enactment of the Indian Arts and Crafts Act, the effectiveness of the law cannot be judged by the number of cases brought by the federal government against individuals and companies since then. The Federal Trade Commission filed complaints against two Seattle-based companies, Ivory Jacks and Northwest Tribal Arts, for mass-producing so-called American-Indian artifacts in the mid-1990s. The two companies were fined $20,000 apiece. However, the statute has proven effective, according to Susan Harjo, president of the Washington, D.C.–based Morningstar Institute, a Native American advocacy organization focusing on cultural and treaty rights, because "invoking the law generally accomplishes its intent without cases needing to be brought or brought to fruition. The market has cleaned up its act, and many of the arts

fairs, competitions, and Indian markets have declined applications of pseudo-Indian artists."

As part of its program to promote American-Indian and Alaska-Native arts and crafts, the Indian Arts and Crafts Board produces the *Source Directory of Native American and Alaska Native Owned and Operated Arts and Crafts Businesses*. There are 190 businesses listed in the Directory, including arts and crafts cooperatives, tribal arts and crafts enterprises, businesses and galleries privately owned and operated by individuals, designers, craftspeople, and artists who are enrolled members of federally recognized tribes, and a few nonprofit organizations that develop and market arts and crafts products and that are managed by enrolled members of federally recognized tribes. The directory costs $8 and can be purchased through the Superintendent of Documents, U.S. Government Printing Office, P.O. Box 371954, Pittsburgh, PA 15250-7954, 202-512-1800, or one may examine it electronically through the Department of the Interior's Web site: *www.doi.gov/iacb/order/source_info.html*.

A spotcheck of galleries, museums, fairs, and other venues where Native-American artwork is shown and sold has also revealed a growing, if not fully complete, appreciation on the part of collectors of what it means to be an American Indian artist under the law. "Some collectors have not bought a work, because it wasn't made by a documented Native American," said Julie Wagner, director of Galeria Abiquiu in Abiquiu, New Mexico. "They will pay more for a work by an artist who is fully documented." On the other hand, Bailey Nelson, owner of an art gallery in Seattle, Washington, noted that "people rarely ask if the artist is enrolled or not. Sometimes, I might get into the artist's maternal or paternal linkage to a particular tribe, and it glazes their eyes over." Still, these and other galleries regularly ask the artists they represent for written assurances when they claim to be Native American, "because of the potential of fraud allegations," said Paul Lewin, owner of Adagio Galleries in Palm Springs, California. "No one wants the Justice Department coming down on you." As an example, John Kostura, who directs a Web site that offers for sale artworks by Native American artists (*www.ArtNatAm.com*), noted, "I require a copy of each of the artist's Tribal Membership Card before I list them on ArtNatAm. Also, the artist must stipulate in our contract that they are a member of a recognized tribe."

Contemporary artists are only able to have their work exhibited at the Smithsonian National Museum of the American Indian, the Wheelwright Museum of the American Indian in Santa Fe, New Mexico, and the Indian Fair and Market, held annually at the Heard Museum in Phoenix, Arizona, if they can produce a card from the federal government's Bureau of Indian

Affairs, a Certificate of Indian Blood, or tribal enrollment number. The same procedures are followed elsewhere as well. "Straight out, we say we want proof of enrollment," said Ray Gonyea, curator or Native-American art and culture at the Eiteljorg Museum in Indianapolis, Indiana, which also exhibits the work of living American Indian artists.

The Indian Arts and Crafts Act, and the clarifications added to it since 1990, have sought to eliminate some of the confusion arising from disparate claims for who is an actual American Indian. Some artists have listed themselves as having an American-Indian heritage, background, lineage, descent, or blood; others claim members in tribes not recognized by the federal government. The law now states that enrollment in a federally recognized tribe is the sole basis for claims of being an American-Indian artist. Some artists without proper pedigree and who, perhaps, made false claims for themselves have been excluded from shows and institutions devoted to Native-American art—art galleries, on the other hand, generally do not refuse to show artists whose work bears the markings of American-Indian art but are not enrolled. The market is sizeable for work that looks American Indian, and galleries are not subject to allegations of fraud if they do not knowingly make false claims about the artists.

In the 1980s, the Heard Museum was embarrassed by protests from Native Americans over a show of Randy Lee White, a painter who claimed a Sioux heritage but could not document any connection to the tribe. "He claimed the Sioux, but the Sioux would not claim him," Susan Harjo said. The Heard has since increased its requirements for artists shown at the museum and at its annual Indian Fair and Market. Another painter who has been the subject of protests by members of the Native-American community is John Nieto, who subsequently downgraded his claims of tribal lineage from "internationally known and highly collected Native-American artist" to an artist with "mixed Indian and Spanish blood."

While the Indian Arts and Crafts Act was primarily written to counter the flood of mass-produced imports—"dreamcatchers made by people of Vietnamese descent and marketed as Native American, for instance," said Chris Chaney—the fine art market has been a primary area of concern. "The fine art market is a small percentage of the volume of sales and a large percentage of the revenues" in the $1 billion-plus American-Indian market, according to Angela Gonzalez, a professor of rural sociology at Cornell University who researched the genesis and effects of the law. She noted that the statute remains controversial because of the way in which some full-blooded or part–American Indian fine artists are unable to legally claim themselves Native American. Richard Zane Smith, a sculptor and potter in Glorietta, New Mexico, for example, noted that he would be in violation of

the law if he described himself as Native American, because he is a member of the Wyandot tribe of Kansas, which is recognized by the state of Kansas but not by the federal government (only the Oklahoma Wyandots are federally recognized). The problem also stems from the fact that every tribe determines its enrolled membership in different ways. The Pueblos, for instance, allow people to claim tribal descent only on the mother's side; the son of a Pueblo man and non-Pueblo woman could not be enrolled. One tribe in Alaska reportedly employs a DNA test to determine who is a member. The Hopis require 50 percent "blood quantum" for enrollment, while other tribes permit those who can only prove one-quarter bloodline; yet still other tribes require proof of bloodlines plus having some ongoing connection to the community, which is often troublesome for individuals raised in cities.

The blood-quantum issue generally poses difficulties for people who are the product of intermarriage, which was the aim of the federal government's policy of forced assimilation that persisted until only a few decades ago. The Indian Arts and Crafts Act requires Native Americans to register with only one tribe, which also creates quandaries for some. "I belong to three nations," said Michael Horse, an actor and painter in North Hollywood, California. "I'm one-eighth this and one-eighth that. I'm tired of explaining myself in fractions. I know who I am." And, because the law does not respond to his personal situation, Horse has refused to apply to any one tribe for enrollment.

The law "may be unfair to some," said Gloria Lomahoftewa, assistant to the director of Native American relations at the Heard Museum who is part Hopi and Choctaw herself. "That's why it's so important that your children marry within the tribe."

Other artists have also called the statute unfair, claiming that the issue of "Who is a real Indian?" is leftover racism from the nineteenth century, which the federal government in the twentieth century must now legally enforce. Jaune Quick-to-See Smith, a painter and enrolled member of the Flathead Salish tribe ("with Cree and Shoshoni blood"), complained, "no other ethnic group in this country has to carry a cultural ID card in order to show and sell their art—or to write—or to speak on a public podium. People never ask, and they should, why are American Indians subject to quantifying questions such as 'How much Indian are you?' Would a black person or a Latino answer such a question? Not likely, because physical features often don't reveal one's culture. Culture can define such things as religious preference, foods, language, with its slang and humor, special holidays or celebrations, maybe dress, many other things, including worldview. Defining someone's cultural authenticity by degrees of race is not

only a lunatic idea but it is cultural hegemony right out of our colonial past." She added that "this law violates First Amendment rights. I fear that censorship results from this law."

Another artist whose career has actually suffered from the law, Jimmie Durham, who claims to be Cherokee but is not an enrolled member (and is unable to show his work at a number of Western museums), described blood quantum as "a bunch of racist nonsense." He added, "Saying you are Indian or not sounds good, but it also makes people choose one ancestry over another. I don't see urban Indians as second-class citizens, or reservation Indians as the epitome of all that is truly red."

Considering the fact that some paintings and sculpture in the American-Indian market sell for as high as $40,000, the disputes over who may participate in these events sometimes become quite bitter. The Indian Arts and Crafts Act, for its part, does not prohibit anyone from creating any kind of art they like, nor does it prohibit any collector from buying it. The statute may simply make some artist's work a bit more difficult to find.

Asian-American Artists

As with African Americans, Asian Americans have a "heritage month," in May, when a number of festivals take place around the country. As with African-American collectors of African-American artists, "the buying field among Asian Americans is in its infancy," said Robert Lee, director of the New York City–based Asian American Arts Centre, an organization founded in 1974 to highlight the work of Asian-American artists. Successful artists and craftspeople need to "make it within the white community." To Lee, the future looks brighter than the present, because of sheer numbers. "More Asians are in schools studying the arts than in the past, and their presence can't be ignored. There will be a wave of Asian-American artists in the future." Presumably, these artists and craftspeople will be featured at the same galleries and shows as their white counterparts, but some may look to the exhibition opportunities presented by organizations and societies devoted to Asian arts.

Anything Asian necessarily encompasses a wide variety of peoples, languages, and cultures, and the interests of one segment of this population cannot be viewed as identical to all of the others. However, all artists look to exhibit and, perhaps, sell their work; a source of information for the Asian-American community is the Asian American Arts Alliance (74 Varick Street, New York, NY 10013, 212-941-9208, *www.aaartsalliance.org*), which

acts as an information clearinghouse for individuals and organizations, as well as provides advocacy, technical assistance, and financial management.

For Ken Chu, an installation artist and program director at the Manhattan arts organization Creative Capital, "showing at culture-specific arts organizations was how I got my start as an artist. It was my springboard." He noted that exhibitions of his work at the Asian America Art Centre, Asia Society, and the Museum of Chinese in the Americas helped him establish a "network of curators, critics, and other artists." However, he cautioned artists to "be conscious of how many shows you have" at culture-specific arts organizations, "because you start to get pigeon-holed. A lot of us see ourselves primarily as artists, not as Asian-American artists, and you want to be able to cross over at some point" to more mainstream arts centers and museums.

Latino Artists

Similar to Asian-American arts groups, many Latino or Hispanic organizations hold cultural events during a heritage month or at another time, and these may include an arts and crafts contingent but are not arts and crafts shows in themselves. For instance, there are numerous "Taste of" celebrations around the United States that focus on the food of a particular region or nationality, and artists and craftspeople are allowed to participate as vendors. The benefit of these events is the opportunity to present work in a setting that reflects one's heritage.

However, in order for pieces to be treated as art or fine crafts, these objects often need a venue that exalts them and prompts viewers to show a certain level of respect. Think of this as the institutional theory of art: The white walls of a museum or gallery and distractions that are only other works of art go a long way toward making viewers treat them as precious objects for which real money might be paid. "What's wrong with Latino festivals," said Felipe Rangel, a mask-maker in Queens, New York, "is the target group being catered to. They go to have a fun time, drink beer, and dance. People aren't prepared for what we put into the pieces and the prices we charge, and they get angry at us. The people who sponsor these festivals use us artists as a decoration." He added that he and other craftspeople also find themselves at these festivals competing with importers who "buy truck loads of cheap things from Guatemala and always beat us on price."

There are a growing number of art galleries that feature the work of Latino artists, although they predominantly exhibit work by artists who live and work in Central or South America. The Association of Hispanic Arts

(250 West 26th Street, NY, NY 10001, 212-727-7227, *www.latinoarts.org*) maintains a Latino Arts Directory, listing art galleries and exhibition spaces that are Latino-owned or regularly feature Latino artists, such as Taller Boricua and En Foco in New York City, the National Hispanic Cultural Center in Albuquerque, New Mexico, and the Mexican Museum in Chicago.

Minority Artists and Craftspeople

"As an African-American artist, you have to get into networks and the right circles," said Mary Martin, a glass artist and collagist in Pittsburgh, Pennsylvania. "And, if you're not privy to that circle, it's hard to get offered shows." She is not alone in her assumptions. The arts and crafts world is very much a who-you-know and who-knows-you place, and what works for some creators doesn't work for others. A number of trade publications—including *Art Calendar, American Artist* magazine, *The Artist's Magazine, The Crafts Report*, and *Sunshine Artist*—regularly offer marketing and sales tips for artisans, with the assumption that the ideas presented are applicable for all, but maybe they're not. Perhaps, if our society were even more polarized, artists and craftspeople of different nationalities and races would be shown, honored, and supported by their native communities, but the fact remains that the overwhelming number of buyers are Caucasian and it is to them—and to the mainstream art world—that minority creators must ultimately look. In some respects, we have come full circle: there are opportunities for minority artists and craftspeople to show and sell their work in contexts that reflect their heritage and where the potential for discrimination is greatly lessened, yet the possibility of earning a living from sales still requires them to compete for openings at mainstream shows and galleries with their Caucasian counterparts.

While shows that have an ethnic focus will not support these artists and craftspeople, they may provide a welcoming first step into the larger arts and crafts realm. They may also be part of an effort to create one's own network of patrons and backers. Additionally, artists and craftspeople may expand their networks by looking further afield. For instance, there are minority journalists who may be particularly receptive to writing about creators who share their background. As it is one of the goals of the Asian American Journalists Association to generate more coverage of Asian Americans, one might e-mail a request for the name of an Asian-American journalist writing in the features, lifestyle, or arts and entertainment fields in one's area. Similarly, "we can do a search on our database of Latino journalists who cover the appropriate area," said Joseph

Torres, communications director of the National Association of Hispanic Journalists. Among the relevant organizations to contact are the National Association of Black Journalists (301-445-7100, *www.nabj.org*), the National Association of Hispanic Journalists (888-346-NAHJ, *www.nahj.org*) and the Asian American Journalists Association (415-346-2051, *www.aaja.org*).

Additionally, organizations focusing on certain cultural groups may be helpful in garnering financial assistance for those involved in larger projects. There are others as well, such as the National Black Chamber of Commerce (1350 Connecticut Avenue, N.W., Suite 825, Washington, D.C. 20036, 202-466-6888, *www.nationalbcc.org*), U.S. Pan Asian American Chamber of Commerce (1329 18th Street, N.W., Washington, D.C. 20036, 202-296-5221, *www.uspaacc.com*—there are offices also in Chicago, New York, Dallas, and Los Angeles), and the U.S. Hispanic Chamber of Commerce (2175 K Street, N.W., Washington, D.C. 20037, 202-842-1212, *www.ushcc.com*). A chamber of commerce is an association of business leaders who are likely to have money and know others with money, as well as have an inclination to help their specific community.

Bibliography

W HILE OUT OF FAVOR AND IMPRISONED IN THE TOWER OF LONDON, Sir Walter Raleigh occupied himself with writing *A History of the Whole World.* Nowadays, writers describe ever-smaller pieces of the world, and readers who want a larger picture must build a library (or regularly visit one or more libraries). Like those in other fields, fine artists must keep up to date on their job (and job-seeking) skills and knowledge of how to market their work.

Scholarships

Beckham, Barry. *The Black Student's Guide to Scholarships.* Lanham, MD: Madison Books, 1996.

Bellantoni, John. *College Financial Aid Made Easy.* Berkeley, CA: Ten Speed Press, 1997.

Berry, Lemuel, Jr. *Minority Financial Aid Directory.* Dubuque, IA: Kendal Hunt, 1995.

The Complete Scholarship Book. Lawrenceville, NJ: Sourcebooks, 1996.

Directory of Financial Aid for Minorities. El Dorado Hills, CA: Reference Service Press, 1997.

Directory of Financial Aid for Women. El Dorado Hills, CA: Reference Service Press, 2003.

Directory of Private Scholarships and Grants. Seattle, WA: Student Financial Services, 1996.

Financial Aid for African Americans. El Dorado Hills, CA: Reference Service Press, 2001.

Financial Aid for Asian Americans. El Dorado Hills, CA: Reference Service Press, 2001.

Financial Aid for Hispanic Americans. El Dorado Hills, CA: Reference Service Press, 2001.

Financial Aid for Native Americans. El Dorado Hills, CA: Reference Service Press, 2001.

Jaszczak, Sandra, Ed. *Scholarships, Fellowships and Loans.* Detroit, MI: Gale Research, Inc., 1996.

Peterson's College Money Handbook. Lawrenceville, NJ: Peterson's, 2003.

Schlachter, Gail Ann, and R. David Weber. *High School Senior's Guide to Merit and Other No-Need Funding.* El Dorado Hills, CA: Reference Service Press, 2002.

Schwartz, John. *College Scholarships and Financial Aid.* New York: MacMillan, 1997.

Student Services, Inc. *The Complete Scholarship Book.* Lawrenceville, NJ: Sourcebooks, Inc., 2000.

The Student Guide: Financial Aid from the U.S. Department of Education. Federal Student Aid Information Center (P.O. Box 84, Washington, D.C. 20044-0084, 800-433-3243, *www.ed.gov/prog_info/SFA*, free).

General Job-Search Assistance

Adams Resume Almanac. New York: Adams Publishing, 1998.

Allen, Jeffrey G. *The Complete Q & A Job Interview Book.* New York: John Wiley and Sons, 1997.

Bolles, Richard Nelson. *What Color Is Your Parachute?* Berkeley, CA: Ten Speed Press, 2003.

Camenson, Blythe. *Great Jobs for Art Majors.* New York: McGraw-Hill, 2003.

Christensen, Warren, Ed. *National Directory of Arts Internships.* San Francisco: National Network for Artist Placement, 2003.

Criscito, Pat. *Designing the Perfect Résumé.* New York: Barron's, 1995.

Criscito, Pat. *Résumés in Cyberspace.* New York: Barron's, 1997.

Crispin, Gerry, and Mark Mehler. *CareerXRoads.* New York: MMC Group, 2003.

Elderkin, Kenton W. *How to Get Interviews from Classified Job Ads.* Manassas Park, VA: Impact Publications, 1995.

Electronic Job Search Almanac. New York: Adams Media Corporation, 2000.

Fan, J. Michael. *The Very Quick Job Search.* Indianapolis, IN: JIST Works, Inc., 1996.

Fleishman, Michael. *Starting Your Career as a Freelance Illustrator or Graphic Designer,* rev. ed. New York: Allworth Press, 2001.

Fox, Marcia, and Pat Morton. *Job Search 101.* Indianapolis, IN: JIST Works, Inc., 1997.

Goldfarb, Roz. *Careers by Design.* New York: Allworth Press, 2002.

Hamadeh, Samer, Mark Oldman, and H. S. Hamadeh. *The Job Vault.* New York: Houghton Mifflin, 1997.

Haubenstock, Susan H., and David Joselit. *Career Opportunities in Art.* New York: Facts on File, 1994.

Holden, Donald. *Art Career Guide.* New York: Watson-Guptill Publications, 1983.

The Internship Bible. Princeton, NJ: Princeton Review, 2003.

Internships 1998. Lawrenceville, NJ: Peterson's, 2002.

Job Almanac 1998. New York: Adams Media Corporation, 2001.

Job Hotlines USA. Overland Park, KS: Career Communications, Inc., 1995.

Job Smart. Princeton, NJ: The Princeton Review, 1997.

Kravetz, Stacy. *Welcome to the Real World.* New York: W. W. Norton, 1997.

Langley, Stephen, and James Abruzzo. *Jobs in Arts and Media Managements: What They Are and How to Get One.* New York: ACA Books, 1990.

Lauber, Daniel. *Non-Profits' Job Finder.* Lanham, MD: Planning/Communications, Inc., 1997.

Marino, Kim. *Just Résumés.* New York: John Wiley and Sons, 1997.

The National Jobbanks. New York: Adams Publishing, 1996.

Occupational Outlook Handbook. Indianapolis, IN: JIST Works, Inc., 1998.

Oldman, Mark, and Samer Hamadeh. *America's Top 100 Internships.* New York City: Villard Books, 1996.

Résumés for College Students and Recent Graduates. Chicago: VGM Career Horizons, 1998.

Résumés for Communication Careers. Chicago: VGM Career Horizons, 1998.

Schmidt, Robert. *The National Jobline Directory.* New York: Adams Publishing, 1994.

Slean, Cheryl. *The National Resource Guide for the Placement of Artists.* San Francisco: National Network for Artist Placement, 1998.

Summer on Campus. New York: College Board Publications, 1995.

Wendleton, Kate. *Job Search Secrets.* New York: Five O'Clock Books, 1996.

Career Skills for Artists

ArtCalendar. *Making a Living as an Artist.* Guilford, CT: Lyons Press, 2002.

Bowler, Gail. *Artists and Writers Colonies: Retreats, Residencies and Respites for the Creative Mind.* Accord, NY: Blue Heron Press, 1995.

Caplin, Lee. *The Business of Art.* New York: Prentice Hall, 1998.

Cochrane, Diana. *This Business of Art.* New York: Watson-Guptill, 1988.

Grant, Daniel. *How to Grow as an Artist.* New York City: Allworth Press, 2002.

Grant, Daniel. *The Artist's Guide: Making It in New York City.* New York: Allworth Press, 2001.

Grant, Daniel. *The Business of Being an Artist.* New York City: Allworth Press, 2000.

Grant, Daniel. *The Artists Resource Handbook.* New York: Allworth Press, 1997.

Graphic Artists Guild Handbook: Pricing and Ethical Guidelines. New York: Graphic Artists Guild, 2001.

Indian Arts and Crafts Board. *Potential Marketing Outlets for Native American Artists and Craftspeople.* Indian Arts and Crafts Board (U.S. Department of the Interior, 1849 C Street, N.W., MS-4004, Washington, D.C. 20240-0001), 1993.

Janecek, Lenore. *Health Insurance: A Guide for Artists, Consultants, Entrepreneurs and Other Self-Employed.* New York: American Council for the Arts, 1993.

Langley, Stephen, and James Abruzzo. *Jobs in Arts and Media Management.* New York: American Council for the Arts, 1992.

Martin, Daniel J., ed. *Guide to Arts Administration Training and Research.* Philadelphia: Association of Arts Administration Educators, 1997.

MFA Programs in the Visual Arts: A Directory. New York: College Art Association of America, 2004.

Michels, Caroll. *How to Survive and Prosper as an Artist.* New York: Henry Holt and Company, 2001.

NAAO Directory. Washington, D.C.: National Association of Artists Organizations, 1992.

Phillips, Renee. *New York Contemporary Art Galleries.* New York: Manhattan Arts International, 2000.

Shaw Associates. *The Guide to Arts and Crafts Workshops.* Dallas: Shaw Associates, 2003.

Shaw Associates. *The Guide to Photography Workshops and Schools.* Dallas: Shaw Associates, 2003.

Shaw Associates. *The Guide to Writers Conferences.* Dallas: Shaw Associates, 2003.

Viders, Sue. *Producing and Marketing Prints.* Cincinnati: Color-Q, Inc., 1992.

Art and the Law

Borchard, William M. *Trademarks and the Arts.* New York: Reed Foundation, 1989.

Conner, Floyd, et al. *The Artist's Friendly Legal Guide.* Cincinnati: North Light Books, 1988.

Crawford, Tad. *Business and Legal Forms for Authors and Self-Publishers.* New York: Allworth Press, 1999.

Crawford, Tad. *Business and Legal Forms for Fine Artists.* New York: Allworth Press, 1999.

Crawford, Tad. *Legal Guide for the Visual Artist.* New York: Allworth Press, 1999.

Crawford, Tad. *The Artist-Gallery Partnership.* New York: Allworth Press, 1998.

Crawford, Tad. *Business and Legal Forms for Illustrators.* New York: Allworth Press, 1998.

Leland, Caryn. *Licensing Art and Design.* New York: Allworth Press, 1995.

Health and Safety in the Arts and Crafts

Mayer, Ralph. *The Artist's Handbook.* New York: Viking, 1991.

Mayer, Ralph. *The Painter's Craft.* New York: Penguin Books, 1991.

McCann, Michael. *Artist Beware.* Guilford, CT: Globe Pequot Press, 2001.

Rossol, Monona. *The Artist's Complete Health and Safety Guide.* New York: Allworth Press, 2001.

Shaw, Susan D., and Monona Rossol. *Overexposure: Health Hazards in Photography.* New York: American Council for the Arts and Allworth Press, 1991.

Of Related Interest

Jeffri, Joan. *The Emerging Arts: Management, Survival and Growth.* New York: Praeger, 1980.

Misey, Johanna L., ed. *National Directory of Multi-Cultural Arts Organizations*. Washington, D.C.: National Assembly of State Arts Agencies, 1990.

Mitchell, W. J. T., ed. *Art and the Public Sphere*. Chicago: University of Chicago Press, 1992.

Naude, Virginia, and Glenn Wharton. *Guide to the Maintenance of Outdoor Sculpture*. Washington, D.C.: American Institute for Conservation of Historic and Artistic Works, 1992.

Pascarelli, Ernest T., and Patrick T. Terenzini. *How College Affects Students*. New York: Jossey-Bass, 1991.

Shore, Irma, and Beatrice Jacinto. *Access to Art: A Museum Directory for Blind and Visually Impaired People*. New York: American Foundation for the Blind, 1989.

Snyder, Jill. *Caring for Your Art: A Guide for Artists, Collectors, Galleries, and Art Institutions*. New York: Allworth Press, 2001.

Index

Books from Allworth Press

Allworth Press is an imprint of Allworth Communications, Inc. Selected titles are listed below.

An Artist's Guide: Making it in New York City
by Daniel Grant (paperback, 6 × 9, 256 pages, $18.95)

The Business of Being an Artist, Third Edition
by Daniel Grant (paperback, 6 × 9, 352 pages, $19.95)

How to Grow as an Artist
by Daniel Grant (paperback, 6 × 9, 240 pages, $19.95)

The Fine Artist's Guide to Marketing and Self-Promotion, Revised Edition
by Julius Vitali (paperback, 6 × 9, 256 pages, $19.95)

Business and Legal Forms for Fine Artists, Revised Edition
by Tad Crawford (paperback, includes CD-ROM, 8¹/₂ × 11, 160 pages, $19.95)

Legal Guide for the Visual Artist, Fourth Edition
by Tad Crawford (paperback, 8¹/₂ × 11, 272 pages, $19.95)

The Artist's Guide to New Markets: Opportunities to Show and Sell Art Beyond Galleries
by Peggy Hadden (paperback, 5¹/₂ × 8¹/₂, 252 pages, $18.95)

The Artist's Quest for Inspiration, Second Edition
by Peggy Hadden (paperback, 6 × 9, 288 pages, $19.95)

The Quotable Artist
by Peggy Hadden (hardcover, 7¹/₂ × 7¹/₂, 224 pages, $19.95)

The Artist's Complete Health and Safety Guide, Third Edition
by Monona Rossol (paperback, 6 × 9, 416 pages, $24.95)

The Artist-Gallery Partnership: A Practical Guide to Consigning Art, Revised Edition
by Tad Crawford and Susan Mellon (paperback, 6 × 9, 216 pages, $16.95)

Caring for Your Art: A Guide for Artists, Collectors, Galleries and Art Institutions, Third Edition
by Jill Snyder (paperback, 6 × 9, 256 pages, 41 b&w illus.,$19.95)

Artists Communities: A Directory of Residencies in the United States That Offer Time and Space for Creativity, Second Edition
by Alliance of Artist' Communities (paperback, 6³/₄ × 9⁷/₈, 256 pages, 82 b&w illus., $18.95)

Please write to request our free catalog. To order by credit card, call 1-800-491-2808 or send a check or money order to Allworth Press, 10 East 23rd Street, Suite 210, New York, NY 10010. Include $5 for shipping and handling for the first book ordered and $1 for each additional book. Ten dollars plus $1 for each additional book if ordering from Canada. New York State residents must add sales tax.

To see our complete catalog on the World Wide Web, or to order online, you can find us at ***www.allworth.com.***